IMAGES
of America

CHARLESTON

AN ALBUM FROM THE COLLECTION OF
THE CHARLESTON MUSEUM

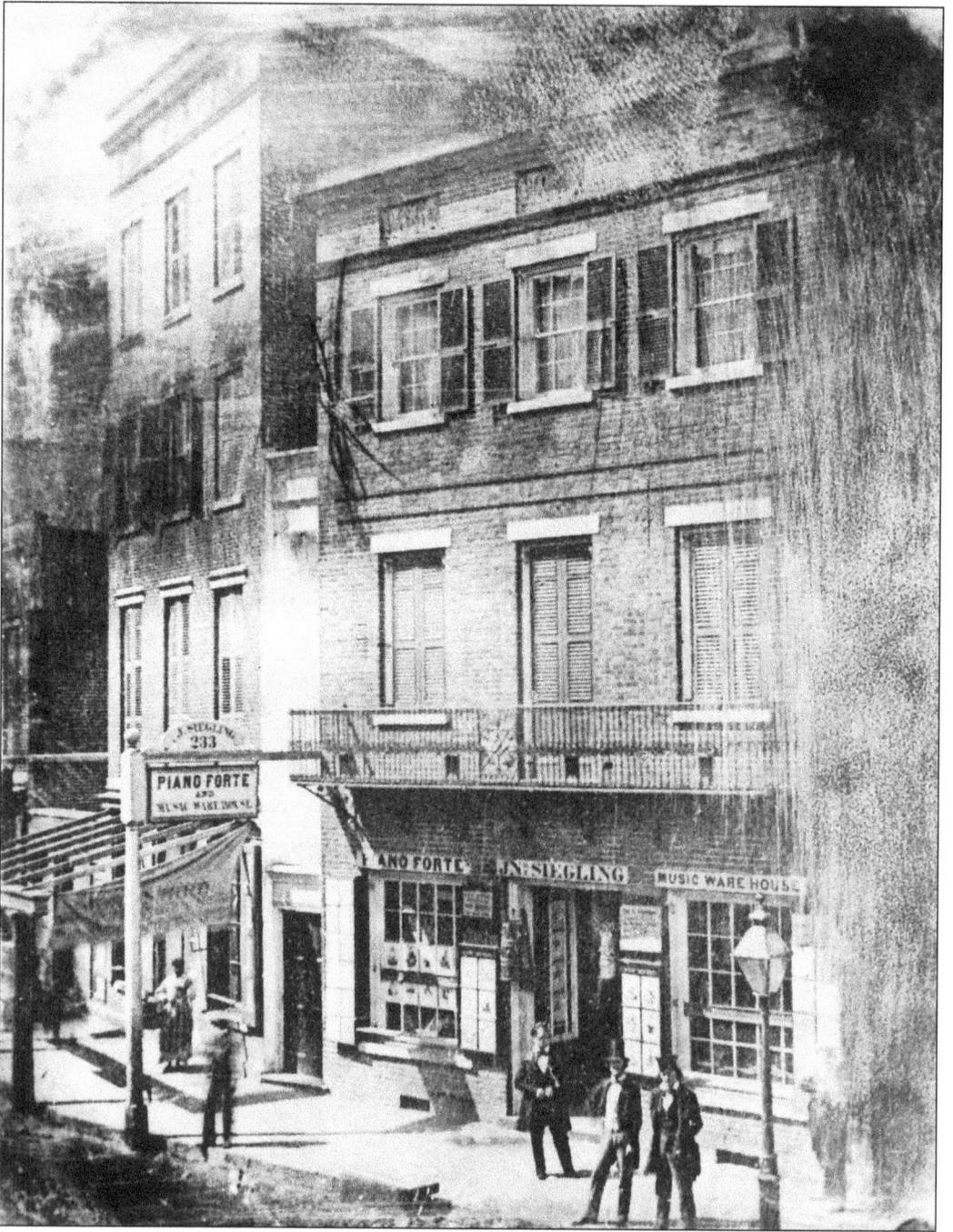

This daguerreotype of the Siegling Music House at 243 King Street was made in the mid-1800s. The posed nature of the scene was not an accident, as exposures could take minutes. This image represents one of the earliest photographs in The Charleston Museum Collection. (MK 8986)

IMAGES
of America

CHARLESTON

AN ALBUM FROM THE COLLECTION OF THE CHARLESTON MUSEUM

Mary Moore Jacoby and John W. Meffert

ARCADIA
PUBLISHING

Published by Arcadia Publishing
Charleston, South Carolina

Library of Congress Catalog Card Number: 2004113864

For all general information contact Arcadia Publishing at:
Telephone 843-853-2070
Fax 843-853-0044
E-mail sales@arcadiapublishing.com
For customer service and orders:
Toll-Free 1-888-313-2665

Visit us on the Internet at www.arcadiapublishing.com

"October in Charleston must be like summertime in Alaska—little yellow butterflies flit here and there; people promenade for the sheer joy of it along the High Battery. The water in the quiet harbor is blue as it has not been all summer. Friend greets friend . . . when the air is cool in the shade and warm in the sun and a gentle breeze is blowing, we will tell that it is a typical Charleston day."—Elizabeth O'Neill Verner, *Mellowed by Time.*

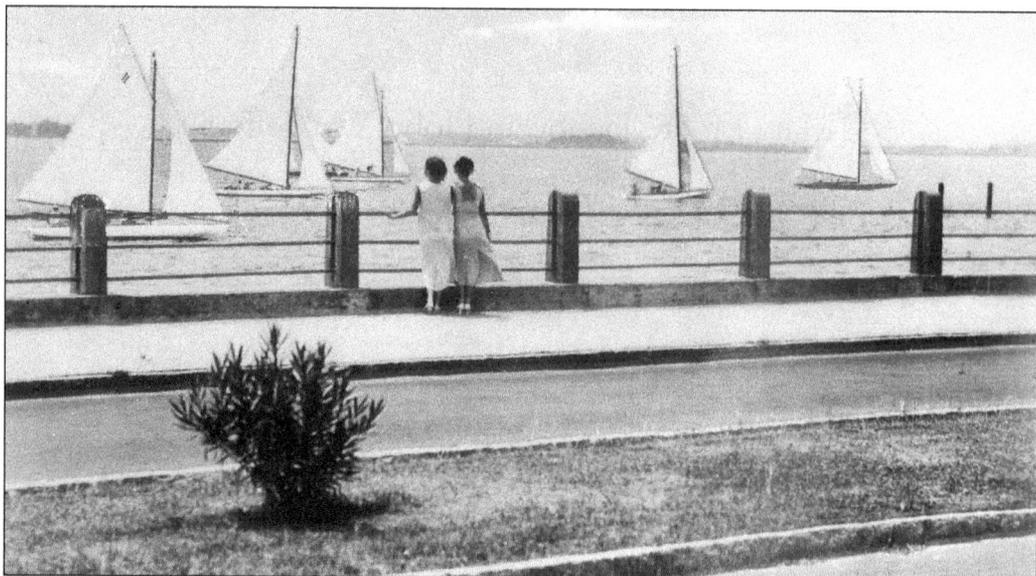

Enjoyment of the harbor, whether on land or water, has been a constant feature of life in Charleston. In this 1933 photograph, two women observe racing boats sailing back toward the City Marina. The road in the foreground was added in the 1920s to connect the recently developed area of Murray Boulevard with East Bay Street. The elevated promenade replaced the earlier oyster shell walls. (MK 1616)

CONTENTS

ACKNOWLEDGMENTS

In 1998 The Charleston Museum celebrates its 225th year as an active institution. Over these many years it has served the city not simply as a repository for the preservation of indigenous artifacts, paintings, decorative arts, and craftsmanship, but the Museum's collections have also included stewardship of numerous historic houses as well as the Dill Sanctuary, one of the largest natural preserves associated with a museum in the Southeast. The Charleston Museum itself has become part of the city's cultural heritage, perhaps the most tangible example of the city's motto, "She guards her buildings, her customs and her laws."

To quote the words of a gentleman who wrote of Charleston's recovery after the 1886 earthquake: "We have dwelt long among the ruins, learning the useful lesson that the life of an institution abides in its men and women, and not its walls and towers." So it is that the authors gratefully acknowledge the support, encouragement, and enthusiasm of the dedicated staff of America's first museum. The Museum's director, John Brumgardt, along with Sharon Bennett and Brien Varnado, provided direction for the project from its inception. Mary Giles was most generous with her time, providing much needed guidance throughout the process of developing this book: leading us through vast numbers of catalogued items in the photographic material and assisting with every phase of the project. Special thanks are also due to Gretchen Rhinehardt, Elizabeth Williams, Cathy Vann, Laura Langland, Gena Runey, Don Nuzum, and Scott Graham for their help and assistance.

We would especially like to thank the following individuals, who gave time and energy to preparing, reviewing, and correcting the copy: Joan Algar, Helen Brown, Wilson Fullbright, Katherine Hammersley, Sarah Hammersley, Pat Hash, Valerie Perry, Elise Pinckney, Denise Scholl, Gene Waddell, and Jane and Charles Waring.

Finally, we would like to acknowledge the work of the many photographers who took the pictures, chief among them M.B. Paine, Robert Achurch, and Franklin Frost Sams. These three in particular took a profound interest in the life of their city, neighborhoods, and families. Thanks to their vision, we now have a picture of life as it was experienced long ago in this small city by the sea.

M.B. Paine
(MK 9961A)

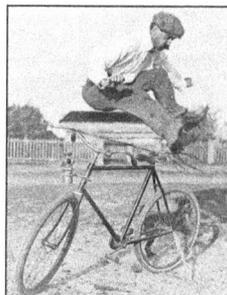

Robert Achurch
(MK 14830)

Franklin Frost Sams
(MK 7789)

INTRODUCTION

Charleston has long been recognized as the quintessential Southern city, retaining the character and the values of a culture that once shaped the national destiny. Since 1975 our cityscape has withstood significant transformation, as the pace of the new Sunbelt economy has brought unprecedented development along the entire Eastern Seaboard. Charleston has grown from a city of 80,000 inhabitants in 1965 to more than 250,000 to date. The land area of the city has increased from 18 square miles in 1970 to more than 75 square miles. The growth in population and in area has meant commensurate change in the way of life in Charleston and in the Lowcountry. These changes mirror the shift of the nation as a whole from small local community life to the more homogeneous life of contemporary urban America.

Thus far, Charleston has retained the character and feel of a dwelling place: a good place to come from and a good place to come home. The character of the region is so strong that more than five million visitors come to Charleston annually to experience its charm. Charleston artist Elizabeth O'Neill Verner described the effect experienced by residents and visitors alike: "It is impossible for me to enter Charleston from any side, whether by land or sea, and not feel that here the land is precious, here is a place worth keeping, this of all the world, is home . . . others feel it too, who are not at home in the sense that home means native land."

For a Charlestonian, whether a "been here" or a "come here," the sense of a place worth keeping is the foundation for the life of the city. The residents are ever watchful sentinels of their home life and their closely-held traditions. Charlestonians are natural preservationists—in a city of dwelling places—where the continuity of public and family life is celebrated and conscientiously carried forward.

Given the number of published histories of the city, the authors chose to instead produce a "family album"—to make accessible The Charleston Museum's extensive photographic record of public and private life in Charleston. *Charleston: An Album from the Collection of The Charleston Museum* should be enjoyed as an accumulation of images that provide a lyrical view of a culture that is self-proud for good reason. The images inform us about daily life in a small, provincial capital that continually defies the caprices of war, weather, and time. The pictures reveal the unconquerable nature of a people who have, for so many generations, maintained Charleston and the Lowcountry as their home.

This book is divided into sections that reflect selections chosen from over 22,000 images in the Museum's collection. The "MK" numbers that follow the captions are catalogue numbers for the original images in the museum archives' cataloguing system. The letters "AWC" following the "MK" numbers indicate images that were drawn from the 1893 publication, *Art Work of Charleston*. As with any family album there are photographs that do not have as much information as we might wish. The Charleston Museum welcomes written correspondence from those who can contribute further to the documentation of the photographic collection. It is the authors' intention to share the visual wealth of The Charleston Museum's photographic collection, now, on the occasion of its 225th anniversary.

Charleston's tradition of preservation is not just about the past, but rather incorporates wisely each generation's contribution for the future. In a small volume entitled *Charleston Grows* (1949), Herbert Ravenel Sass observed:

We look to the future, but we shall keep the past, and this most fortunately we can do, because it is here before our eyes in the beloved stones and streets of the town. There are many reasons for keeping it, and one reason is that, living amid these works and memorials of a time which had both strength and beauty, we may hope to derive something from them. If we can find in ourselves the same qualities of which the old houses speak, we can make, in our new way, with our factory chimneys and our ship funnels, a new Charleston that may be worthy of the old.

We echo this sentiment, and hope that the new visions for Charleston will continue to be worthy of her glorious past.

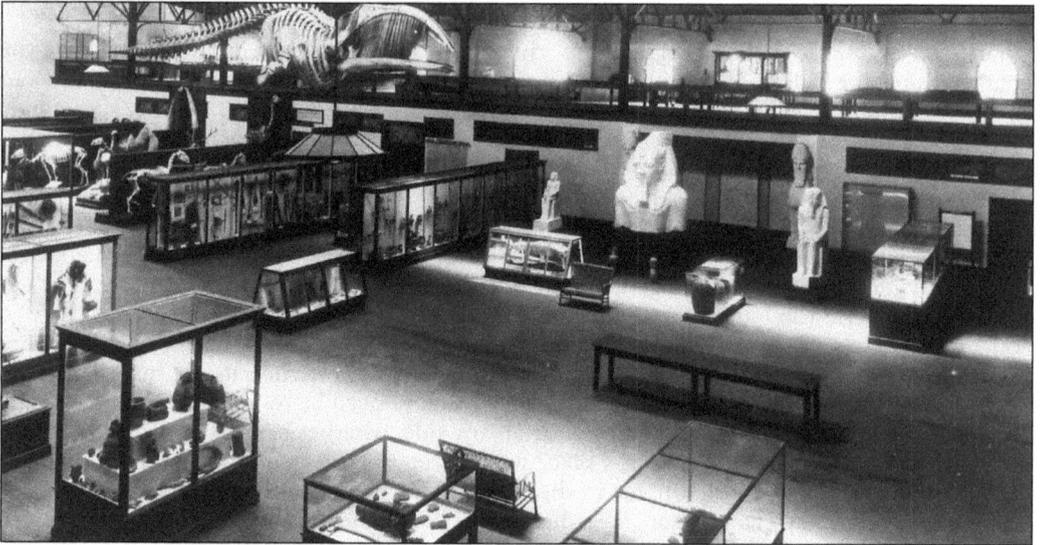

The Great Hall of the Charleston Museum on Rutledge Avenue presented the museum's collections for over seventy-five years. In this 1950s view of the interior, the whale hangs over exhibits of rice culture, Indian artifacts, the Egyptian collection, and natural history specimens. (MK 3359)

The Charleston Museum is the oldest museum in North America. For many years it was the only museum in the state of South Carolina. The educational purposes of the museum are indicated in this nineteenth-century leaflet provided to attract the public. (MK 7038B)

One

AMERICA'S
FIRST MUSEUM

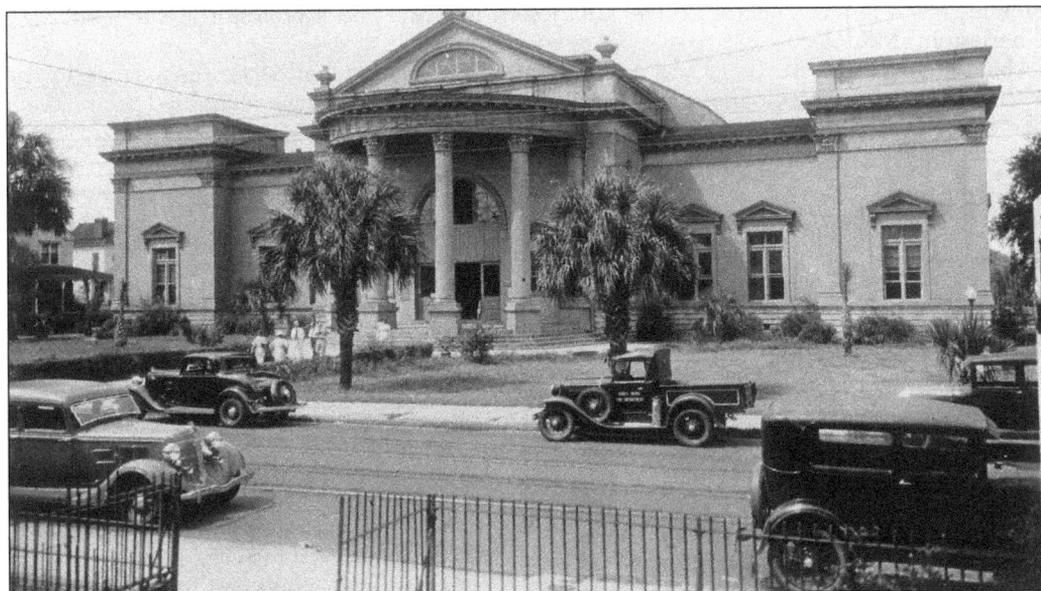

Architect Frank P. Milburn designed the Thomson Memorial Auditorium in 1899. Constructed in only ninety days, the building housed the first reunion of United Confederate Veterans. By 1907, the Museum's director, Paul M. Rea, persuaded the City to turn the building over to the Museum to house its collections. The building exterior facing Rutledge Avenue was quite grand, while the building itself was not quite so grand. Built as a temporary building of lathe wood and plaster, it was not designed to house the heritage of the city. The roof leaked and, though each director requested support for a new facility, it was not until the 1970s that planning was completed for a new museum. (MK 6772)

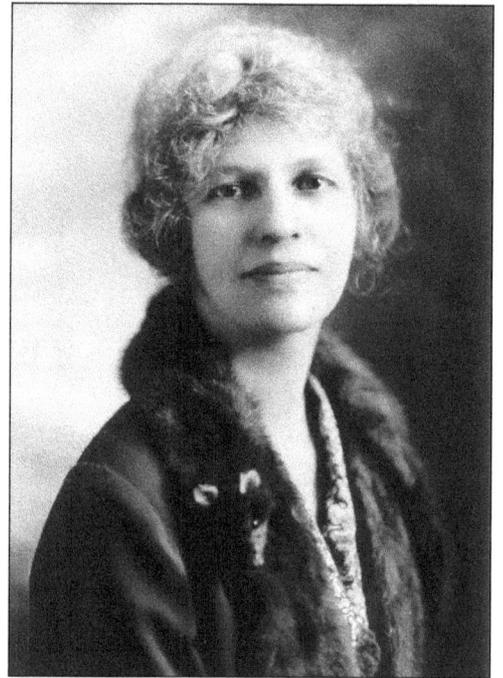

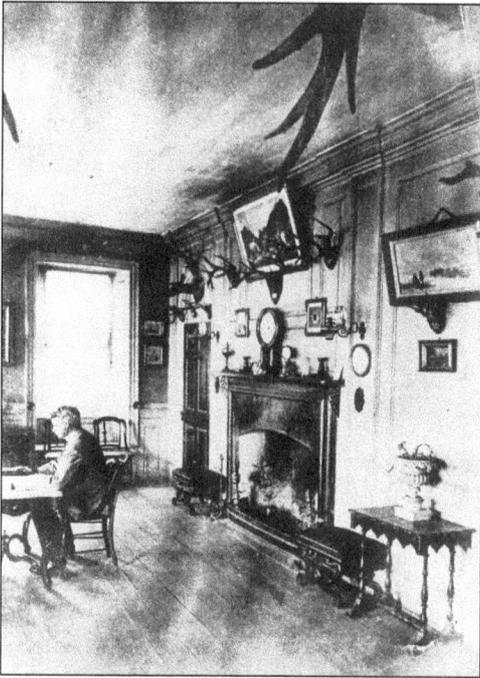

(Above left) Professor Francis Holmes works in the parlor of his country house, Ingleside. Holmes was a former director of The Charleston Museum and a professor at the College of Charleston. (MK 9930)

(Above right) Laura M. Bragg was one of the leaders of the Charleston Renaissance in the 1920s. Director of The Charleston Museum from 1920 to 1931, Bragg revitalized the museum and created Charleston's first free library. (MK 1861)

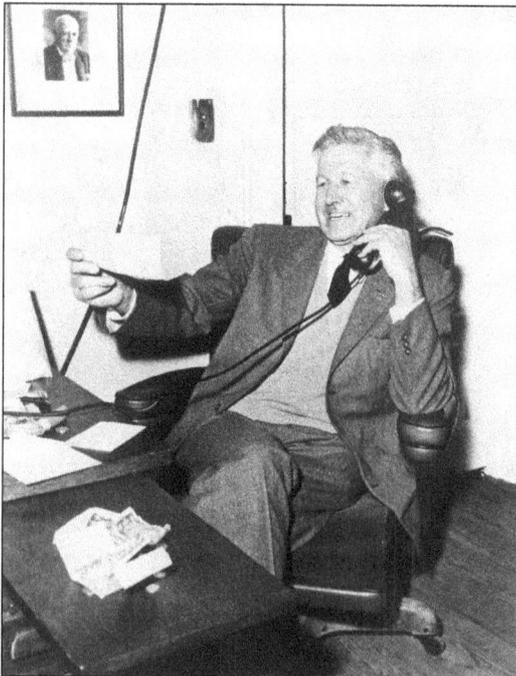

(At left) Milby Burton, director of The Charleston Museum from 1933 to 1972, was one of Charleston's greatest boosters. Actively involved in every effort to preserve Charleston's past from the 1920s forward, Burton brought a lively intellect and a sense of humor to efforts to preserve the past. He successfully acquired the Heyward-Washington House and Joseph Manigault House as house museums, while building the collections and initiating the effort for a permanent home for the museum. (MK 10854)

The Heyward-Washington House is shown here in 1928, prior to the Museum's purchase of the property. The house retained its original interior woodwork above the ground floor. The possibility that the original woodwork might be sold to a buyer in another city led The Preservation Society to mount an effort to purchase the building. Restoration of the building started with removal of the bakery on the first floor. The house was opened as Charleston's first museum house in the 1930s. (MK 18415)

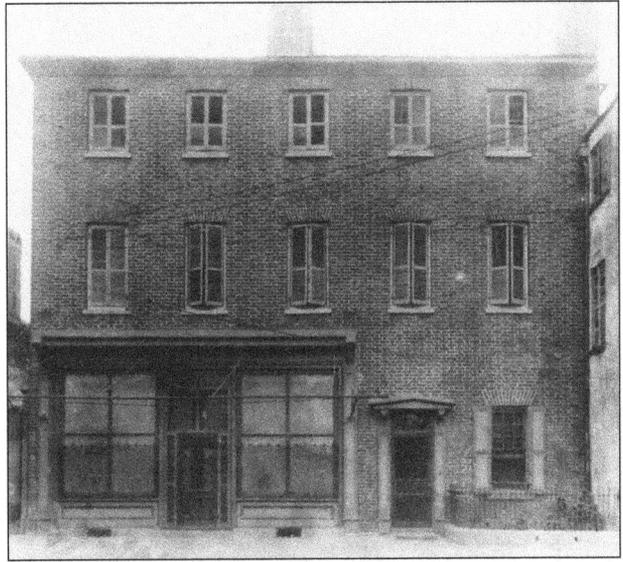

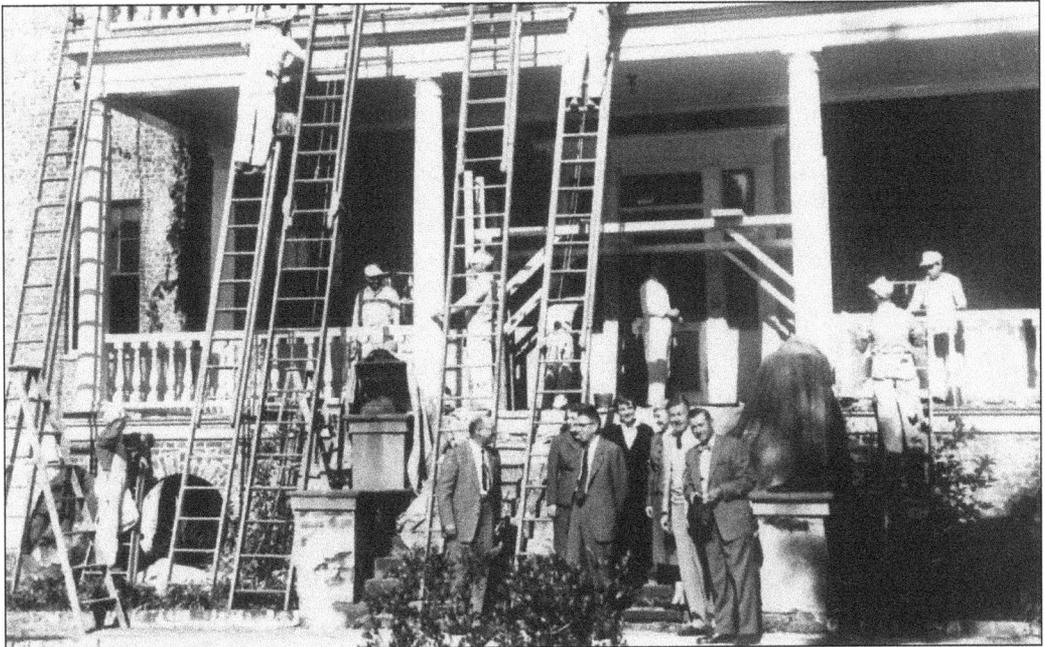

The Joseph Manigault House became the second house restoration acquired by the Museum. Originally saved from the wrecking ball by Mr. and Mrs. Ernest Pringle in the 1920s, the combined efforts of the Pringles and the newly formed Preservation Society of Charleston failed to keep the property from the tax auction in 1933. Museum Director Milby Burton convinced the heiress of the A & P food stores fortune, the Princess Pignatelli, to anonymously purchase the property and donate it to the Museum for restoration. Here, workmen swarm to prepare the house for an opening. Albert Simons directed a volunteer crew toward permanent improvements to the property. After W.W.II, the Manigault House was restored using funds from a bequest of Princess Pignatelli in honor of her mother, Mary Guerard. The house officially opened as a house museum in March 1949. (MK 5351)

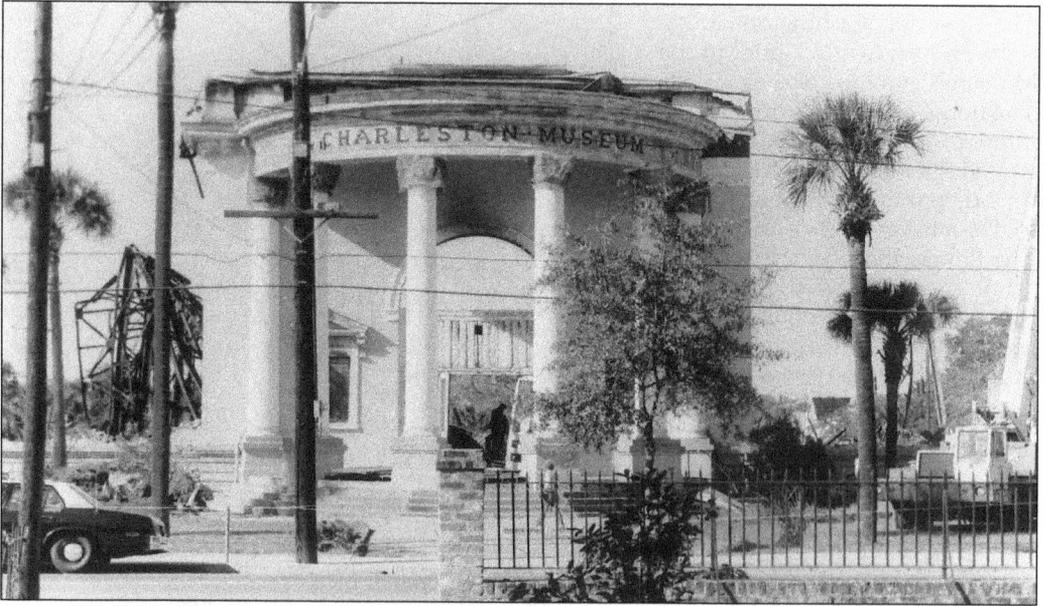

This photograph taken shortly after the fire of October 17, 1982, shows all that remained of the building on Rutledge Avenue, only two months after the collections were moved to the new museum building on Meeting Street. Fire had always been the great fear of Museum staffers who were relieved to be in the new facility. After much debate, it was determined that the columns of the portico of the old museum would remain at the old address. The columns are now the central visual feature of Cannon Park at the corner of Bennett Street and Rutledge Avenue. (MK 5140E)

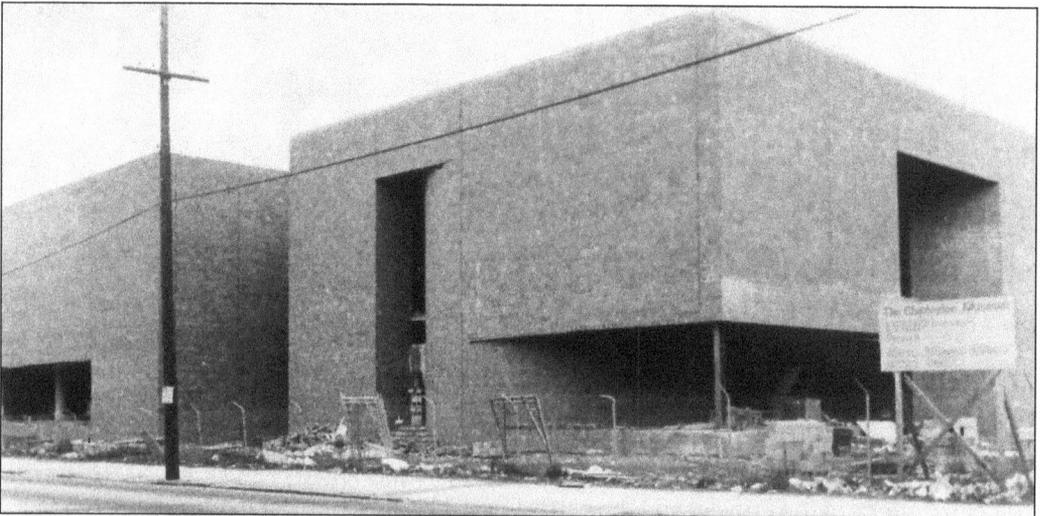

Approval of the plans initiated the construction process for the new museum at 360 Meeting Street. Site work began in 1979 and proceeded until the formal dedication in 1982. The location was chosen to draw visitors to a new cultural district including the Museum, the Aiken-Rhett House, and the proposed Visitors Reception and Transportation Center. The museum building is nearing completion in this late 1981 photograph. The building, designed by the firm of Chrissman and Solomon, represented the latest thinking in museum architecture of the period and won a design competition in 1976. (MK 13463)

12

Two

AFTER THE RECENT UNPLEASANTNESS

"The very ideals of which in their political and social applications Charleston had been the author and to which for 200 years it had given its utmost devotion, had been cast down and branded as not only unsound but darkly wicked. It was this spiritual disaster, this discovery that truth could perish, that stunts Charleston's mind and numbed its body and those who seek for a reason for its long lethargy need search no further than this."—H.R. Sass, Charleston Grows (1949) pp. 20–21.

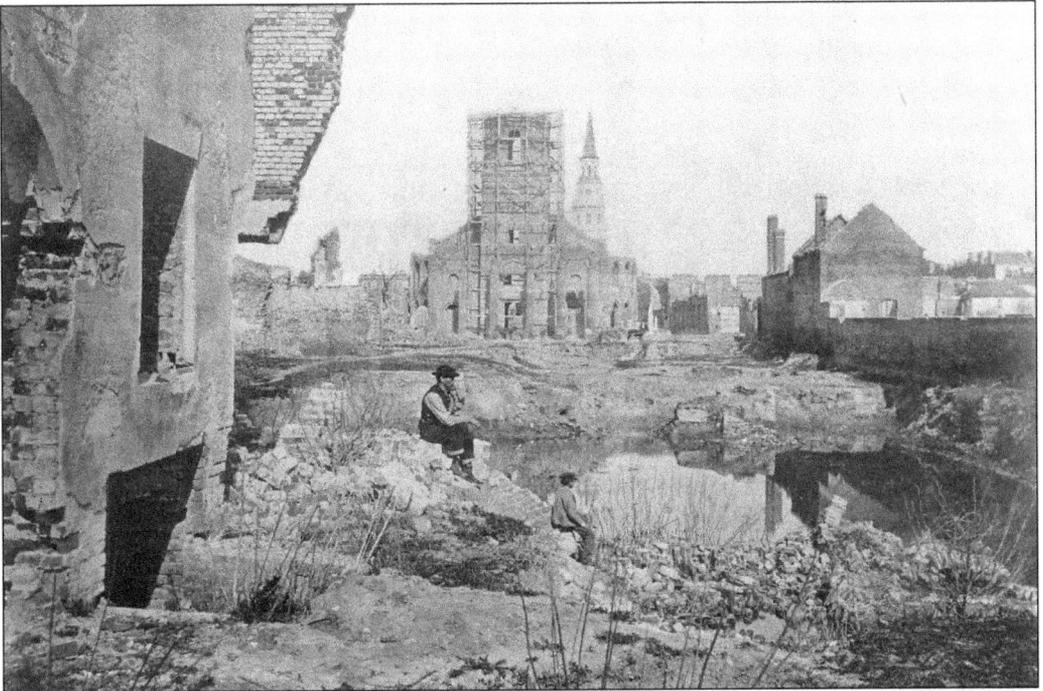

A destructive fire that swept the peninsula in 1861 destroyed over 530 acres of the city. A photograph by General Sherman's photographer, George N. Barnard, documents the condition of the city. Even before the Union bombardment, this area was in ruins. Because of the ongoing upheaval, very little was rebuilt until long after the war was over. (MK 22919)

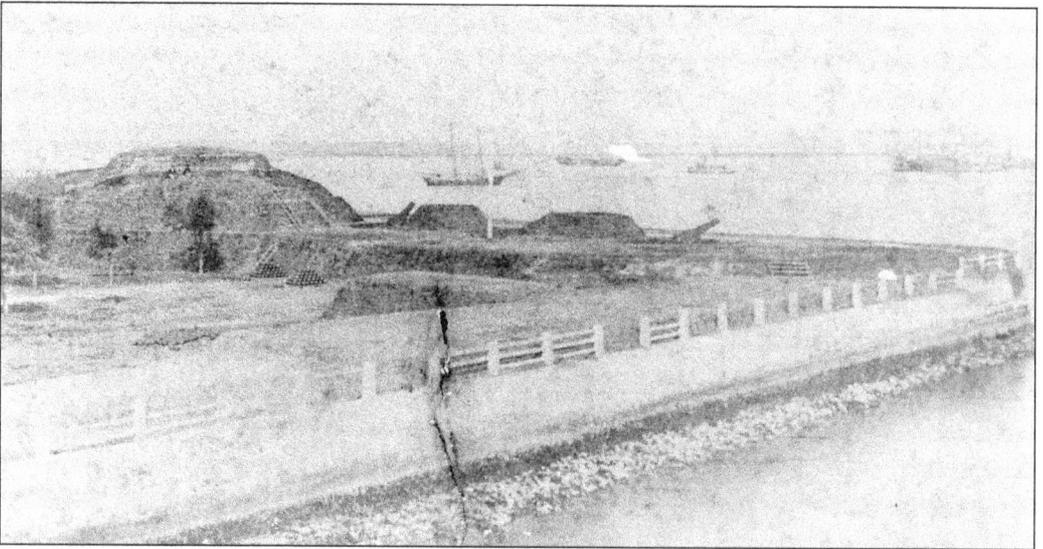

This 1865 view shows the condition of White Point Gardens immediately after the abandonment of the city by Confederate forces. Note the excavation of the park itself to provide soil for the raised batteries. Charleston endured the longest siege ever mounted against an American city and never fell to Union forces. (MK 14724)

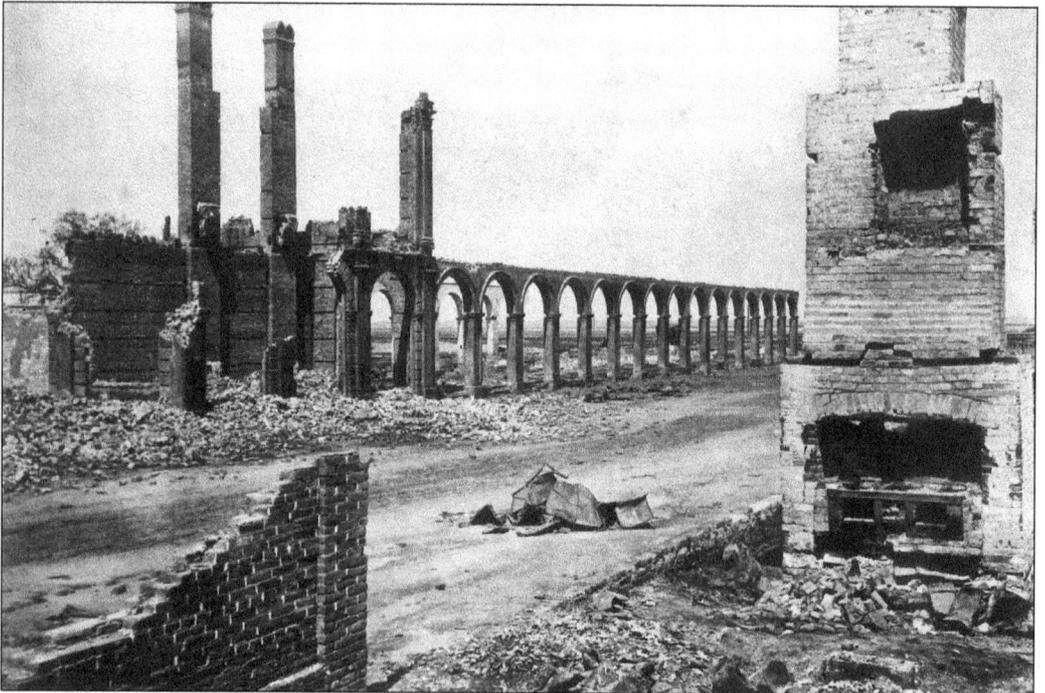

George Barnard photographed the Northeastern Railroad Depot in 1865. The destruction of the Depot was one of the great tragedies of the war. The evacuating Confederate soldiers set fire to cotton stores that might fall into Union hands. It was reported that a group of children carried gunpowder from a shed to throw at the warehouse fire, creating a trail of powder. The fire spread on the trail, and the resulting explosion destroyed the depot and all around it, killing 150 people. For a city already devastated, this was the final blow. (MK 22918)

14

Former governor William Aiken is shown in this 1870s portrait beside furnishings acquired on his European tours. With wealth accumulated from his many plantations, Governor Aiken and his wife were able to elegantly appoint their new house on Wragg Mall. (MK 10198)

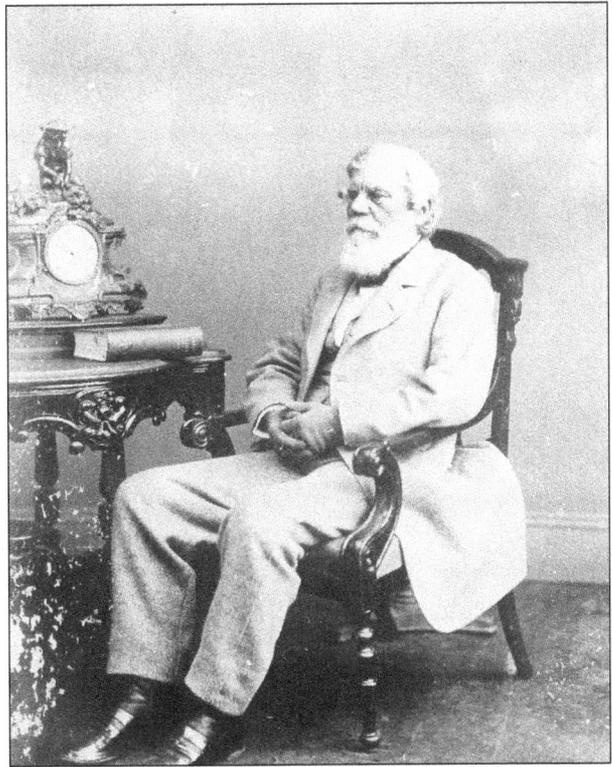

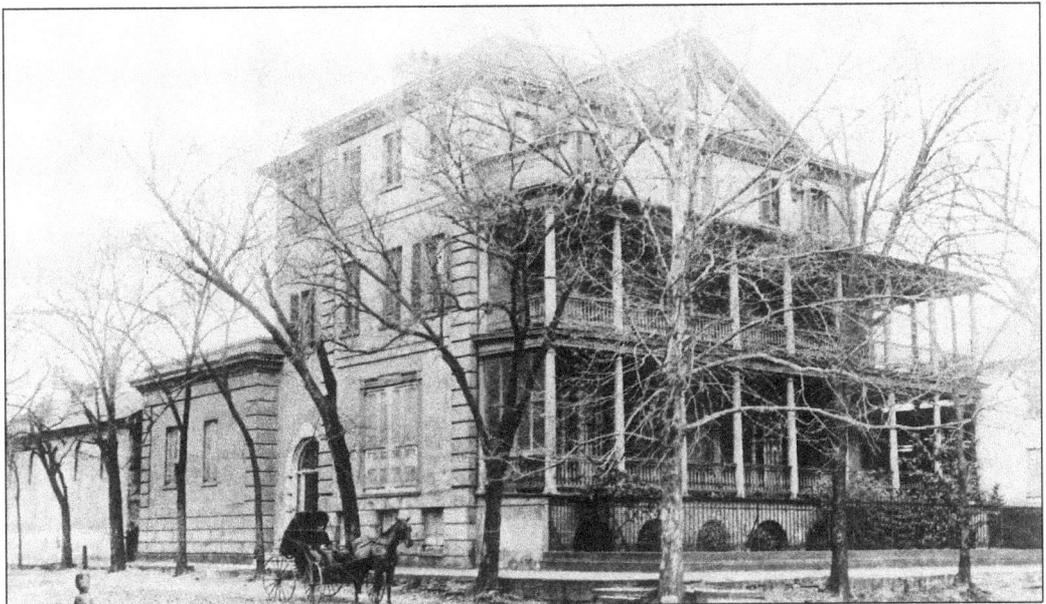

William Aiken survived the war with his land holdings intact and lived in the great house on Wragg Mall that he and his wife acquired in 1833. The house was remodeled in the early 1830s to accommodate acquisitions from their wedding trip. The house remained in the family's possession until it was donated to The Charleston Museum in the early 1970s with many of the original furnishings and decorations intact. (MK 22910, AWC)

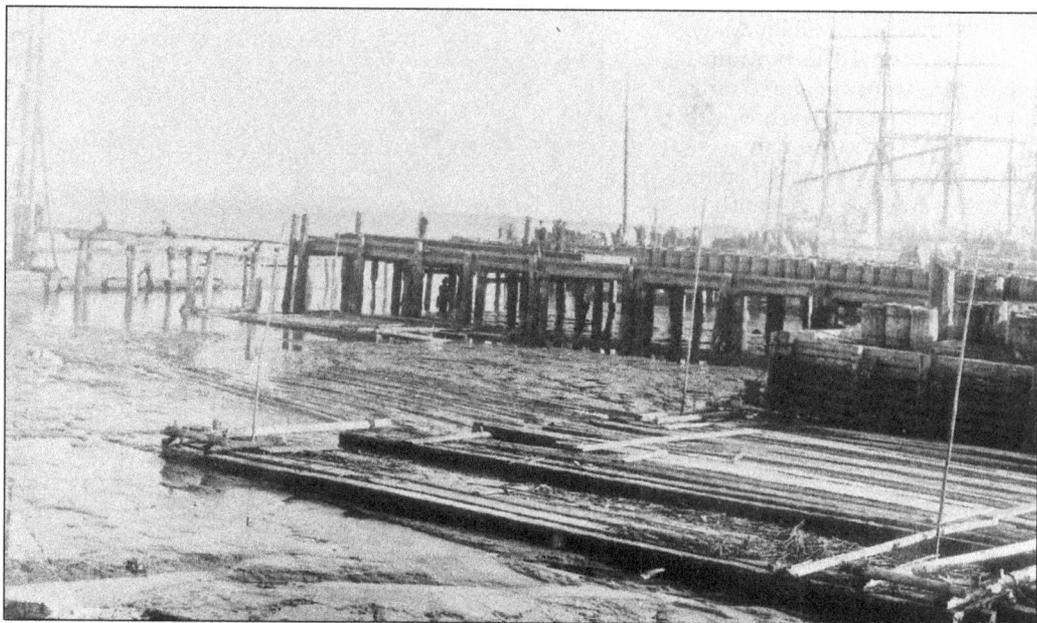

In 1870 the Anderson Lumber Co. wharves along the Ashley River showed log rafts and logs awaiting transport. Lumber remained a key industry for the port of Charleston. Demand for lumber increased during the 1880s with the growth of Victorian "streetcar suburbs" in the city and in other parts of the country. (MK 22697)

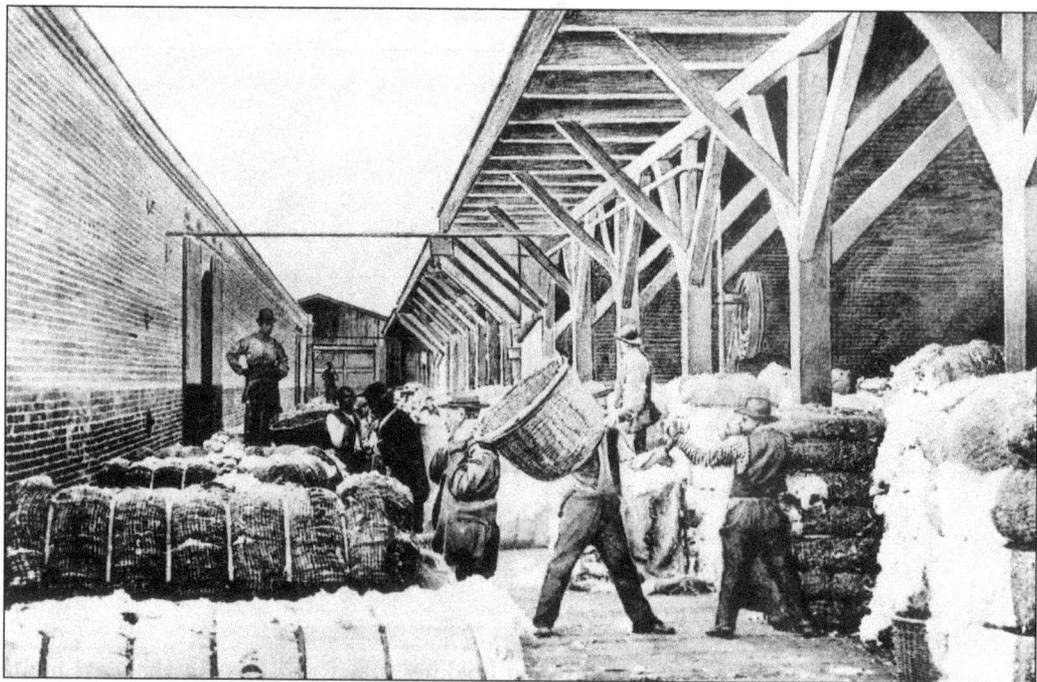

The Union Cotton Compress, at 286 East Bay Street, stood opposite the end of Pinckney Street above the city market. Cotton was brought here to be compressed into bales for shipping through Union Terminal to ports around the world. This photograph, made c. 1890, is from a booklet entitled *Indelible Photographs* by A. Witteman. (MK 7244)

16

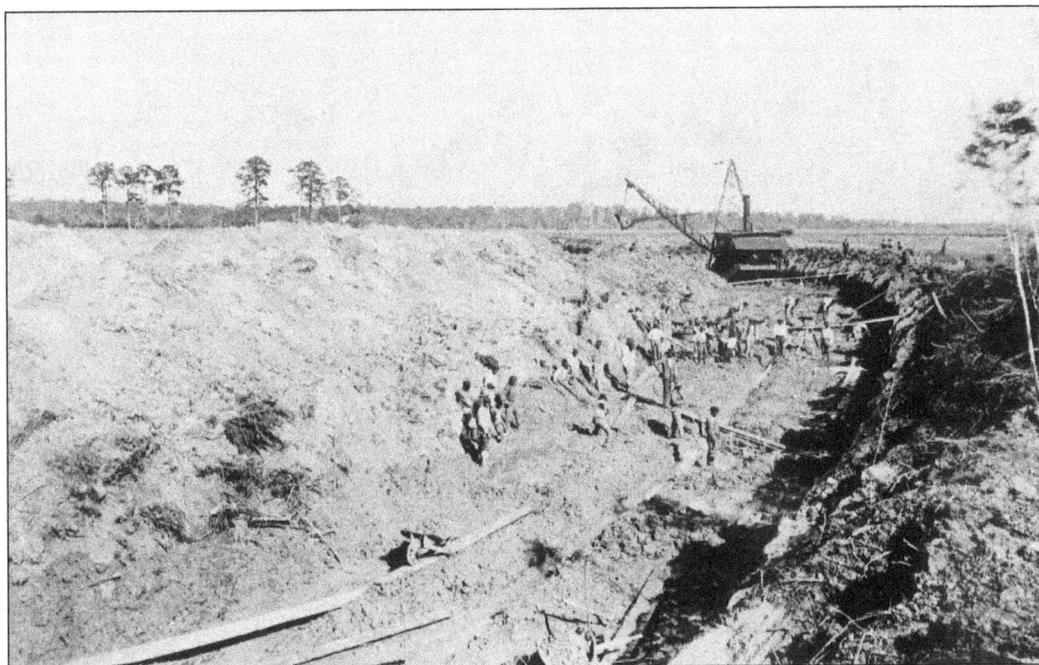

The phosphate industry developed after 1870 as the Lowcountry's major source of revenue second to cotton. The rich beds of fossil material underlying the Lowcountry were recognized in the 1850s as a source of material for fertilizer. Technology developed in the 1860s, and steam equipment, such as the crane in the distance, enabled the phosphate rock to be mined commercially. The process involved removing the upper level of the topsoil, mining the fossil beds, and crushing the rock to a fine powder. (MK 22913, AWC)

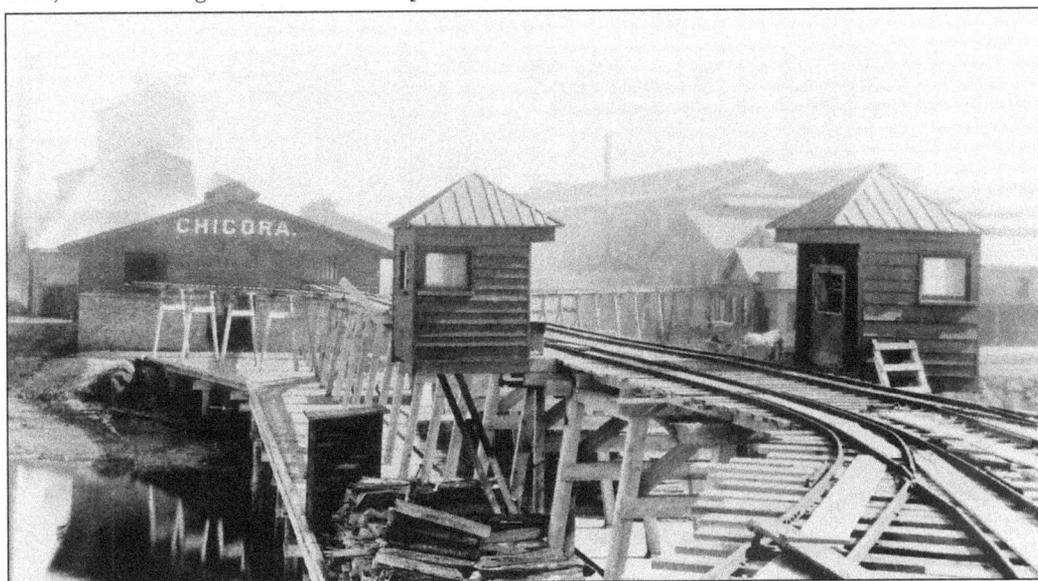

The Chicora Phosphate Works on the upper Ashley River was an example of the new post-war industrial development. Rock was mined and then transported by barge or rail to facilities like this one where it was pulverized, bagged, and sent through the port of Charleston to all parts of the globe. (MK 22646, AWC)

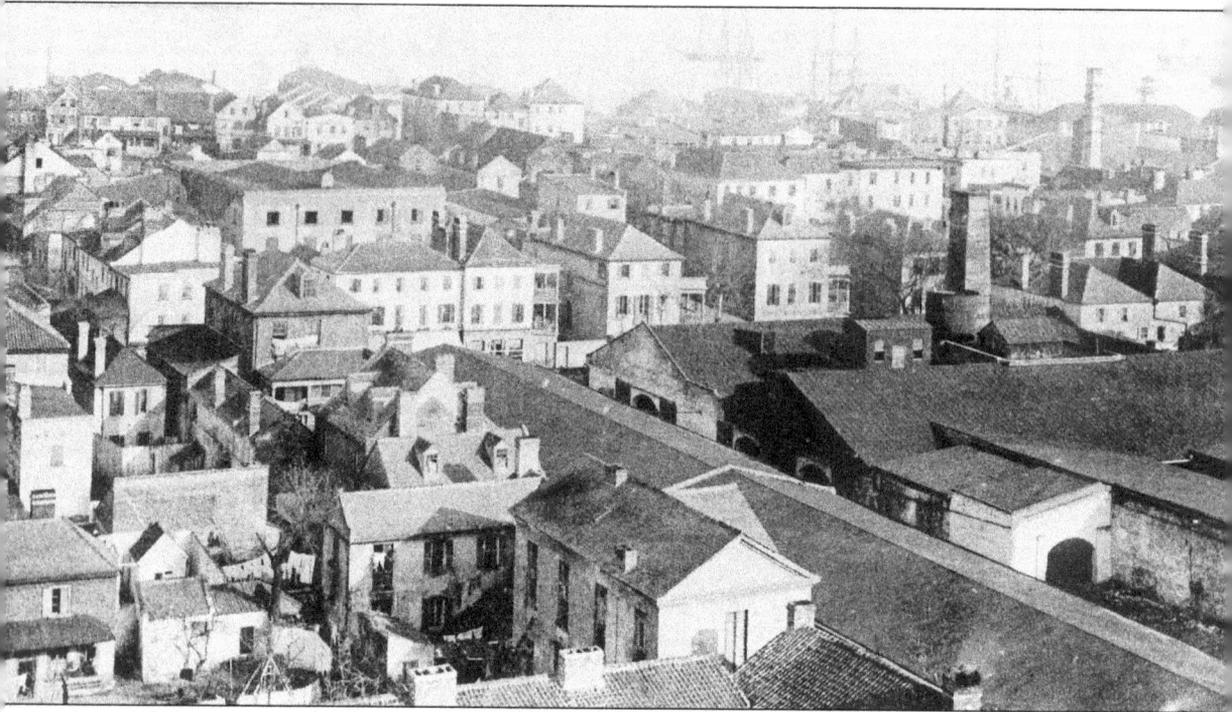

By the end of Reconstruction, Charleston had begun to recover. Although port activity did not attain its pre-war levels, the city regained a higher level of economic stability. The lower peninsula south of Broad Street remained an area of mixed uses. In the foreground, the law offices of the famous Unionist James Louis Petigru look out to a scene of warehouses and industrial buildings. In the distance, smokestacks rise over Church Street. (MK 22647, AWC)

Three

ON THE WATER

"Charles-Town . . . stands on a point very convenient for trade, being between two pleasant and navigable rivers."—John Lawson, A New Voyage to Carolina, 1709.

"Many ports have outgrown their seafaring roots, while others have historic buildings that ignore the water. Charleston has always turned its face seaward. The Charleston single house, it has been said, was designed like a ship at full sail, trimmed to catch the wind that blew in from the Atlantic."
—Earnest Wood, Southern Living, 1988.

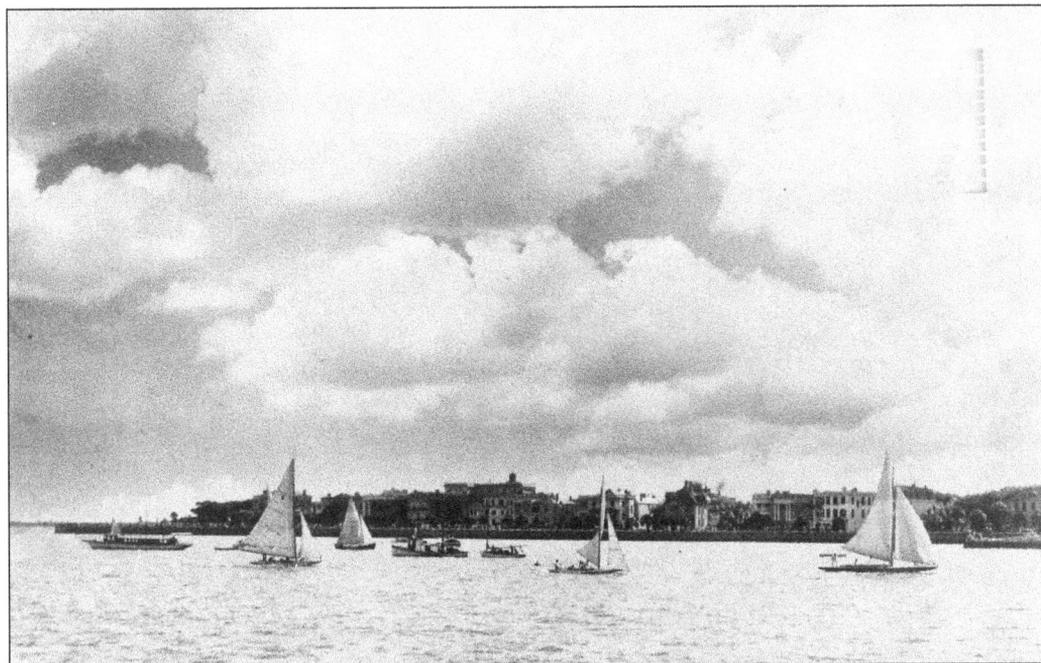

M.B. Paine entitled this photograph *Boats and the Old City by the Sea*. The Battery has witnessed the beginning and end of sailboat races from the Carolina Yacht Club since its inception in 1883. Here, under a typical summer sky, boats are returning to the Yacht Club dock after a race in July 1936. (MK 8072)

The waterfront along East Bay Street remained a commercial part of the city through the 1940s. Here at North and South Adger's Wharf, boats are tied to docks. (MK 1702)

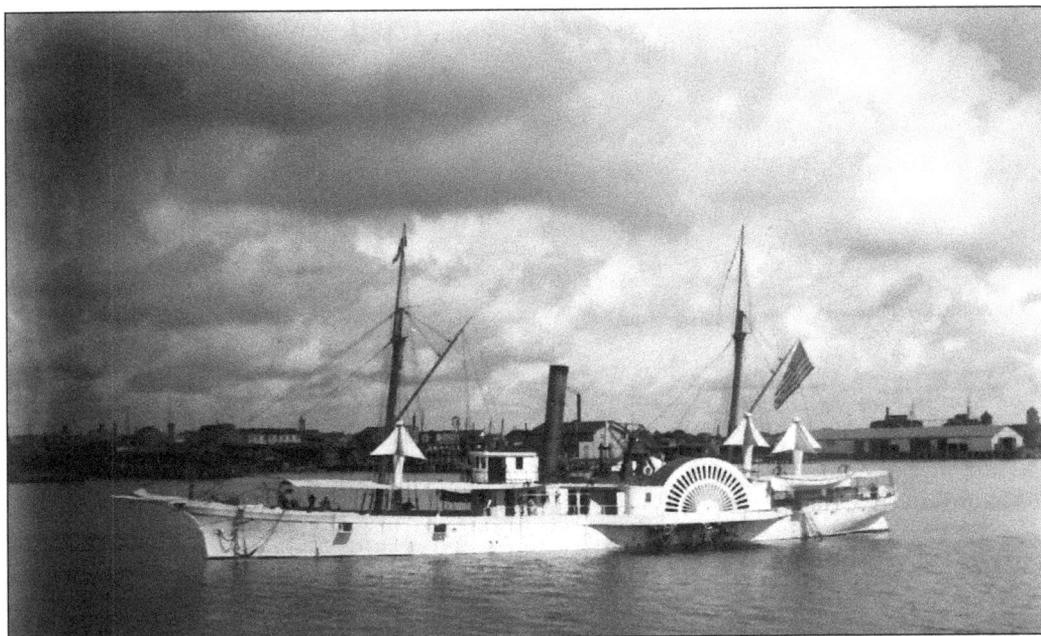

Charleston became the jumping-off point for the U.S. Navy on the way to and from Cuba during the Spanish-American War. The revenue cutter *Colfax* is shown with its paddle wheel and masts as it anchored in the harbor in 1898. (MK 7647)

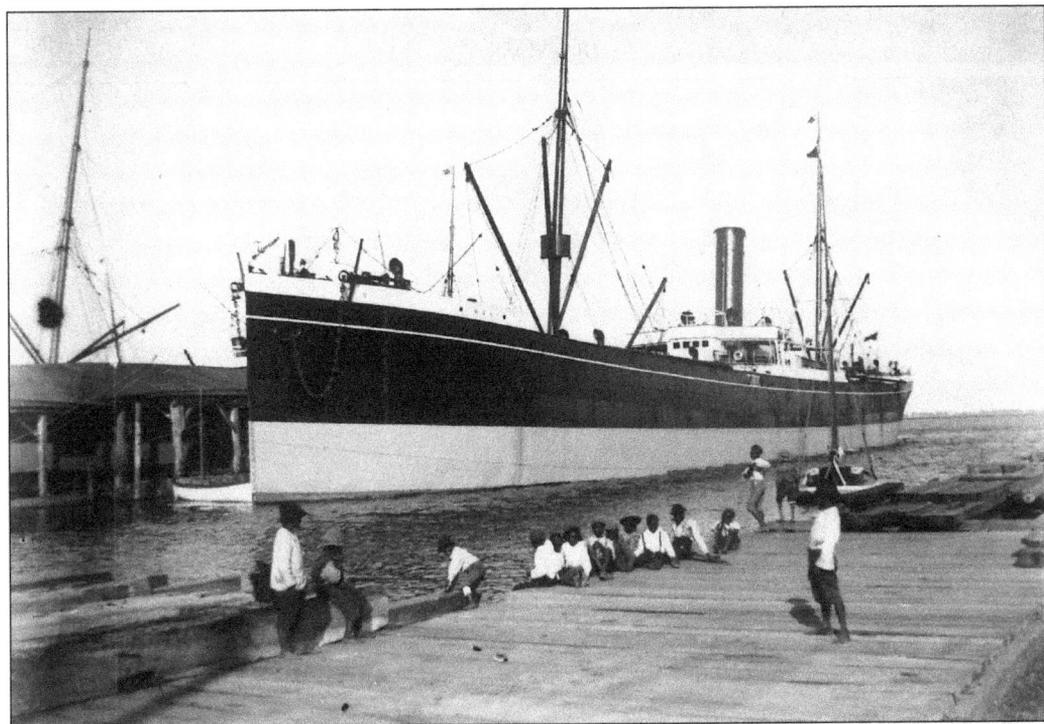

Dr. Franklin Frost Sams took this portrait of the *Imani*, a banana freighter, at the banana docks on the Cooper River side of the city. At one time, almost eighty percent of all the bananas imported to the United States arrived by way of Charleston for transshipment. (MK 7557)

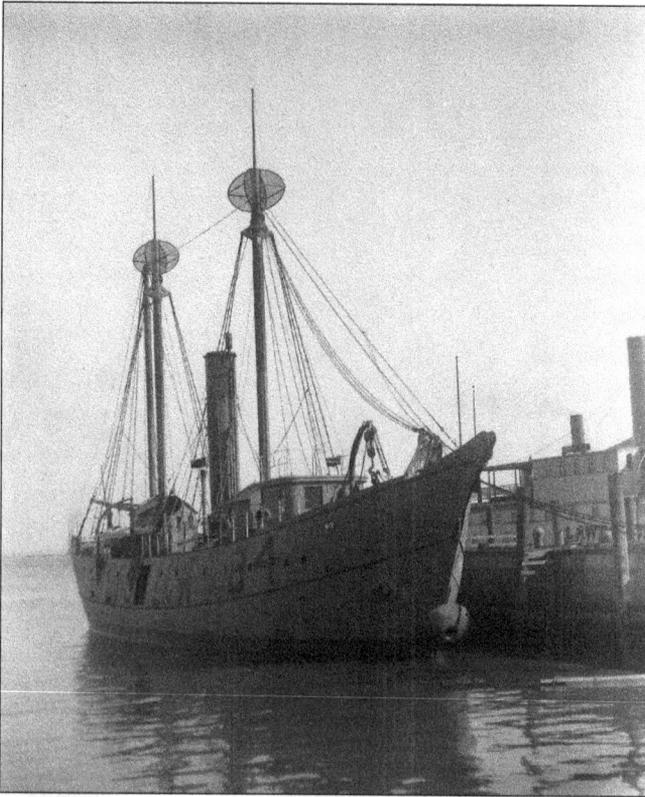

Lightship #84 was photographed at dock in Charleston, c. 1900. Such lightships were used to mark navigational hazards, sandbars, and shoals near the harbor entrance. The construction of the Charleston jetties took many years and required the use of lightships to mark the entrance as the jetties were being built. (MK 7817)

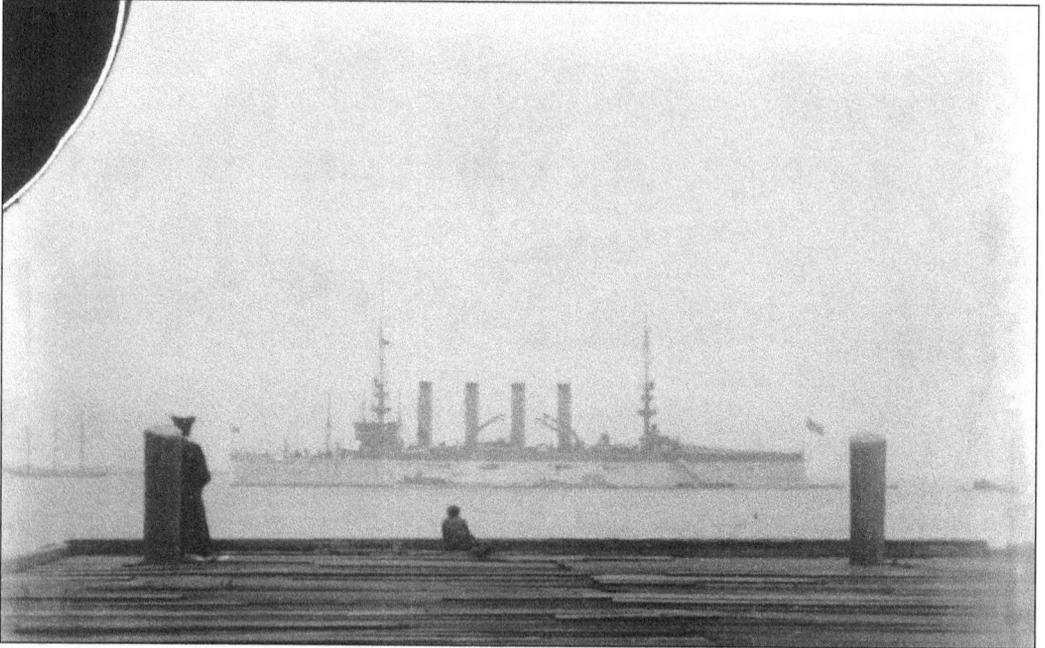

The USS *Charleston* is shown beyond the Union Wharf in January 1906. The *Charleston* is visiting the new Naval Station established in 1905 at Chicora Park, now North Charleston. (MK 7757)

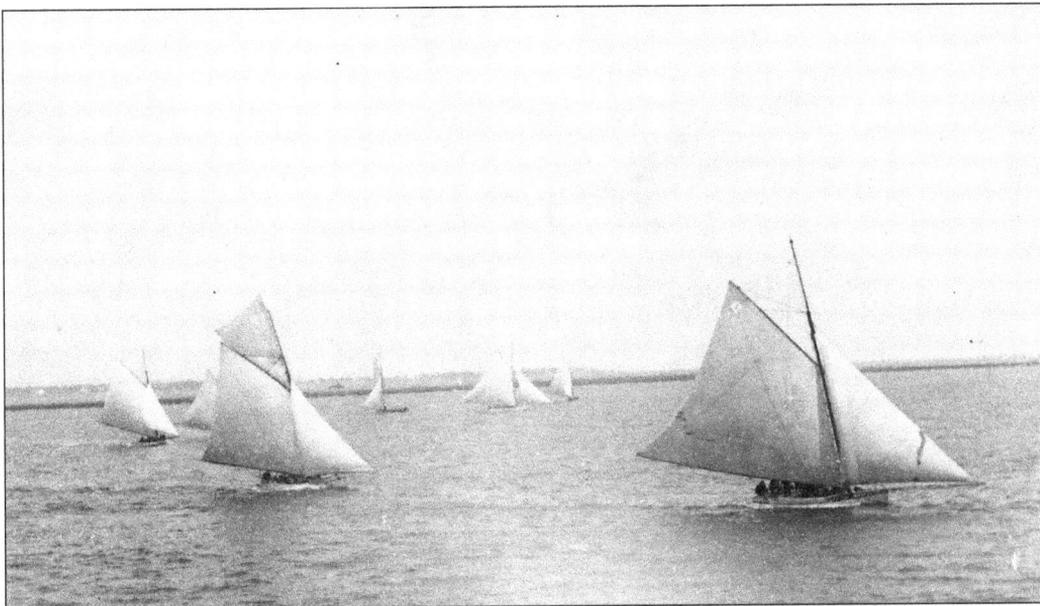

This 1904 view of a Carolina Yacht Club regatta shows a special type of boat called a Sandbagger. These boats carried one hundred sandbags as ballast so that they could be overcanvassed for greater speed. They sailed in New York Harbor, Chesapeake Bay, and Charleston Harbor. (MK 18546)

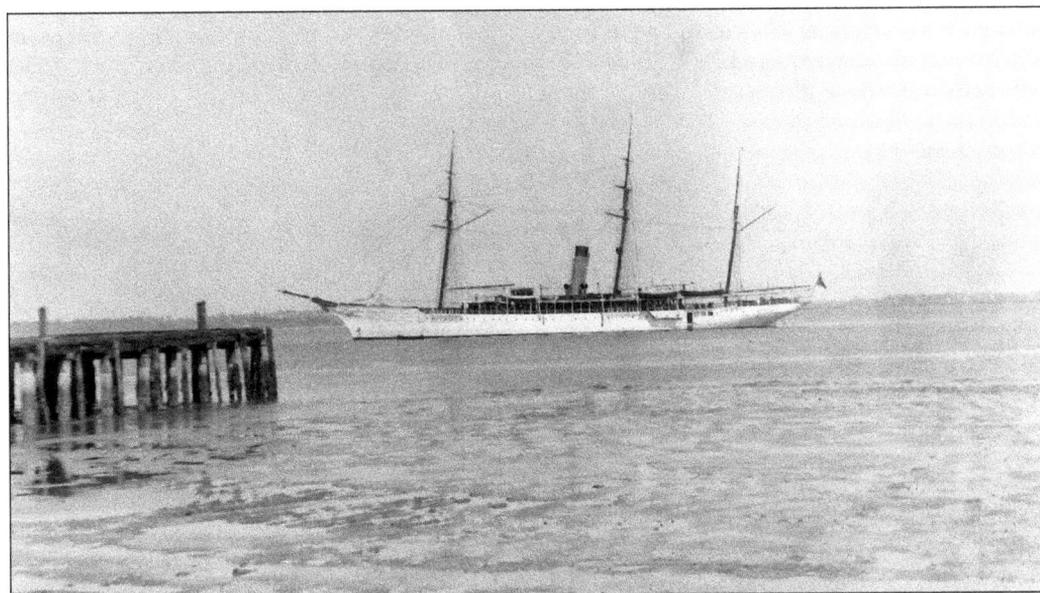

Financier Jay Gould's three-masted ship, the *Niagara*, was said to be the largest private yacht in the world when it visited Charleston in 1907. Charleston has always been a popular stopping point for yachts traveling south to the Caribbean. (MK 7821)

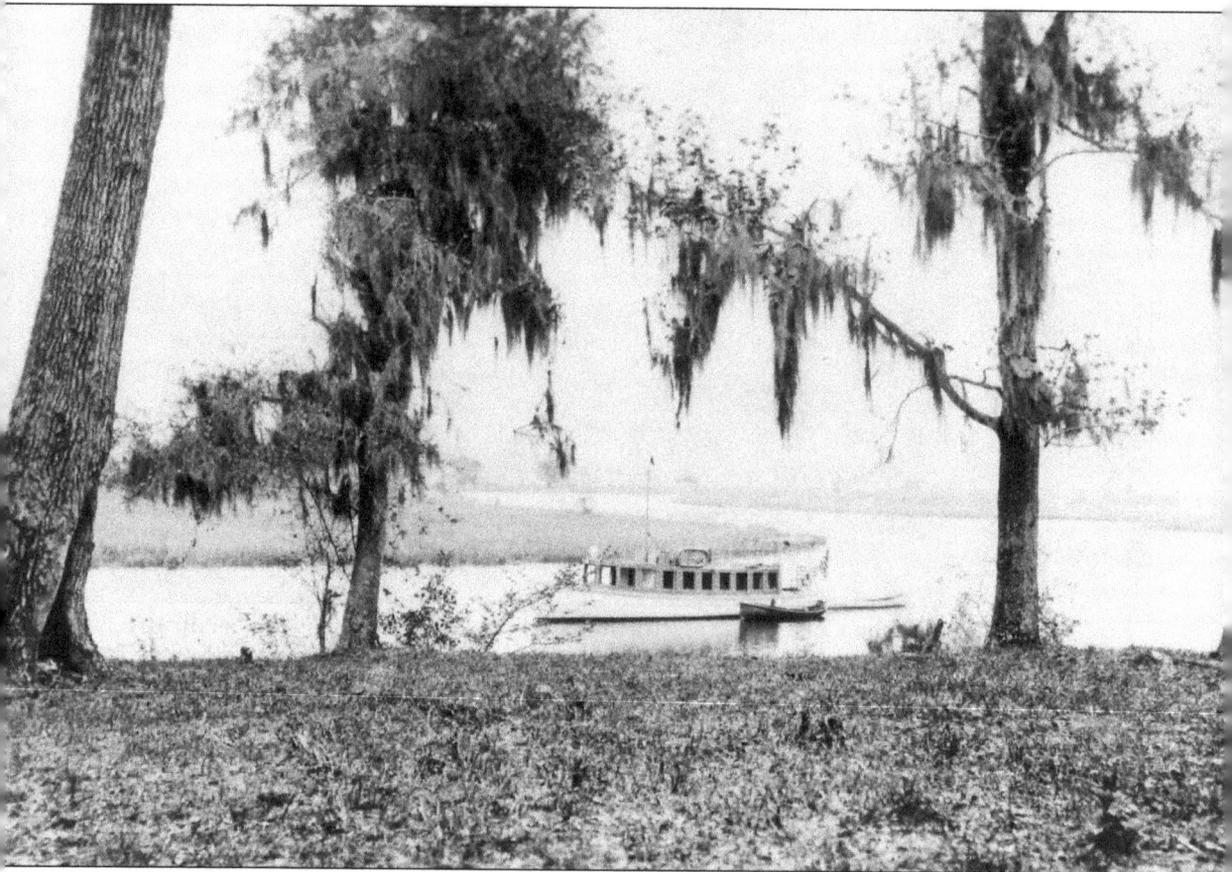

Water excursions from Charleston were a very popular diversion. In this photograph, taken in 1919, the *Vadie*, owned by H.P. Williams, is moored near Pompion Hill Chapel on the Cooper River. (MK 4324)

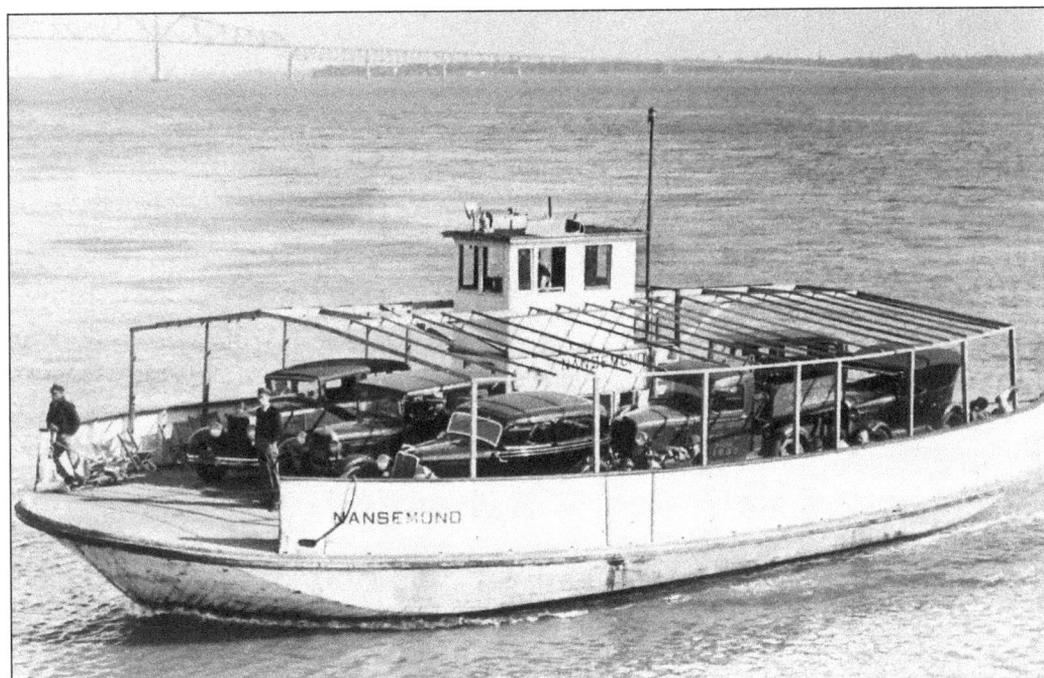

The *Nansemond* ferried traffic to and from Sullivan's Island into the 1930s. The new Cooper River Bridge rises in the background, signaling the beginning of the end for the old ferries that had for so many years been a fixture on the harbor scene for the Ashley and Cooper River waterfronts. (MK 4938)

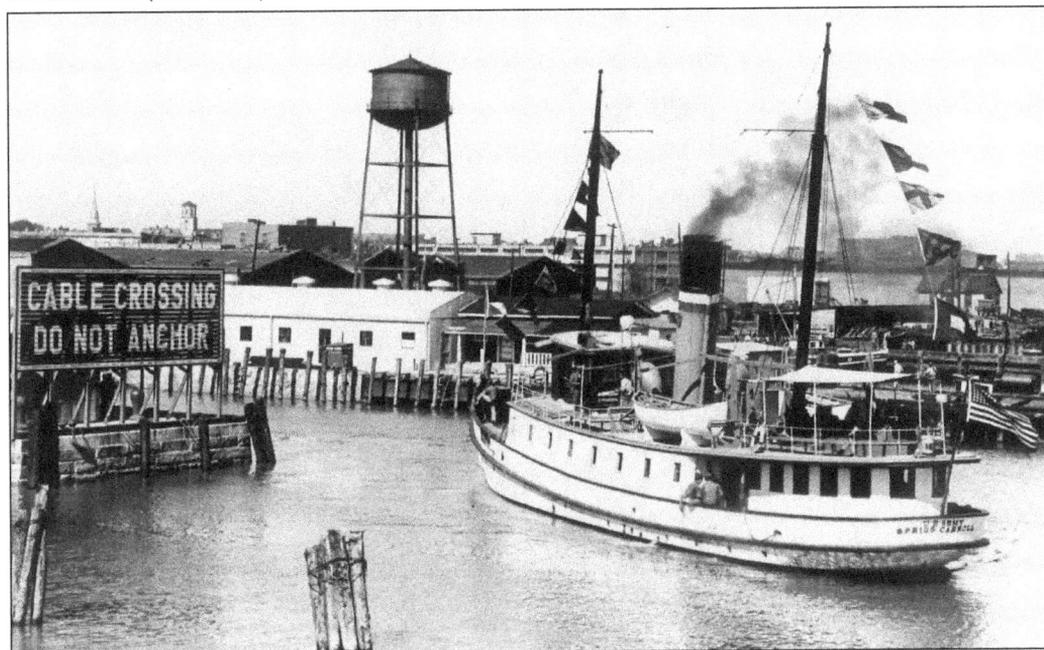

In this undated photograph, the U.S. Army ship *Sprigg Carroll* docks at the piers just above the U.S. Custom House. Note the industrial nature of the waterfront and the steeples of the Second Presbyterian Church and Citadel Square Baptist Church in the distance at left. (MK 434)

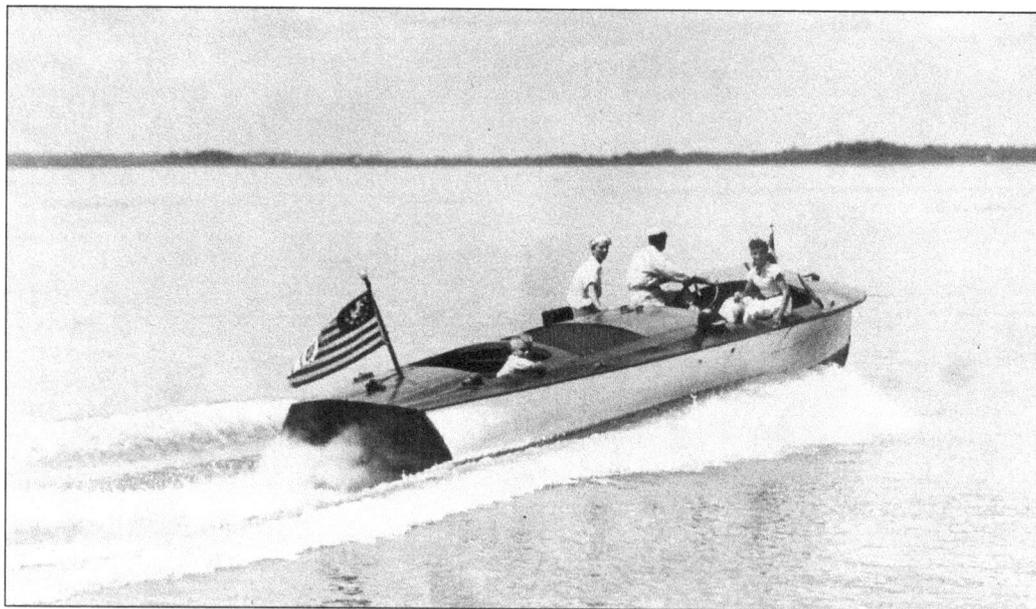

The *L'il Francis* was typical of the smaller power boats that populated the harbor in the 1930s. As part of the tour boats that operated from the Gray Line Boat docks at the Battery, the *L'il Francis* provided tourists an option to the larger boats, the *Frances III* or the *Dicksadee*. (MK 480)

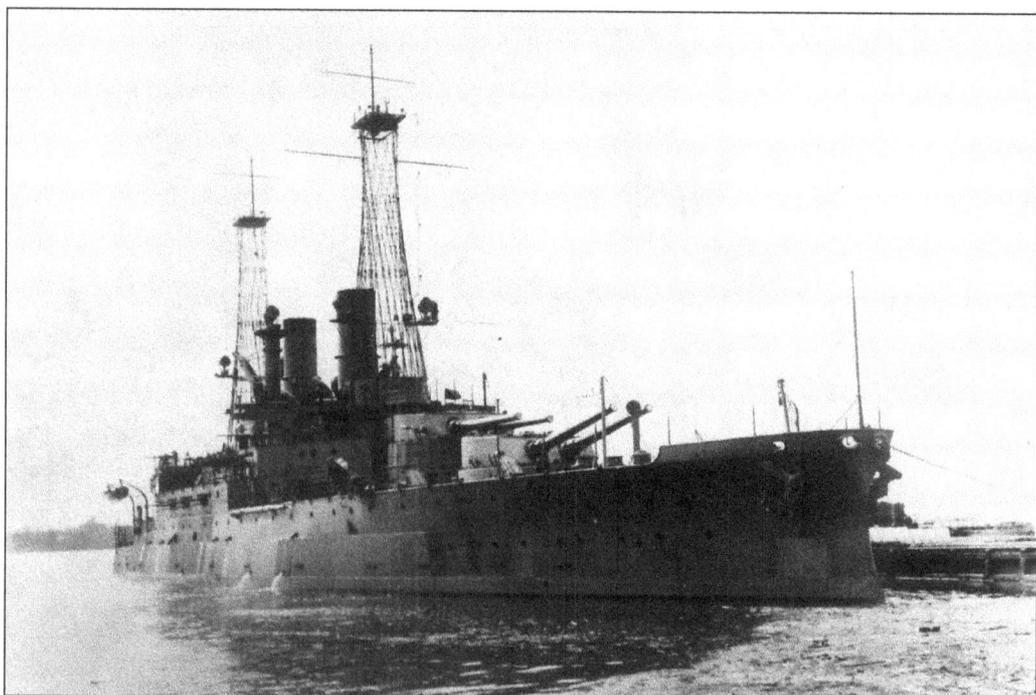

The USS *South Carolina* is tied to the dock at the recently opened Navy facility on the Cooper River. (MK 14505)

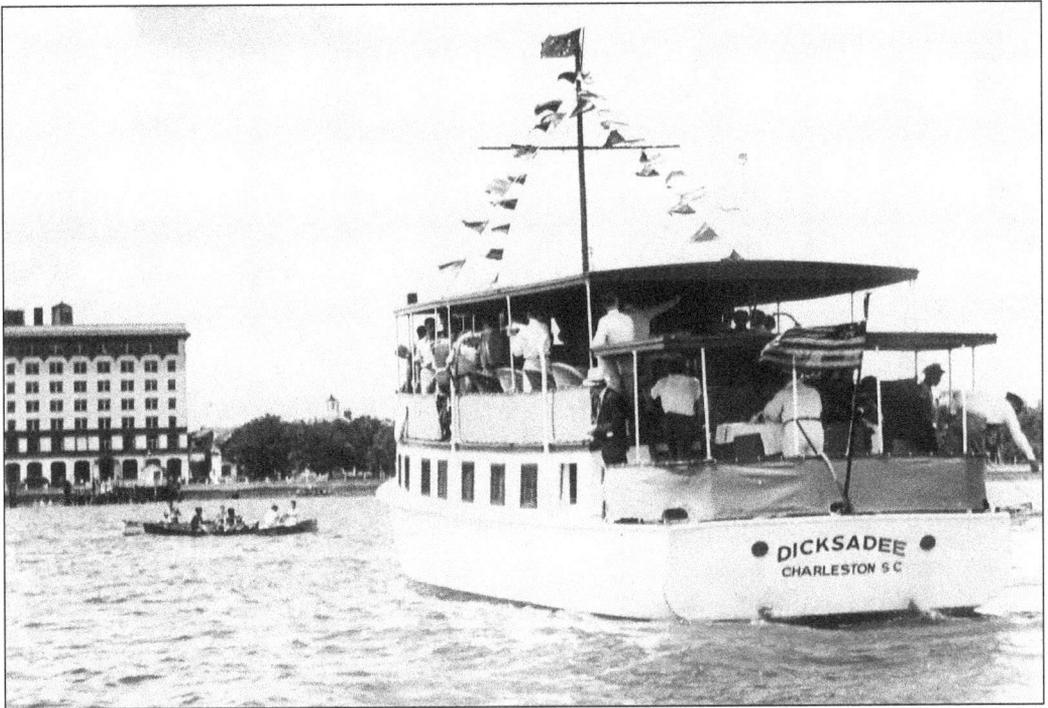

The *Dicksadee* heads back to the tour boat dock off the Fort Sumter Hotel in this 1930s view. The tour boats and harbor excursions have long been features of Charleston's harbor traffic. (MK 856)

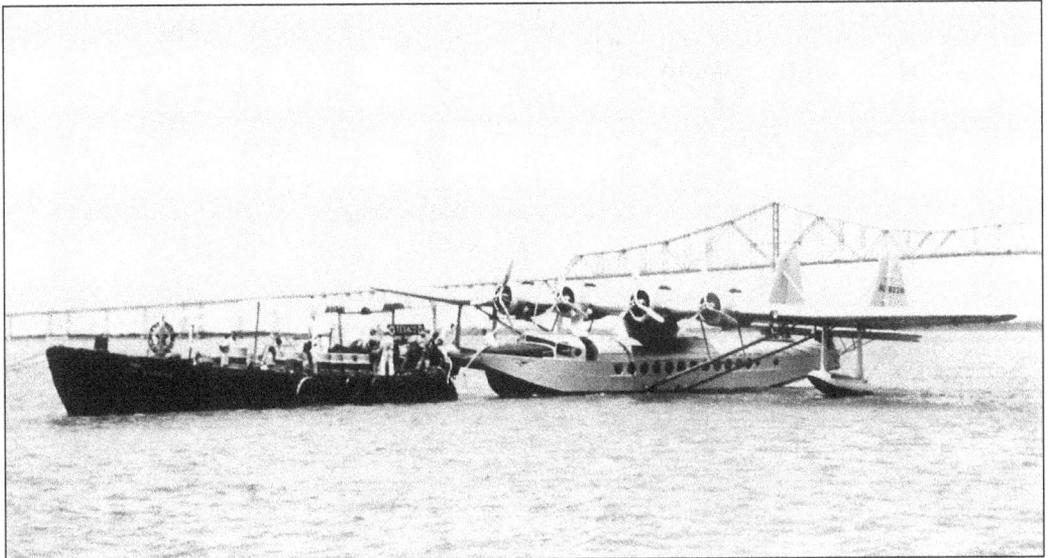

The arrival of wealthy Northerners who owned hunting estates and partnership shooting clubs in the Lowcountry helped put Charleston on the map. Airplane service to and from the city was just beginning when this 1935 view was taken, and there were discussions of having regular American Boeing Clipper service to Charleston. A Pan American flight American Boeing Clipper is docked in the harbor, below the recently opened Cooper River Bridge. (MK 915)

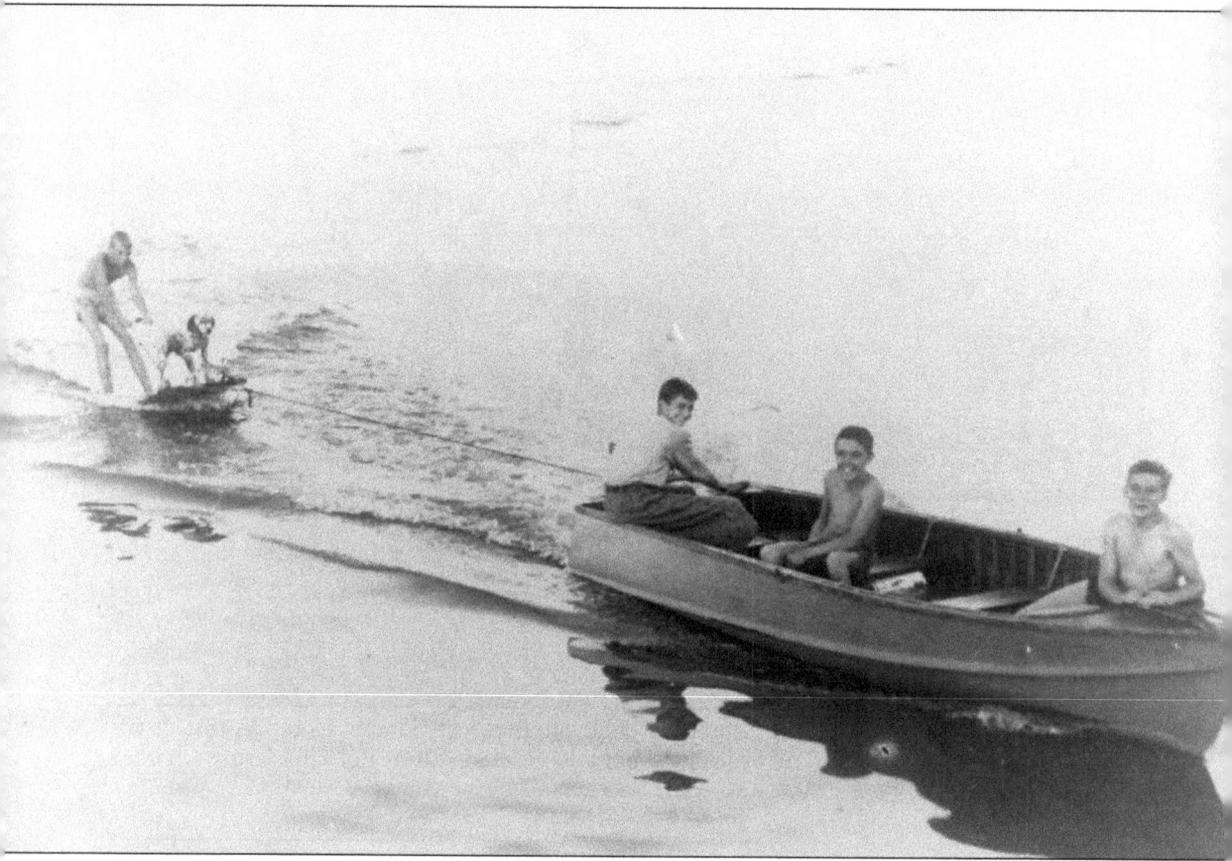

Frederick "Beanie" Rutledge, and Happy the dog test the waters while George Paul, Jack Leonard, and Jack Minott enjoy the ride. (MK 4863)

Four

AROUND TOWN

"Civilizations that relinquish the art of maintaining civilized cities have lost the ability to survive through time."—Mayor Joseph Riley, Business in the Community Conference sponsored by HRH Prince Charles in February 1990.

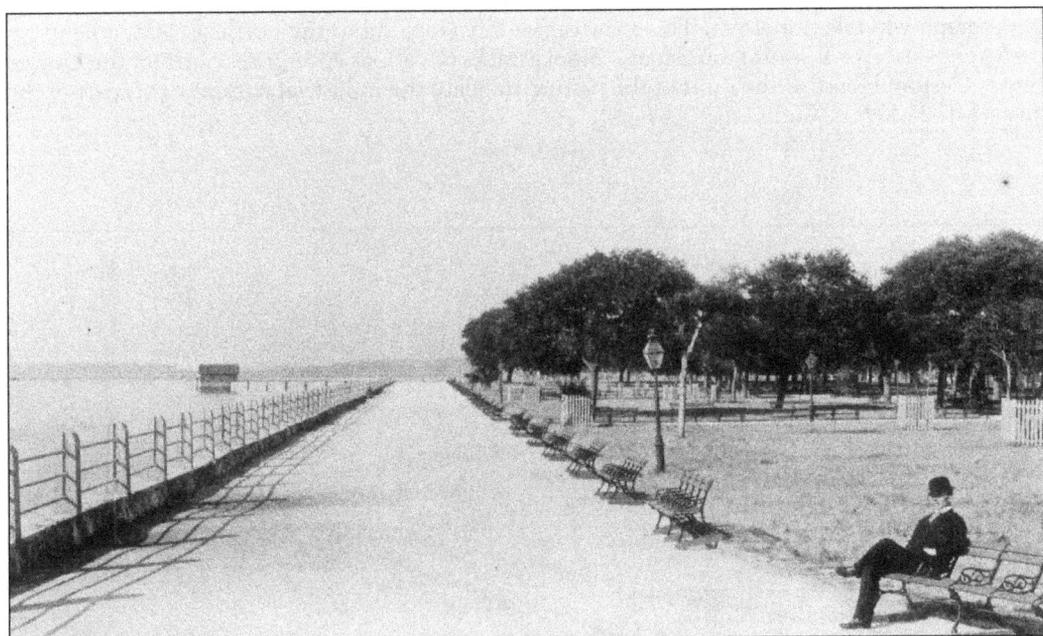

Here, in this 1893 view of White Point Gardens, a civilized gentleman enjoys the quiet of the waterfront. The city was active in parks improvement. Planting became a major civic activity, balancing the trees that were being cut to allow for electric lines and telephone poles. (MK 22902, AWC)

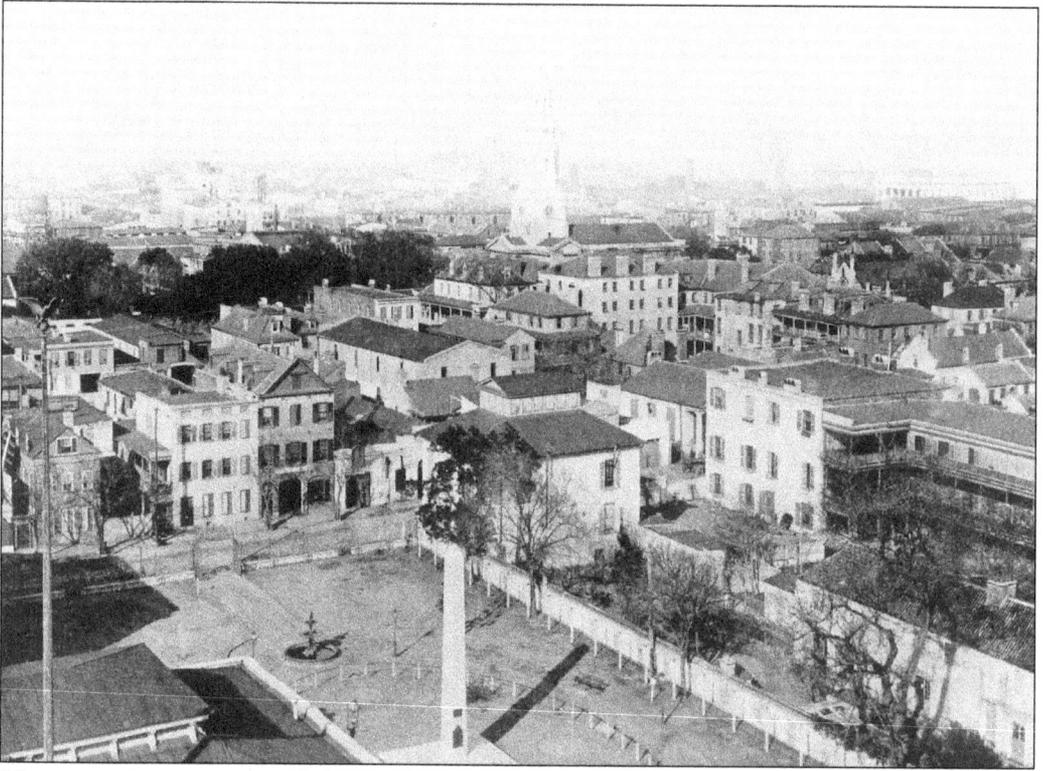

The general appearance of the roofscape of Charleston has changed very little since this photograph was taken in 1893. This view of the city (looking to the northeast) documents an early renovation of Washington Square. Smokestacks of various enterprises north of the United States Custom House at the right of the picture indicate the industrial nature of this part of the city. (MK 21209, AWC)

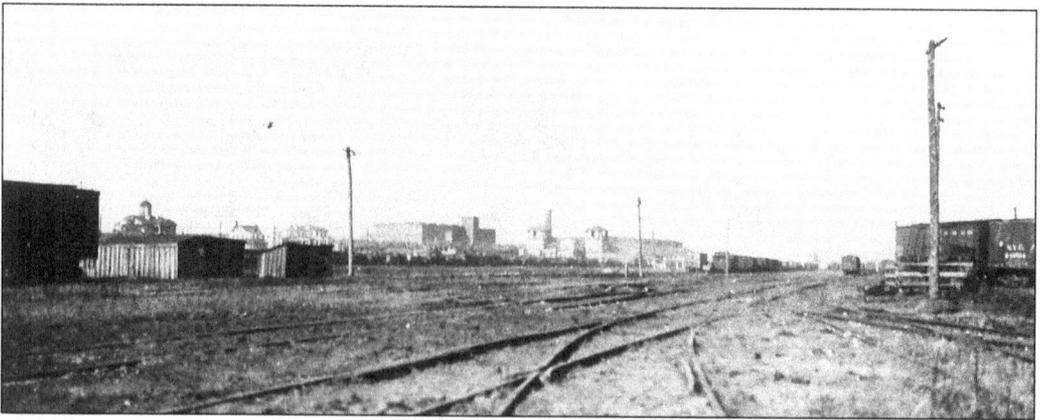

This picture of the freight yards of the Seaboard Railroad shows the effects of the Depression on trade in Charleston. The view across the yard looks to East Bay Street, the Charleston Tobacco Factory, and the Union Terminal Building. To the left, the great houses of an earlier era rise proudly on what was once waterfront property in the city suburbs. (MK 7181)

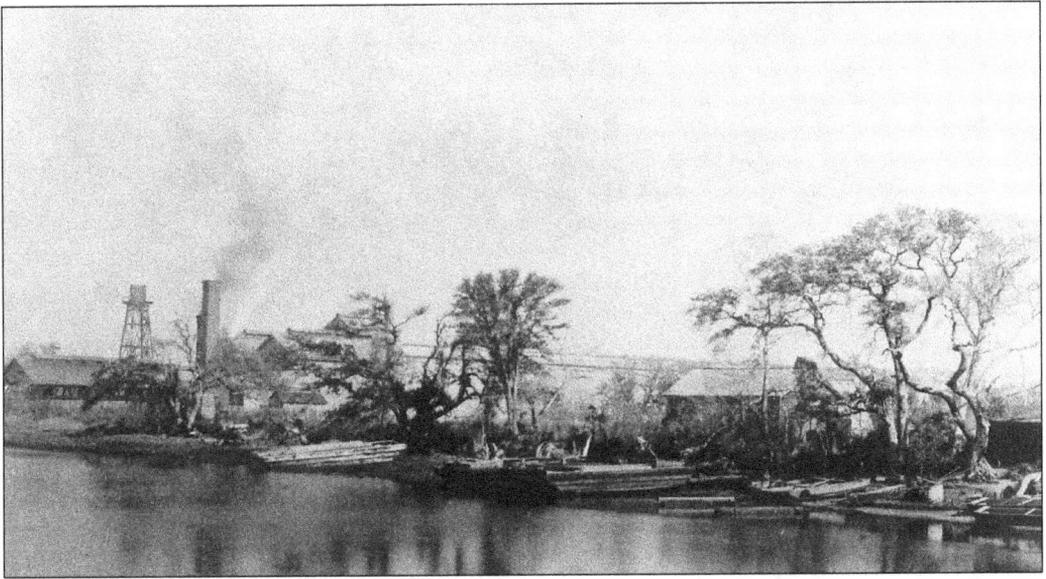

After 1870 the Phosphate Works sprang up on both sides of the Ashley River, in the Neck area of the peninsula, for a distance of 10 miles. (MK 21207, AWC)

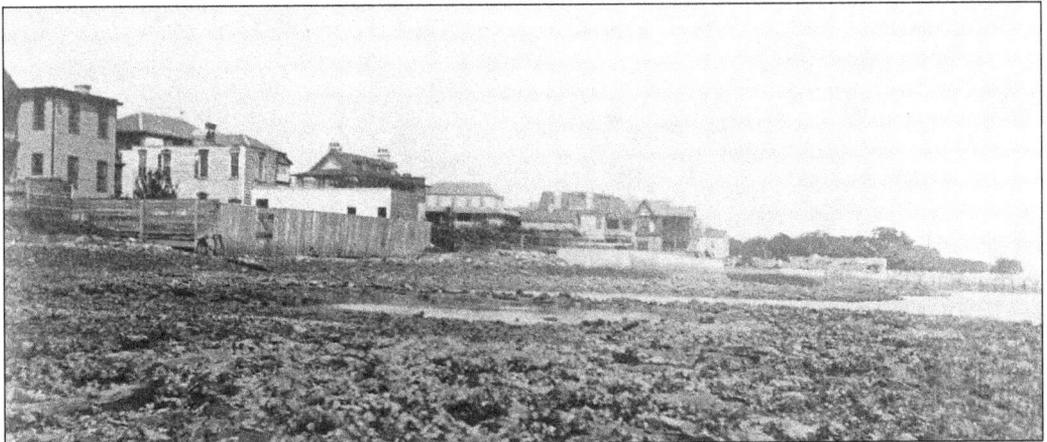

This photograph by A.H. Ford shows the area at the west end of Tradd Street where Murray Boulevard now lies. The White Point Gardens Park is at the right of the picture in the distance. In 1909 plans were drawn to fill the area of forty-seven mud flats. Beginning in 1916, residences were constructed along Murray Boulevard, named for Andrew Murray, an orphan who made good and gave something back to the city by contributing money to this new endeavor. (MK 7069D)

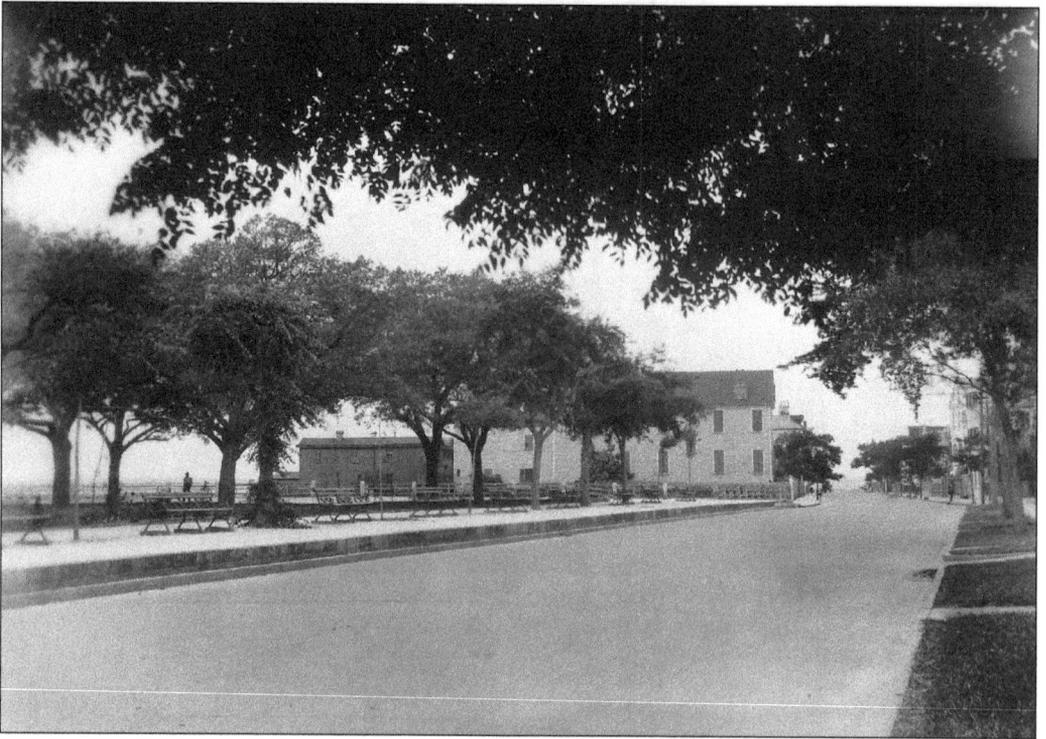

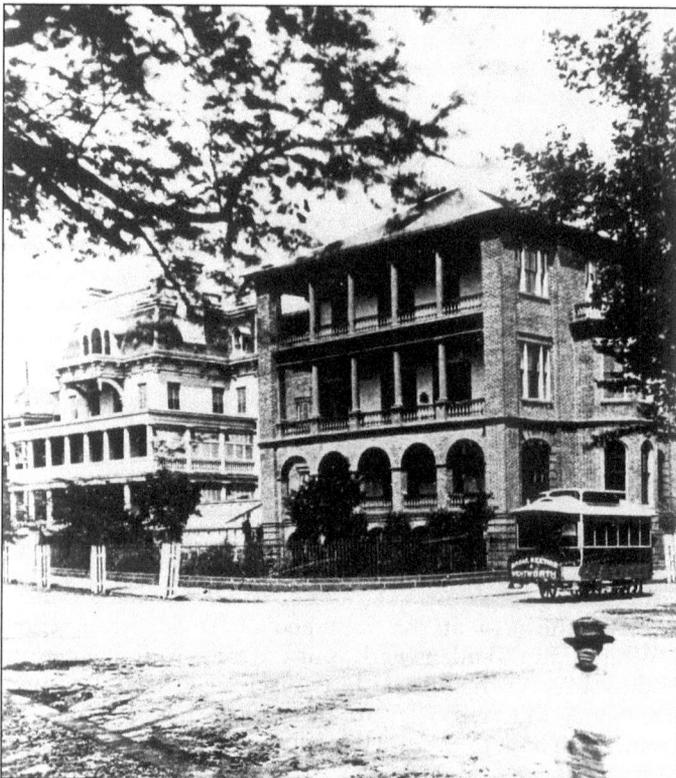

This *c.* 1900 view of South Battery shows the area where the Fort Sumter Hotel was built twenty-three years later. The end of the street is visible at right. (MK 15207)

Number One Meeting Street was completed by 1850 by George Robertson. The scale of the house is impressive. The arcaded porch on the first floor was lost in the 1886 earthquake. Next door on the left at 20 South Battery is the house built *c.* 1843 for a Mr. Stevens. Originally a Greek Revival house, the property was remodeled in 1870 with a mansard roof in the Second Empire style—then all the rage. The upper balcony has since disappeared from the house. (MK 3345)

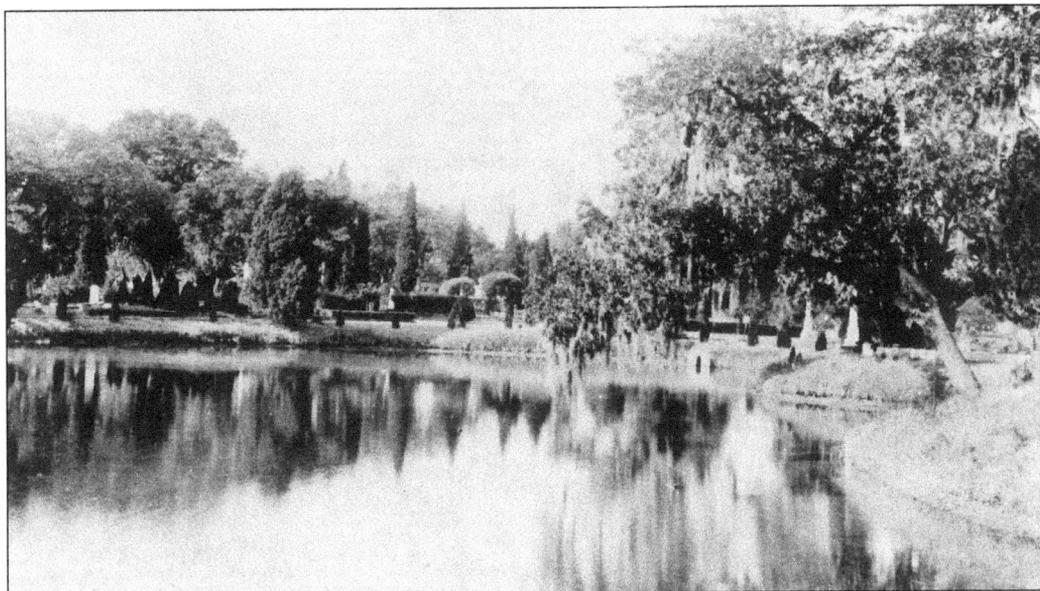

The heart of Magnolia Cemetery was always a favorite destination for picnics and outings. Families vied with each other to produce monuments worthy of their lineage. Fine examples of stone sculpture and cast iron may be found on the grounds. Magnolia Cemetery continues to serve as a choice resting spot for many Charlestonians. (MK 22907, AWC)

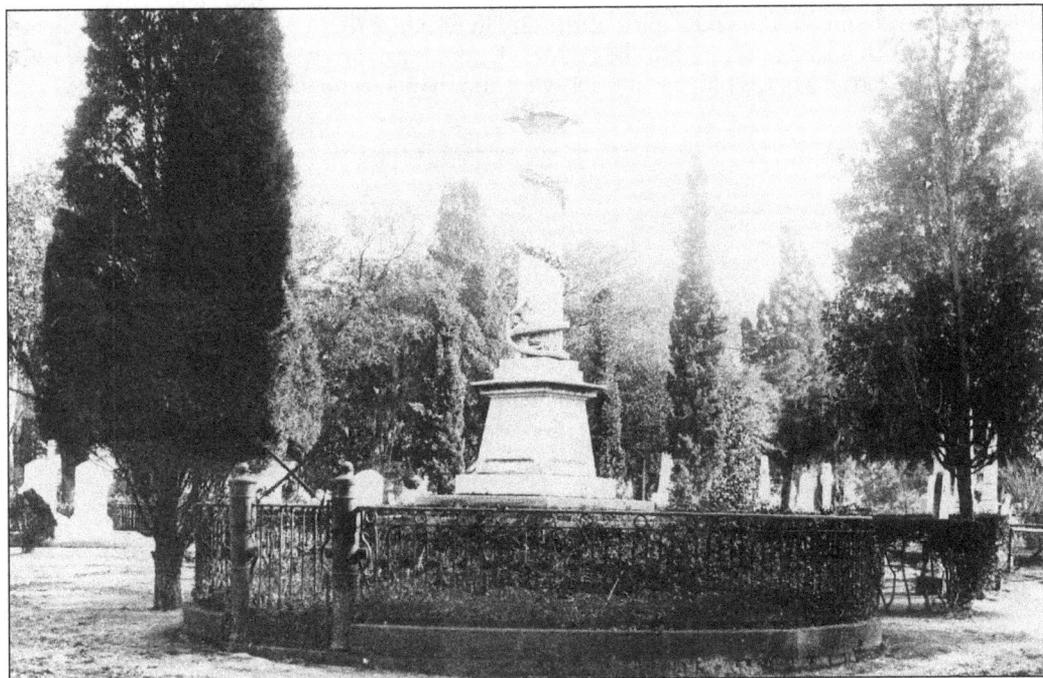

This wonderful monument to William Washington was designed by E.B. White. It was constructed by W.T. White, Charleston's most famous stone carver and monument builder. The monument commemorates the battles fought by Colonel Washington and his infantry. The group lives on to the present-day as the Washington Light Infantry. The rattlesnake at the base is a symbol that evokes the revolutionary cry, "Don't tread on me." (MK 22690, AWC)

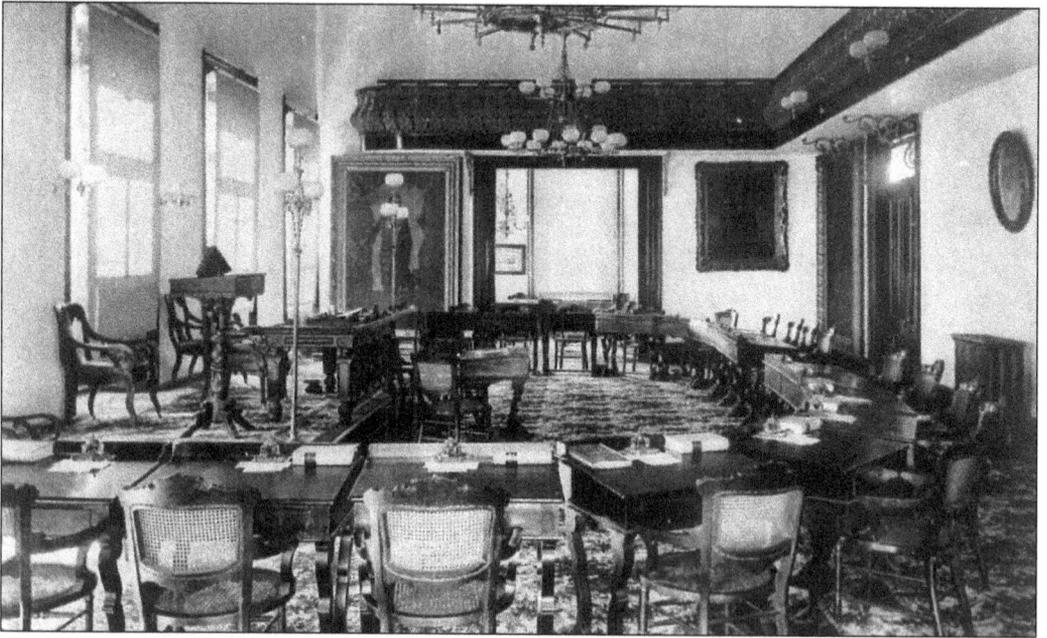

The City Council's chambers in City Hall were photographed in 1882 for the city yearbook following extensive renovations under the direction of Mr. Henry Oliver. William Ashmead Courtenay, mayor from 1879 to 1881, celebrated the new Council chambers and remarked that this work was a symbol of the new spirit of the city in response to the charges ". . . of some of our fellow citizens that we are thought to be ruthless iconoclasts, disrespectful of the past and fixed in resolve to destroy what is old, desirous only for that which is new."(MK 1963A)

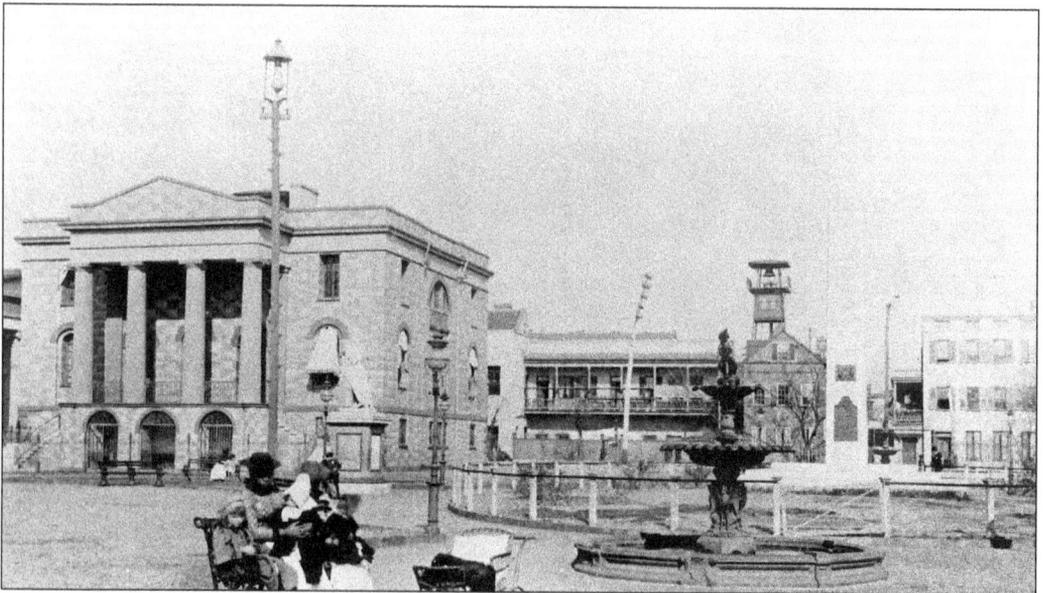

Washington Square Park benefited from the addition of the Monument to the Confederate Dead, shown in this 1893 view of the park. What had once been "an eyesore" was much improved with the addition of the monument and the fountain. (MK 22641, AWC)

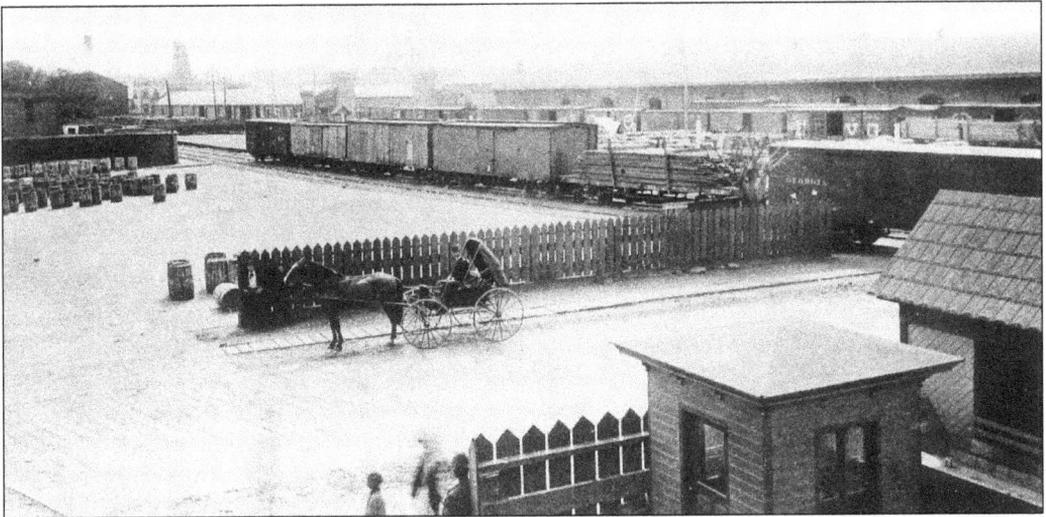

This 1893 view shows the freight yard of the South Carolina Railway, precursor of Southern Railway. The large 1859 warehouse building to the right is now the Chamber of Commerce. The Camden Depot gates standing in the middle distance will be restored as part of the Visitors Reception and Transportation Center. (MK 22903, AWC)

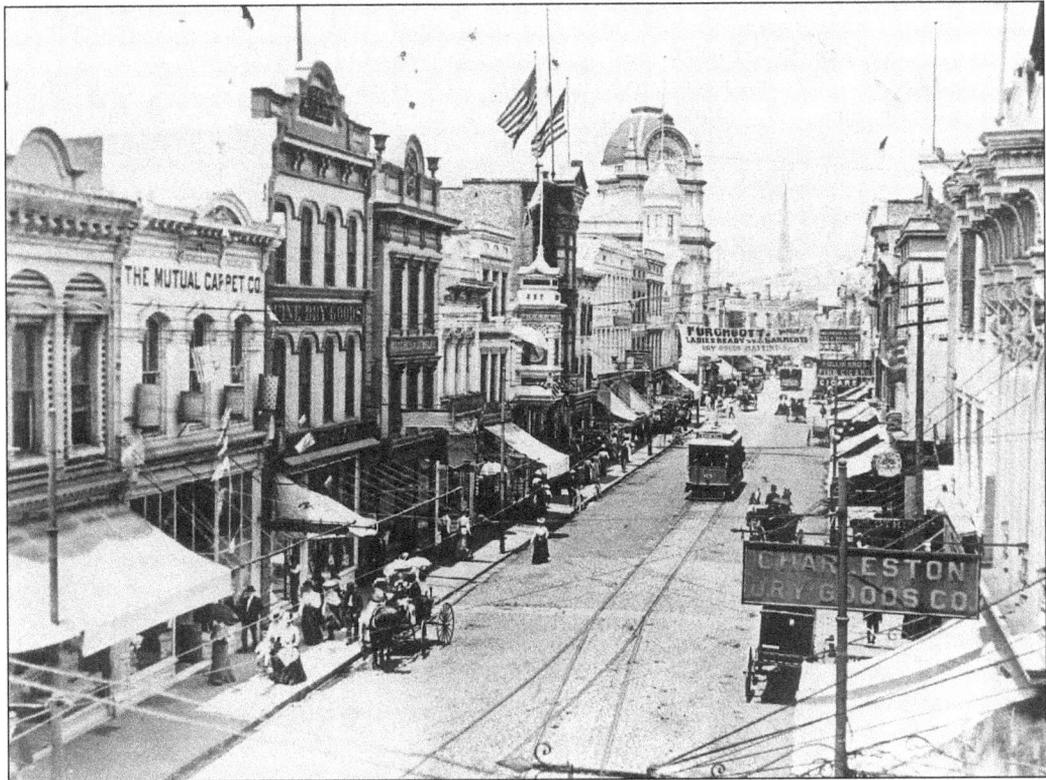

This 1901 view of King Street, looking to the north, shows a busy commercial center. The large domed building in the center of the photograph was Hirsch Israel Company at the southwest corner of King and Wentworth Streets. In the far distance is the spire of St. Matthew's Lutheran Church, the tallest in Charleston. (MK 5856)

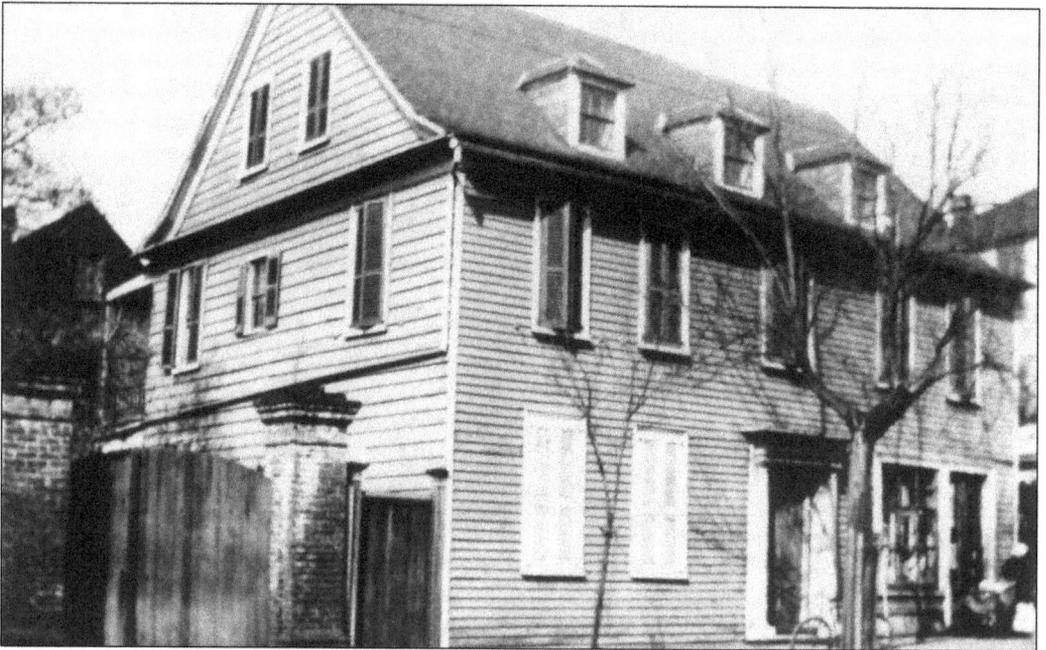

The eighteenth-century frame house at the corner of Broad and King Streets was originally the home of one of the nation's earliest meteorologists, Dr. John Lining. Dr. Lining's house was later converted for use as an apothecary shop for Poulnot's Pharmacy. The pharmacy occupied the building in this early 1900s photograph, when the drug store was in the corner of the building with residential apartments above. It was purchased by the Preservation Society of Charleston to prevent its demolition for a parking lot in the 1960s. (MK 8328C)

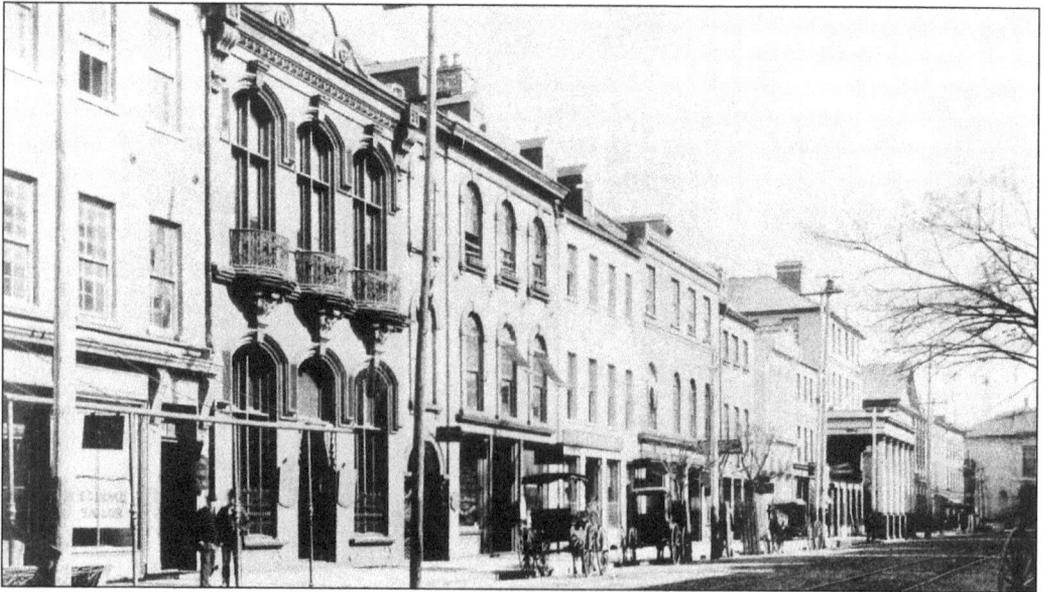

This view of Broad Street shows the sometimes-quiet nature of the city. The buildings in the foreground are now sites occupied by First Federal of Charleston. In the distance the portico marks what was the site of the Bank of South Carolina, now the location of the People's Building, constructed in 1910/11. (MK 22692, AWC)

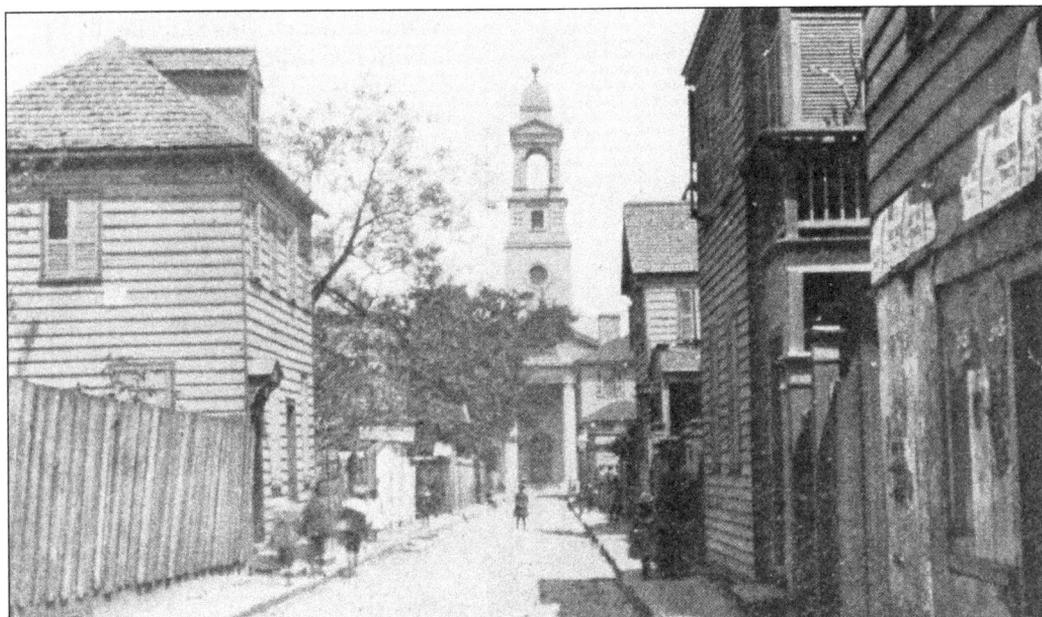

Magazine Street, looking toward the steeple of St. John's Lutheran Church, has changed very little since this late 1890s view. Magazine Street was so called because it connected the powder magazine with the main magazine at the Old City Jail site. (MK 15347B)

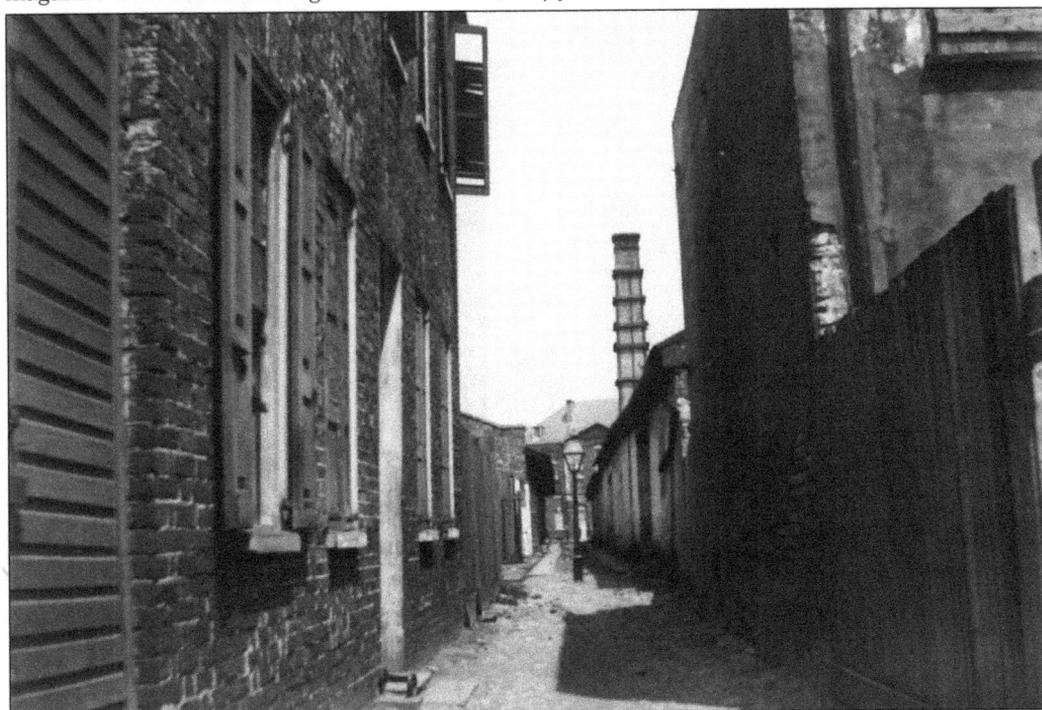

This view shows Longitude Lane in the early 1900s, looking toward the Vanderhorst tenements on East Bay Street. Historically, lanes like this served pedestrian and wagon traffic from the residential section of the city on Church, Meeting, and King Streets to the wharf and commercial areas of East Bay Street. (MK 7578)

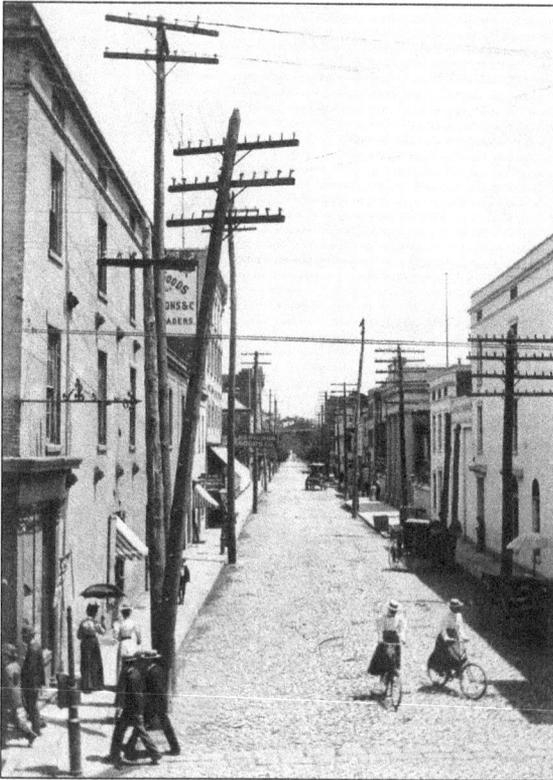

At the corner of King and Hasell Streets, two ladies ride their bicycles. The streets of Charleston had been either planks or dirt until Mayor Courtenay initiated his public improvements for sidewalks and streets in 1880. By the time, this picture was taken c. 1900, the streets were paved with cobblestones, granite block, or brick, and sidewalks were completed on much of the lower peninsula. (MK 5813)

This view of King Street in 1910 shows the many improvements Charleston witnessed at the turn of the century. The trolley tracks ran through Belgian block paving put down around 1885. The electric lights above the street were installed following their introduction at the South Carolina Inter-State and West Indian Exposition of 1902. (MK 9731)

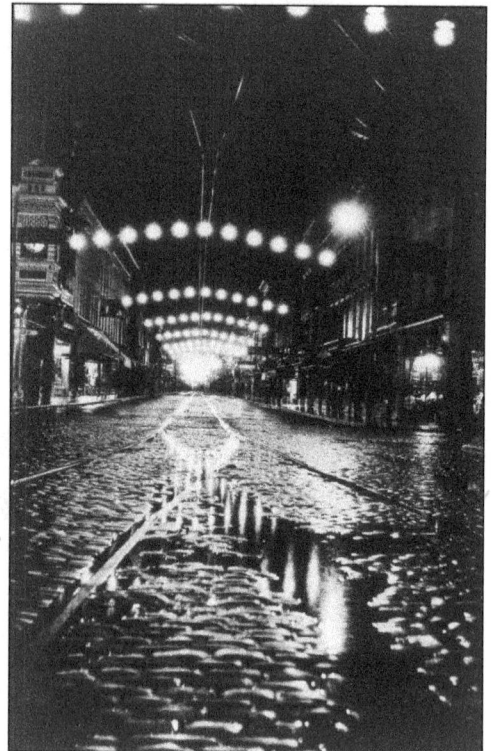

This area of Anson Street, between George and Calhoun Streets, was leveled in the 1970s to make way for the Gaillard Municipal Auditorium. The Midway Ice Cooling Station was typical of small corner stores that served the neighborhoods of Charleston. (MK 970)

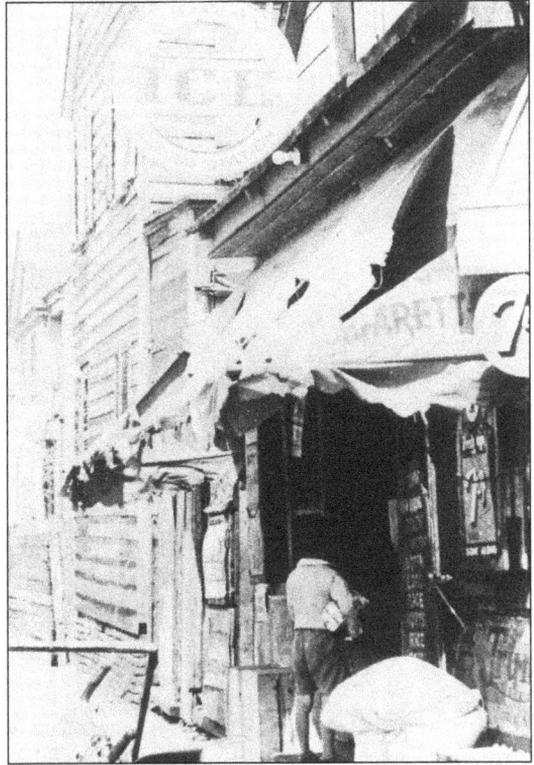

Flower Annie was a familiar sight for local children like Peggy Lucas, and Mollie and Russell McGowan—seen here on Tradd Street. African-American vendors brought their produce through Charleston's residential neighborhoods either by cart or carried in the traditional African manner, as Flower Annie does in this photograph by M.B. Paine. (MK 8784)

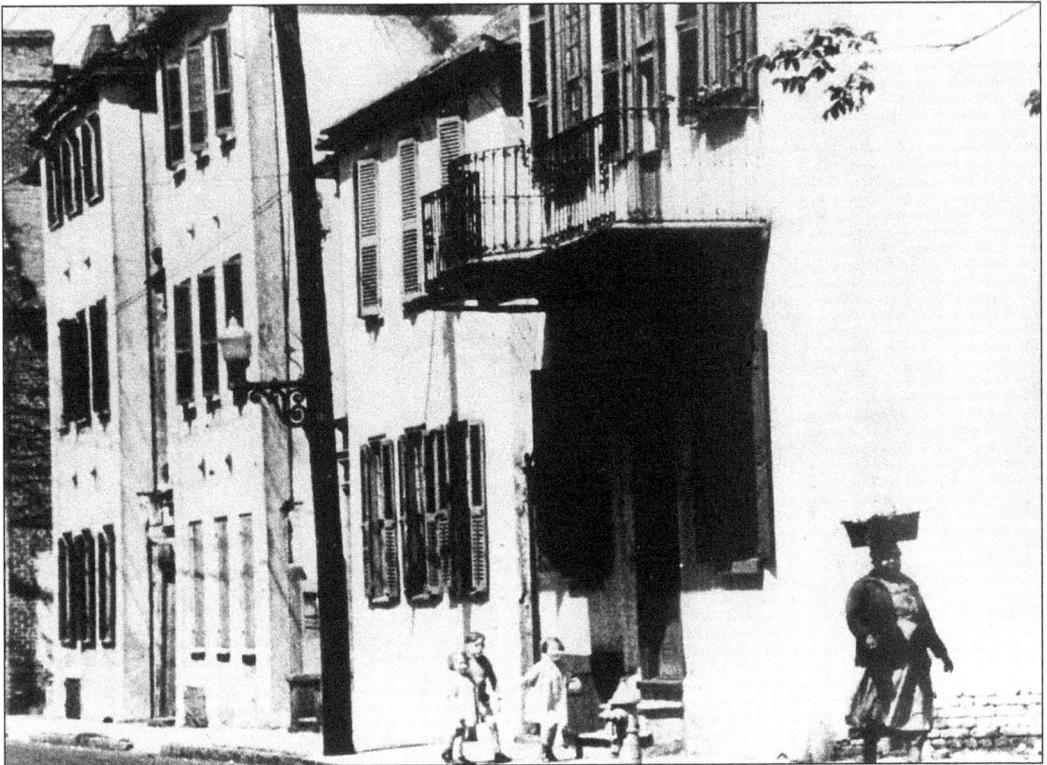

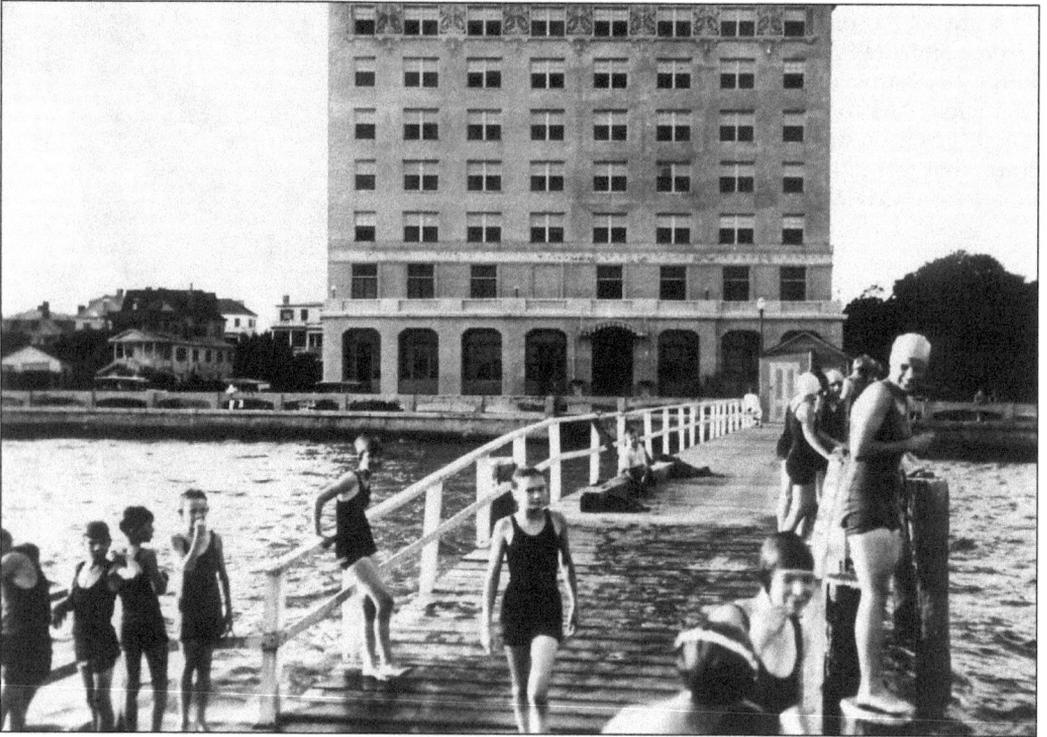

The Fort Sumter Hotel, built in 1925, rises as the tallest building on the waterfront in this 1936 view of the city. The old Battery Dairy Dock had become the place of swimming and diving for local children who enjoyed the harbor on a summer afternoon. (MK 3335)

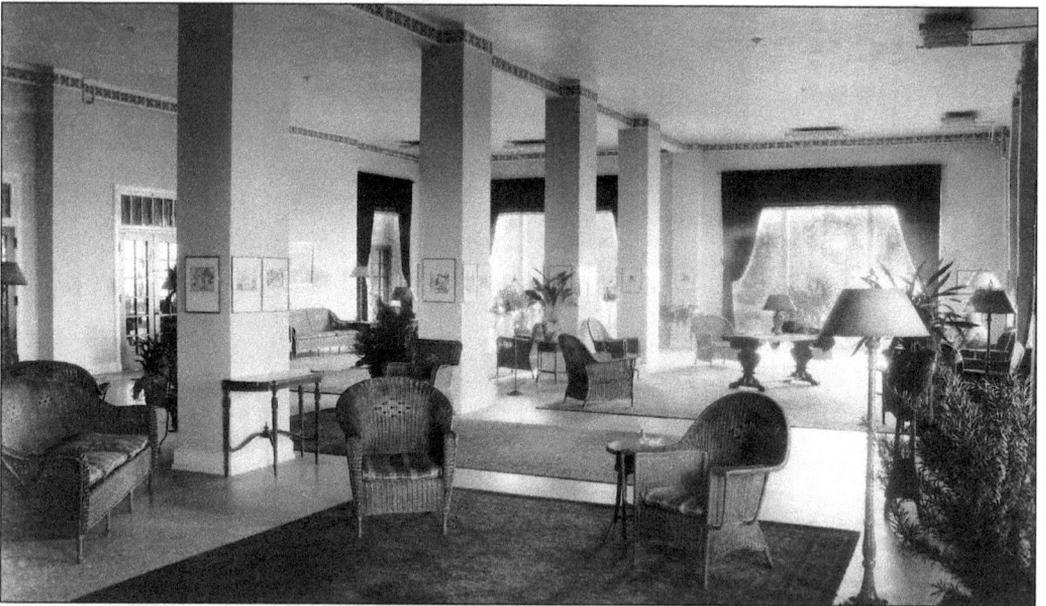

The Fort Sumter Hotel was one of the premier resort hotels on the Southeast coast. In this 1936 photograph, the lobby conveys the easy informal nature of a resort hotel, with sun parlor, wicker furniture, and large glass windows that flooded the room with light. (MK 14486)

The Kress Building on King Street near Wentworth was the newest element of the shopping district when M.B. Paine took this photograph in 1938. Designed by the New York architect Osbert Sibbert, the building reflected Sibbert's belief that the Kress stores should add excitement to the city's commercial heart. In Charleston, he chose an art deco motif with Mayan Revival detailing. (MK 6541)

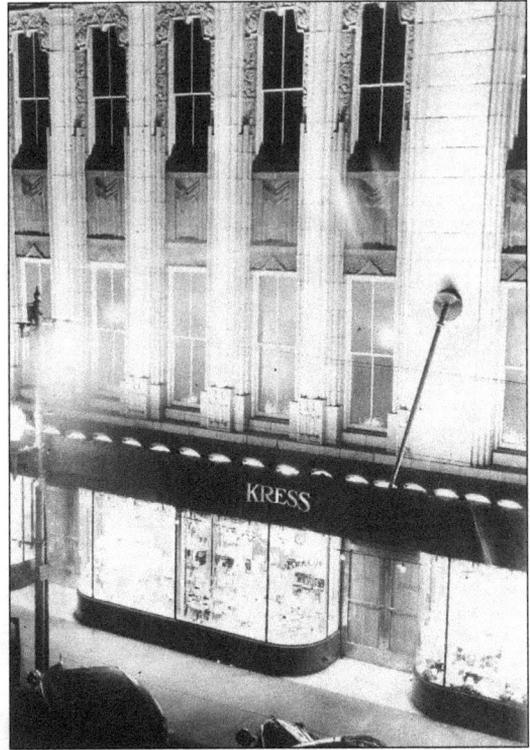

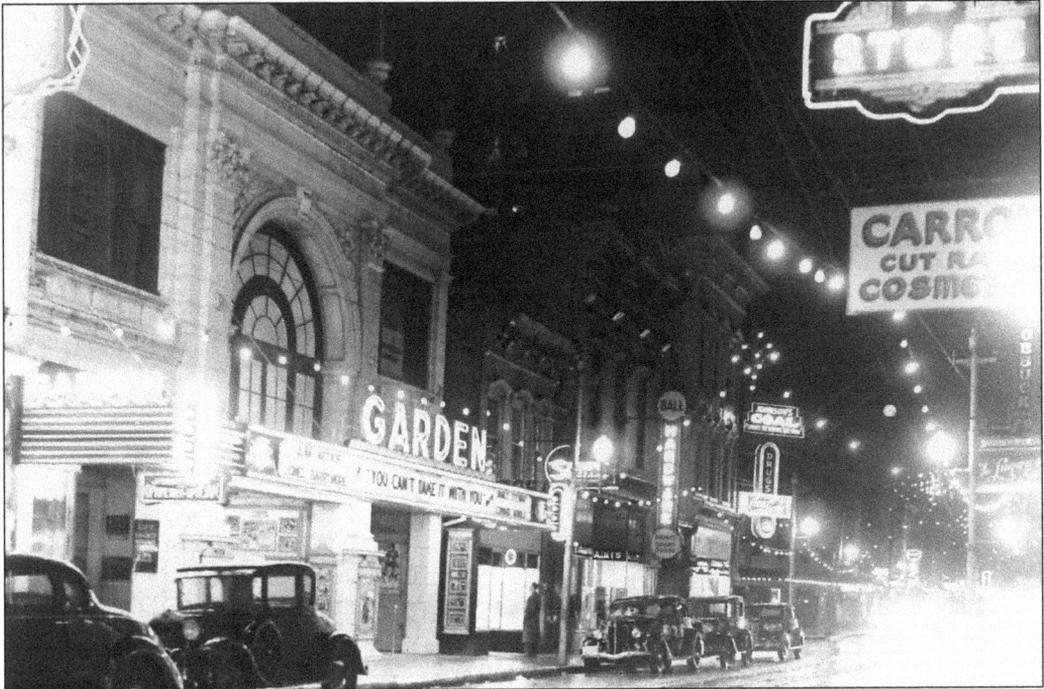

M.B. Paine must have seemed a mysterious figure as he wandered around town day and night, ever-ready to photograph the daily life of the city. On Christmas night of 1938, he photographed the Garden Theatre on King Street with all its big-city lights. (MK 17011B)

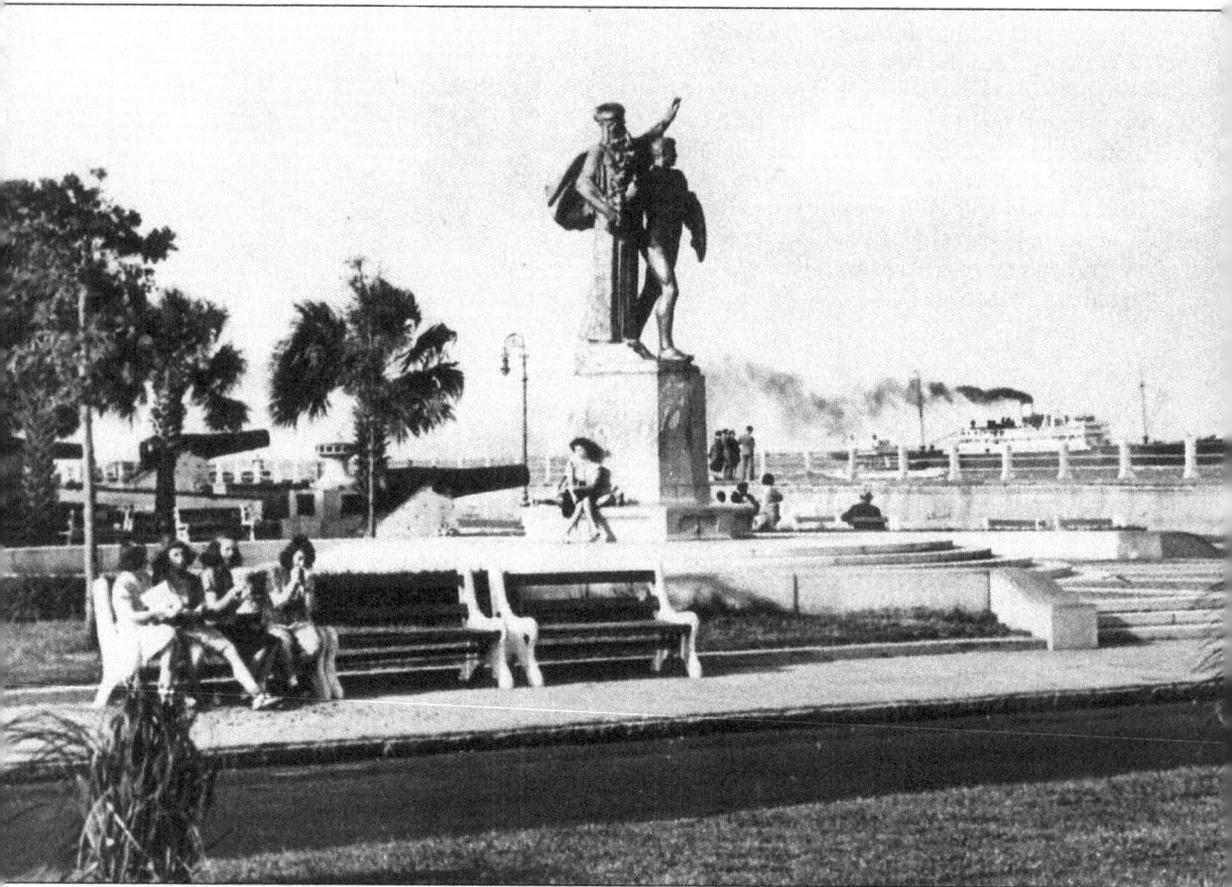

These schoolgirls enjoy an afternoon lunch on the benches in White Point Gardens on May 1, 1939. (MK 17016)

Five

GETTING THERE

"*Our Declaration of Independence on which the ideals of America's freedom was founded, mentions life, liberty and the pursuit of happiness. These seem very simple aims to the average ambitious American who is rushing to get somewhere. To my mind, Charleston realizes all three of these ultimate aims. Perhaps that is why people think us so slow—what is the use of hurrying when one is where one wants to be?*"—Elizabeth O'Neill Verner, *Mellowed By Time.*

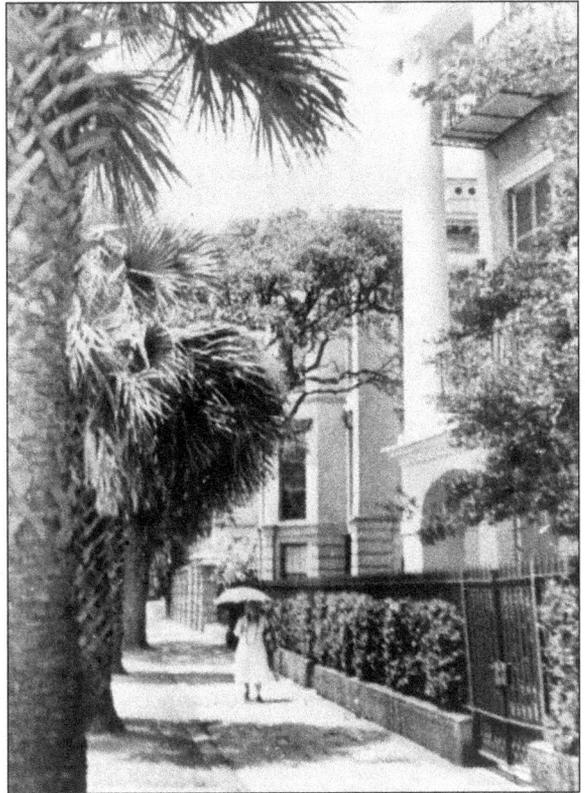

Charleston's best and most basic form of transportation is the unhurried walk. The parasol or umbrella is not only useful as protection from the sun, but has been employed by ladies to reinforce good vehicular etiquette with a light tap on the offending fender. The parasol is always fashionable from April through October. (MK 1441A)

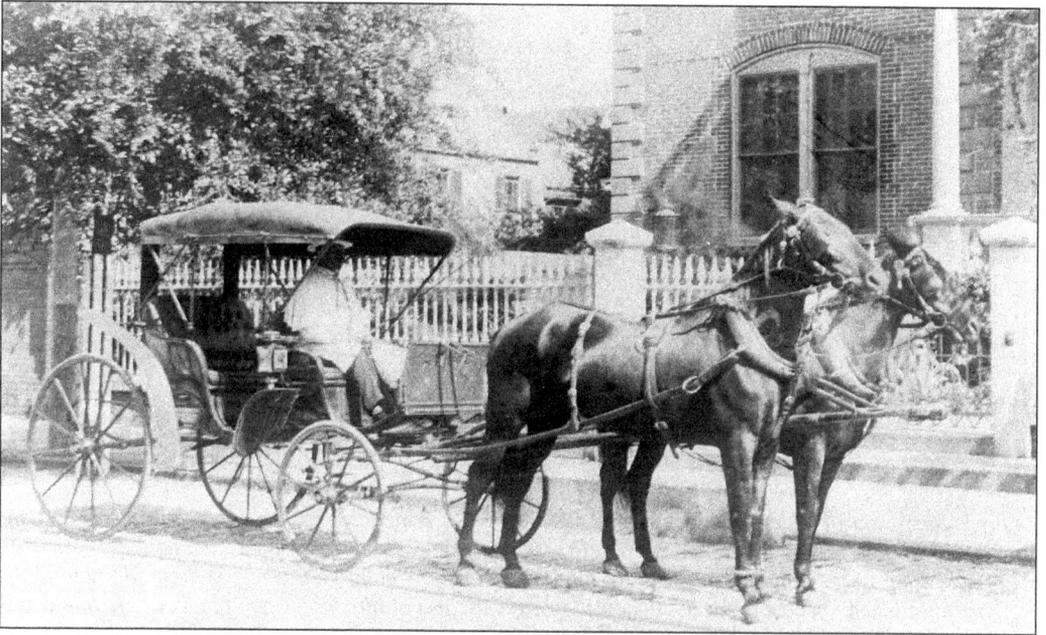

An Extension Top Surrey with team stands in front of the Calhoun Mansion, the home of George Williams, Esquire, one of Charleston's wealthiest individuals at the turn of the century. (MK 15570)

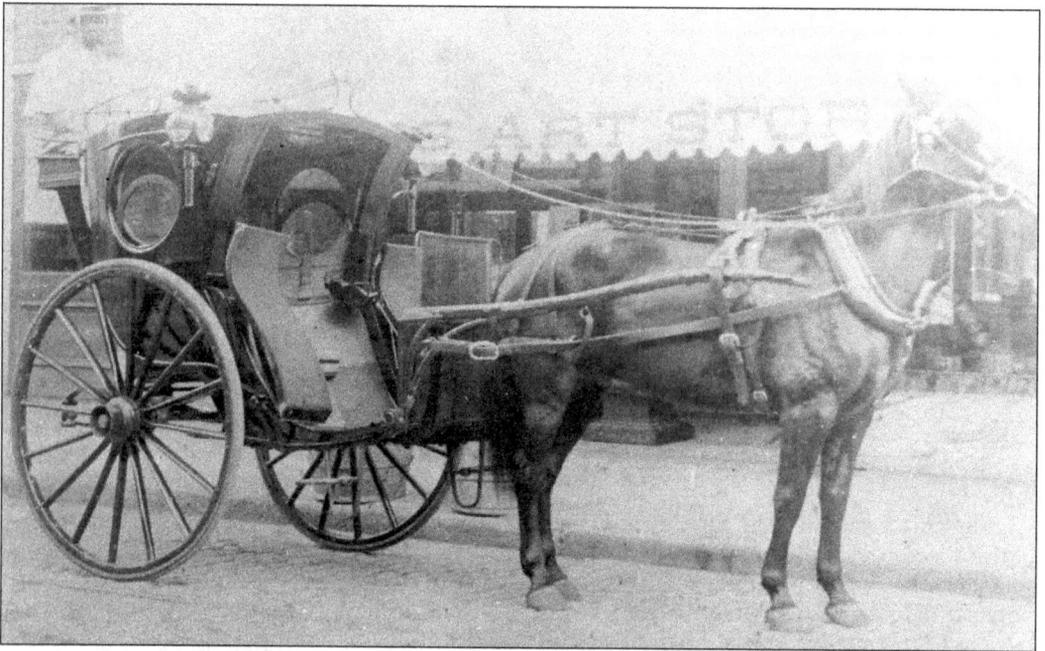

If you didn't own a carriage, you might have traveled in a Hansom Cab—one is shown here in front of Lanneau's Art Store. The cab's features included drop-down windows and double doors that opened in the front to provide easy access for the hoops and wide skirts of the Victorian generation. (MK 9240)

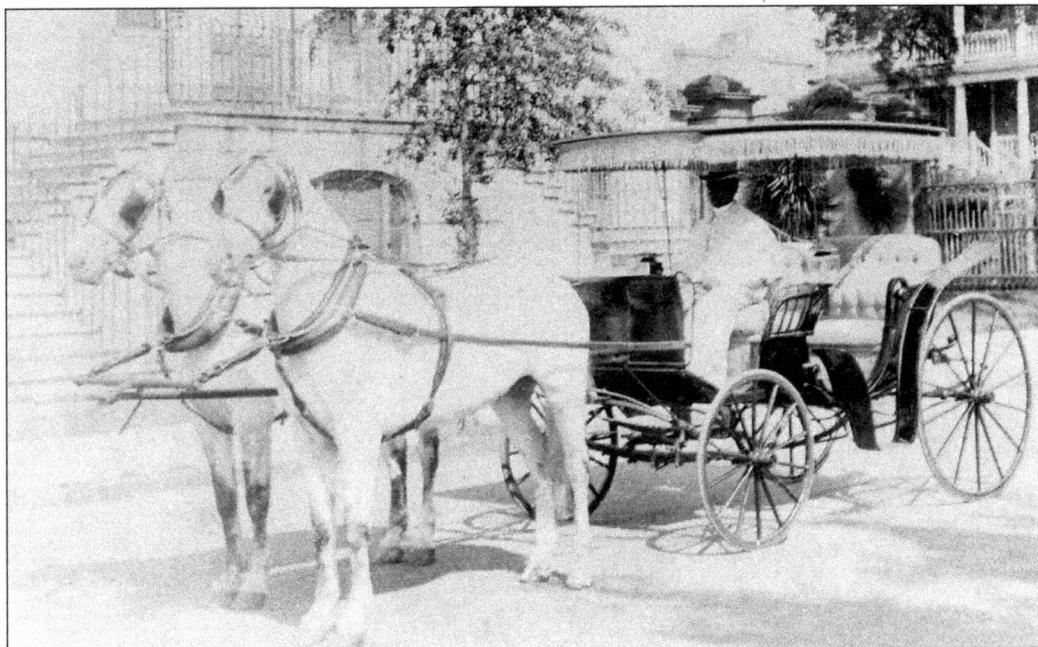

The Canopy Top Surrey with its matched pair of horses shows how Charlestonians traveled during the latter part of the nineteenth century. Posing in front of the William Gibbes House on South Battery, this driver is dressed in his best coaching coat. (MK 9239)

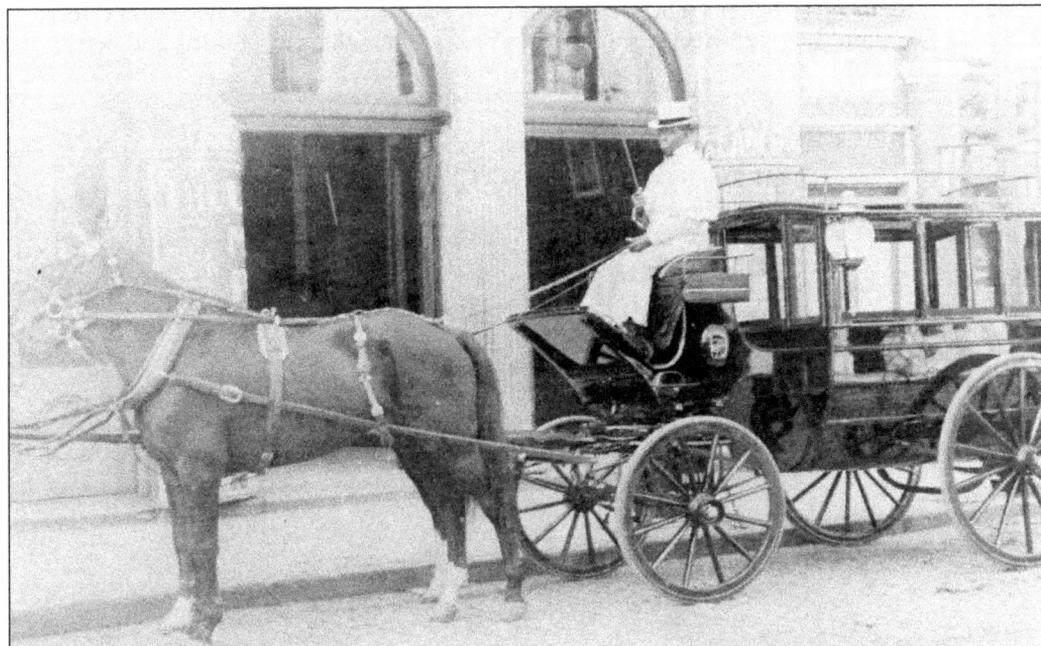

The Academy of Music was the location for Charleston to gather to appreciate music, opera, and dramatic events of the day. The Opera Bus was a special feature on evenings when events were scheduled. The driver, dressed up in his best livery, stands ready at the Academy doors. By 1905, the Opera Bus was already an anachronism and was replaced by the trolley service which provided special opera cars for the events at the theater. (MK 9237)

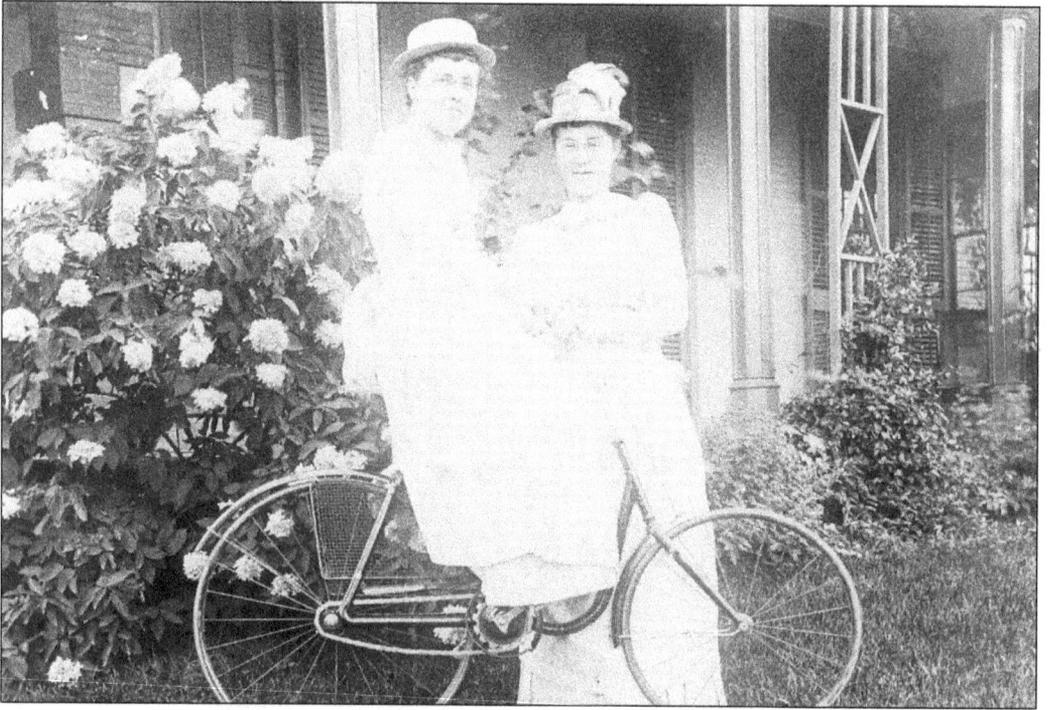

Bicycling was all the rage at the turn of the century. Two young women pose with an unusual model for this 1905 photograph. The smaller front wheel was intended to provide easier steering, while the guard on the rear wheel served to prevent the entanglement of skirts and petticoats. (MK 13816)

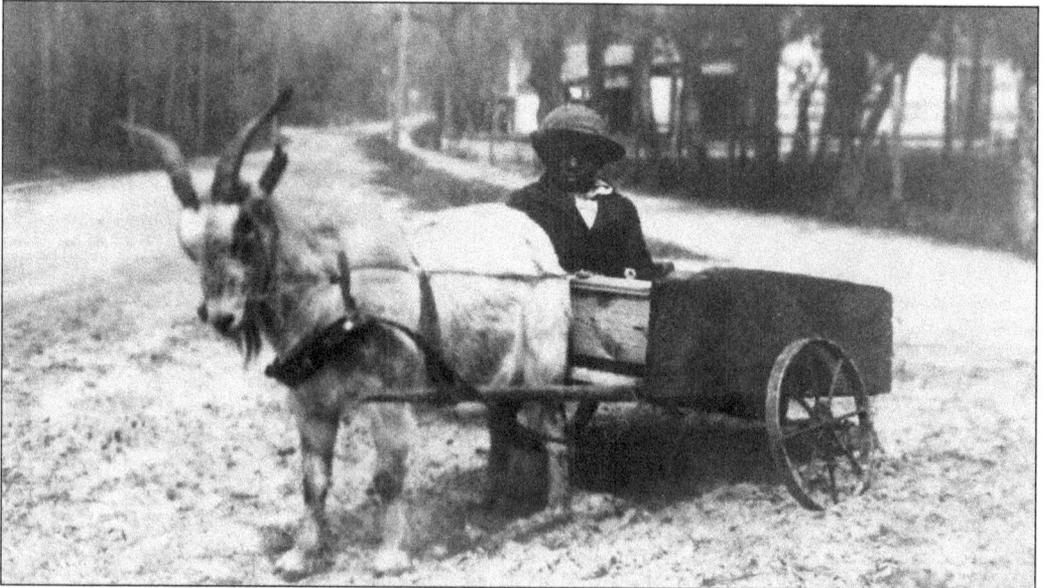

A young man driving a goat cart exhibits one of Charleston's most traditional forms of transportation and reminds one of Samuel Smalls, DuBose Heyward's inspiration for Porgy. Smalls drove a goat cart similar to this one. He is buried in the Presbyterian graveyard on Fort Johnson Road. (MK 1962)

46

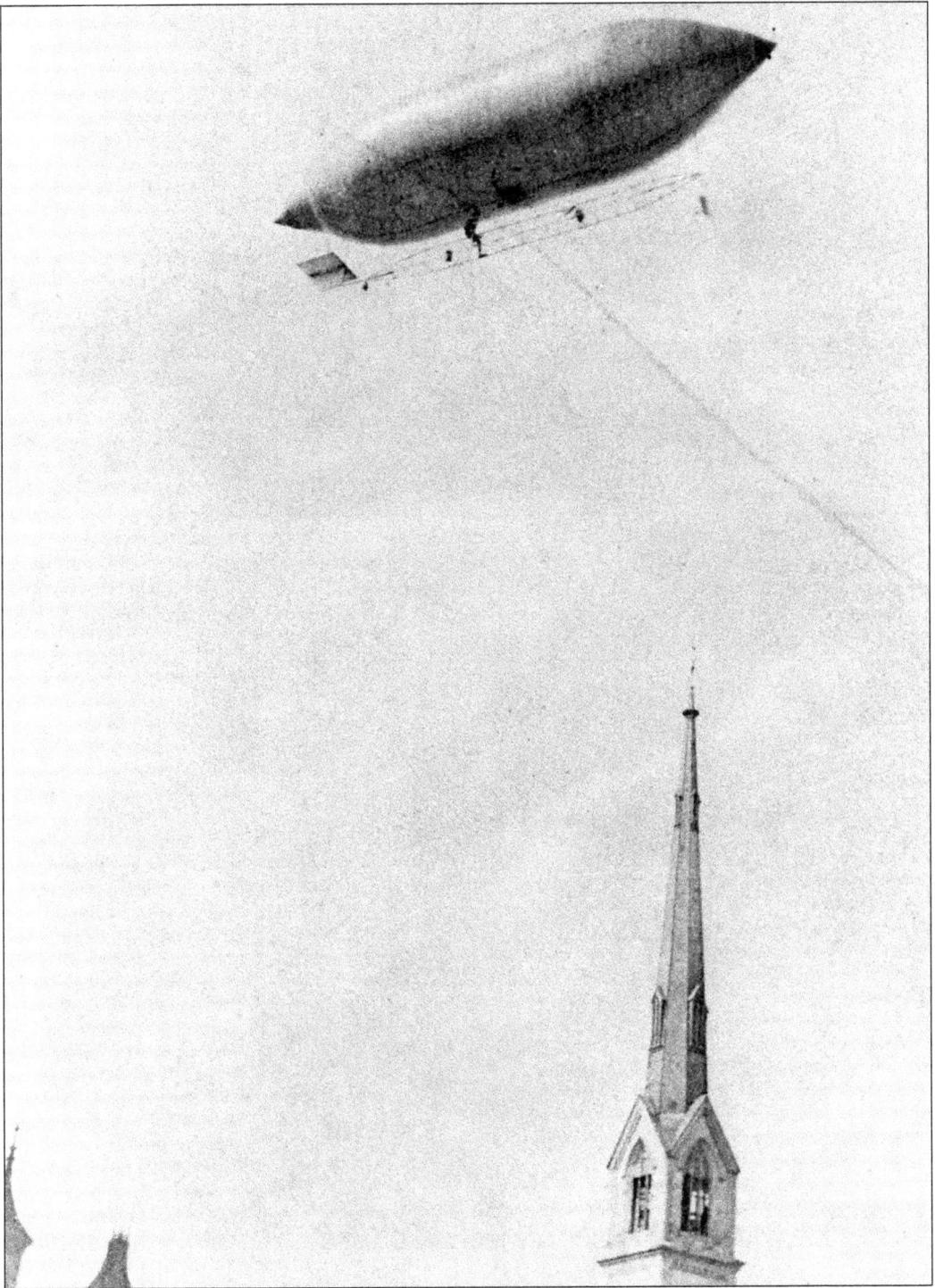

An undated photograph documents an unusual mode of transportation, the dirigible, as it hovers over St. Matthew's Lutheran Church and Marion Square. This version is the type developed during the seige of Paris in the France-Prussian war of the 1870s. (MK 14829)

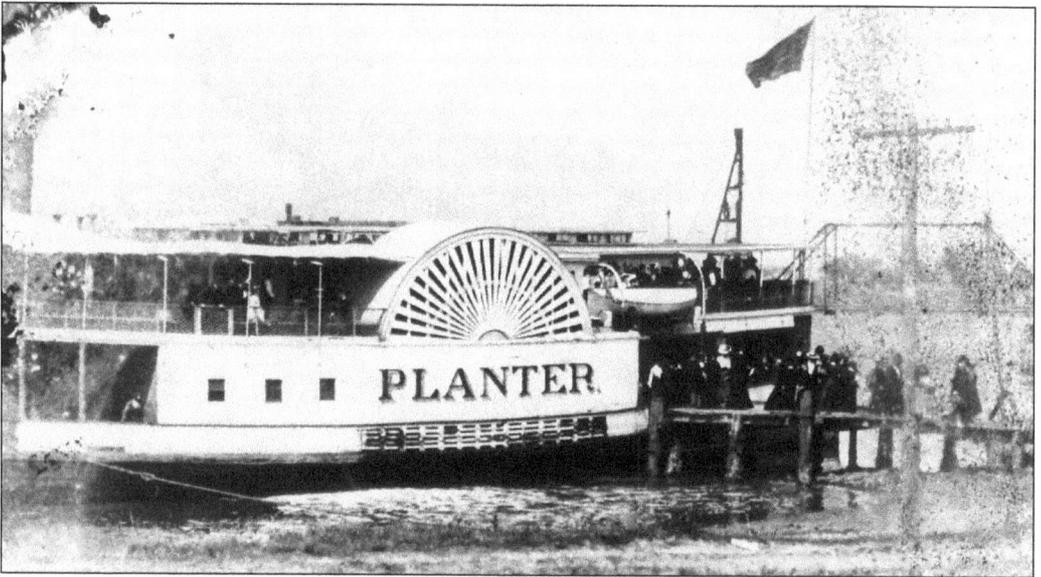

This 1870s view documents travel to the outlying islands of Charleston. Many of the areas across the river from Charleston were serviced by ferryboats. They ran on a regular basis, but the schedule depended on the tides. Here, the paddlewheeler *Planter* is discharging passengers at the Stono River near a station on the Charleston and Savannah railroad seen in the distance. (MK 10257)

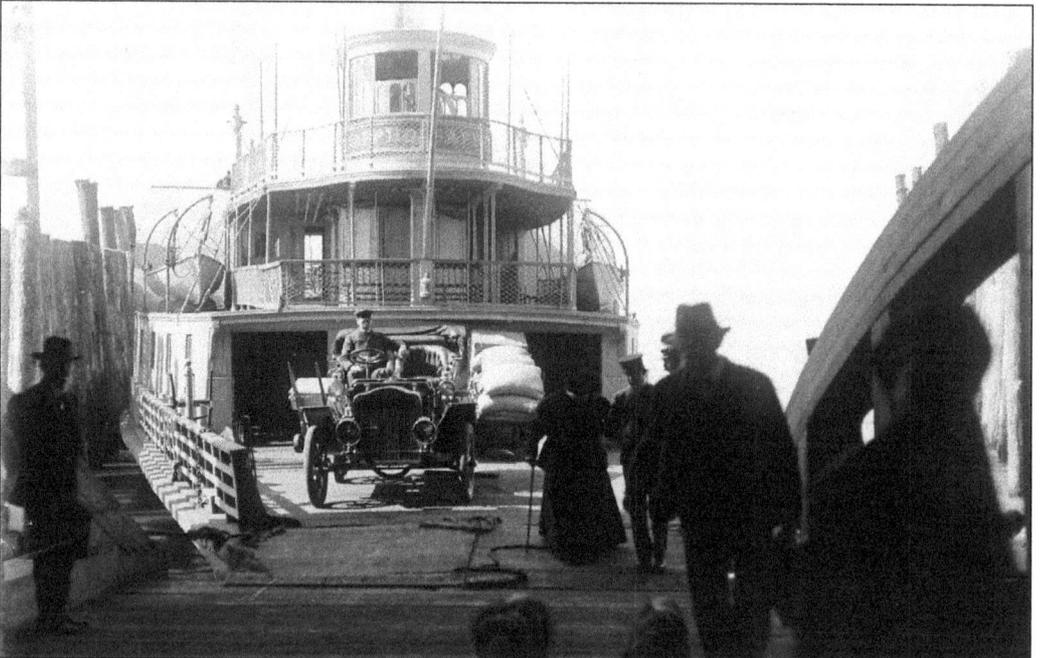

F.W. Wagener arrives at the dock from Mount Pleasant. This 1905 photograph documents the *Sappho*, a ferry that ran between Charleston and Mount Pleasant before the Cooper River Bridge was built. The Cadillac, said to be that which transported President Taft on his visit to the exposition in 1901/02, sits next to the more mundane, but equally important, bags of rice. (MK 14788)

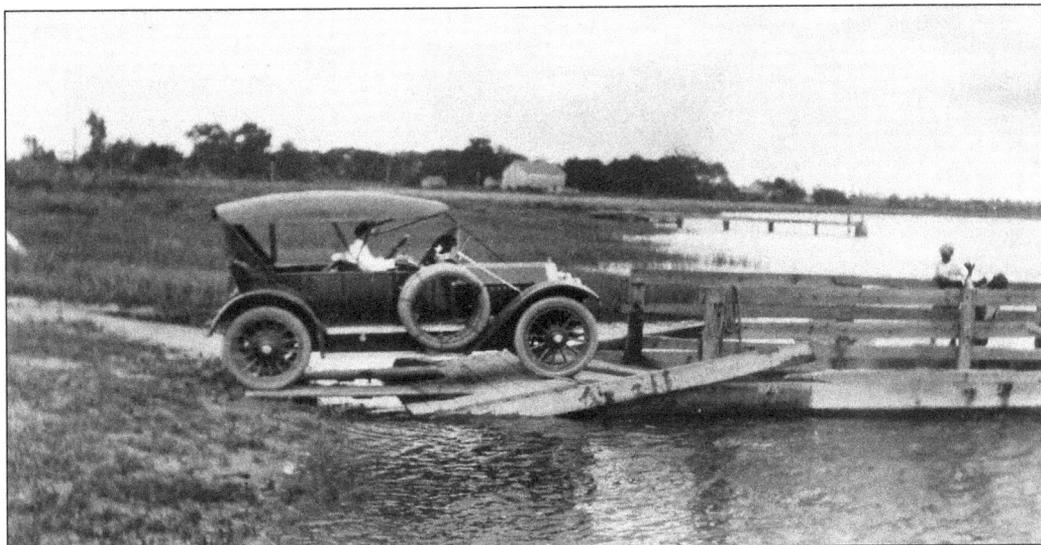

By 1915 wagon roads were used for automobile traffic. Road travel was a difficult affair in the Lowcountry in the early days. The number of creeks, rivers, and wet areas to be crossed to get anywhere made traveling very slow. The poor condition of the roads, which were either soft sand or wet mud, meant that a drive in the country was an adventure in every sense of the word. (MK 4680)

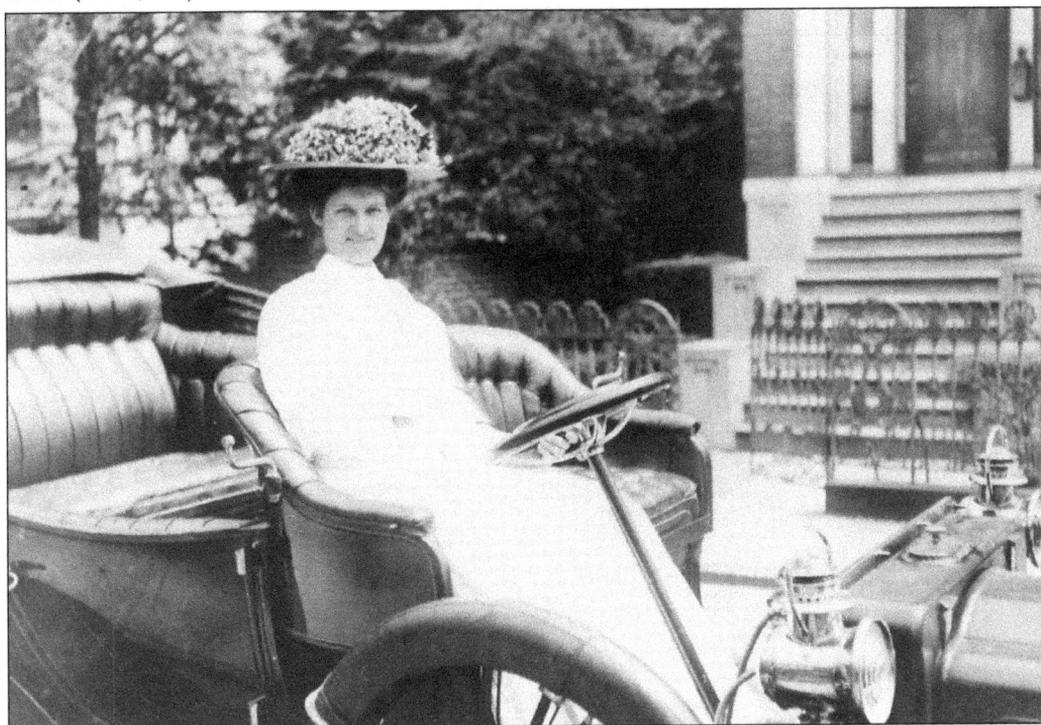

With his 1908 portrait of Mrs. Alex Lucas (née Erna Wieters) sitting in her White steamer, M.B. Paine documented Charleston's first lady owner and driver of a car. According to Paine's notes, Mrs. Lucas purchased this car because it had no gears to shift and did not require cranking. (MK 14780)

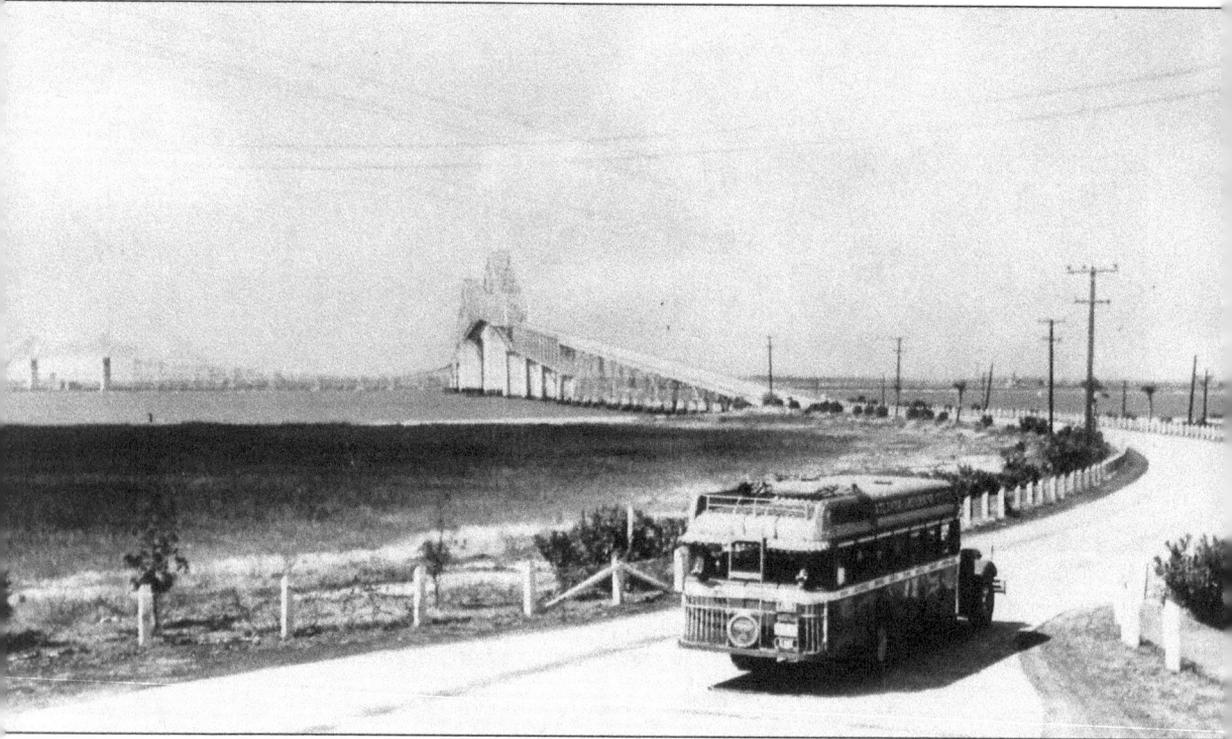

In the 1930s, the Cooper River Bridge was the newest engineering feat in the city. In this photograph, a bus has just left the toll booth on the Mount Pleasant side of the bridge and is headed for downtown. (MK 17310)

Six

AT WORK

"We have learned here in Charleston, S.C., that in order to succeed we must work. The father of Success is WORK. the mother of Success is AMBITION. The oldest son is COMMON SENSE. Some of the other boys are PERSEVERANCE, MODESTY, THOROUGHNESS, FORESIGHT, ENTHUSIASM and COOPERATION, spelled with large letters. The oldest daughter is CHARACTER. Some of her sisters are CHEERFULNESS, LOYALTY, COURTESY, CARE, ECONOMY, SINCERITY and HARMONY. The baby is OPPORTUNITY. We have found that if we got on good terms with the old man that we could get along pretty well with the rest of the family."—Mayor Thomas P. Stoney, City Yearbook 1929.

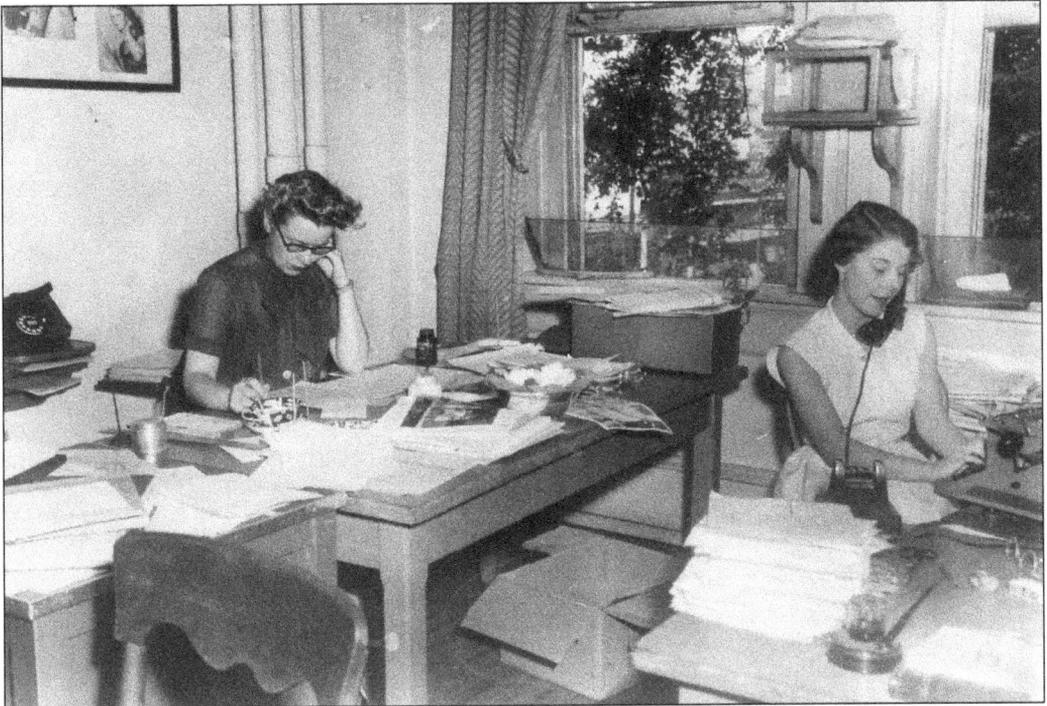

Before air conditioning, the summer working environment was not particularly conducive to productivity. Though air conditioning had been introduced as a concept in the 1920s, it was not until the latter part of the 1950s that it became a regular feature in the work place. Charlotte Walker and Mardelle Musk try keeping cool in the *News and Courier* offices seated next to the windows overlooking the Circular Congretional Church's yard. (MK 18644)

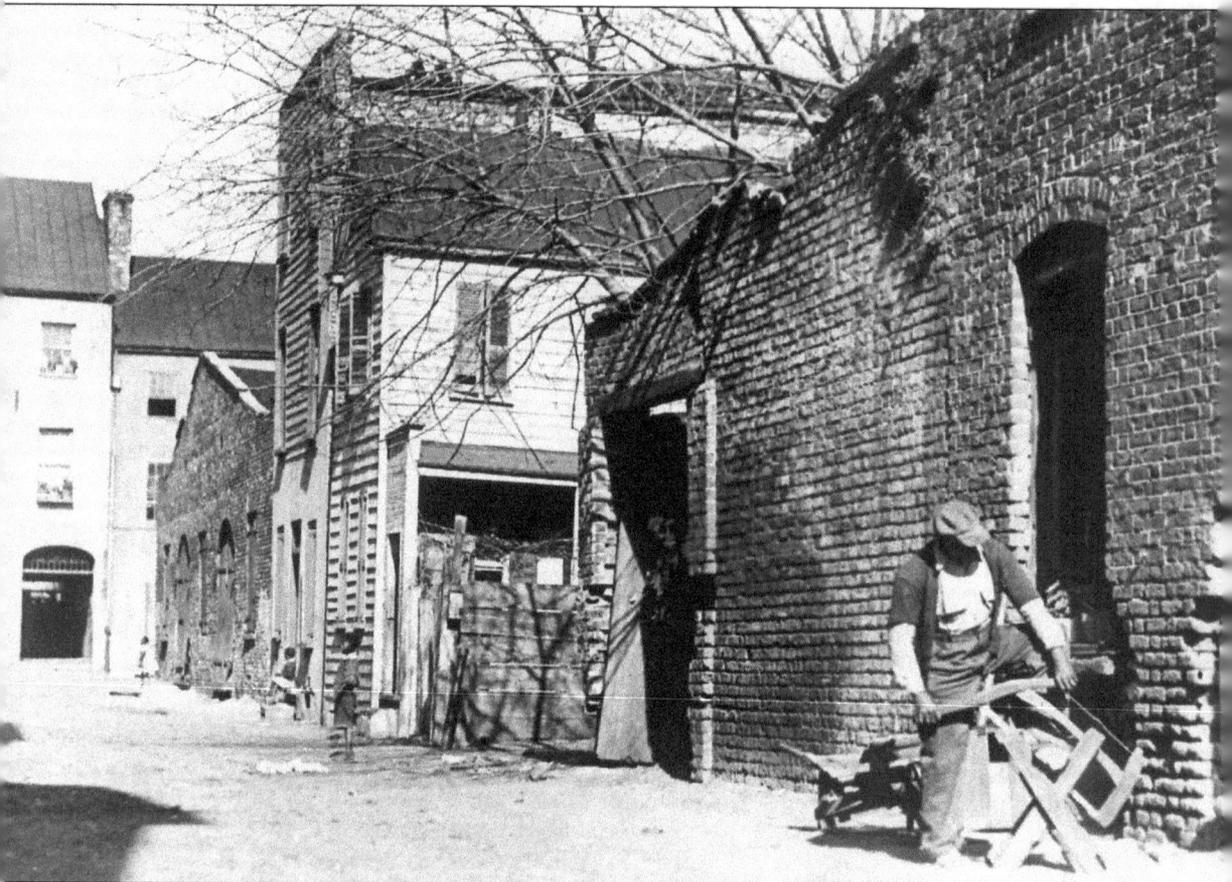

Bedon's Alley was a busy street from the earliest days of the city, with warehouses and commercial activity mixed with residential uses. This 1928 picture shows an old sawyer working at his trade. (MK 3467A)

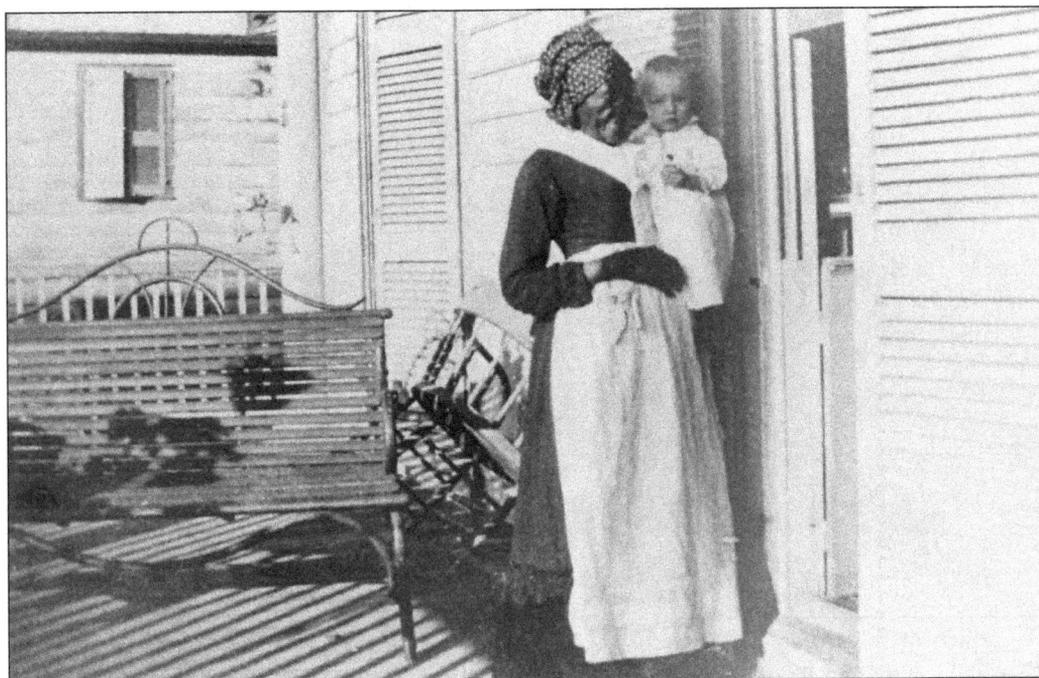

African-American nurses, or "Dahs," often tended the children of white Charlestonians. In this 1880s photo, a "Dah" holds her charge on the piazza of a Charleston home. Note the jib window sash that slides up to provide access to the interior of the house. Jib windows were a familiar feature of such homes, precluding the need for more expensive French doors. (MK 10877)

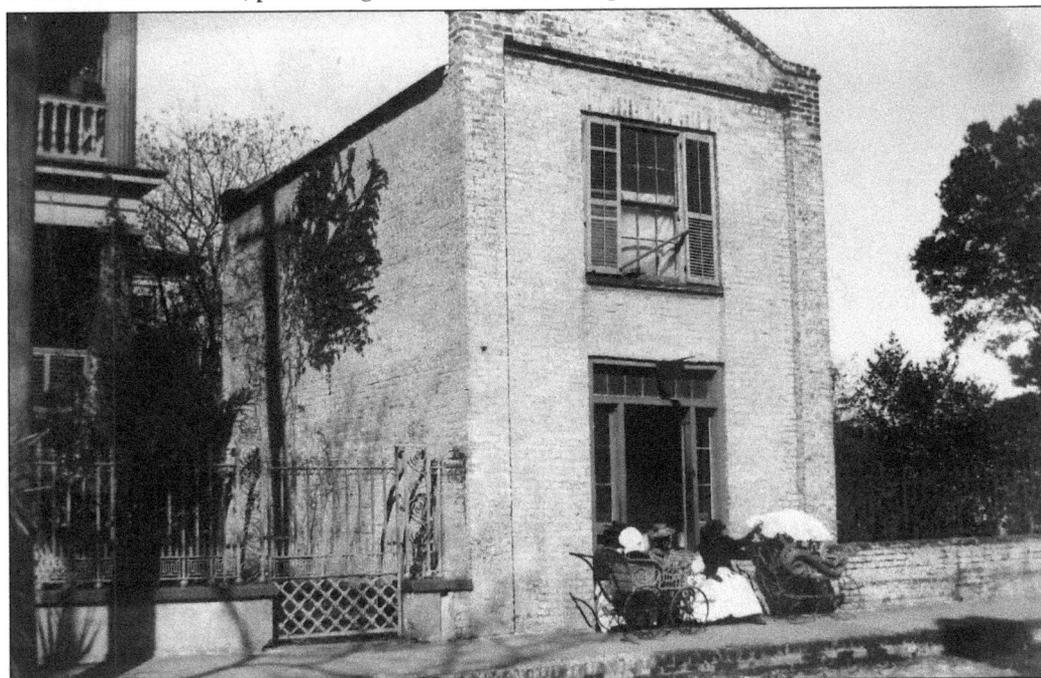

Dr. Franklin Frost Sams took this photograph of "Dahs" with their charges as they sat in front of Dr. DeSaussure's office on Hasell Street, discussing the events of the day. (MK 7562)

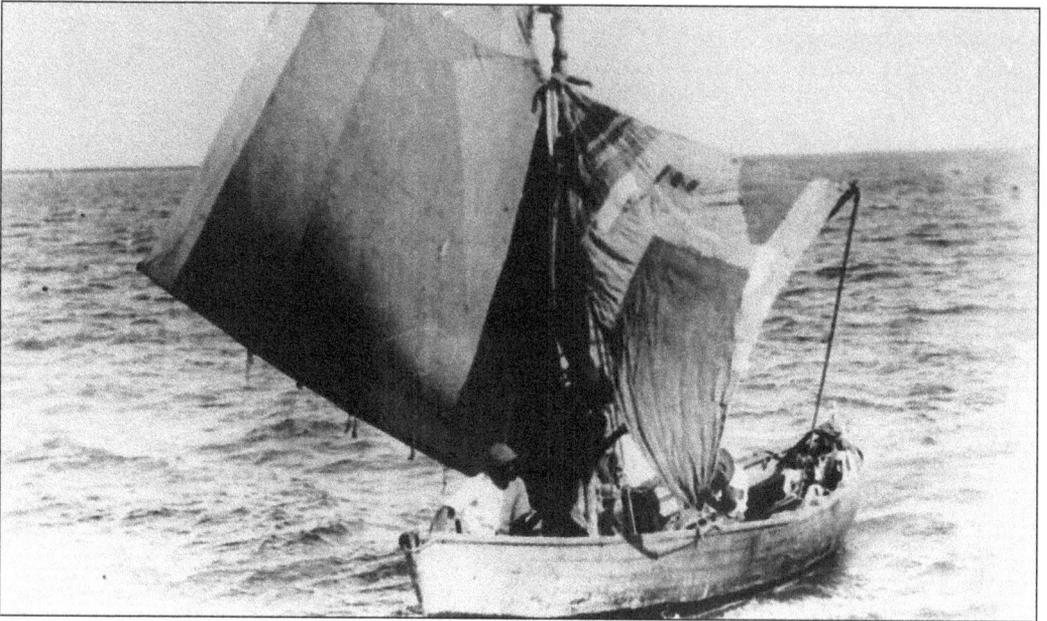

Fishermen of the intrepid "Mosquito Fleet" sail into Charleston Harbor. These small boats provided a source of livelihood for African Americans who harvested fish and shrimp sold by vendors on the streets and in the market. The seamen of the Mosquito Fleet, based in Charleston Harbor, were known for their daring excursions, going to the same spots far out to sea without benefit of a compass. The Fleet knew the tides and weather, and had great expertise in locating fish by the appearance of the water. (MK 3503)

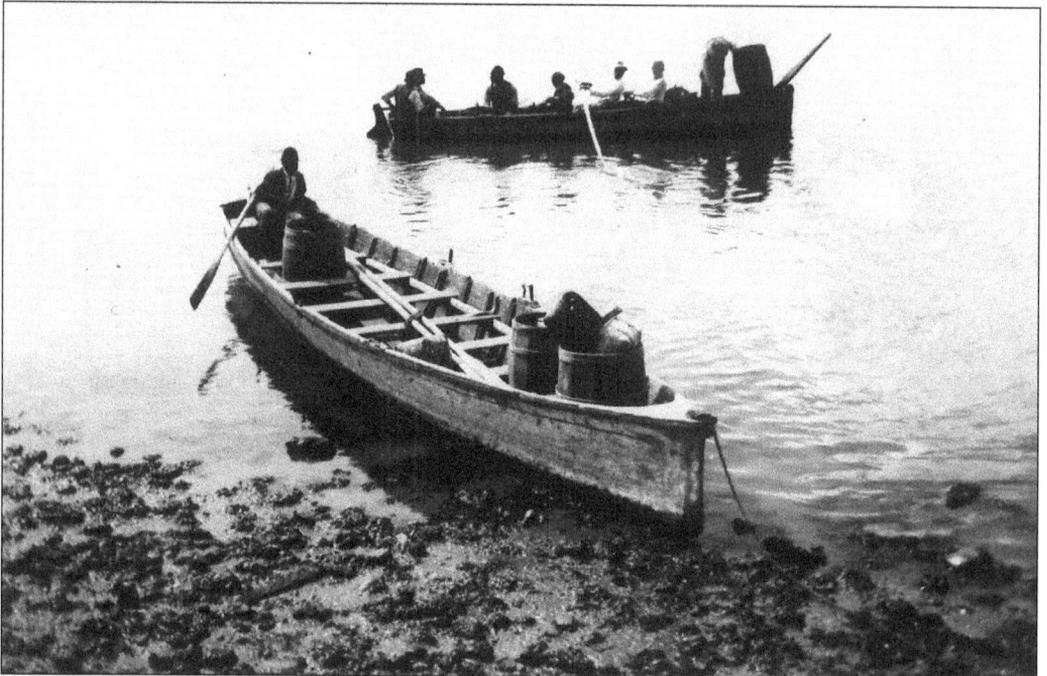

Oystering has been a way of life for centuries in Charleston. In this 1903 image, people in boats are working the mud flats near the harbor. (MK 17540)

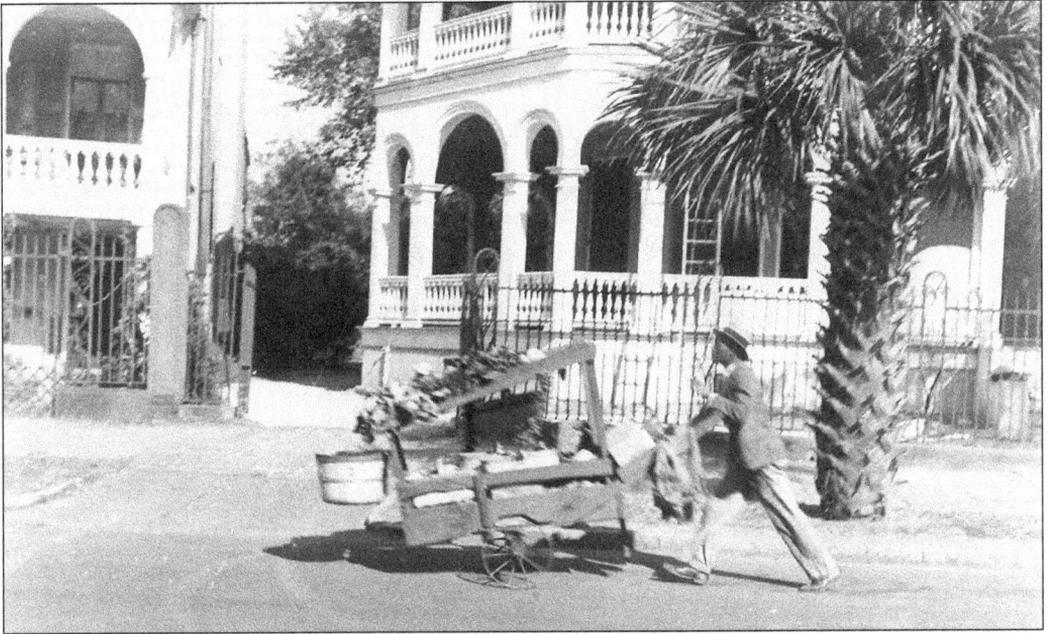

An African-American street vendor hurries past number 26 South Battery in this 1930 photo. Dressed in a suit and boater, he is a purveyor of select okras and tomatoes. (MK 1463)

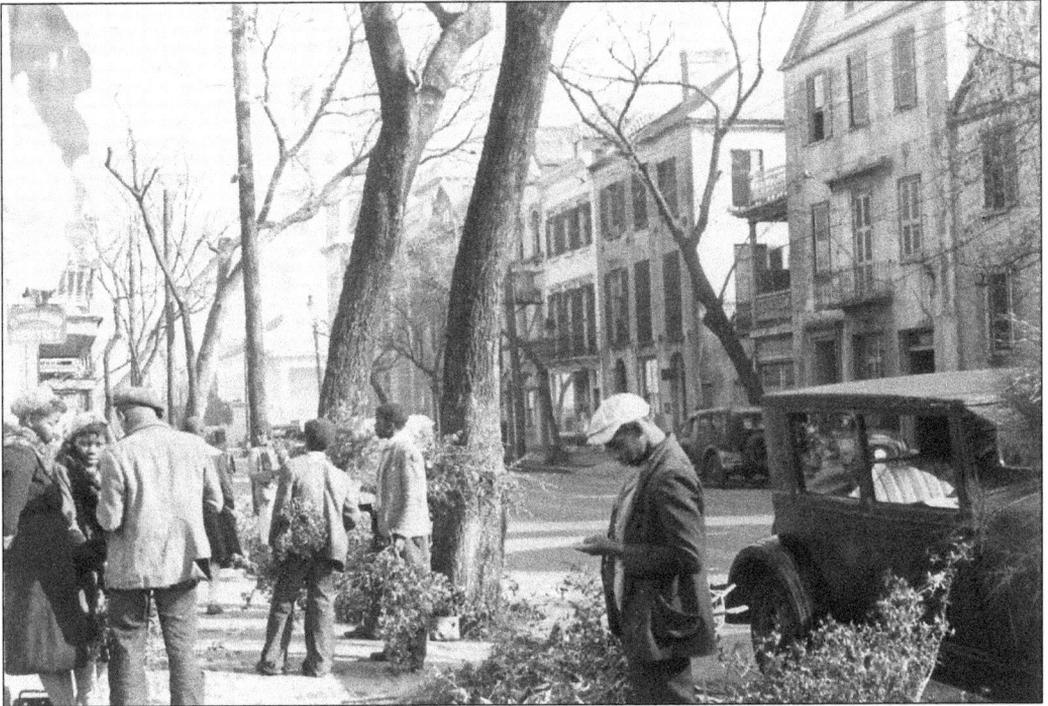

In a 1933 view of Broad Street, young sidewalk vendors sell Christmas flowers. Note the trees that once lined Broad Street, many of which were lost in the tornadoes of 1938. (MK 9781)

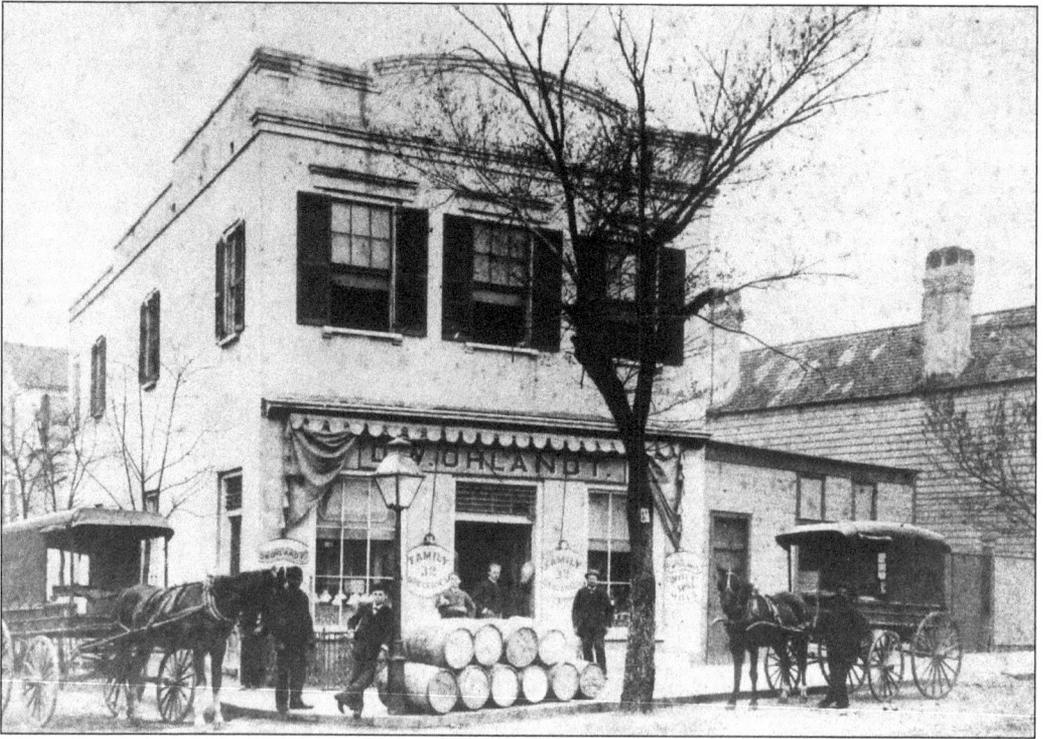

This view of the building at the corner of Meeting and Water Streets documents the prosperous business of D.W. Ohlandt at the turn of the century. Diedrich Ohlandt's family operated this corner store until 1956. The property was sold in 1959 and remodeled as a residence by Marguerite Sinkler Valk. (MK 3446)

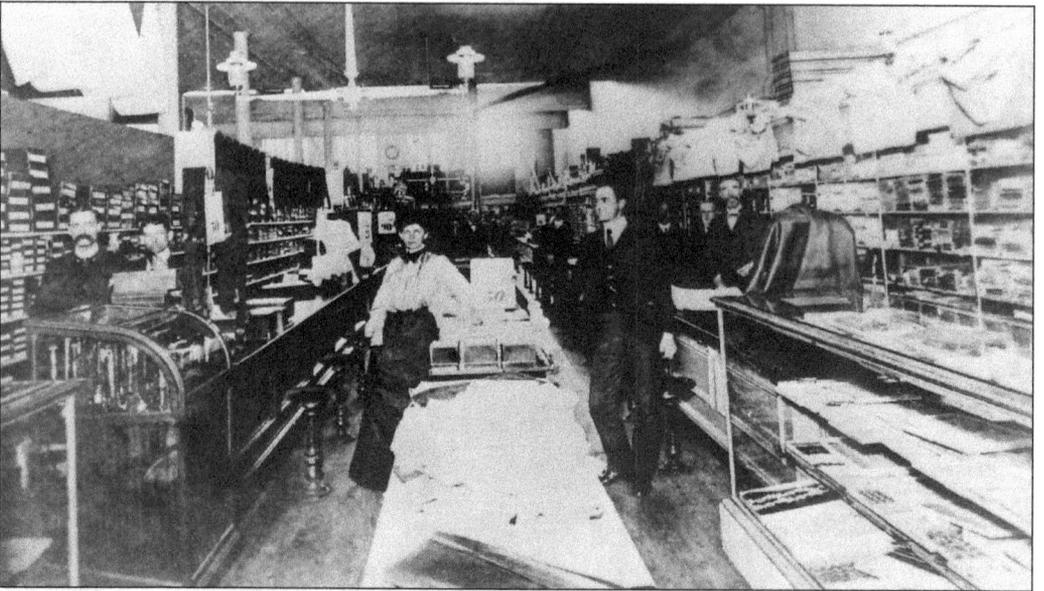

Kerrison's Dry Goods Company was one of Charleston's first department stores. In this 1895 photograph the staff appears ready to welcome customers at the Hasell Street entrance to the store. (MK 9018)

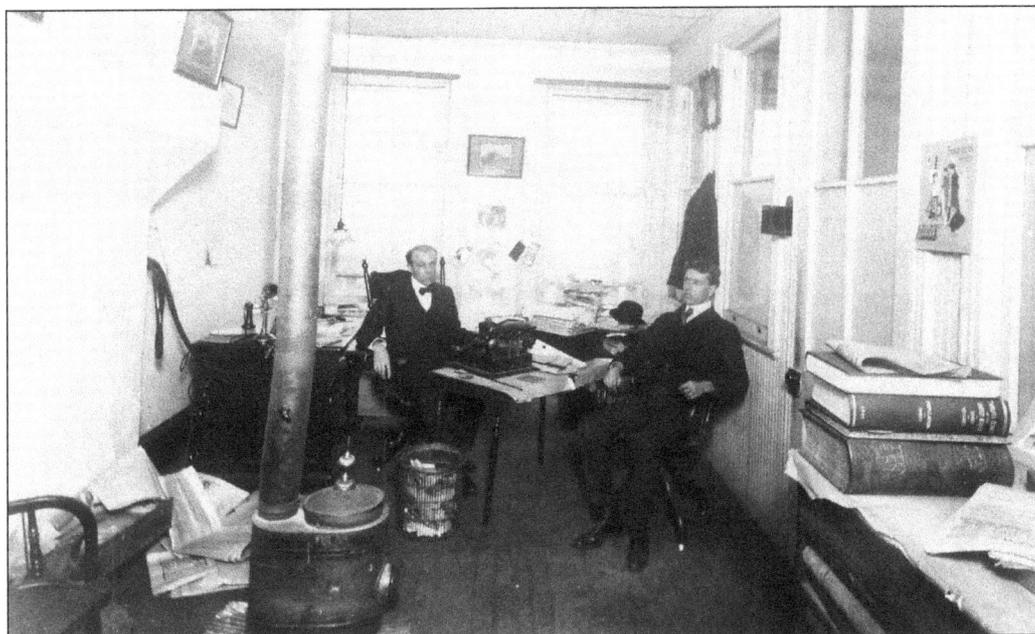

Thomas R. Waring, editor of the *Charleston Evening Post* from 1897 to his death in 1935, is seated in his office. With Mr. Waring is his assistant, Mr. Thomas P. Lesesne, who later served as editor of the News and Courier. Mr. Lesesne was responsible for the creation of the Good Cheer Fund, which continues to operate as a charity today. (MK 1843)

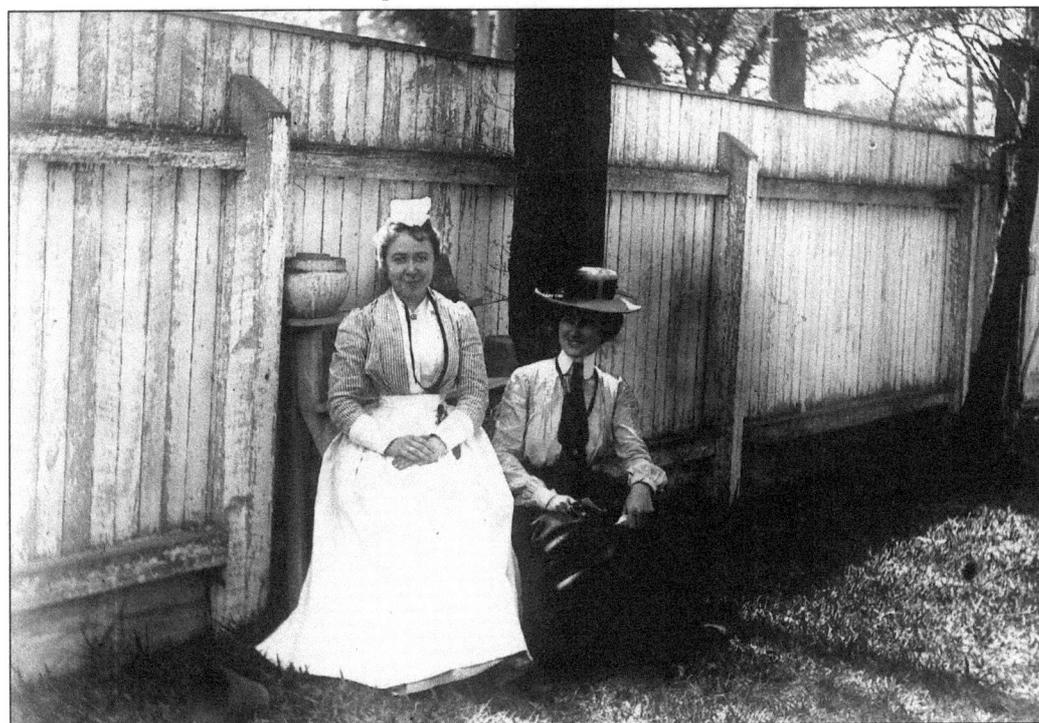

Dr. Franklin Frost Sams took this picture of Miss Macgrath (left) and Miss Walpole, his nurses in the St. Francis Infirmary that once stood at 270 Calhoun Street. (MK 7738)

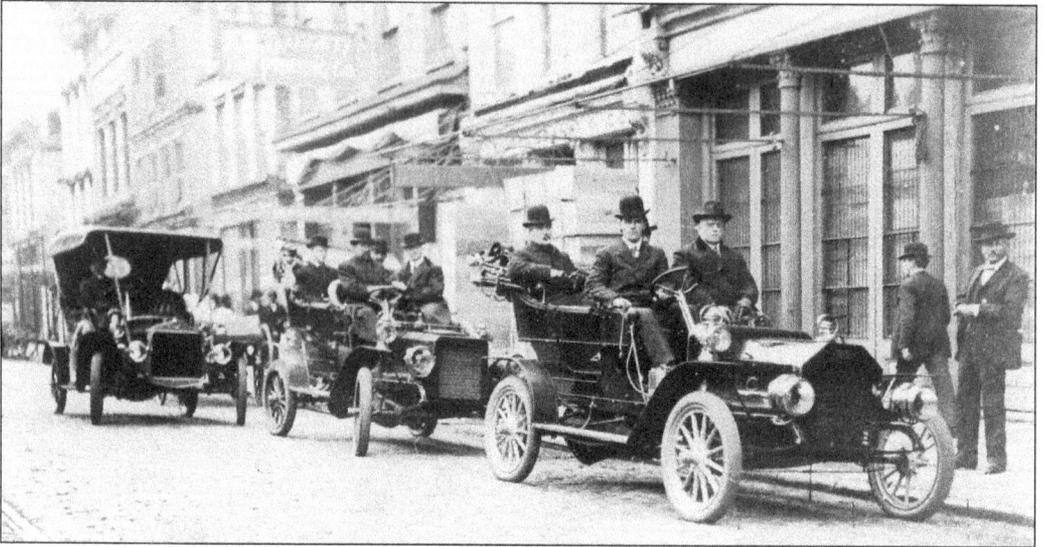

The arrival of the automobile led inevitably to the formation of a Highway Commission, charged with developing roadways and thoroughfares for this new mode of transportation. In this 1906 view, the commissioners are about to leave on their inspection tour of the route proposed for the auto speedway to Summerville. In the first vehicle, the chairman, a Major Hemphill, and secretary, a Colonel Cosgrove, are ready to do their duty. Commissioners Storen and Clark in the second car are followed by Commissioner Connell bringing up the rear in his automobile. (MK 996)

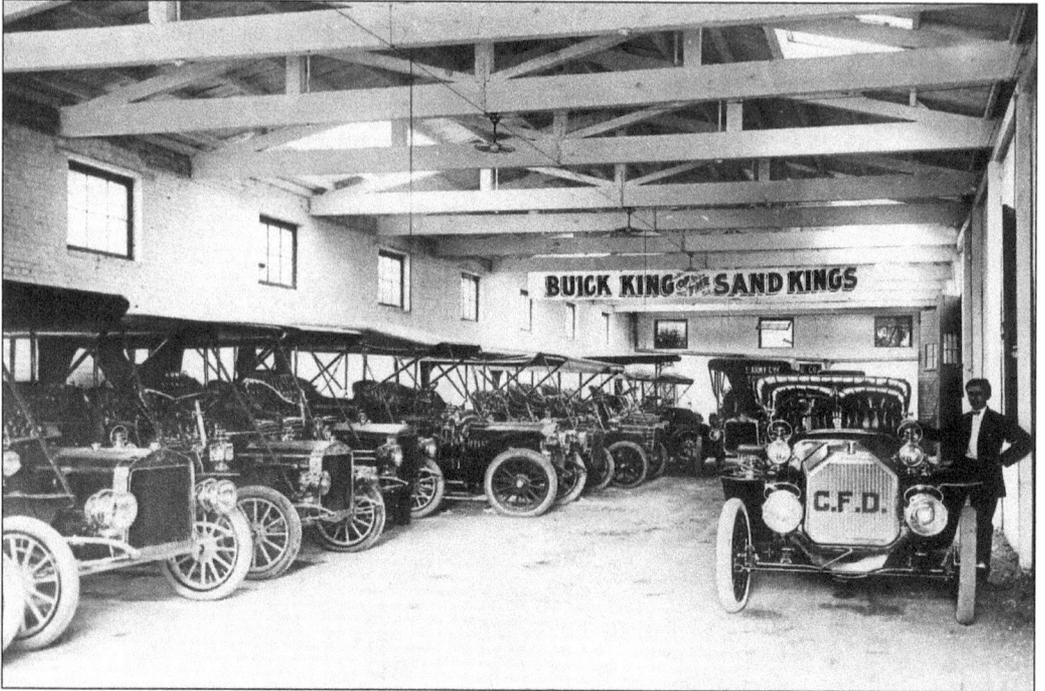

The Charleston Fire Department's first automobile was this Buick "Sand King." The new Buick, known as the "King of Sand Kings," was touted for its performance on the sand flats at Daytona Beach, Florida. (MK 14809)

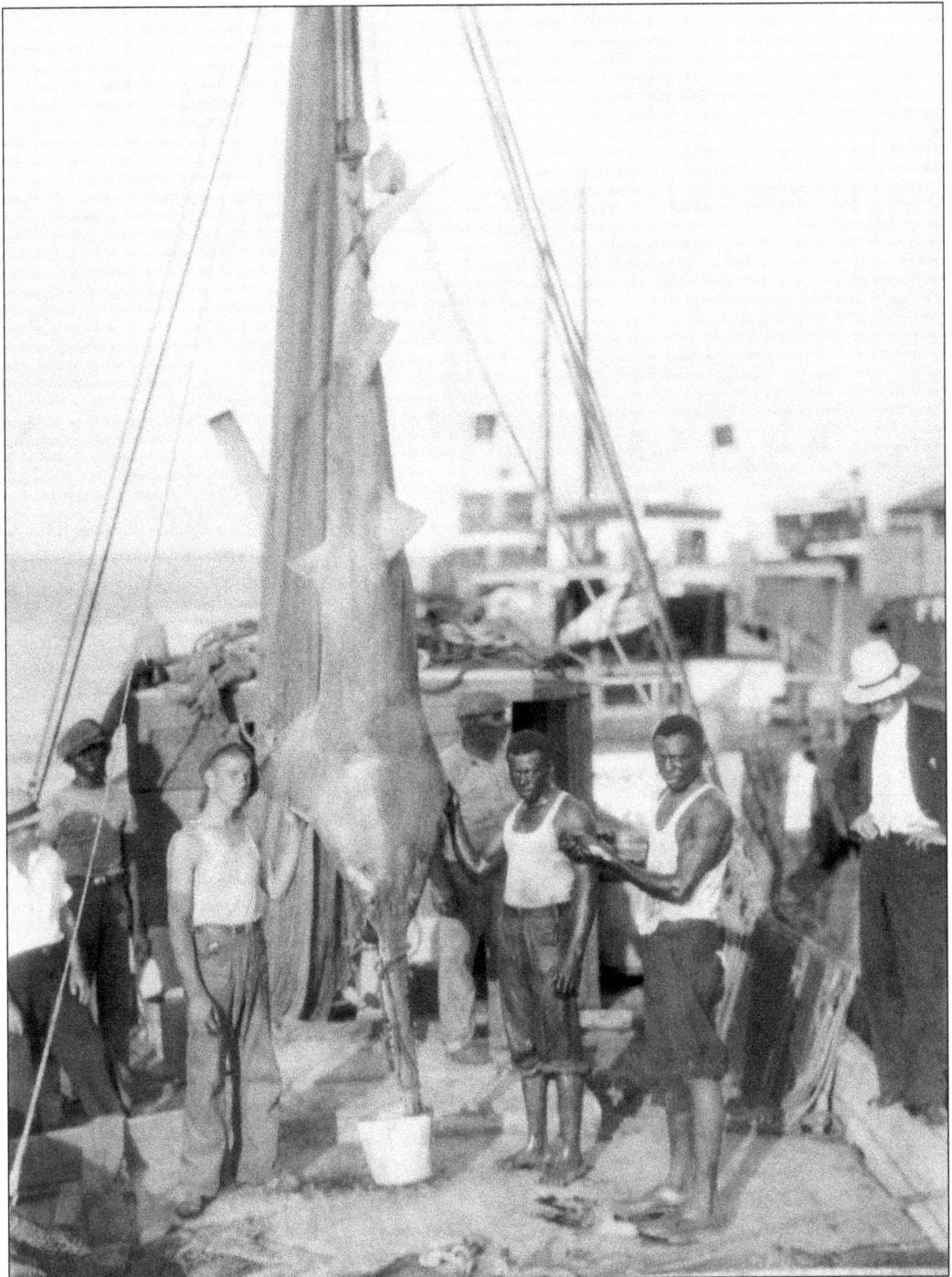

This group of fishermen display one of the largest sand sharks found off Charleston waters in this 1929 photograph. The shark was caught off Porcher's Bluff, north of Mount Pleasant. (MK 20198)

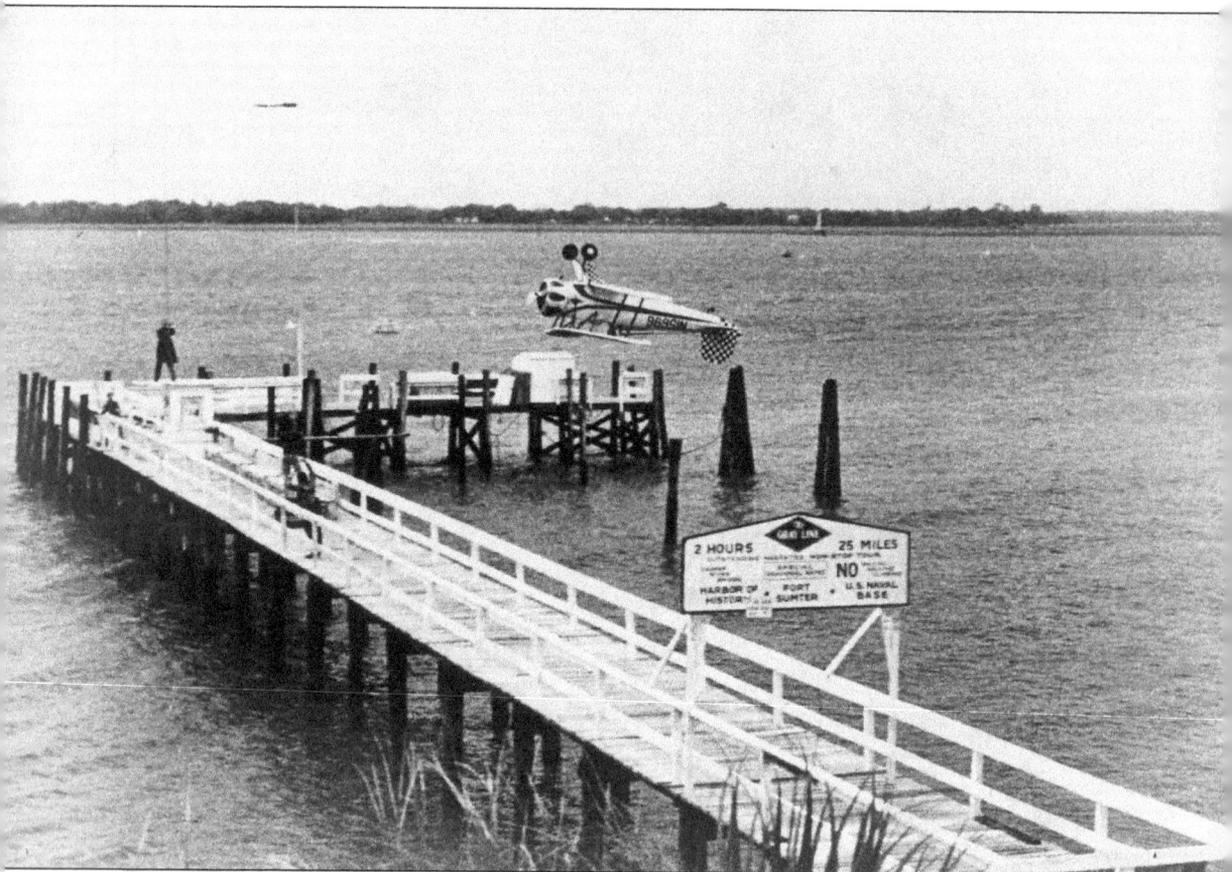

World War II flying ace, Beverly "Bevo" Howard performs his daredevil airplane show off the Battery in this undated photo. Here, "Bevo" flies upside down to pick up a ribbon held by the man standing on the dock. (MK 20315)

On the go and going places, a young Senator Ernest Hollings displays a winning smile as he arrives home to visit his constituents. The photograph is undated. (MK 8383)

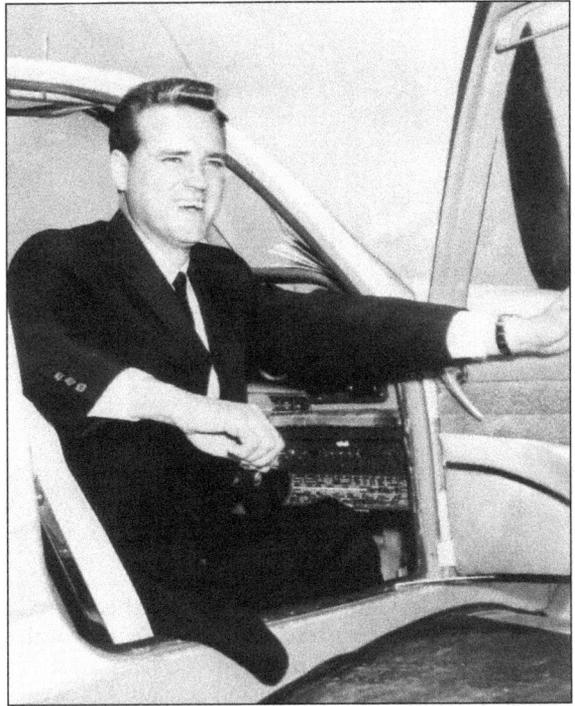

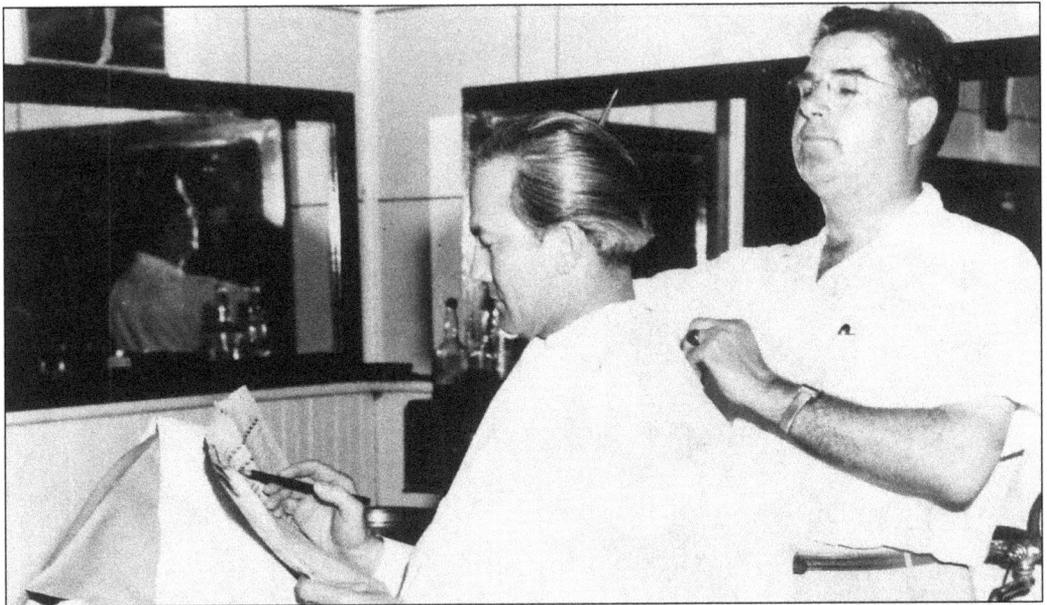

In this photograph staged for a *News and Courier* profile in the early 1950s, Mr. Lawrence Rabon of Rabon's Barber Shop proudly works on the appearance of one of Charleston's most successful native sons, Mendel Rivers. Rivers was renowned in the Washington political scene from 1942 to 1968. As chairman of the powerful Senate Armed Services Committee, he built the military presence at Charleston's Navy Base, Naval Weapons Station, U.S. Coast Guard Base, and U.S. Air Force Base to one of the largest concentrations of military personnel on the East Coast. (MK 8562)

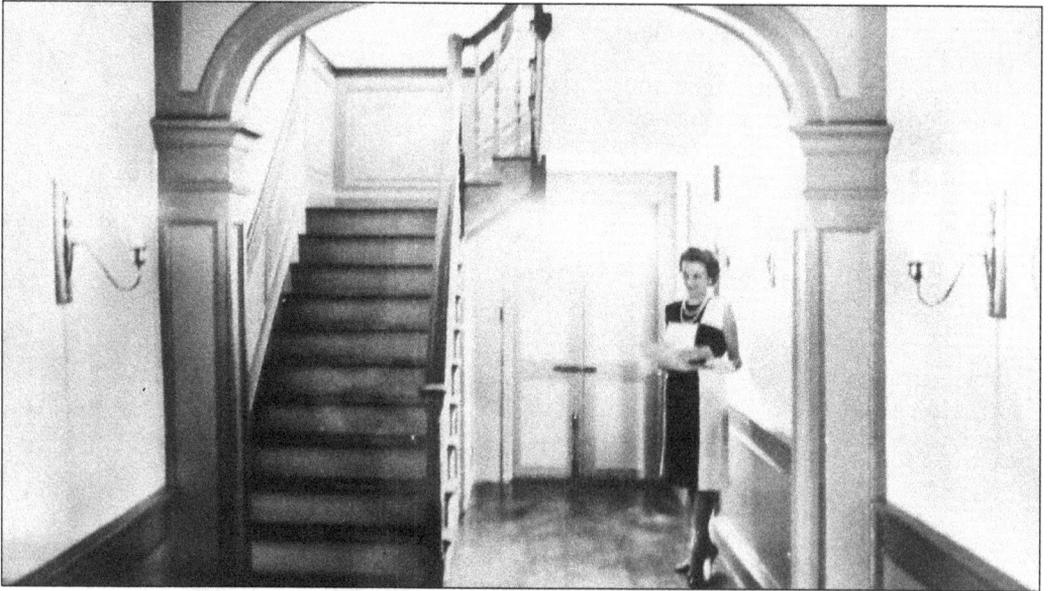

In this *c.* 1962 view of the interior of the recently restored John Lining House at 106 Broad Street, a volunteer hostess prepares for guests of the Preservation Society of Charleston to tour the house. House tours have been a feature of Charleston since the 1920s. Volunteers work hard to produce the Preservation Society of Charleston's tours of homes and gardens in the fall season. (MK 6368H)

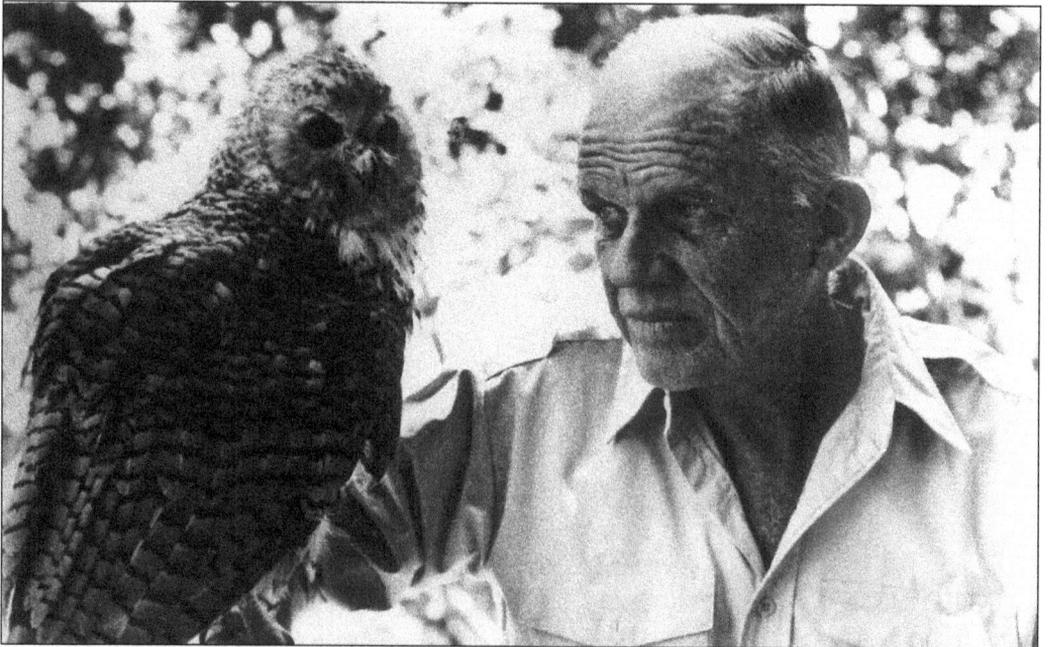

Charleston artist John Henry Dick eyes one of his fine feathered friends at his plantation Dixie, near Charleston. Mr. Dick was an internationally recognized bird artist who studied at the Yale University Art School. Mr. Dick was a latter-day Audubon, painting illustrations for *The Birds of India* and *The Birds of China*. His former home is now a bird sanctuary owned by the College of Charleston. (MK 7119)

Seven

AT HOME

"Home! What a beautiful word. Not perfect, but easy to live in, comfortable. For Charleston is no 'period' city, as no house is a home that sets one date throughout. It is easy to walk into the living room of any house and see at a glance whether it's a home or the product of an interior decorator who knows all the answers but the one that matters. A home must reflect the personality of a family for many generations. It is a repository of treasure, not necessarily of any intrinsic value. Here is a living record, the accumulation of mute witnesses of a family life."—Elizabeth O'Neill Verner, *Mellowed by Time.*

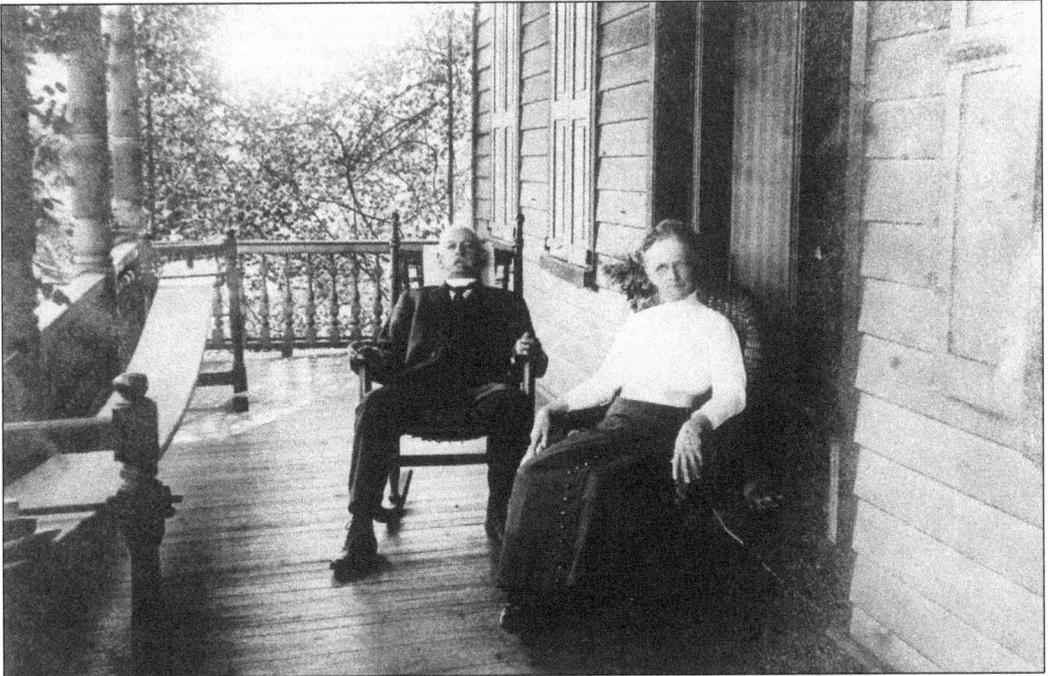

William K. Welling and his wife, Dora Frances Collins Welling, enjoy a quiet afternoon on their piazza at 86 (East) Bay Street. Mr. Welling was a successful lumberman. He lived next door to his lumber yard and mill at 88 (East) Bay Street, which he operated with other members of the family. The joggling board, a familiar item to Lowcountry families, was a form of courting bench designed, some say, to bring the courting couple together as one party or another would bounce the bench. This particular joggling board currently resides at The Charleston Museum's Joseph Manigault House. (MK 17698)

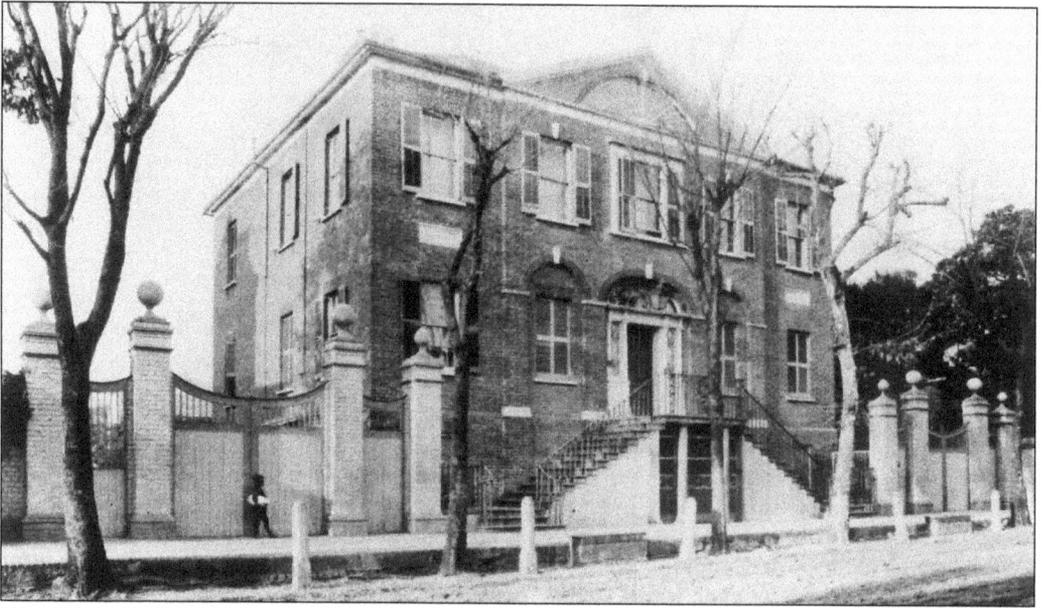

The William Blacklock House at 18 Bull Street is representative of the large suburban villas built near the upper edge of the city in the 1800s. This view taken in the late 1850s portrays the house as the seat of the family, a dwelling place and haven for many years. (MK 22693, AWC)

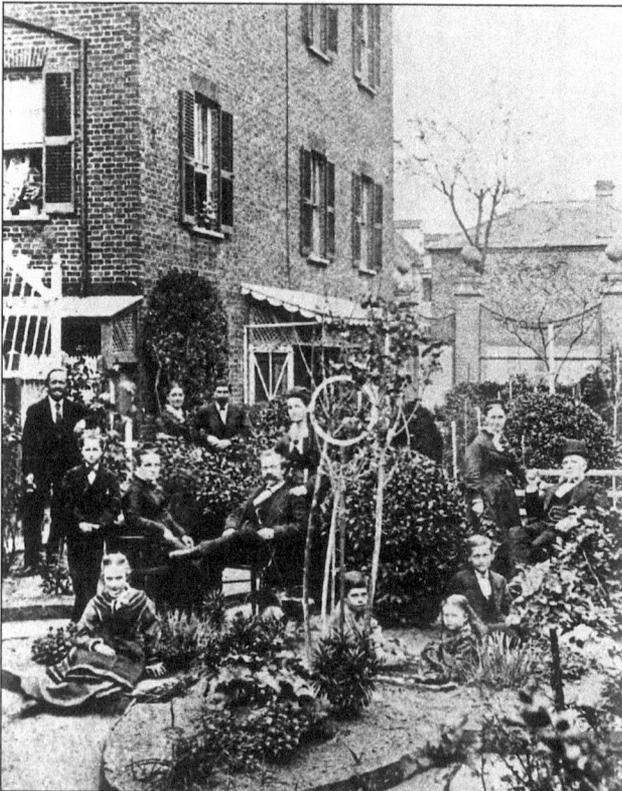

In this 1860s view, the Jahnz family gathers for their portrait in the garden of the Blacklock Home. The family is seated in the parterres of the garden, carefully positioned not to move as the exposure time for a picture of this type could require lengthy waits. (MK 22917)

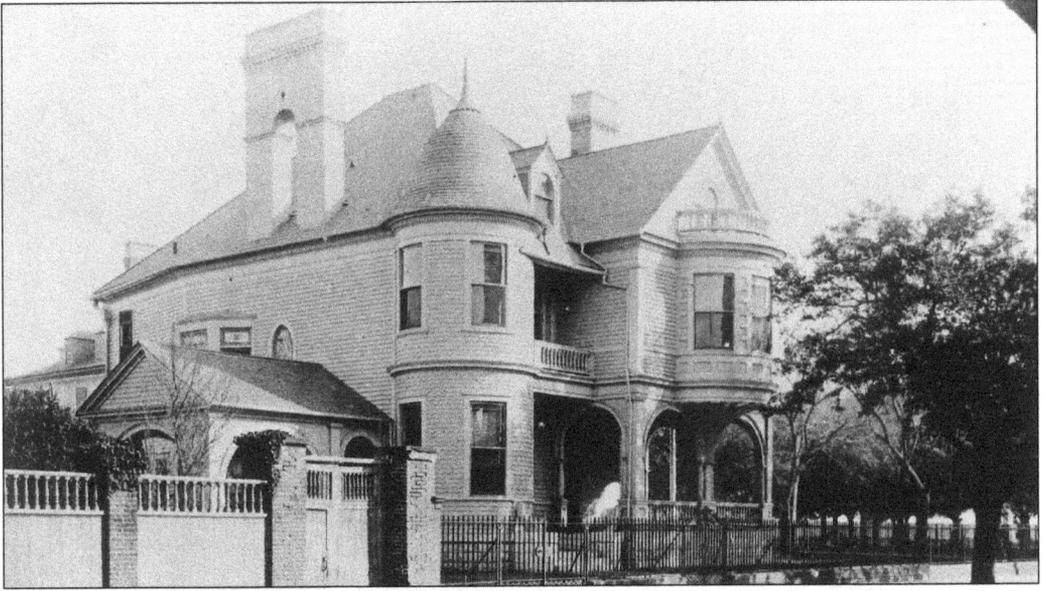

The residence of Waring P. Carrington at Number Two Meeting Street was built in the Queen Anne style and completed in 1892. The Carringtons were jewelers who produced silver objects still coveted today. (MK 22699)

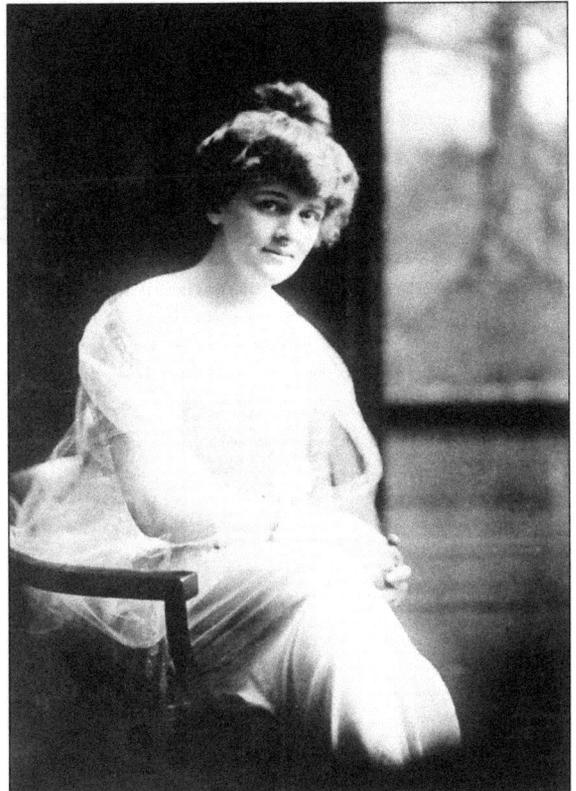

Mrs. Waring P. Carrington (née Martha Williams) looks out at the camera in this 1890s portrait. The daughter of George Williams, Esq., she had the good fortune to marry into the wealthy jewelry family, the Carringtons. Later, Mrs. Carrington gave the money for the bandstand at White Points Gardens in memory of her father, so the family could enjoy the concerts from their porches. (MK 13924)

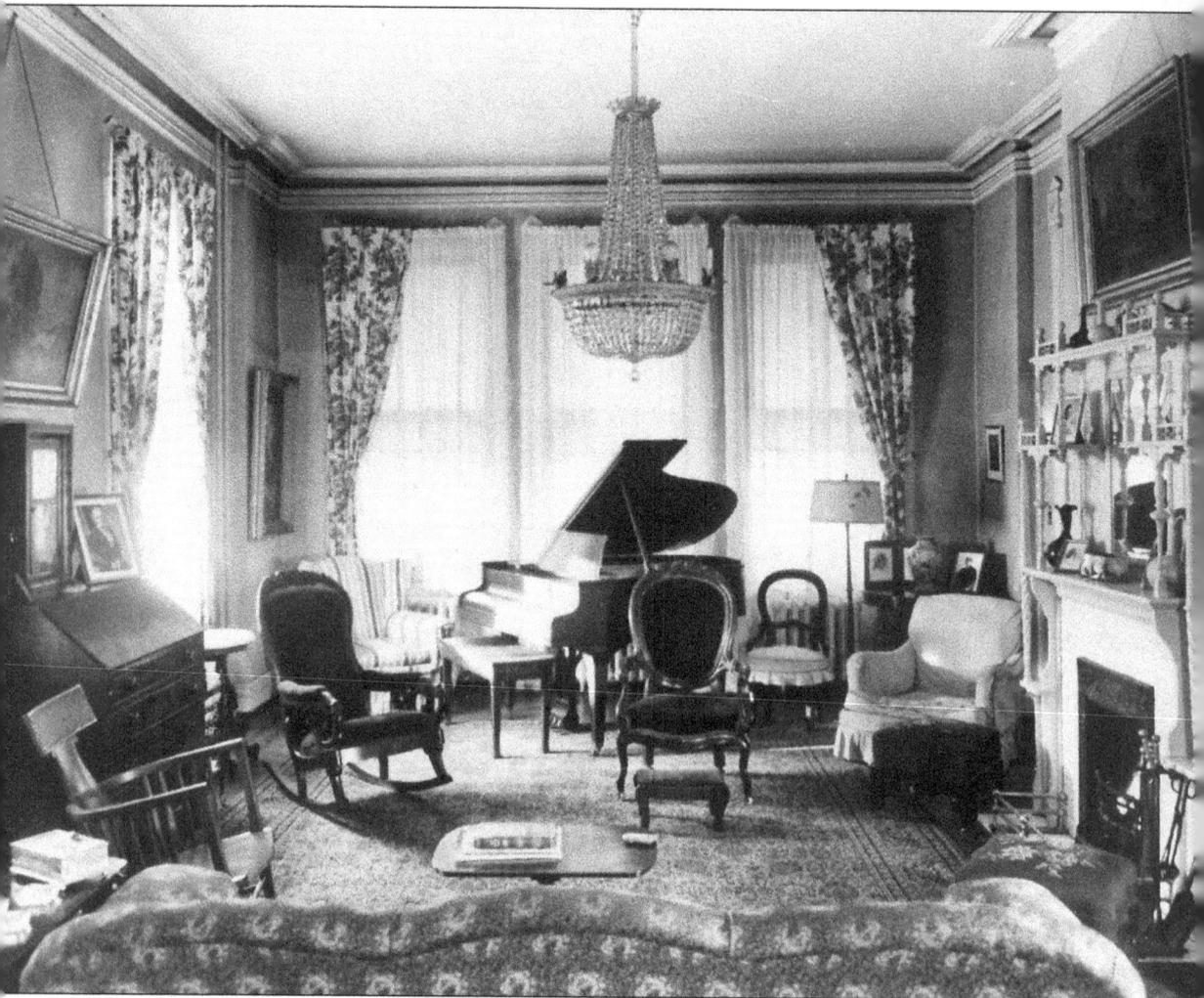

This photograph shows the drawing room of 161 Calhoun Street, built *c.* 1895, as it appeared in the 1950s. The room is an excellent example of a Charleston interior. Comfortable chairs, family mementos, and a grand piano were evidence of a real dwelling in the best sense of the word. The house was demolished in 1960, but the chandelier now hangs in the members room of the Charleston Museum. (MK 6651)

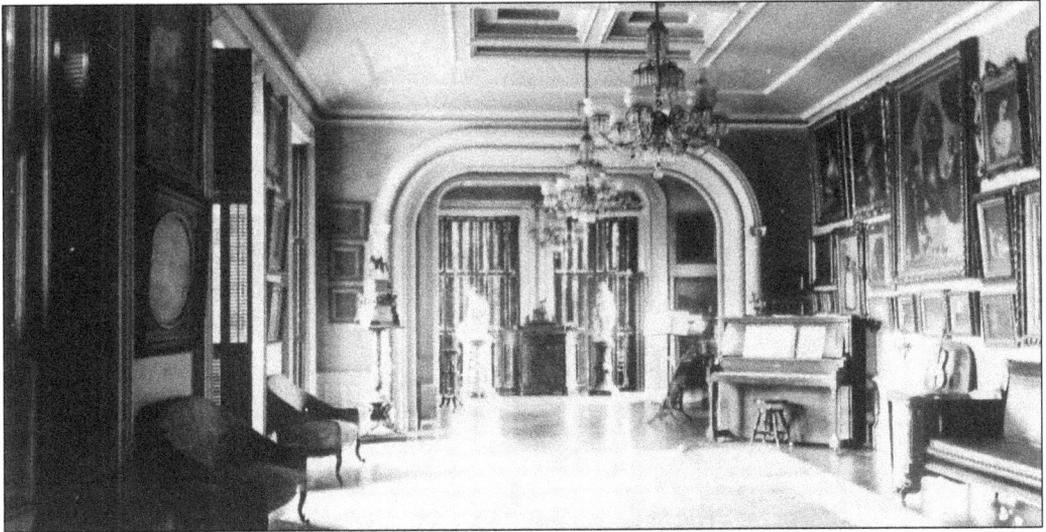

The Siegling family was one of the families responsible for the cultural and musical life of the city. Their music store opened in the early nineteenth century and for 150 years provided Charleston with a source for the range of music necessary for a civilized life. This view of the drawing room of 9 East Battery shows the open arrangement of a living room designed for groups of people to gather for musicals, social events, and other activities appropriate to a salon evening in the European tradition. (MK 3239)

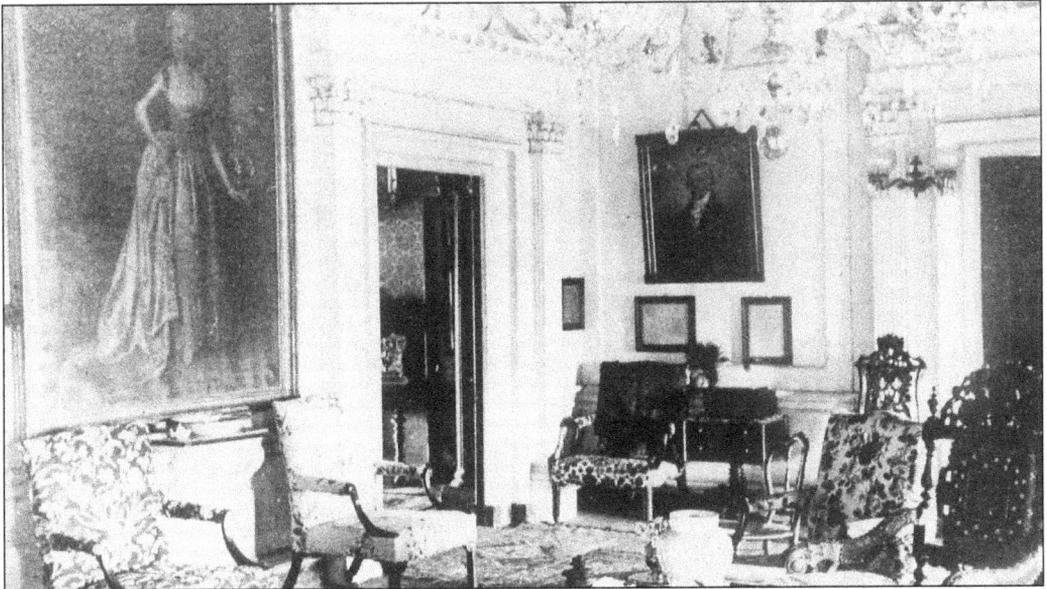

The Miles Brewton House at 27 King Street, built 1765–1769, represents one of the best examples of a dwelling house of Charleston where the continuity of one family over several generations created an eclectic interior. Descendants Susan Pringle Frost and her sister Mary Frost lived in the house from 1912 to 1960 and celebrated the accumulation of mementos, bibelots, and grandeur that were the family heritage. The grand Georgian ballroom with its fine eighteenth-century chandelier is one of the treasures of the city. Largely due to the efforts of Miss Sue and Miss Mary, who bought the interests of more than twenty-five other heirs, the house was passed on to future generations intact. (MK 3200)

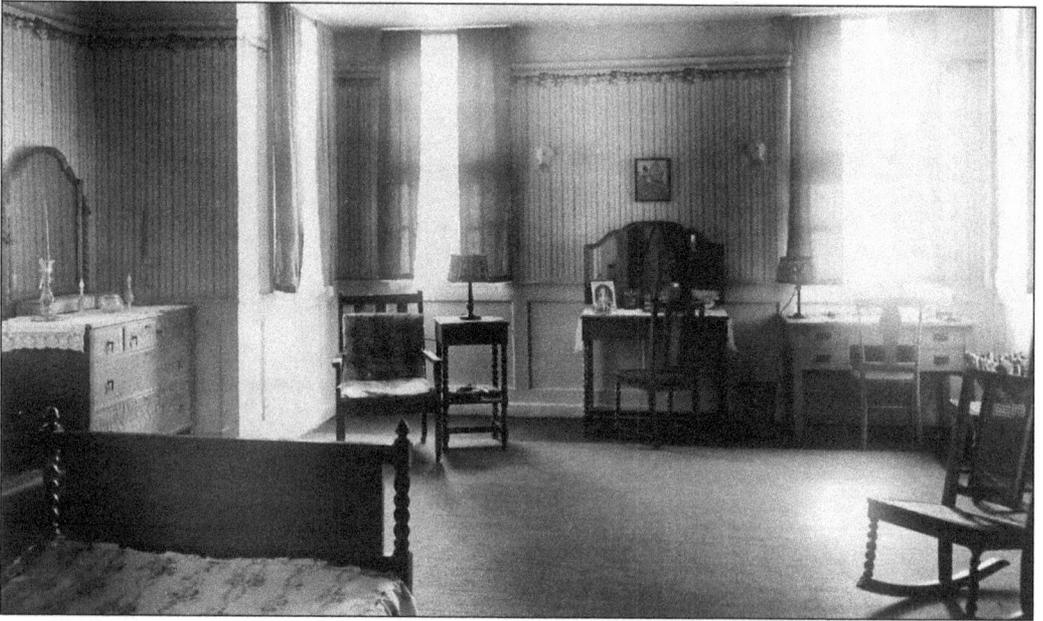

This bedroom, at number 10 Atlantic Street, the home of a member of the Chisolm family, reflects an austerity not often found in the more public rooms of Charleston houses, where the accumulation of years of family life usually gave an overstuffed appearance to the rooms. (MK 3663)

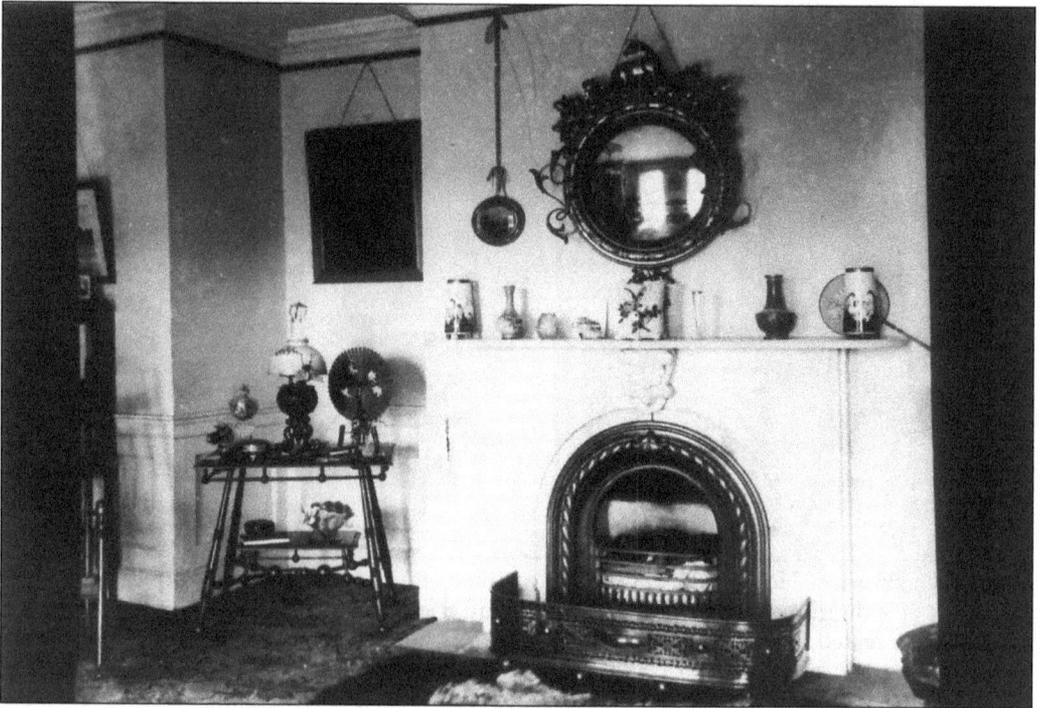

The Charleston mantelpiece of any era provides a fascinating glimpse of what was important to the residents. Here in this shot of an 1890s interior on Ashley Avenue, we see a collection of Japanese ceramics. (MK 1870)

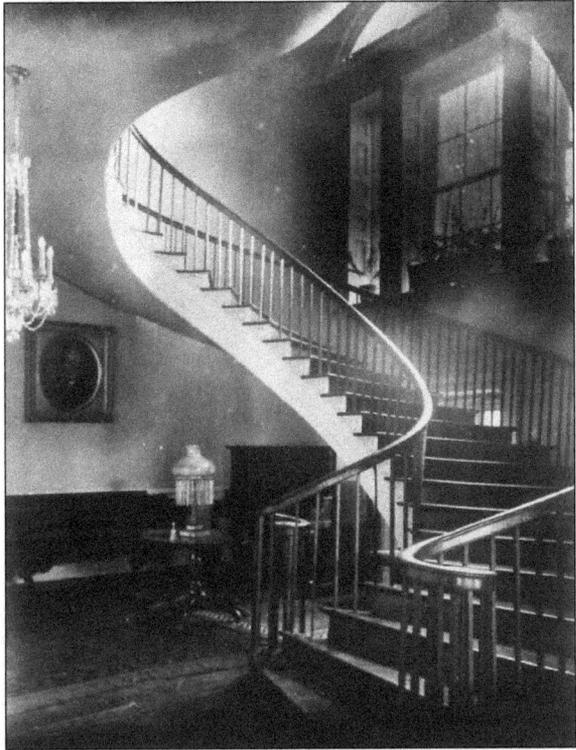

The Nathaniel Russell House at 51 Meeting Street, built *c.* 1808, is recognized as one of Charleston's great residences. Pictured here is the free "flying" staircase, built with no visible support. The property was sold by the Mullaly and Pelzer families in 1955 to the newly formed Historic Charleston Foundation. It was the Foundation's first house museum. (MK 729)

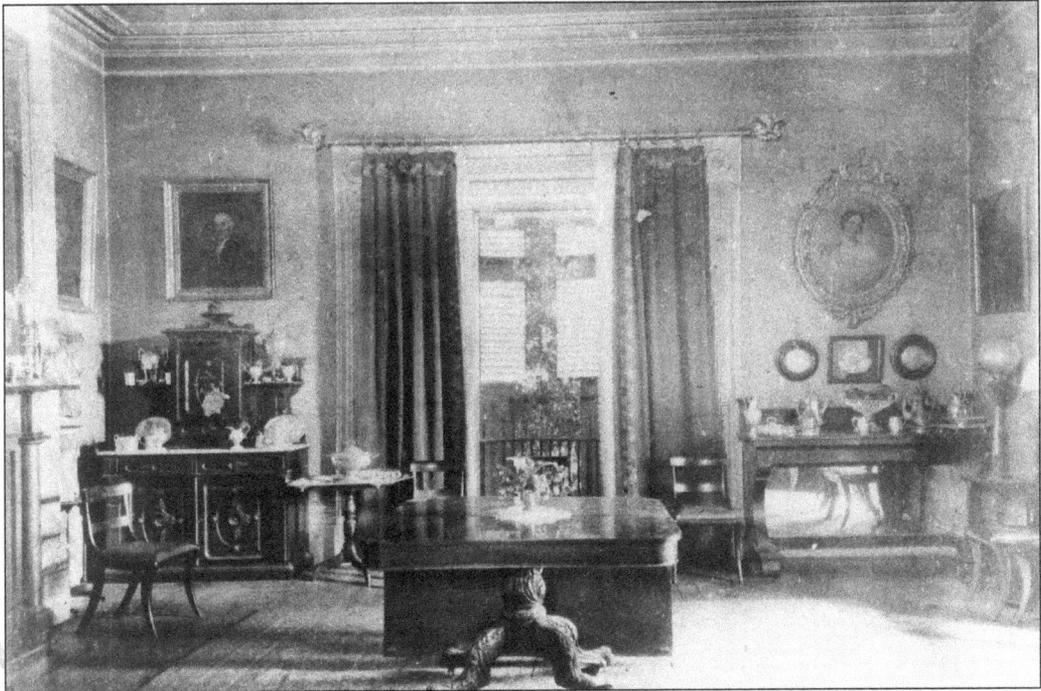

This view of the dining room of the Vanderhorst House at 28 Chapel Street, taken about 1910, shows the collection of a prosperous family. Note the customary ancestral portraits above the sideboard and the pier table. (MK 6373C)

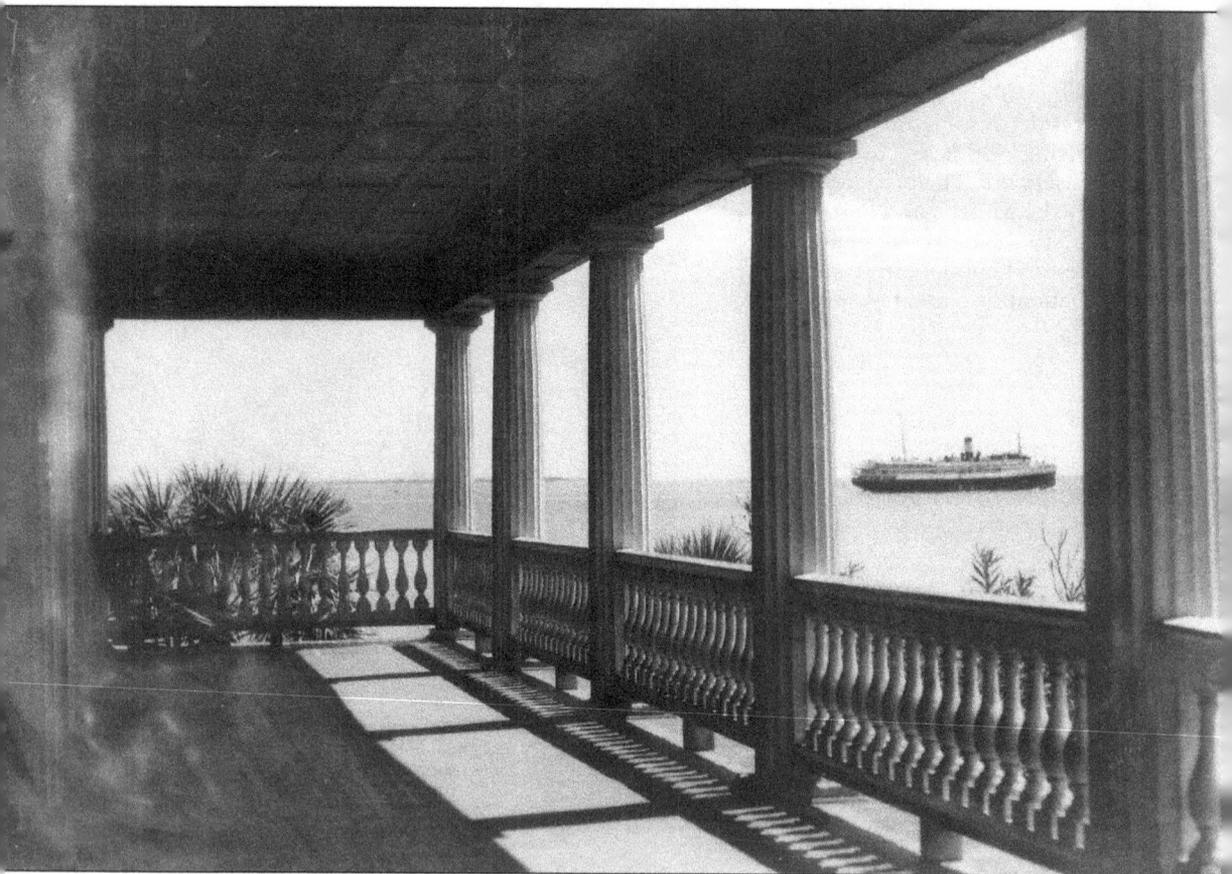

M.B. Paine photographed this view from the piazza of the Edmonston-Alston House. This wonderful picture shows the *Algonquin* or *Cherokee* of the Clyde Mallory line which operated on a regular run between New York and Jacksonville until World War II leaving the harbor, evocative of Charleston's connection to a larger world. (MK 9688)

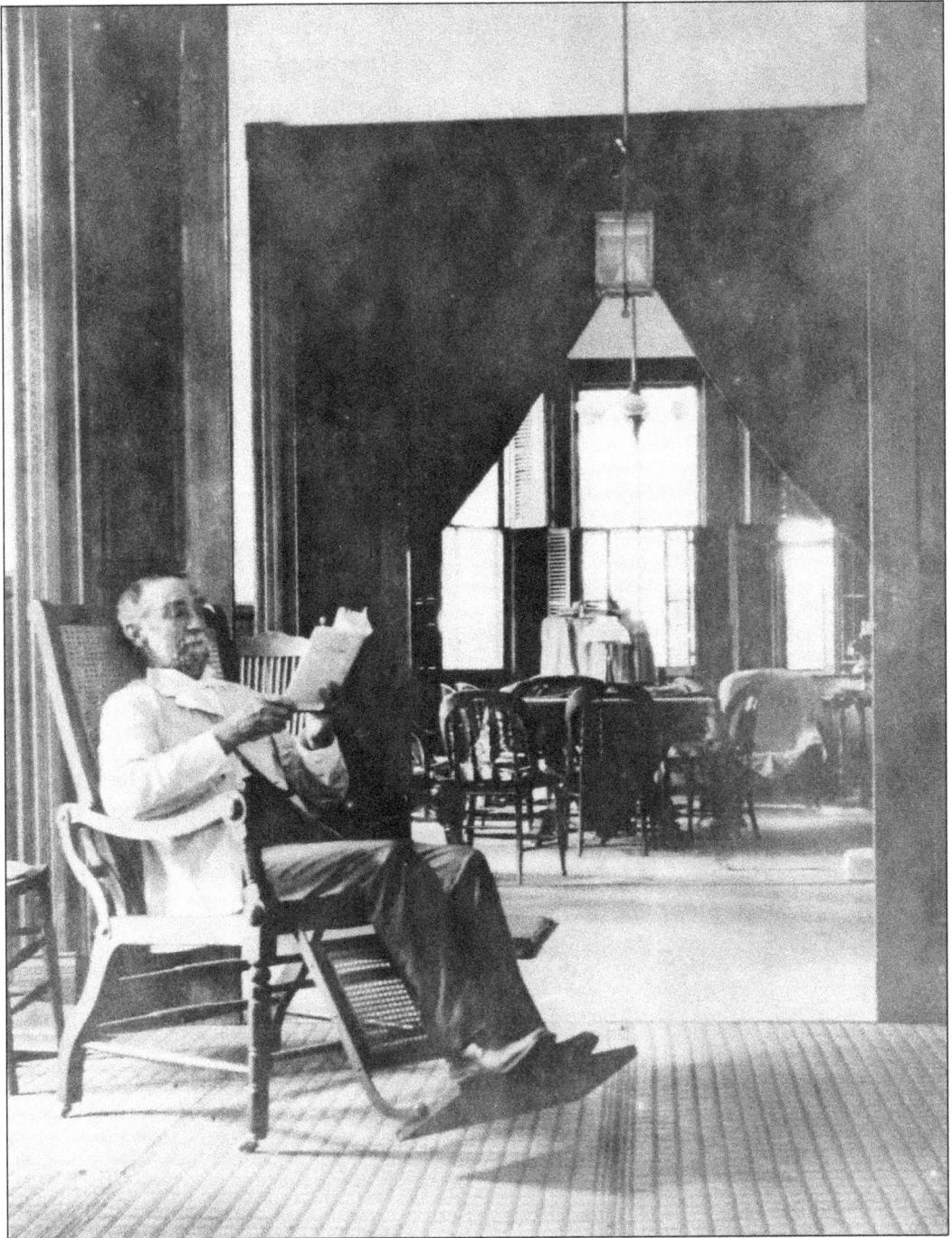

William G. Hinson enjoys his newspaper in the drawing room of his home at Stiles Point on James Island on an August morning in 1910. Mr. Hinson was a historian and collector, and he carried forward the tradition of gentleman planter on his James Island lands. The end of an era was nigh as the next year saw the arrival of the dread boll weevil, which devastated cotton production on all of the coastal islands. By 1917 cotton had virtually ceased being planted on James Island. (MK 10738A)

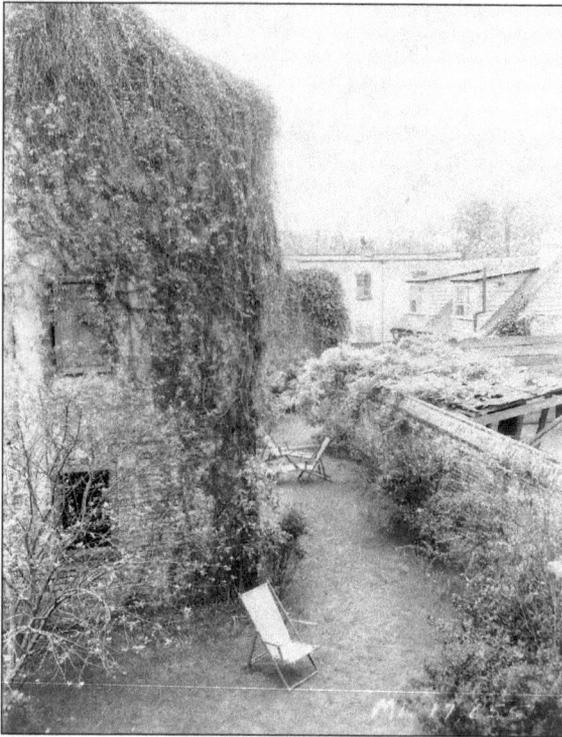

An afternoon in Mrs. Child's garden on Tradd Street included a tête-à-tête in lounge chairs or a solitary seat for reflection beside the old carriage house covered in bignonia vines just coming to bloom in this view of April 1933. (MK 17655)

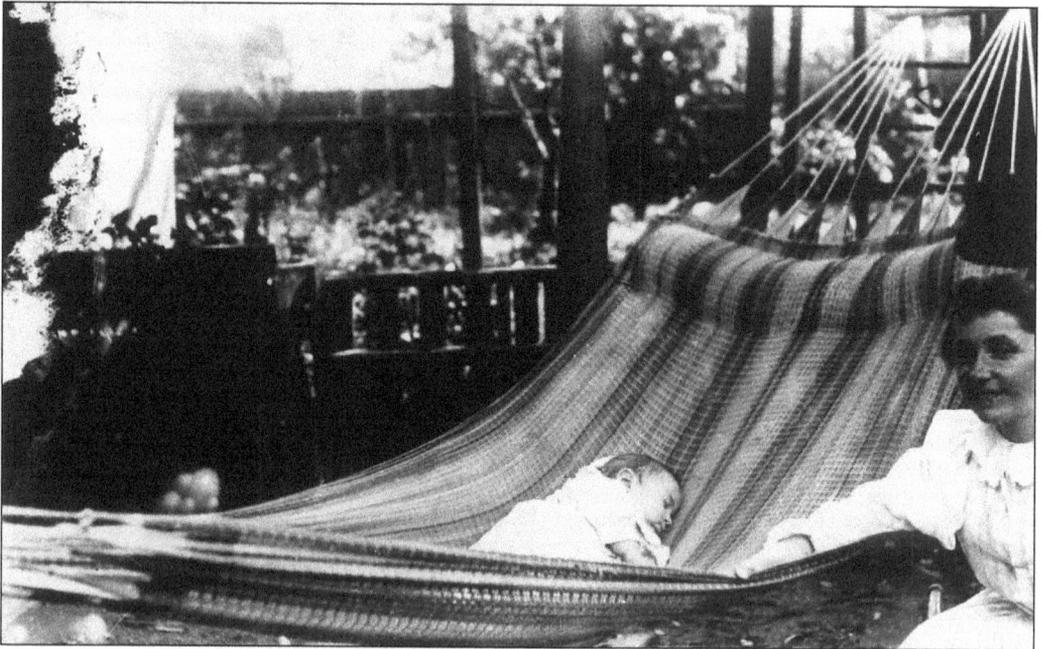

Charleston in the summertime is, in a word, hot. Life before air conditioning was eased by shade and breeze. Here a mother rocks her baby in the garden in that most valuable possession, the hammock. While fans came into use in the 1920s and air conditioning was introduced as early as the 1920s in movie houses, it was not until the 1960s that air conditioning began to be a feature in homes in the city. (MK 10056)

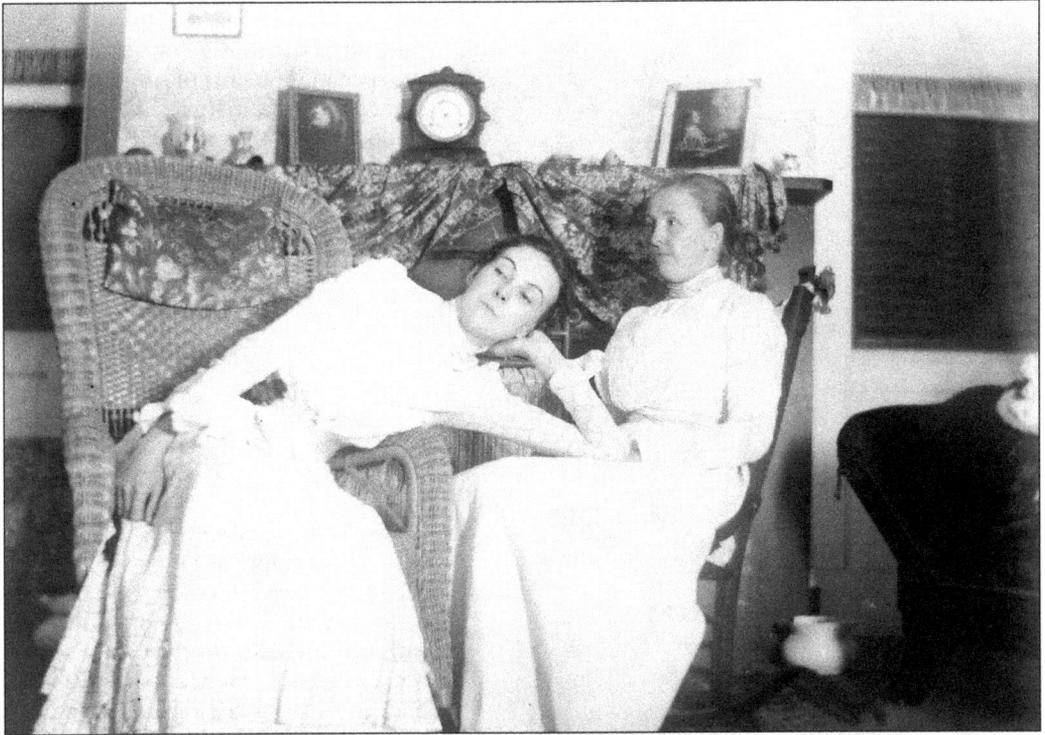

Dr. Franklin Frost Sams photographed his wife Lizzie (left) and her sister Amie as they whiled away an afternoon at home. (MK 7514)

Frances Gregorie Sams and Lillie Moreland Sams stroll in their garden at 37 New Street. Their bonnets give them a rather colonial look as they stroll through the garden, adjacent to the piazza, admiring the full growth of midsummer. (MK 7515)

Franklin Frost Sams lovingly celebrated the routine events and the special moments of his family's life. Here, on Christmas Eve 1899, he documents the gifts and toys of the season, before the children arrive. (MK 7686)

'Twas the night after Christmas in this 1905 photograph, as Frances Sams's friends gathered to enjoy their new toys together. The group of children gathered includes (from left to right) Mary Maybank, Frances Sams, Ruth Simons, Keating Simons, and Don Sams. (MK 7746)

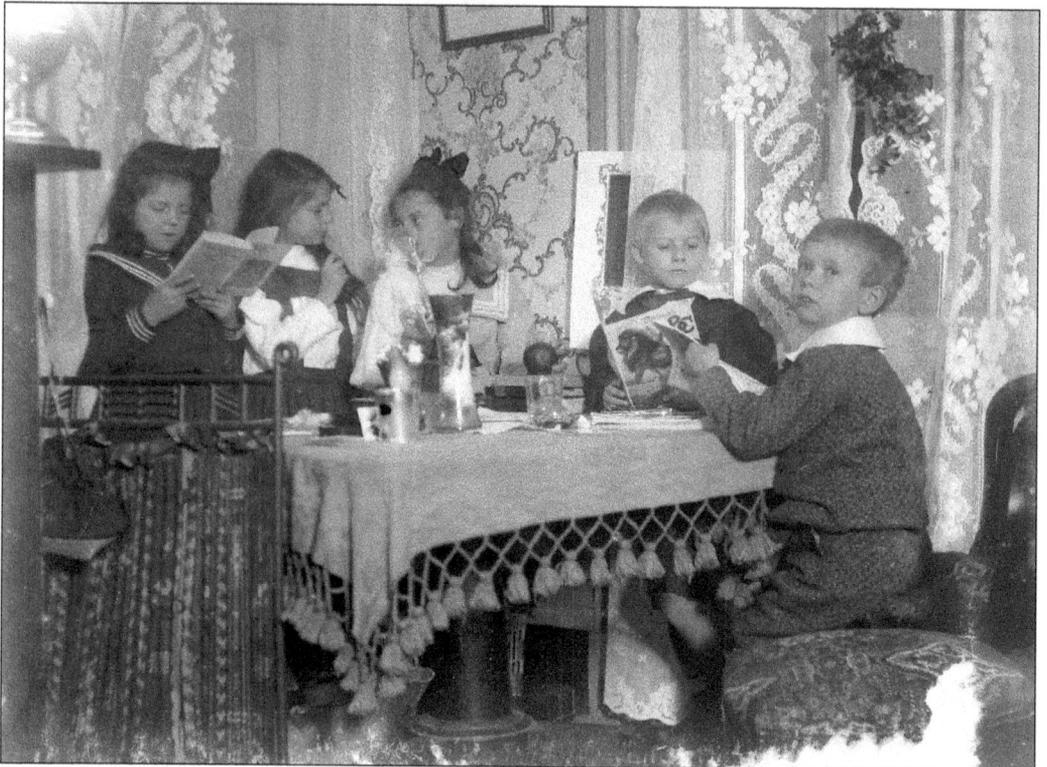

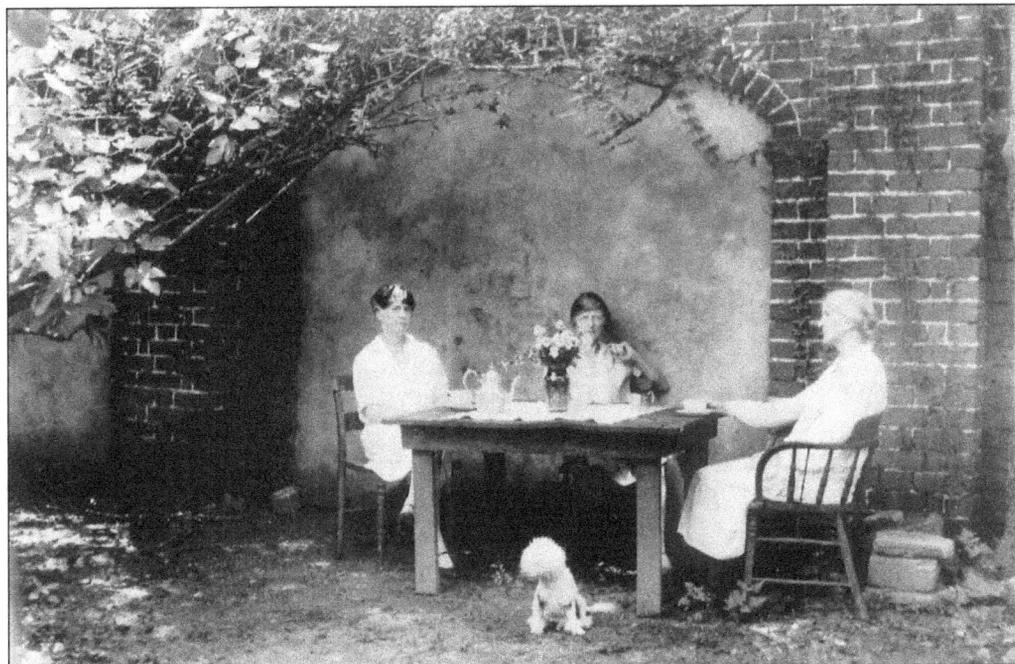

This photograph documents an *al fresco* afternoon tea under the shade of the fig tree and banksia rose in the garden of number 17 Lenwood Boulevard. Miss Annie Sloan (left) welcomes Mary Sloan Cassels (center) and her mother Helen Sloan (right) with her best china and fresh flowers. (MK 15054)

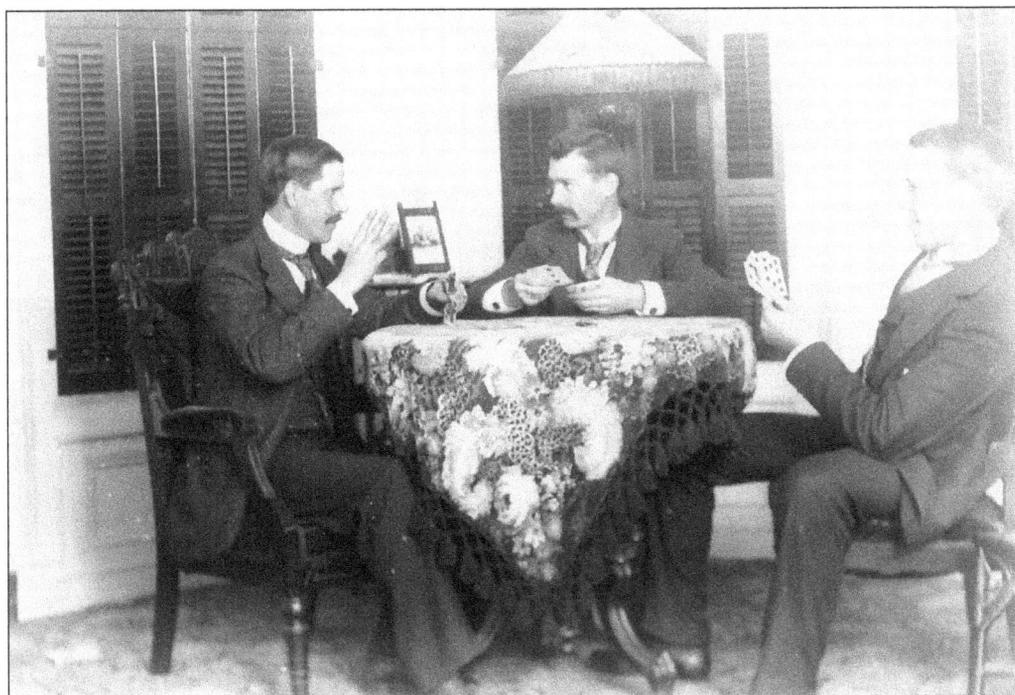

Robert Achurch (left) and his friends Mr. Allan (center) and Mr. Wilson (right) enjoy a game of cards in the drawing room of his new home on Lucas Street. (MK 17964)

The Devereaux Place was an early nineteenth-century villa that stood beside the Ashley River. It had the architectural character and feel of a Louisiana bayou cottage. The site is now occupied by the Bordeleaux Condominiums on Third Avenue. (MK 4441)

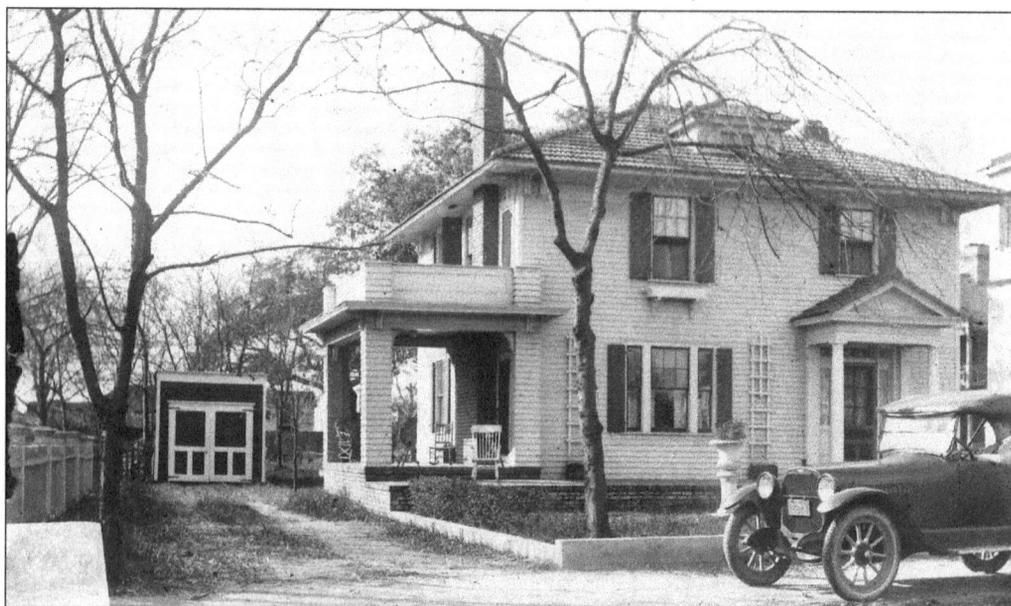

Mr. Robert Achurch proudly sits in his new Chandler automobile in front of his new home at 5 Lucas Street (now Barre Street) on Christmas morning, 1922. The house illustrates the best features of the period with the red tile roof, various outdoor areas for communing with nature, window boxes, and rose trellises. The carriage house has given way to the garage. Unfortunately, the house was razed. (MK 18578B)

Eight

AT PLAY

"The discipline of 75 years of not being able to buy pleasure has developed our capacity to enjoy to the full the things that are not bartered in the market place. Happiness has nothing to do with money at all."—Elizabeth O'Neill Verner, *Mellowed by Time.*

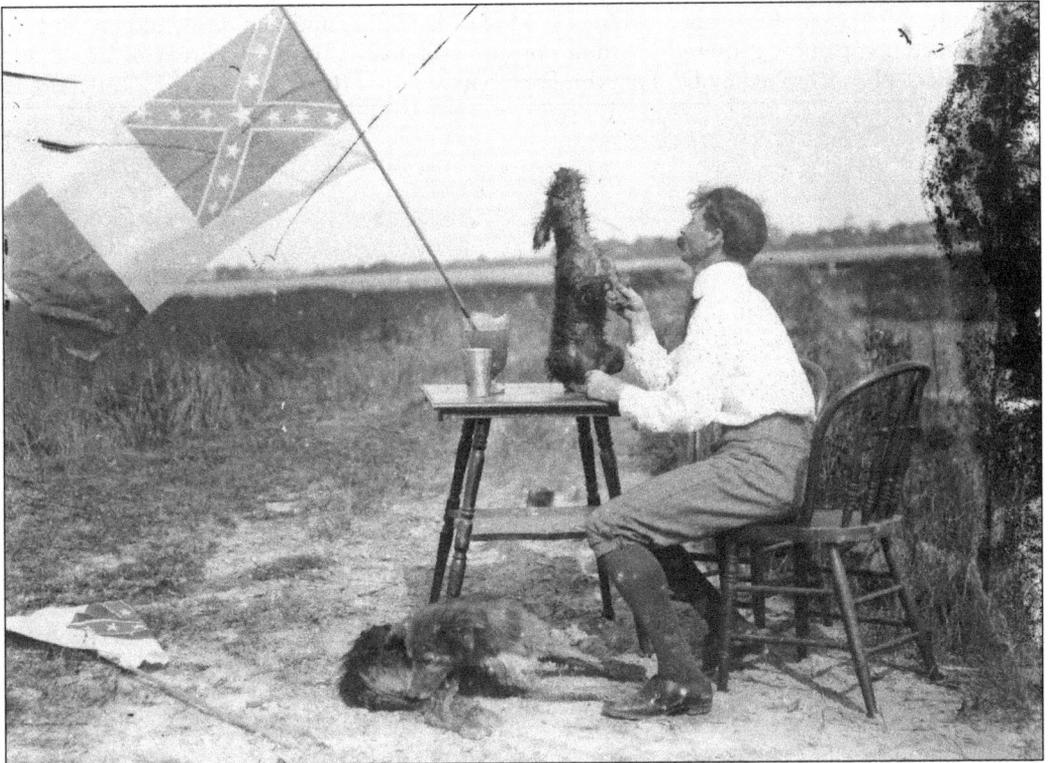

Mr. Robert Achurch photographed himself and friends in this scene at the edge of the marsh. The Confederate flag, a full pitcher, and a julep cup complete the picture. (MK 19801)

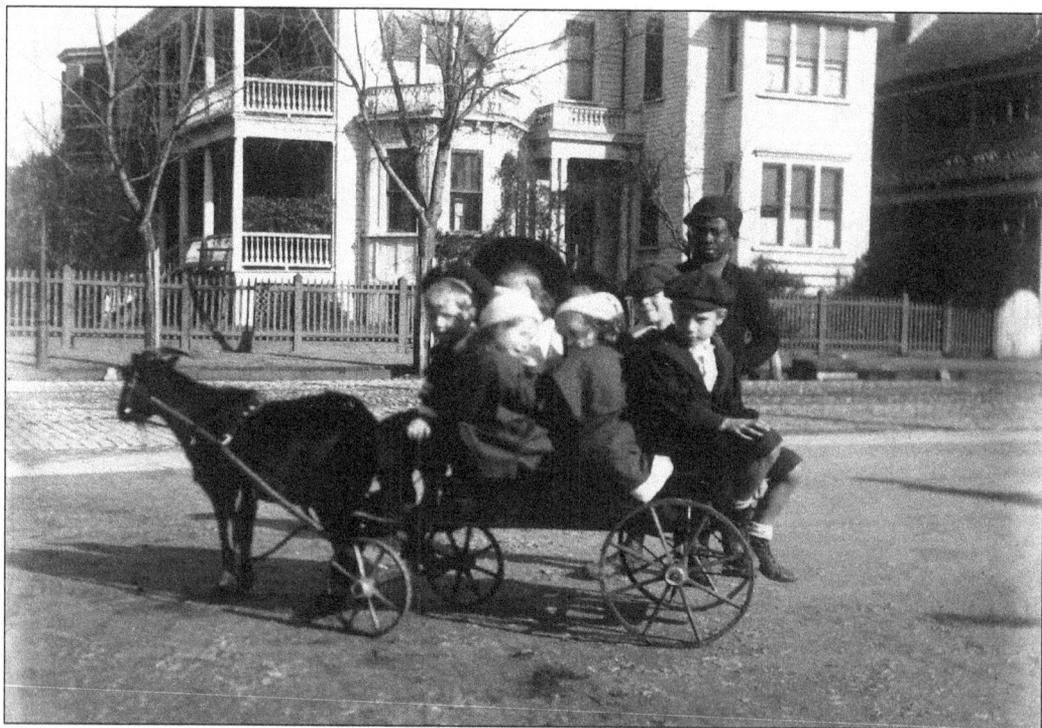

On a late fall day in December 1905, the Maybank, Sams, and Simons children and an unidentified companion gathered for their portrait in a goat cart at the corner of Broad and New Streets, photographed by Dr. Franklin Frost Sams. (MK 7762)

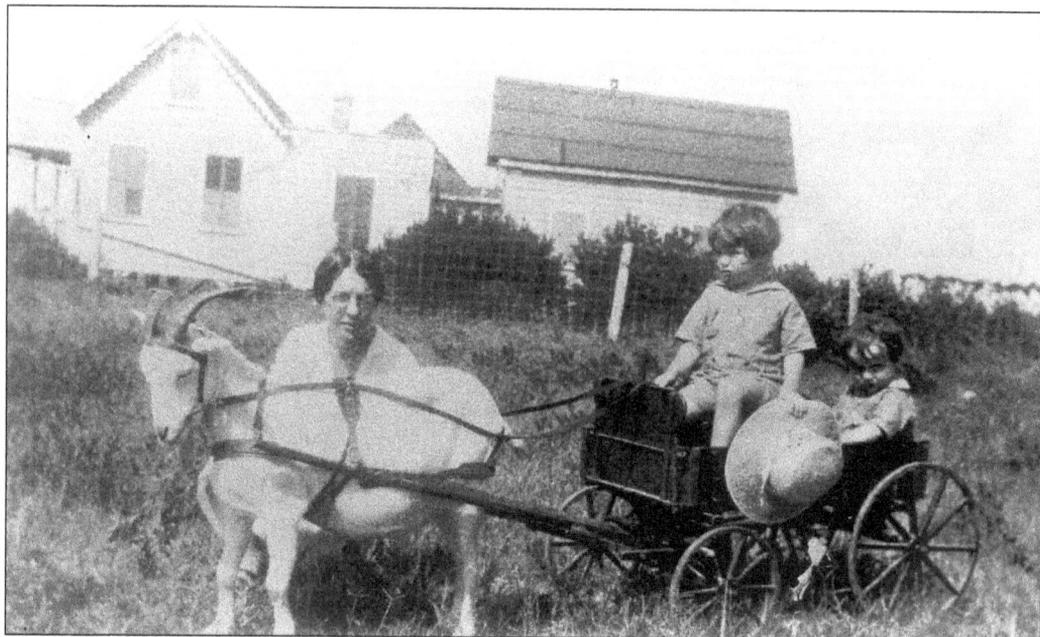

The ubiquitous goat cart can be seen in many images in The Charleston Museum's photograph collection. Here on Sullivan's Island in 1928, Cameron Burn, his brother, and his mother enjoy a sojourn. (MK 7986K)

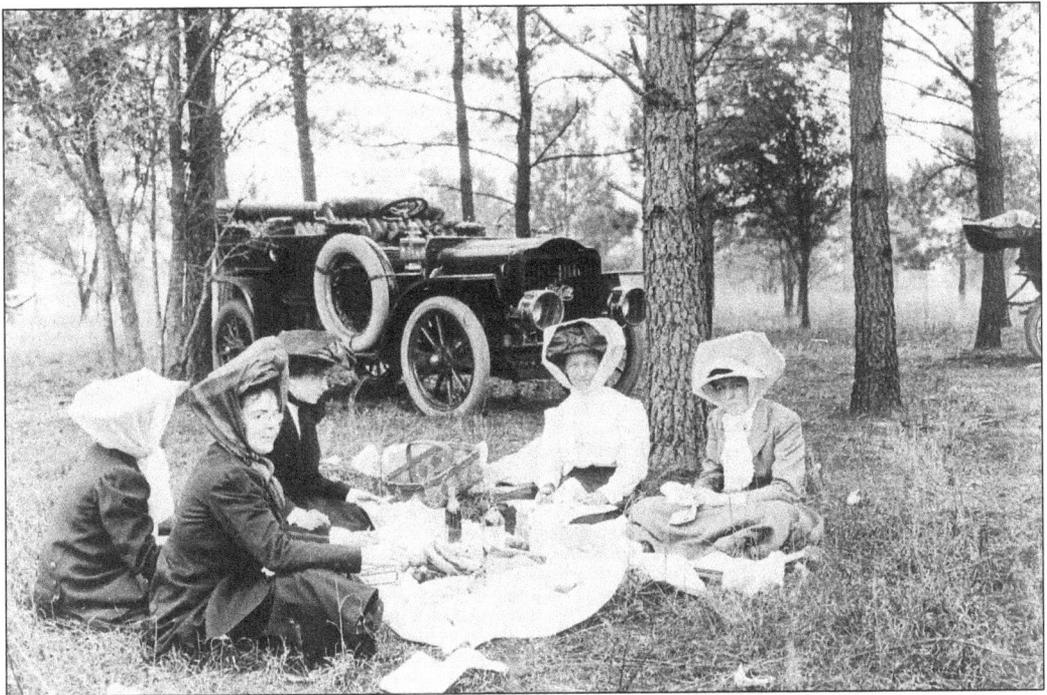

This photo was taken near Otranto Plantation on the Cooper River during the second auto outing of the Charleston Auto Club in 1910. An unidentified group of ladies realize the full benefit of their newfound independence, afforded by the horseless carriage. (MK 13525B)

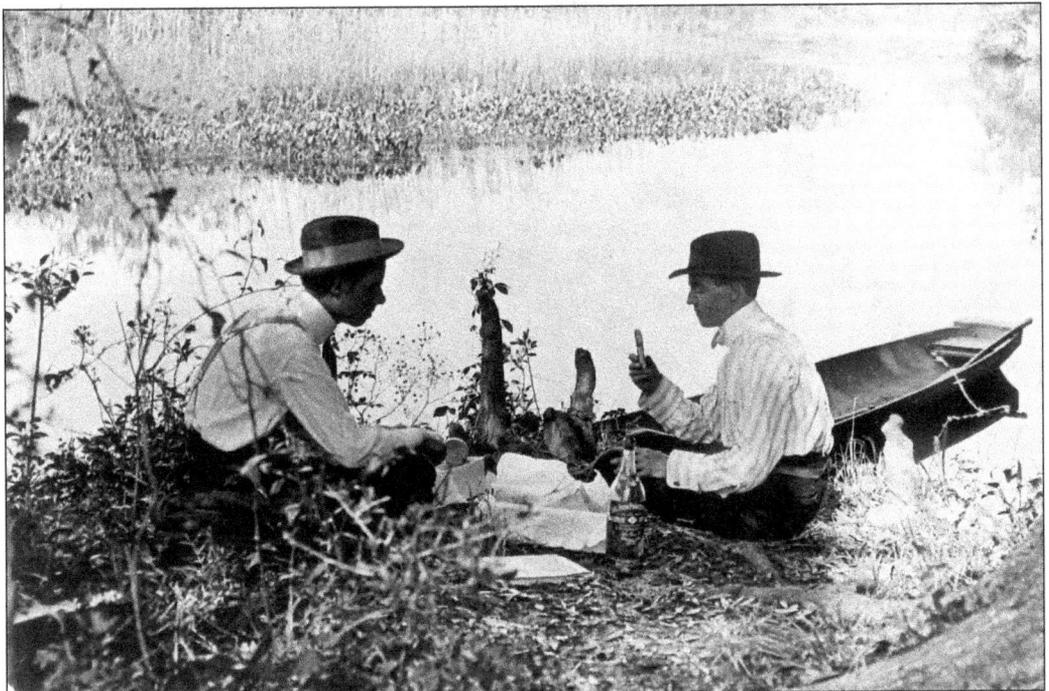

Two gentlemen partake of one of life's extras with bread and wine on a riverside picnic in this early 1900s photograph by M.B. Paine. (MK 14252)

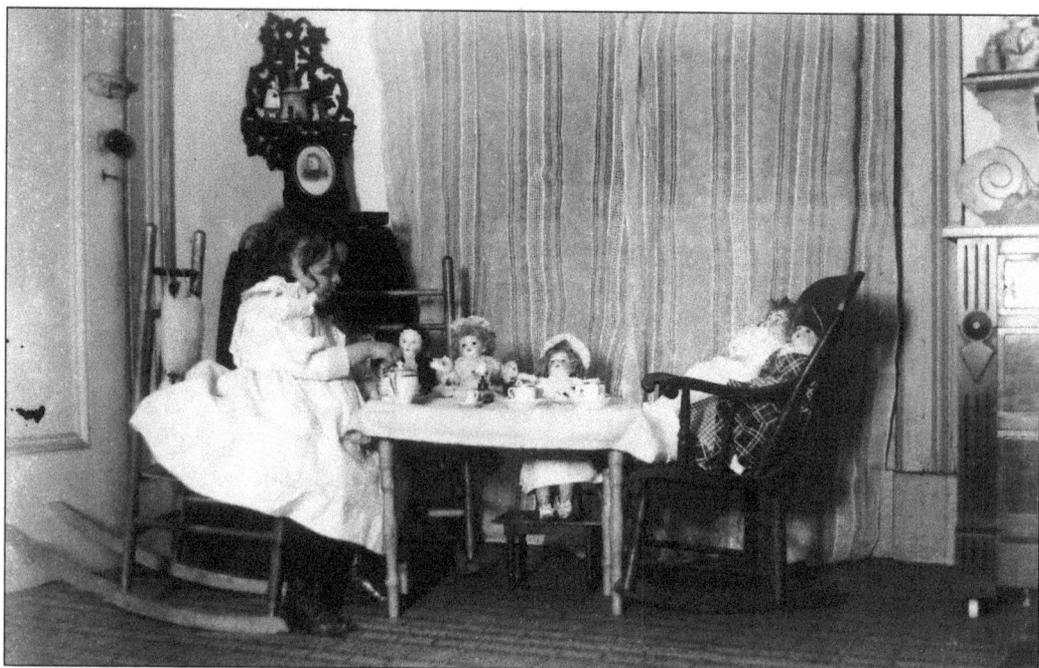

Frances Sams and her dolls sit down to supper at home in this 1902 photograph. (MK 7518)

Charlestonians were well-prepared to welcome dignitaries for the Great Exposition. None was more important than the President. Here, President and Mrs. Theodore R. Roosevelt enjoy an informal lunch with local people. As identified on the photograph, seated at the table are: Rachel Hartley, Anna Heyward Taylor, Ronald Carter, Mr. and Mrs. Roosevelt, Paul Hewes, Mr. Hartley, Grace Withers, Mr. and Mrs. Withers, and Will Beck. (MK 4479)

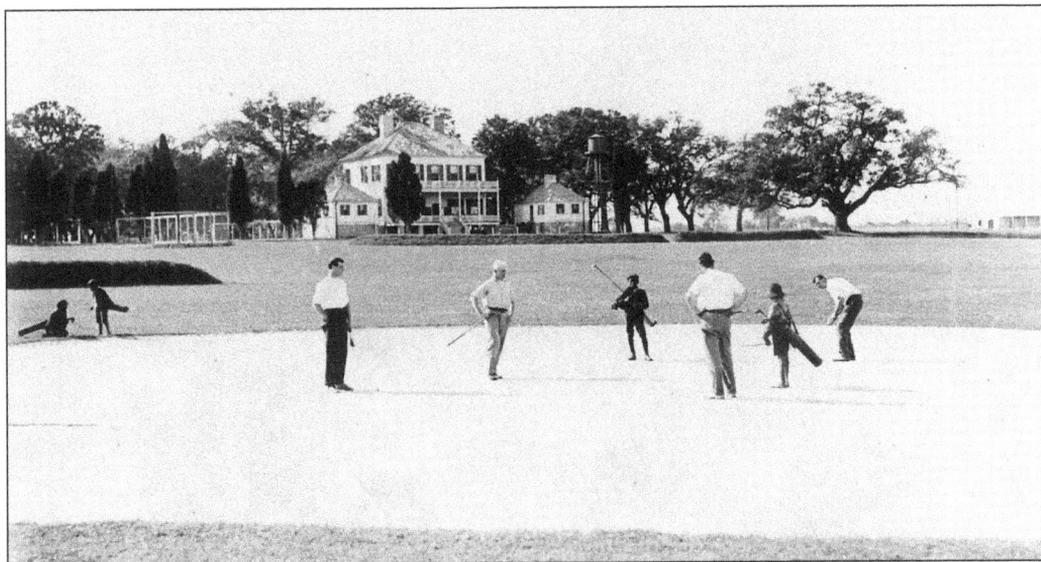

The Country Club of Charleston occupied the grounds of Belvidere Plantation, north of Magnolia Cemetery on old Meeting Street Road. The clubhouse had a separate building for cooking and a water tower to provide water pressure for the kitchen. The property was sold in 1925 to standard oil for development as a refinery, and the Country Club relocated to James Island. (MK 01907)

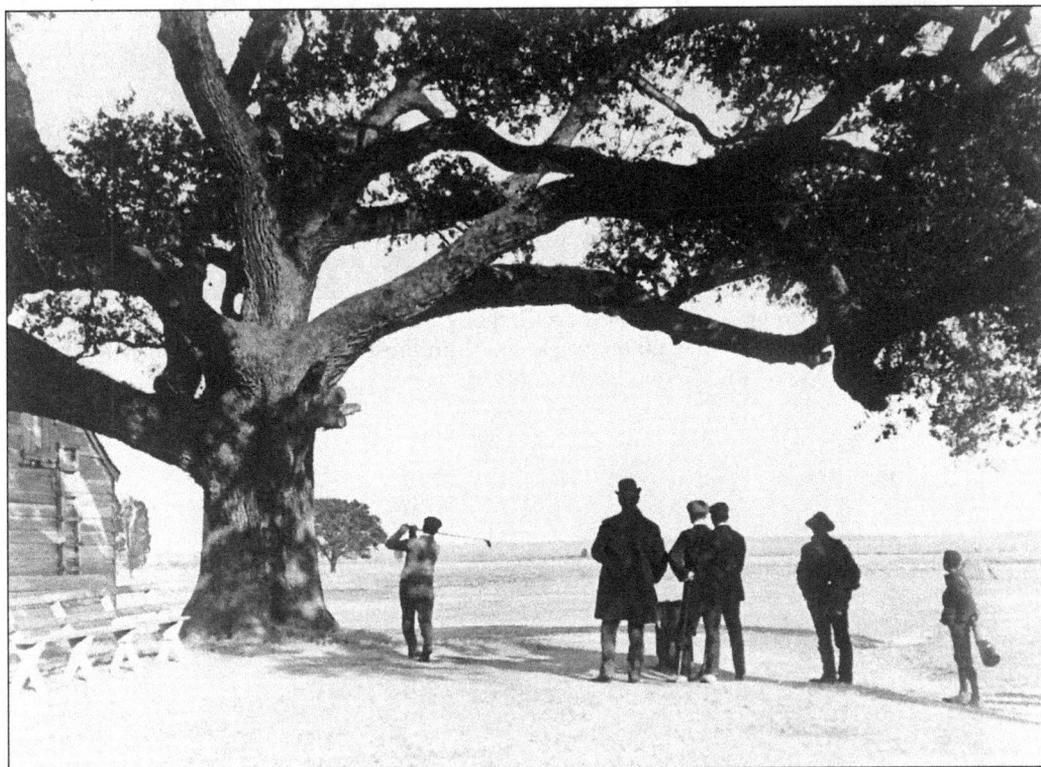

Gentlemen in boaters and caps gather under an oak at the Country Club of Charleston, *c.* 1905, as Professor Braid drives the ball. (MK 3212)

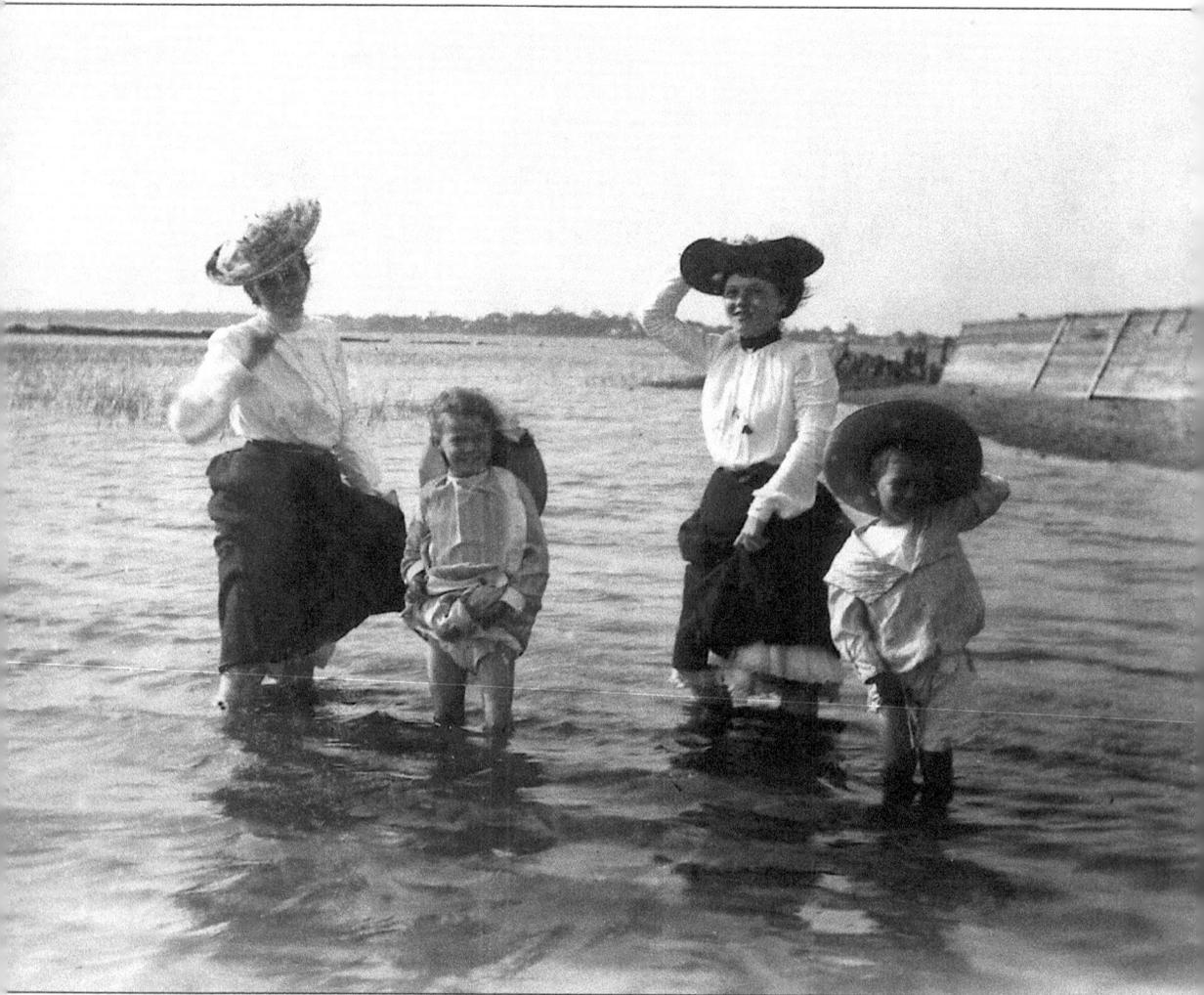

Elizabeth McPherson Gregorie Sams, Francis Gregorie Sams, Lila Gregorie, and Donald Dean Sams enjoy the beach in this view taken by Dr. Franklin Frost Sams in July 1903. (MK 7776)

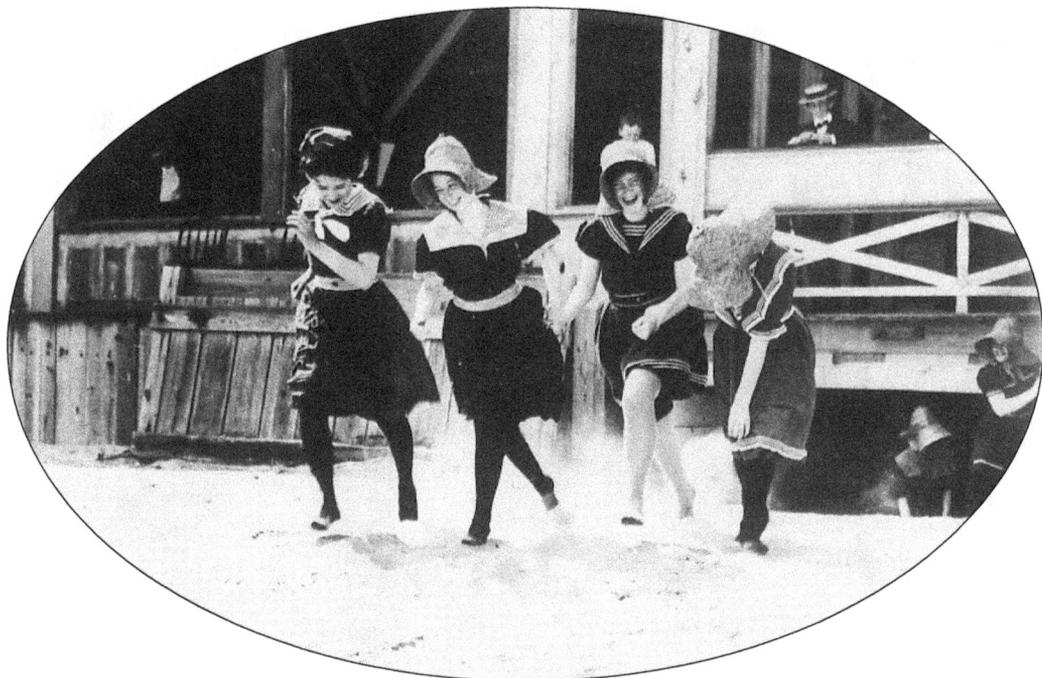

The pavilion at the Isle of Palms was the highlight of a day trip to the beach. Four young women in bathing costumes make a dash for the water in a photograph made in the early part of the century. (MK 14684A)

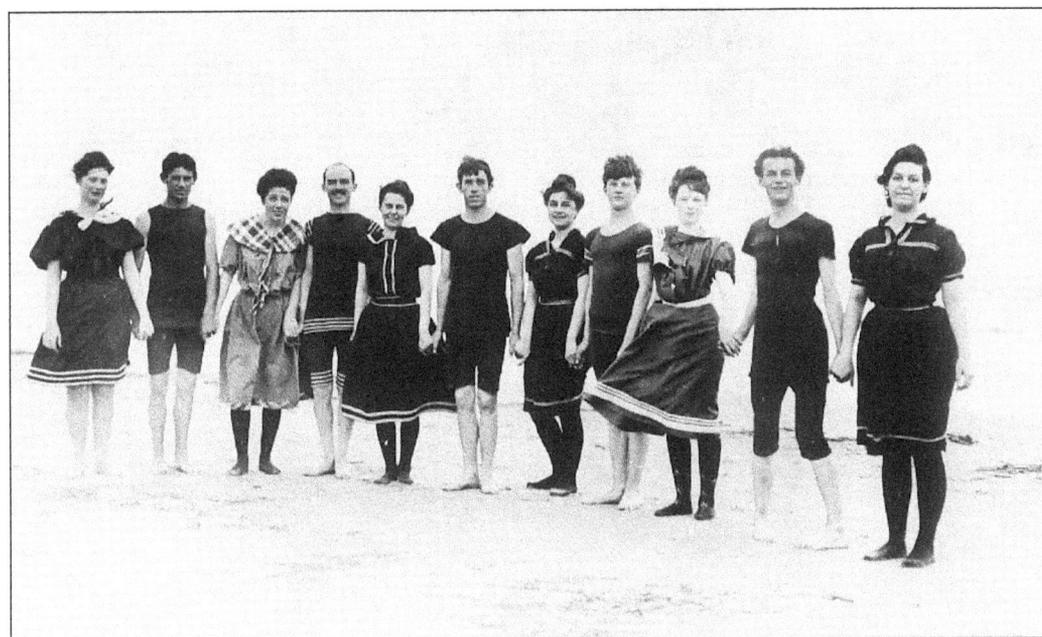

Style on the Isle of Palms in 1902 is evidenced by a display of beachwear: (from left to right) Katie Waring, Tom Buist, Rena Smith, I.G. Ball, J.H. Ball [?], unidentified, Miriam Todd, Billy Smith, Helen McIver, Glover Alston, and unidentified. (MK 9988)

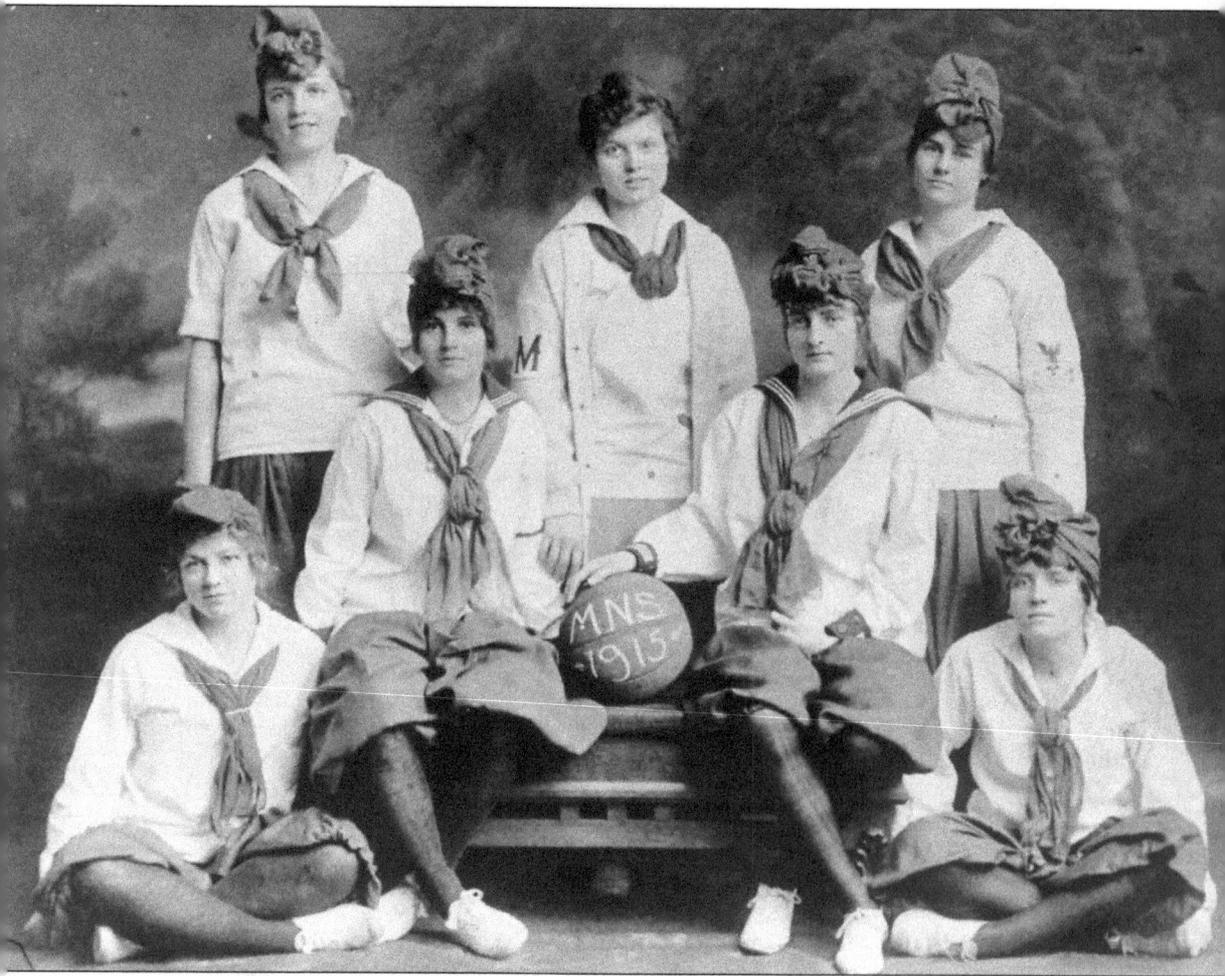

Organized sports were a feature of Memminger Normal School, which offered an education for young women. This 1915 photograph pictures the school's championship basketball team. (MK 9397)

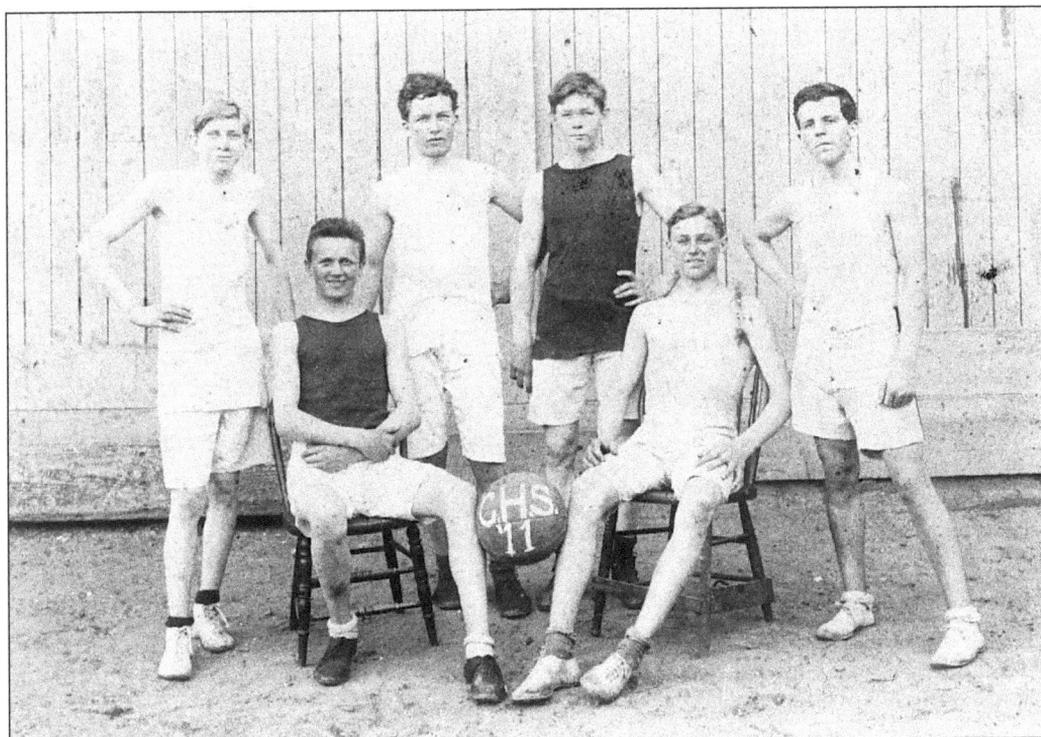

The Charleston High School basketball team of 1911 proudly posed for this photograph in the school lot behind the building that stood at the corner of Meeting and George Streets. (MK 7501)

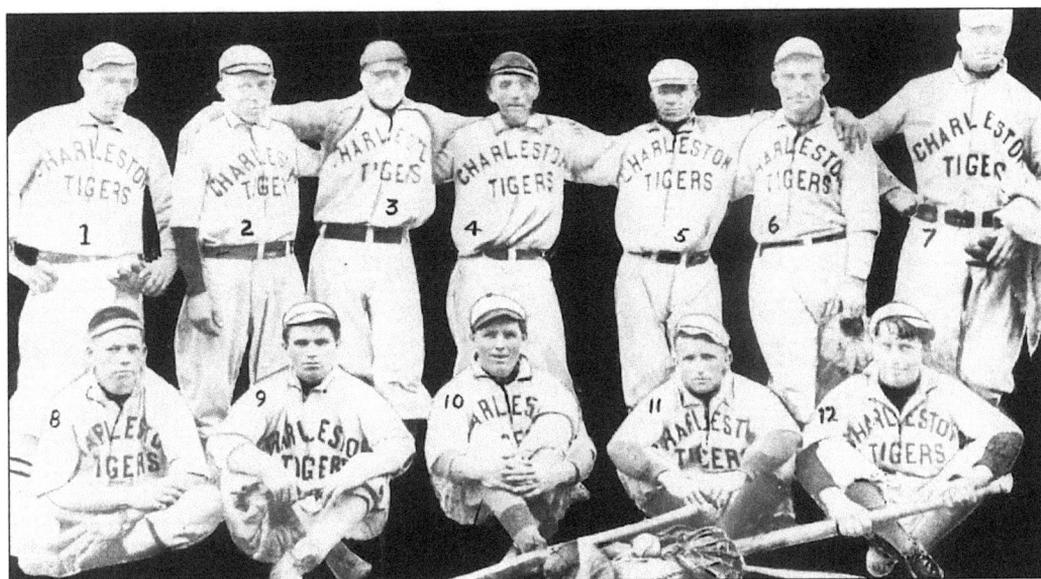

The Charleston Tigers were a semi-pro team. This *c.* 1910 photograph shows the twelve-man team. (MK 7088)

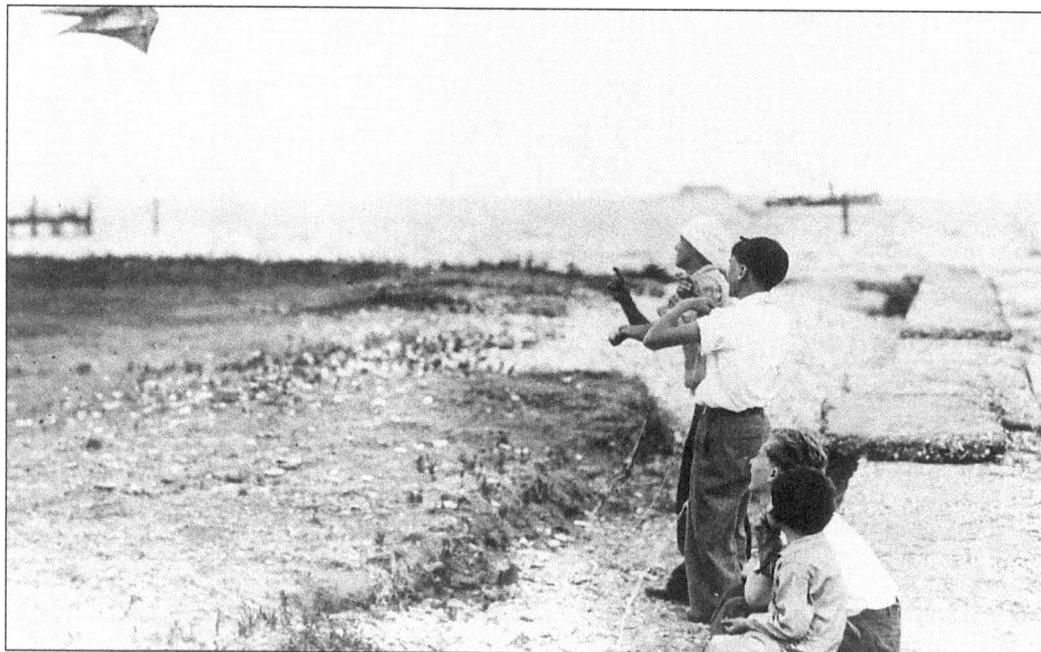

The old docks near the Battery provided an open space for children to fly kites. M.B. Paine captured these lads enjoying the breeze off the harbor in 1930. (MK 9094)

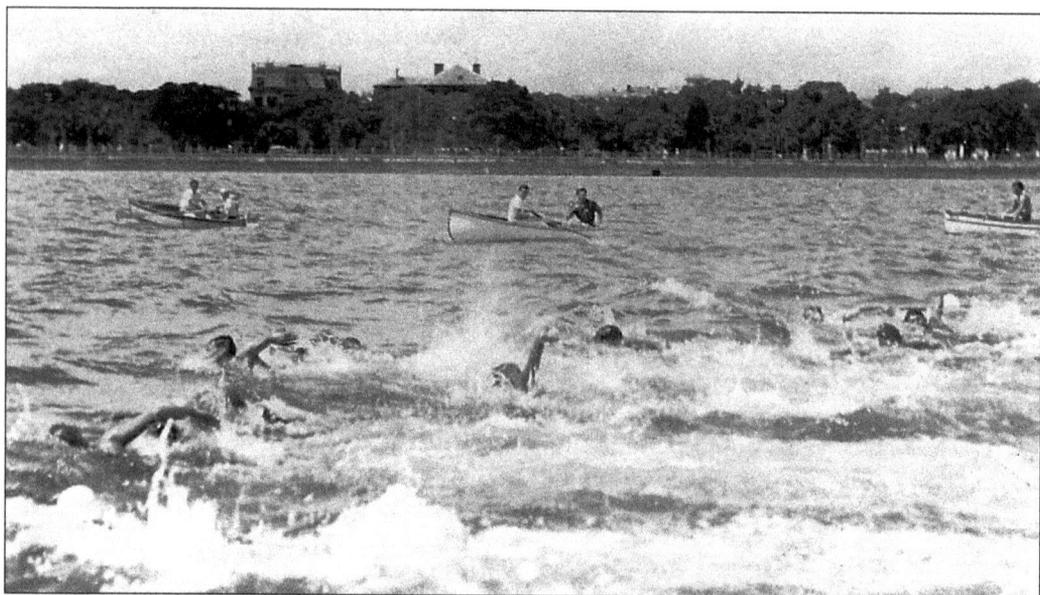

The Peninsular Swim was a race that started on the Cooper River and traveled around the peninsula to the finish line at the new Ashley River Bridge. In this 1930s photograph, swimmers are heading up the Ashley River in front of White Point Gardens at the turn of the tide. (MK 7358)

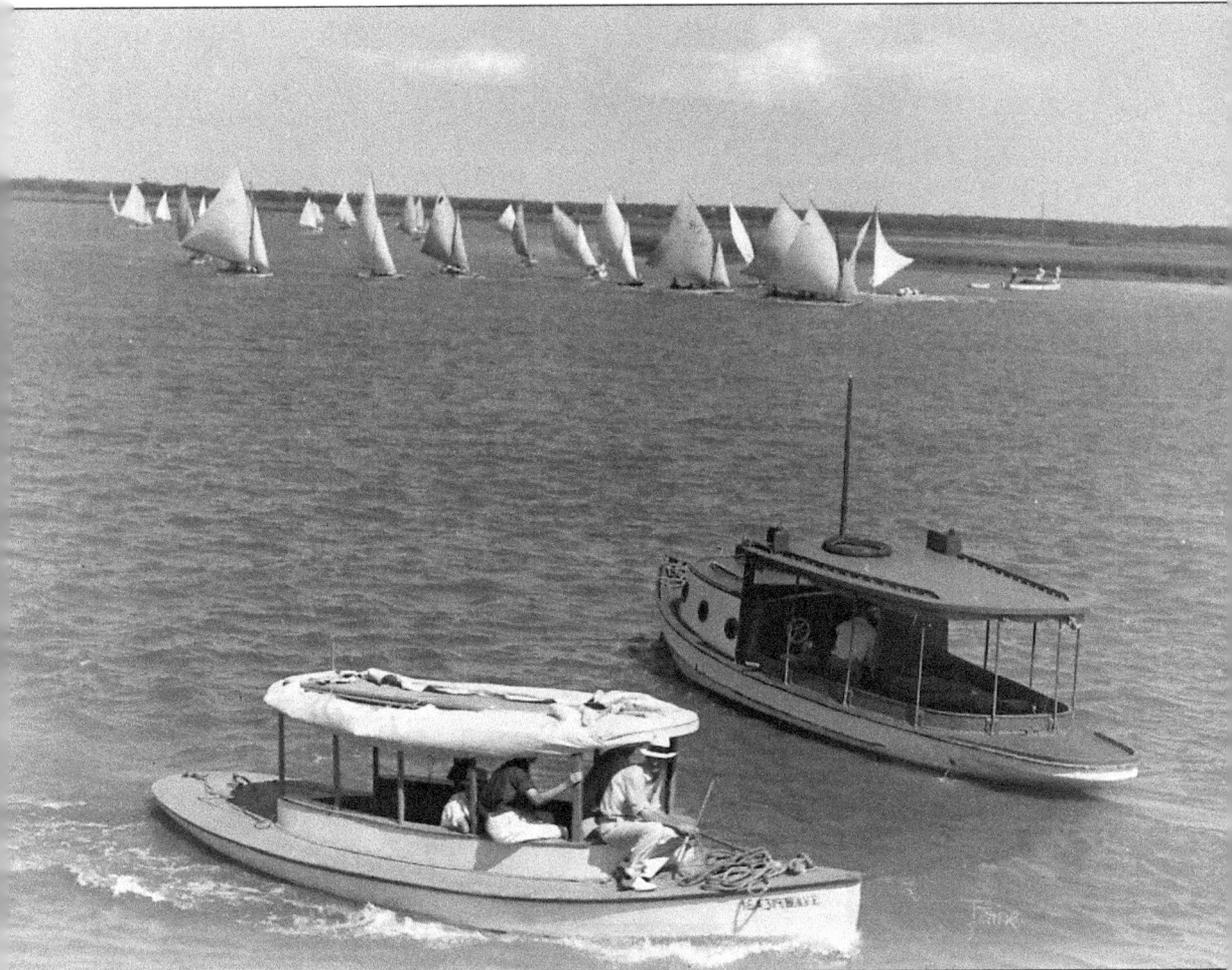

The small village of Rockville at the end of Wadmalaw Island hosts the Rockville Regatta in August, one of the long standing Lowcountry traditions. In this 1936 view, the race committee observes competitors as they make the turn in front of the Yacht Club. (MK 7349H)

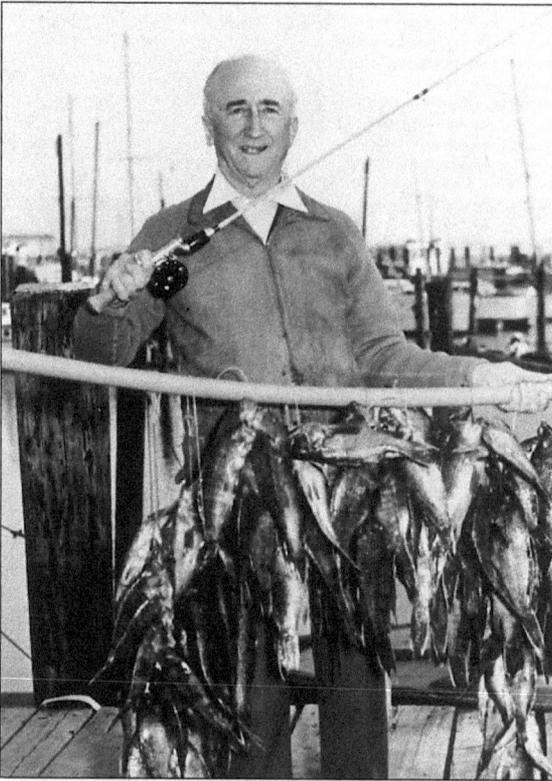

In this photograph taken in the early 1950s, James F. Byrnes proudly displays the yield of his fishing efforts after his retirement from public service. Byrnes served as a U.S. Representative (1911–1915), a U.S. Senator (1931–1941), on the U.S. Supreme Court (1941–1942), and as Secretary of State (1945–1947). (MK 8065)

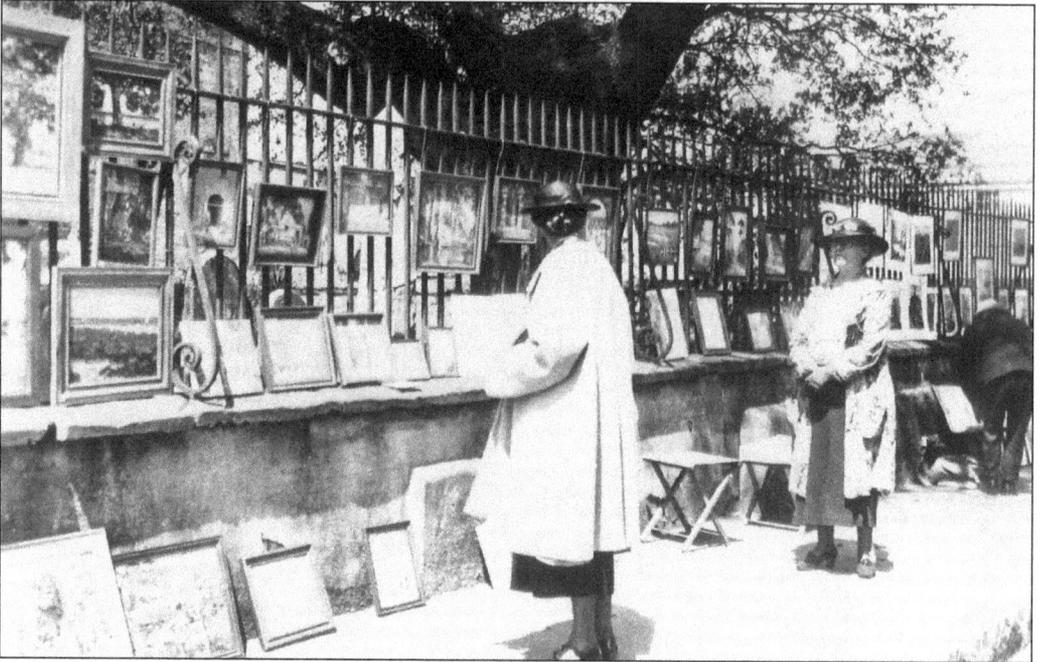

In 1936 the sidewalk art show in front of St. Philip's Church was going strong. The Lowcountry light, reflected from sky to water, is reminiscent of that found in Flemish landscapes of an earlier time. (MK 9766)

Nine

ALL DRESSED UP

"Such is the essence of Charleston, where people know you, know your business and probably have a fixed opinion of you before introductions are made. If in Atlanta the first question people ask you is, 'What do you do?'— in Charleston it's still 'What was your grandmother's maiden name?'"—Barbara Gervais Street, Back to the Old South, 1984.

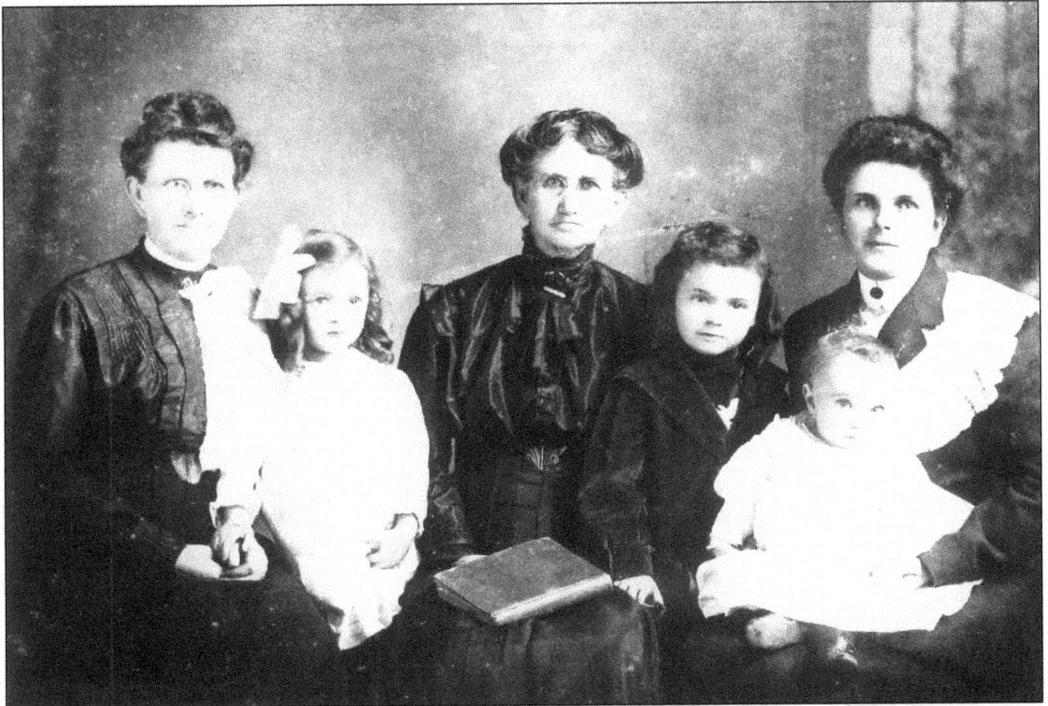

Four generations of Miss Edna O'Hear's family pose for a picture. Miss O'Hear is second from the left and seated next to her grandmother and her great-grandmother. Her mother and her sister hold her younger brother. Edna O'Hear was a longtime volunteer for The Charleston Museum, serving faithfully for many years. (MK 10256)

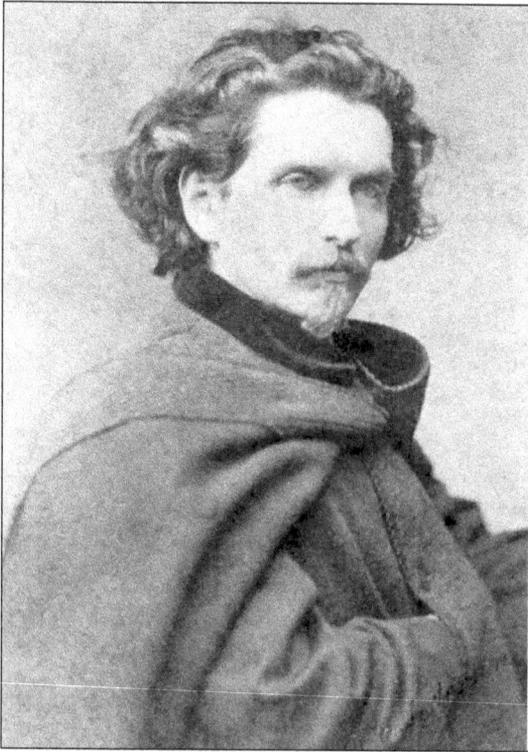

Albert Guerry was a portrait painter and artist from South Carolina who worked in Richmond, Virginia, and Charleston. He cuts a romantic figure in his cape—a *de rigueur* wardrobe item for an artist of the period— in this photographic portrait by D.H. Anderson of Richmond. (MK 420)

In this 1900 photograph, the Dill sisters of 19 Legare and friends are shown in coming-out attire. The portrait includes Daisy Singleton, Genevieve Parkhill, Pauline Dill, Frances Dill, and Mime Coffin. (MK 10941)

The baby's gown suggests that this may have been a christening party. This Rhett/Maybank family portrait was found in the Aiken-Rhett House. (MK 9127A)

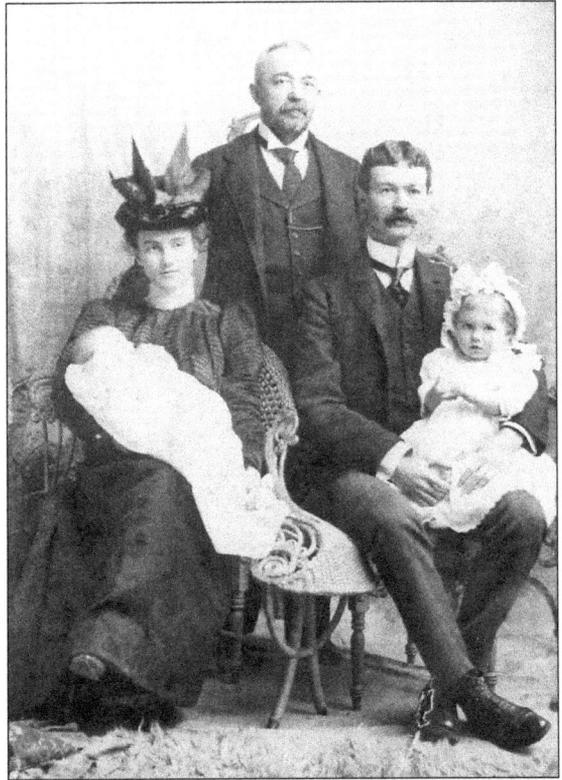

Frances Sams is captured at home by her father. Frances was the model for a number of formal and informal photographs that illustrated the family's domestic activities and pursuits. In this 1895 photograph, she is poised in a doorway at the Sams home on Coming Street. (MK 7518)

The high Battery has always functioned as a promenade for city residents. Built in the 1840s, the seawall was designed by architect/engineer, E.B. White. In the distance is the old Battery Dairy Dock used to deliver milk from James Island, which was destroyed by the hurricane of 1911. (MK 9784)

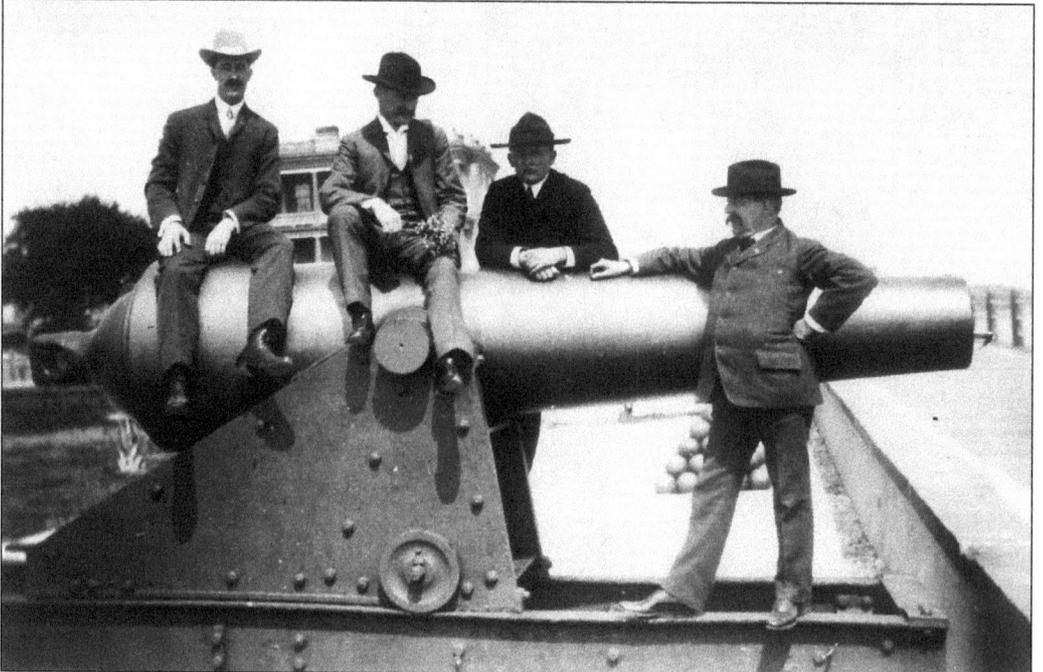

One of the pilgrimage sites on any visitor's itinerary is the Battery. Robert Achurch captures a group of his friends inspecting a cannon at White Point Gardens, c. 1900. (MK 7012)

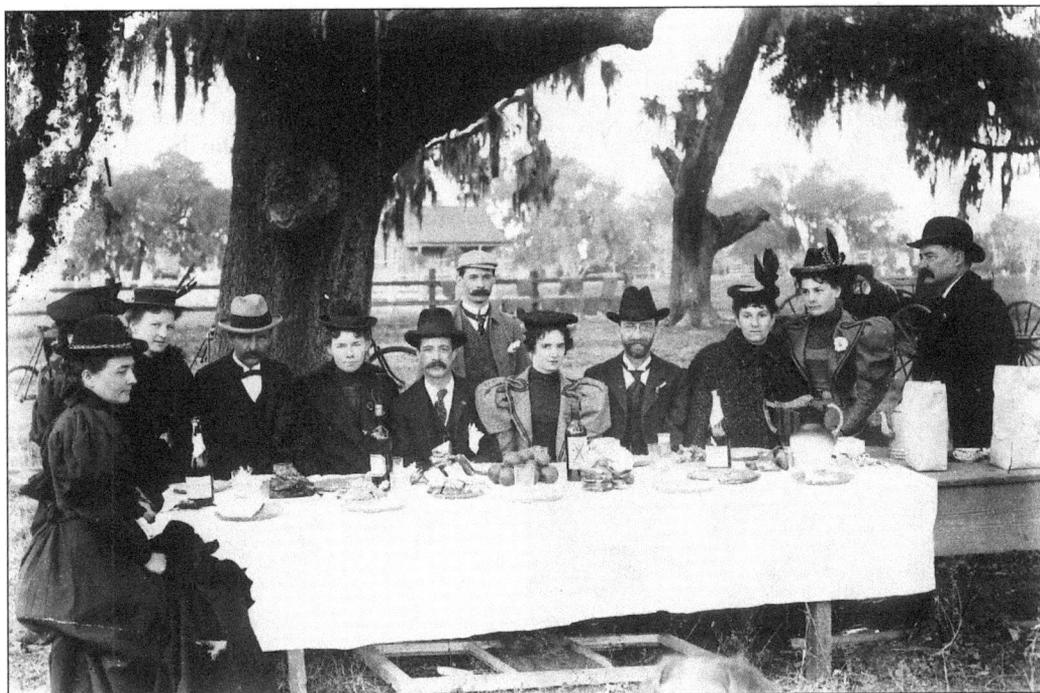

In this late nineteenth-century view, a well-dressed group enjoys a picnic in the country. The photographer, Robert Achurch, stands behind the seated guests. (MK 10043)

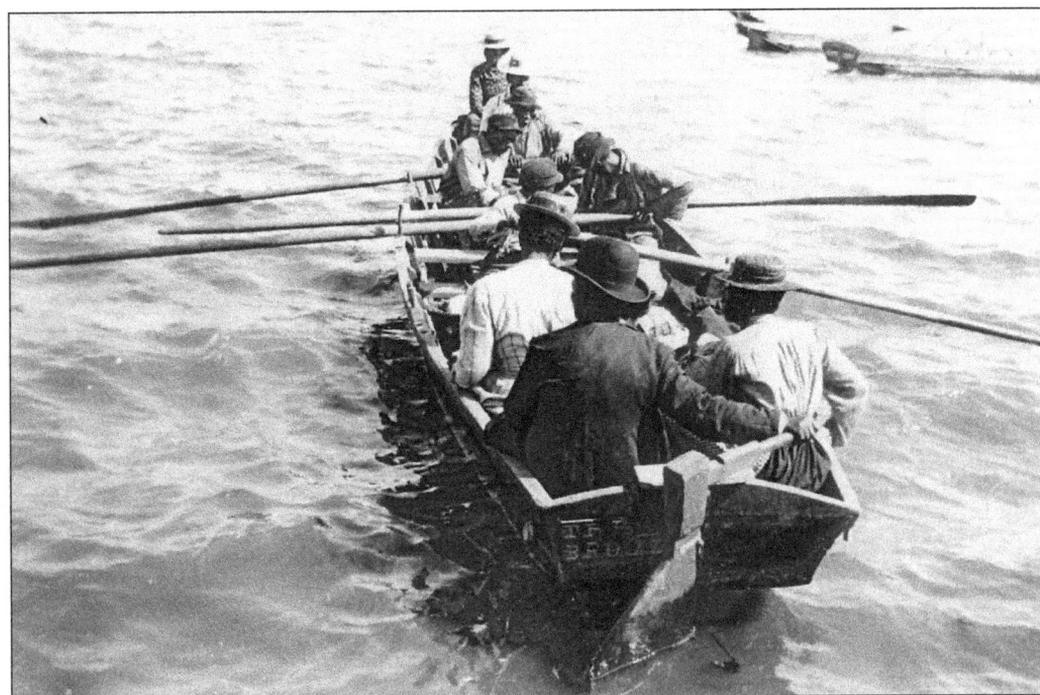

In 1903, a boat with several passengers sets out from Cantini's Wharf at the foot of Rutledge Avenue at Tradd Street, before the construction of Murray Boulevard. (MK 17541)

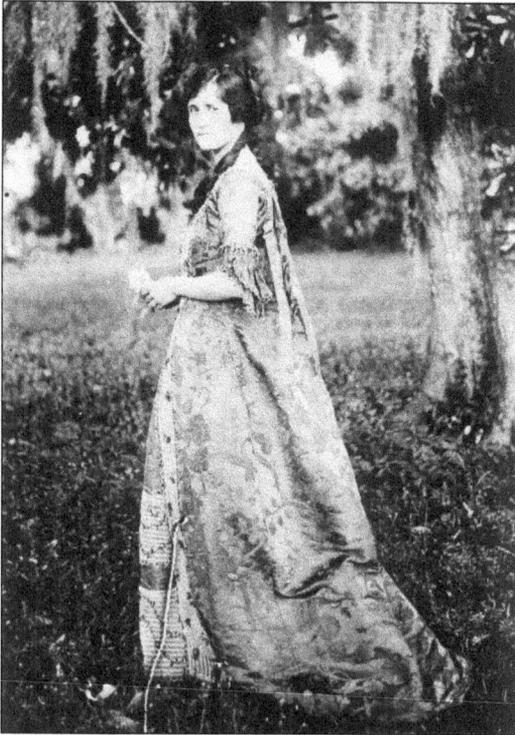

Sallie Pinckney, later Mrs. Milby Burton, poses in a dress of gold brocade made from silk spun before the American Revolution. She is shown at Belmont, once the home of Eliza Lucas Pinckney. The dress is now in the Smithsonian Institution. (MK 5949)

M.B. Paine often used his sister as a model. Mary Paine is shown in her informal parlor. (MK 3600)

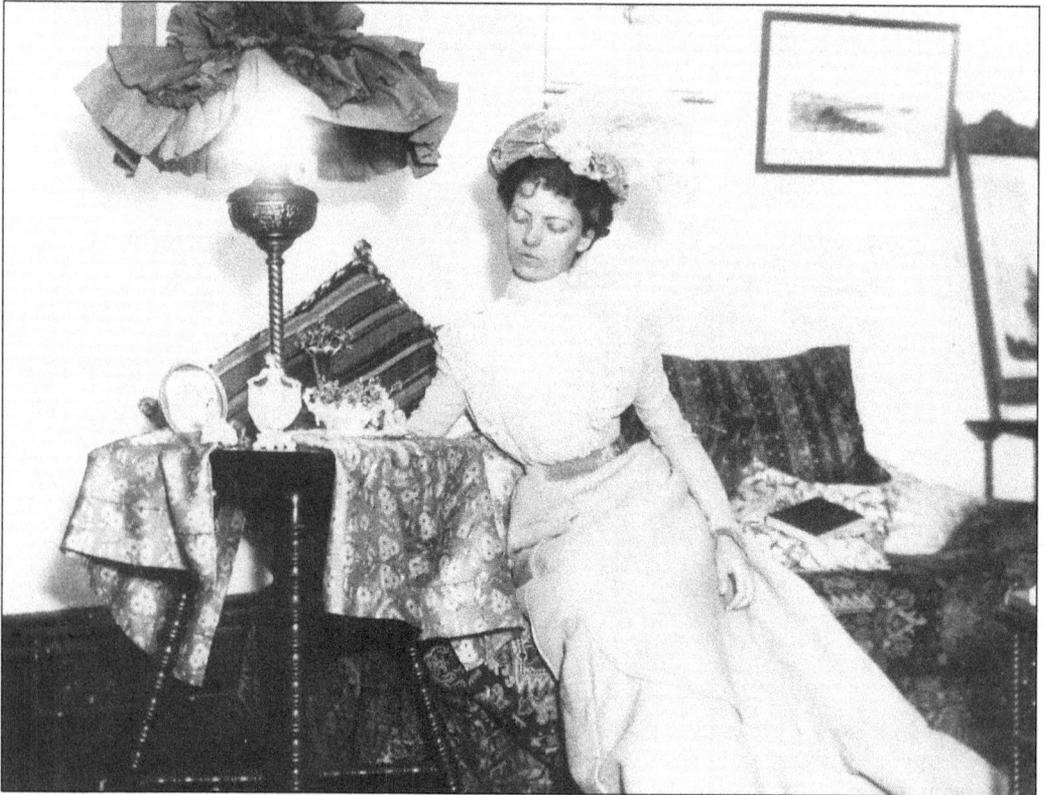

Alice Ravenel Huger Smith was one of Charleston's most acclaimed artists. A woman of great talent and ability, she was instrumental in Charleston's early preservation movement—with her father she published *The Dwelling Houses of Charleston*. She was active with the Carolina Art Association and with The Charleston Museum. (MK 10917C)

(below left) Susan Magette is all dressed up in this photograph *c.* 1915. (MK 621)
(below right) Alice Lucas of the Wedge Plantation, shown here in her picnic outfit, was certainly a catch for any young man, and she won the heart of Archibald Rutledge. After their marriage, she moved to live with him at Hampton Plantation. (MK 3501)

In this photograph by M.B. Paine, Susan Frost (left) and her sister Mary (right) are in period dress and stand on the portico of the Miles Brewton House at 27 King Street to welcome guests to their afternoon event, "The Meaning of A House," held in the 1920s. (MK 9017J)

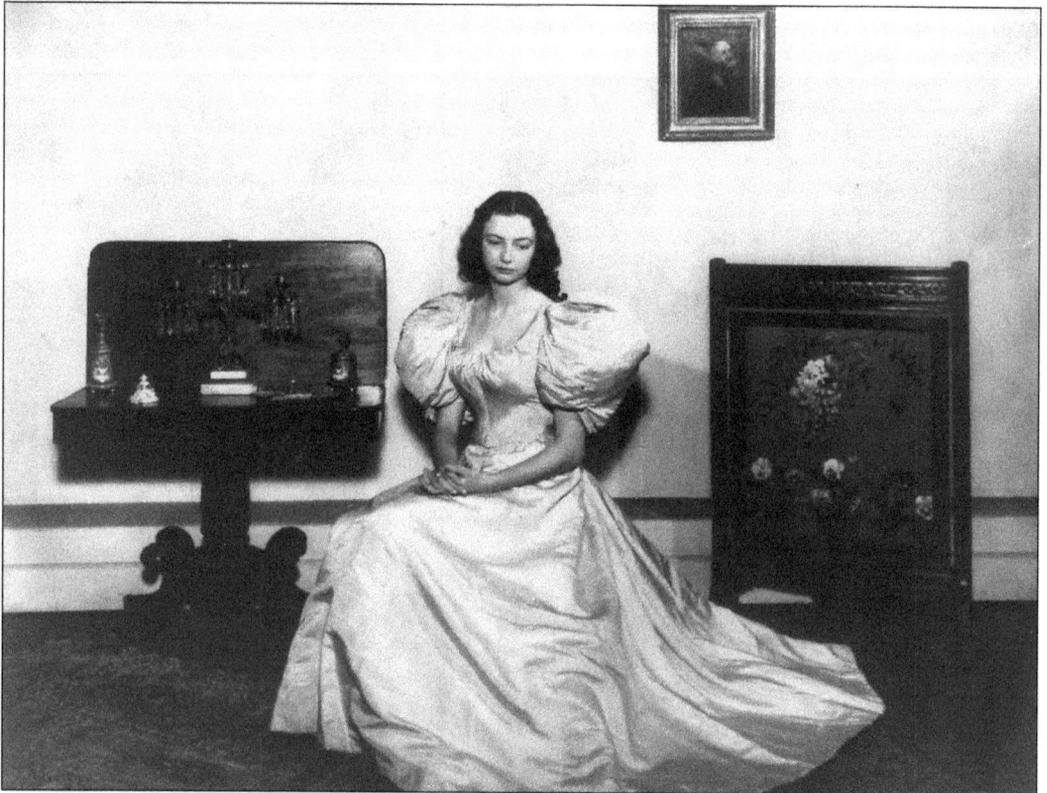

Miss Sarah Hastie wears the trousseau dress made in Paris for her grandmother, Sara Simons, in this 1939 photograph. (MK 18132C)

Mary Bennett looks elegant in her
great-grandmother's dress. The
furnishings surrounding her belonged
to her great-grandparents, Governor
and Mrs. Thomas Bennett. The fine
lacquered pieces were purchased at the
Crystal Palace on an 1850s European
tour. (MK 4668)

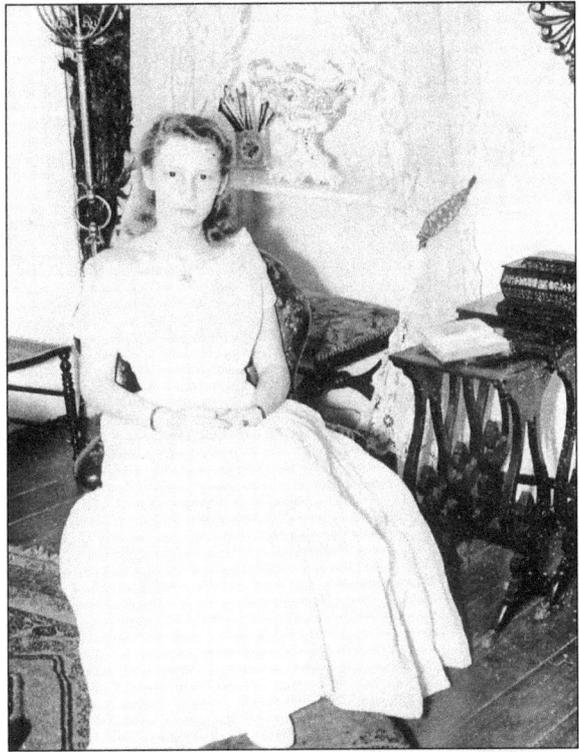

Kathleen Read, daughter of Mr.
and Mrs. William Read, poses in a
gown made by Mrs. Edmund Felder.
The sofa was made by Charleston
furniture maker Thomas Porcher
White. (MK 6318)

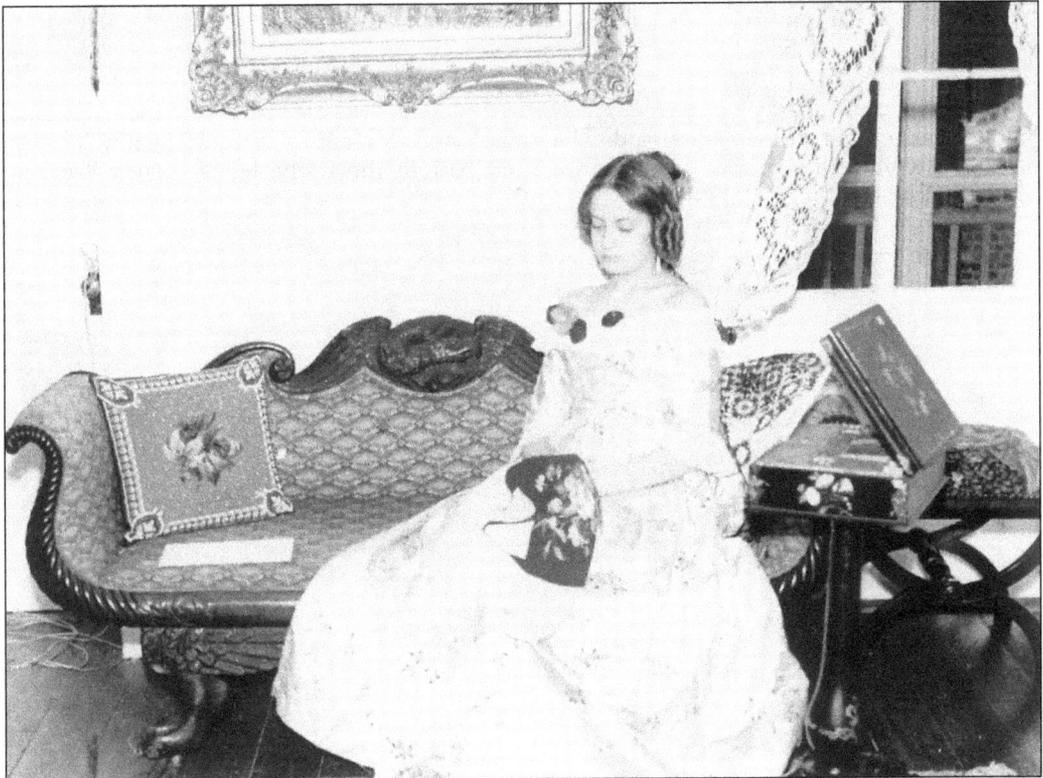

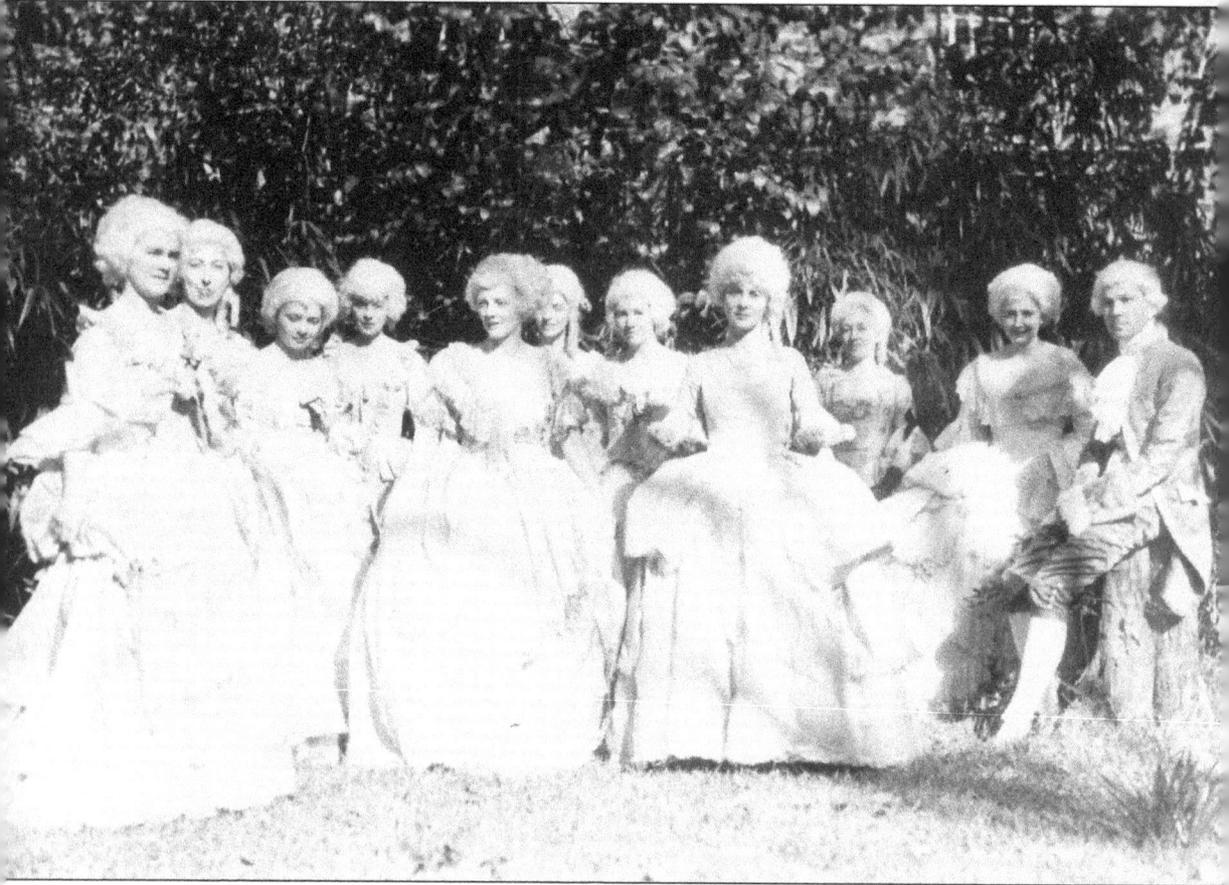

M.B. Paine caught these ladies and The Charleston Museum's director, Milby Burton, dressed in eighteenth-century costumes for their part in the festivities of Azalea Week in 1938. (MK 1246)

Ten

MEMORABLE EVENTS

"It is inspiring to behold amid these grave difficulties the resumption of the business life of our city and the quenchless faith of our people in the future."—Mayor William Ashmead Courtenay, "Special Earthquake Report," *The City Yearbook 1886.*

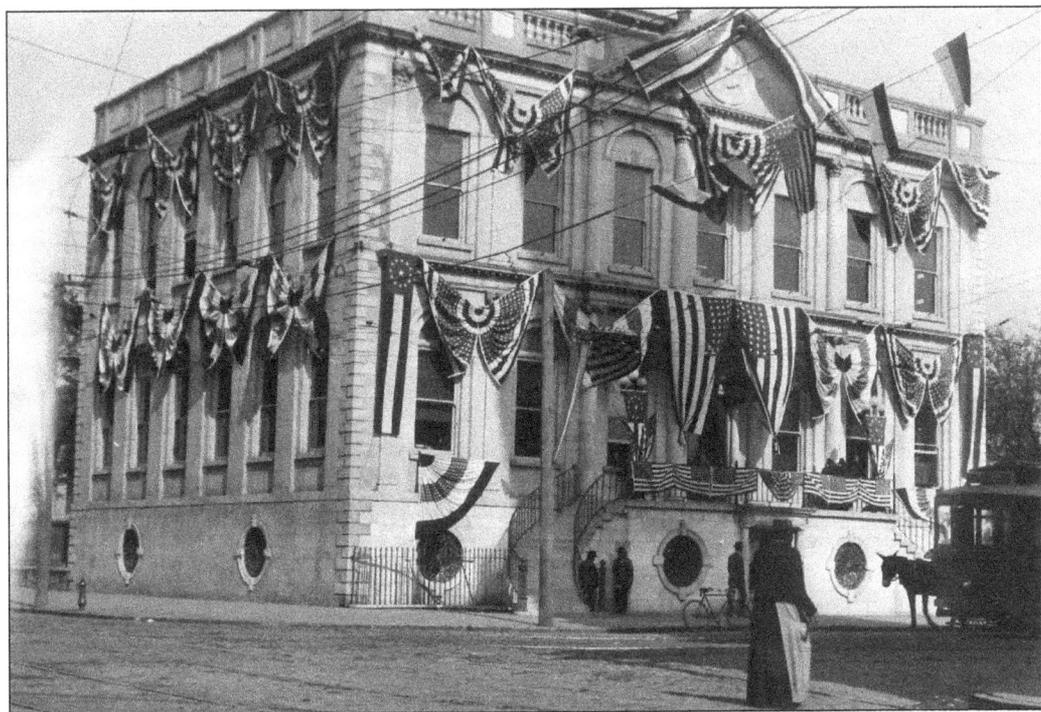

City Hall, on the northeastern corner of Broad and King Streets, is festooned with flags in this *c.* 1917 view. The number of flags indicate a major occasion. (MK 8977B)

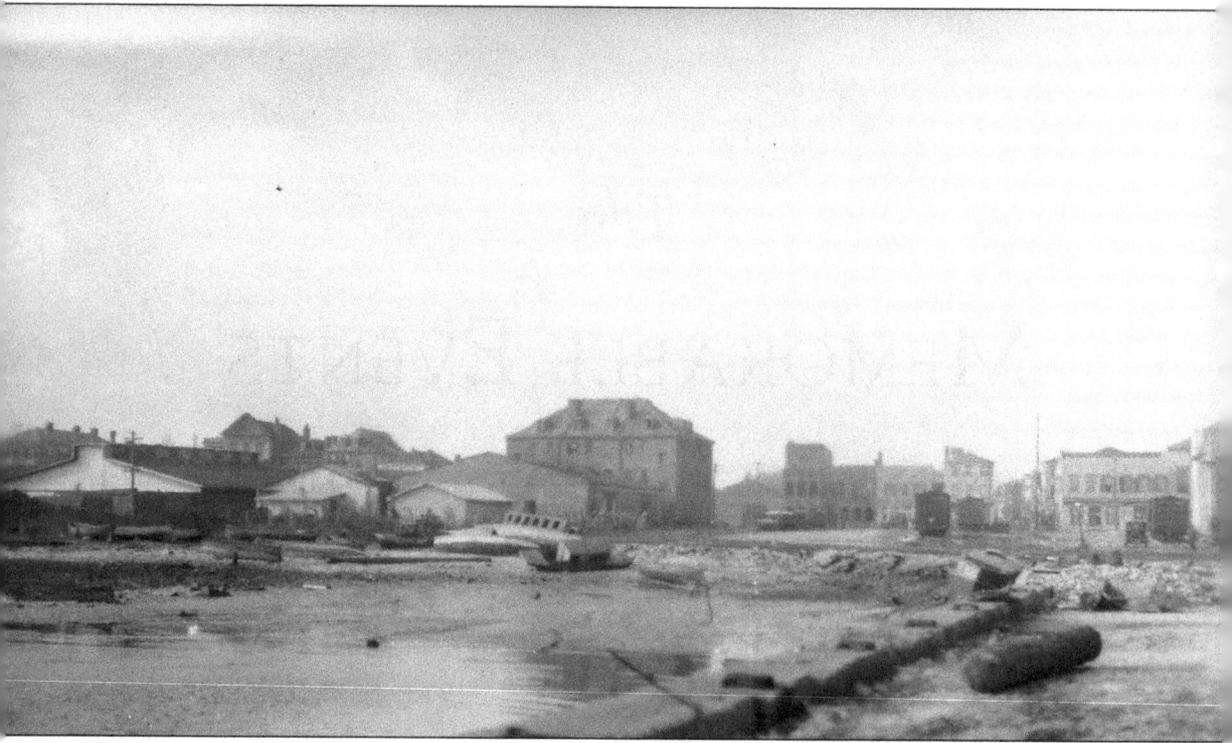

The Cyclone of 1885, as it was called then, was one of the worst hurricanes to hit Charleston. High water left debris scattered all along the waterfront and boats beached on the shore and streets. The warehouses of the Charleston Canning Company can be seen in front of the Vanderhorst Tenements. (MK 7182)

During the great earthquake of August 31, 1886, the parapet fell through the portico roof of the First Baptist Church. Remarkably, the columns remained standing through the quake and severe aftershocks which continued for days. The quake lasted one full minute, and ". . . all the inhabitants of the city stood together in the presence of death in its most terrible form and scarcely one doubted that all would be swallowed together and at once, in one wide yawning grave." *The City Yearbook, 1886.* (MK 121C)

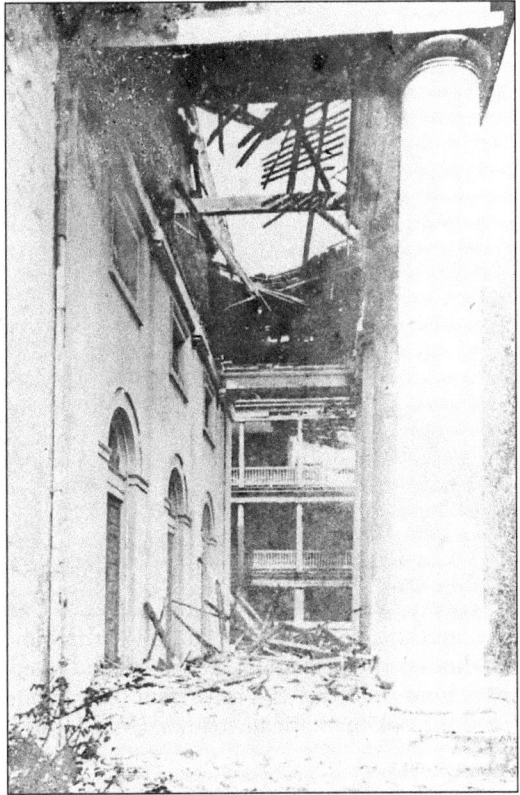

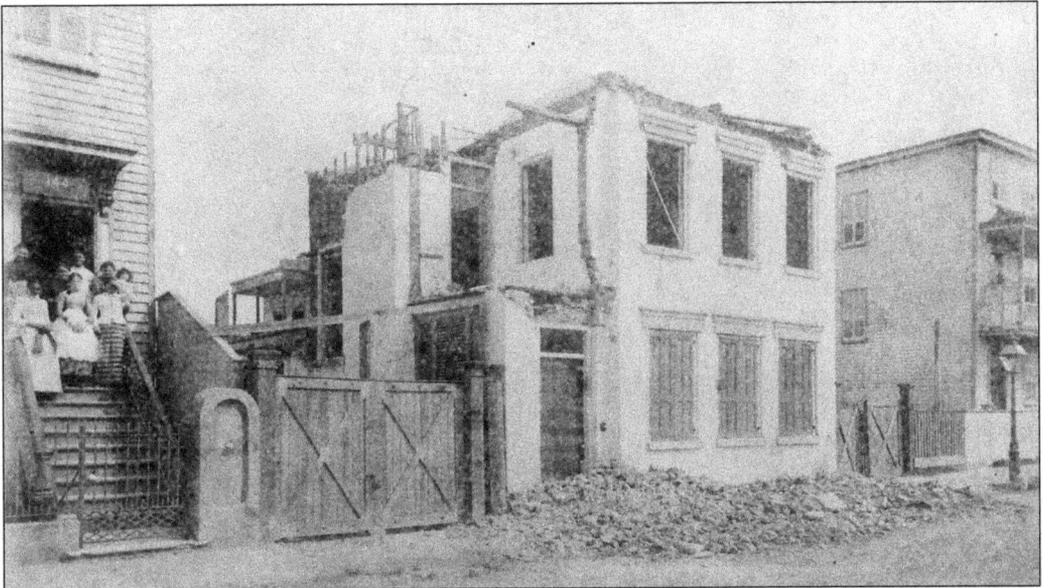

George Cook documented the damaged dome of John Kenny's home at 142 Tradd Street, which suffered severe damage. The wooden house next door at 144 Tradd attests to the flexibility of frame structures, which tended to survive the earthquake better than brick ones. (MK 4159)

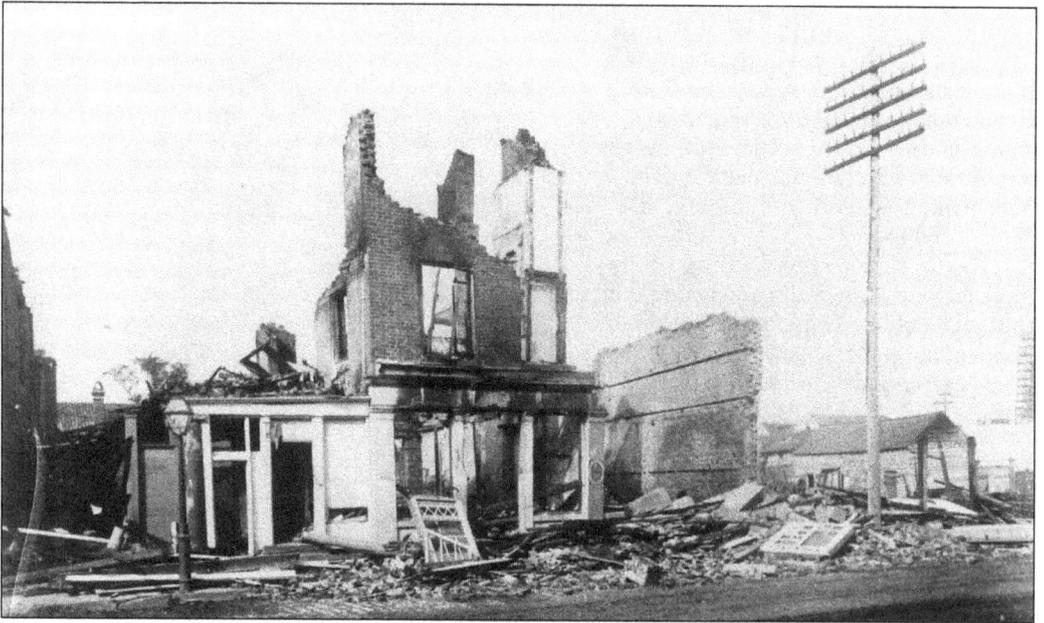

The earthquake shattered buildings throughout the city, but did even greater damage to buildings constructed over creek beds and filled land. At the corner of Warren and King Streets, these houses suffered not only from the earthquake, but from fire as well, as this photograph by George Cook dramatically shows. (MK 4146)

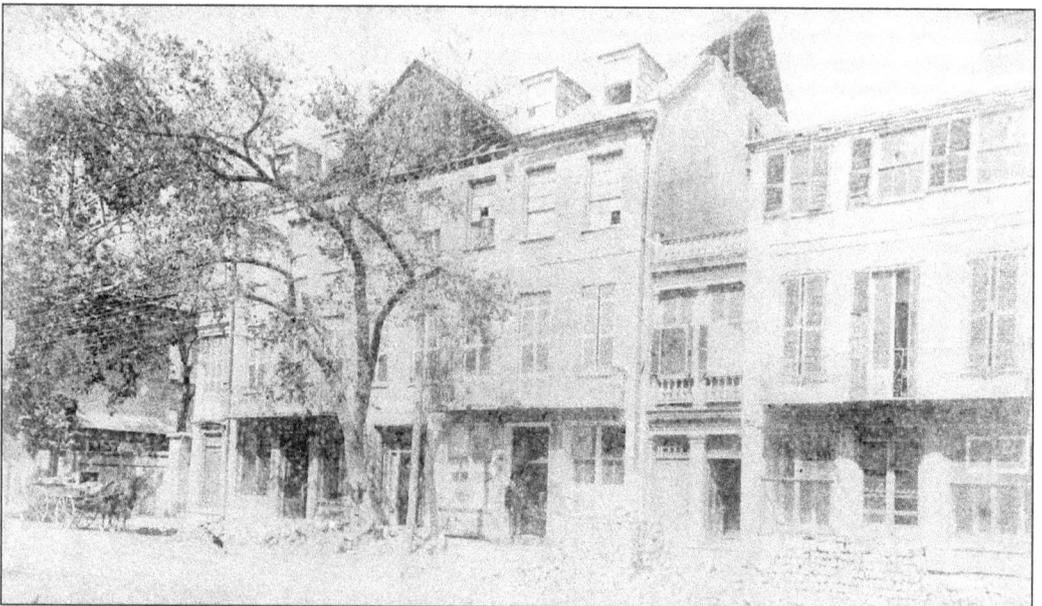

The Confederate Home and College at 62 Broad Street, built just a few years after the Civil War as a center for the education and housing of widows and children of Confederate soldiers, suffered considerable damage. Thanks to a national outpouring of sympathy for the beleaguered city, the Home was rebuilt, and a new mansard roof replaced the old gable system shown here. (MK 95)

102

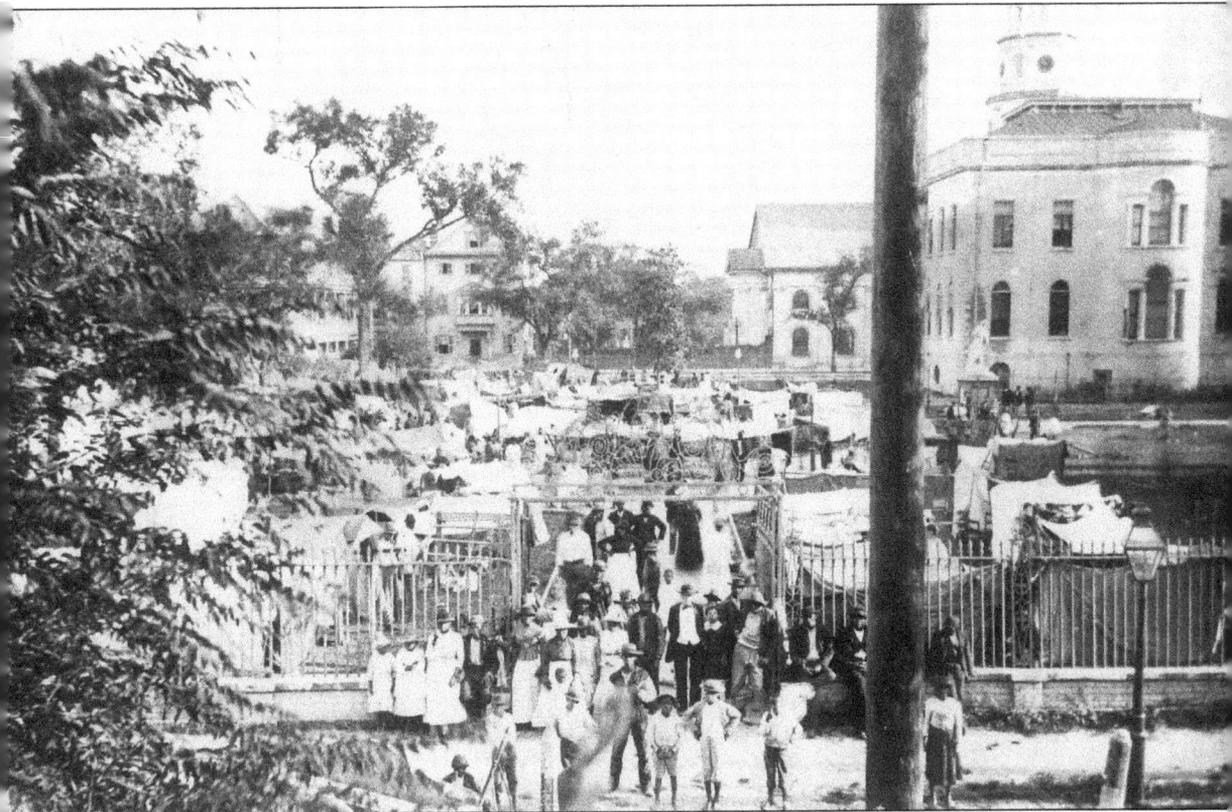

Washington Square Park became a tent city overnight as many residents fled their homes to seek "shelter" in open areas of the city. Aftershocks continued almost a month, and some reported a feeling of seasickness for weeks after the earthquake. (MK 8821)

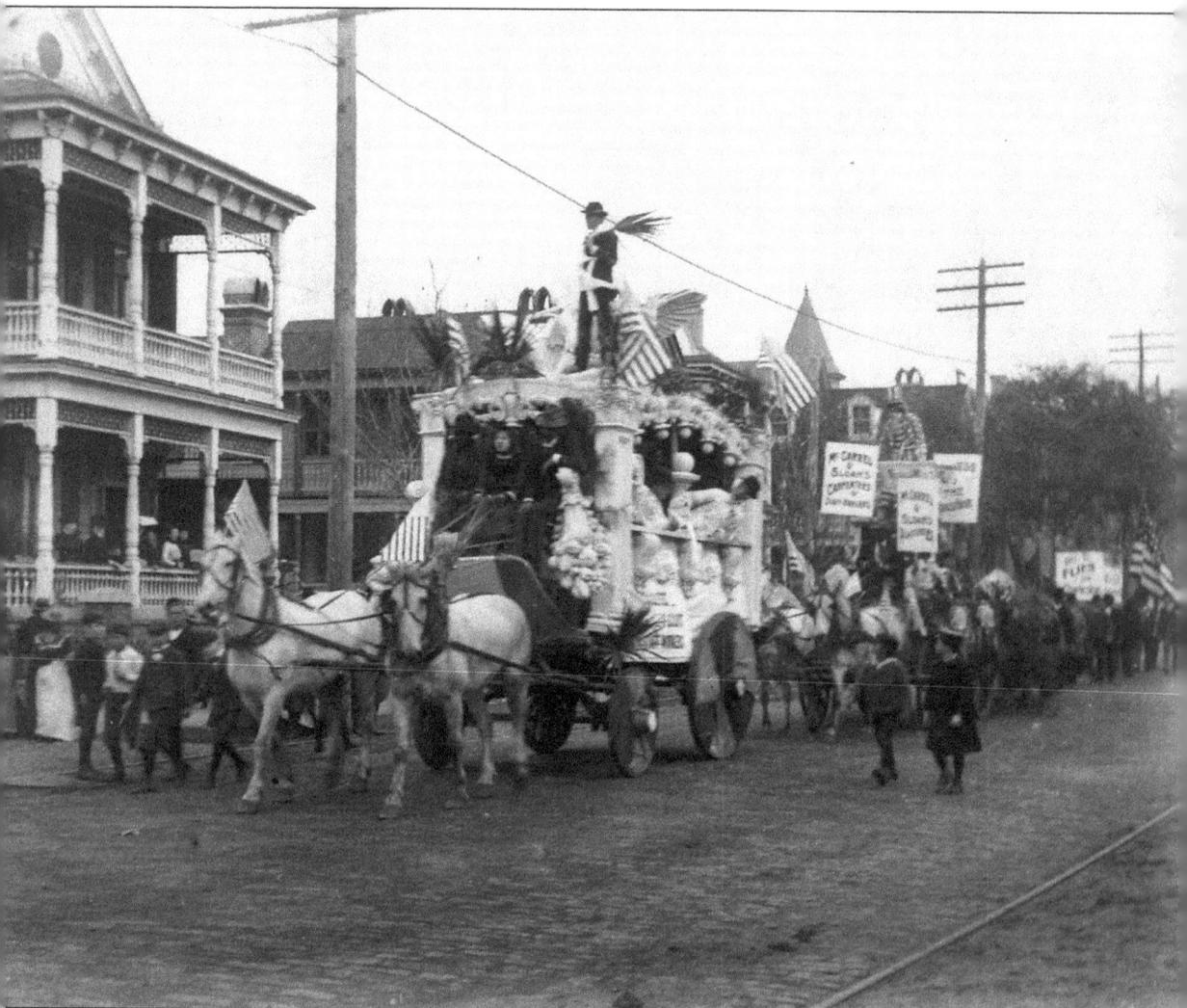

Charleston hoped to attract Panama Canal trade after the Spanish-American War of 1898. The city sponsored the great South Carolina Inter-State and West Indian Exposition of 1901–1902 to do just that. The exposition started with a grand parade. Here a float moves up Rutledge Avenue on its way to the exposition site, now Hampton Park. (MK 7726)

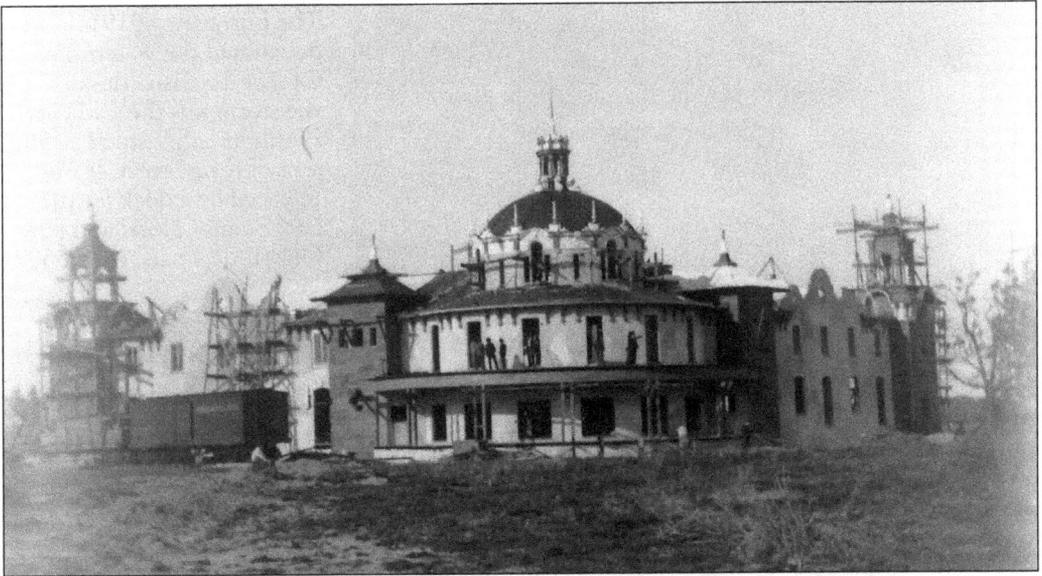

The South Carolina Inter-State and West Indian Exposition was the brainchild of Charleston businessman, Captain F.W. Wagener. He and his partners hoped to show the world the great resources of the region and attract potential investors. By 1900 they began to design and build the Ivory City, on the site of the old Washington Race Course, now Hampton Park. This photograph shows work on the Main Administration Building in April of 1901, one year prior to the opening of the exposition in 1902. (MK 7703)

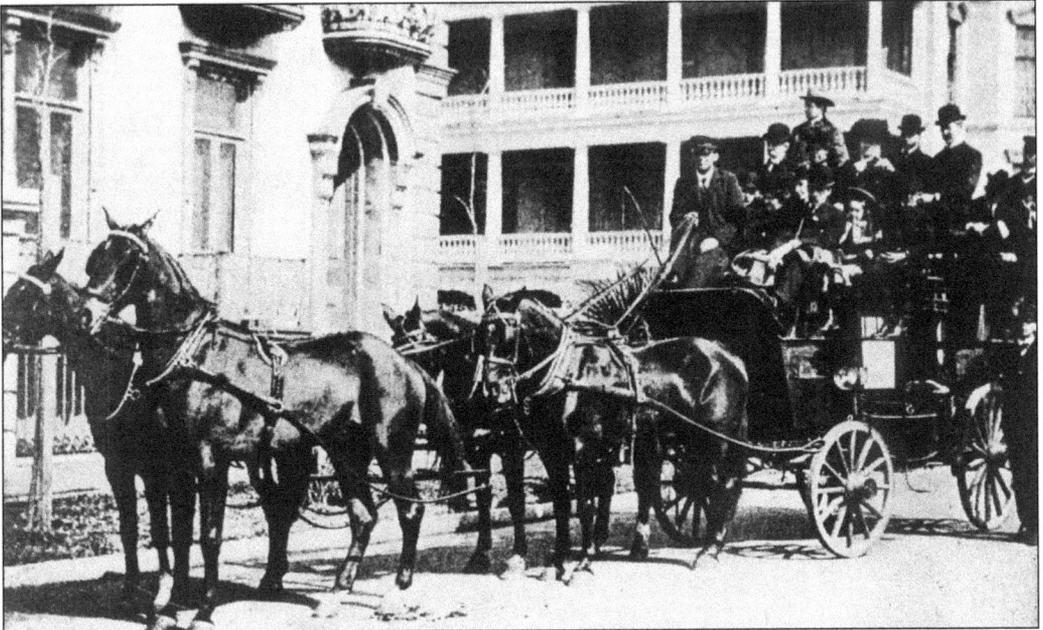

The first organized carriage tours of Charleston may have been those for the exhibition. As a promotional book stated, "One of the most pleasing trips about the city during the Exposition has been the four-in-hand trips by the Tally Ho Niagara for seeing Charleston. Thousands of tourists have enjoyed the sights from the elevated seats upon the top of the coach, the places of interest being pointed out by an attendant." (MK 10896)

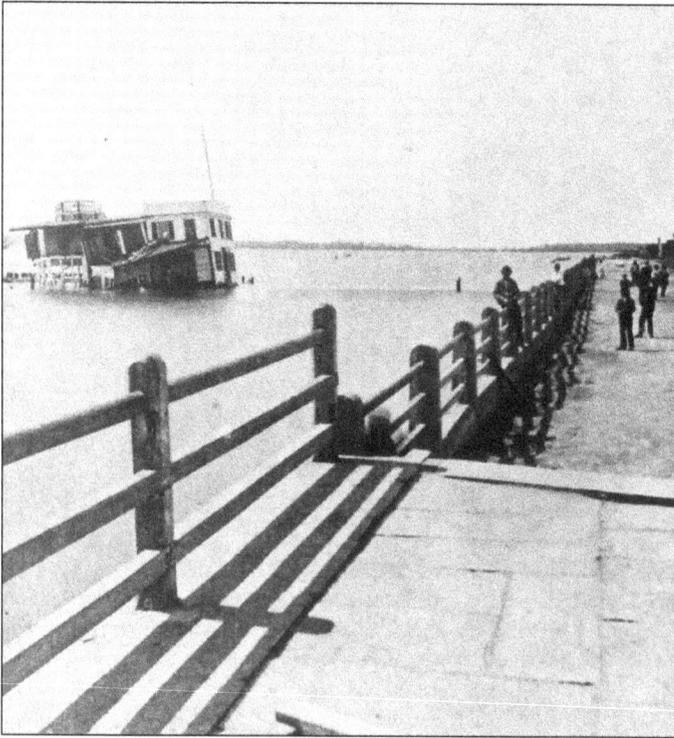

The hurricane of 1911 devastated the waterfront. One of the casualties of the storm was the Old City Bathhouse that stood at the foot of King Street. It was replaced by a dock for the Fort Sumter Hotel and later Gray Line Tours. (MK 3509)

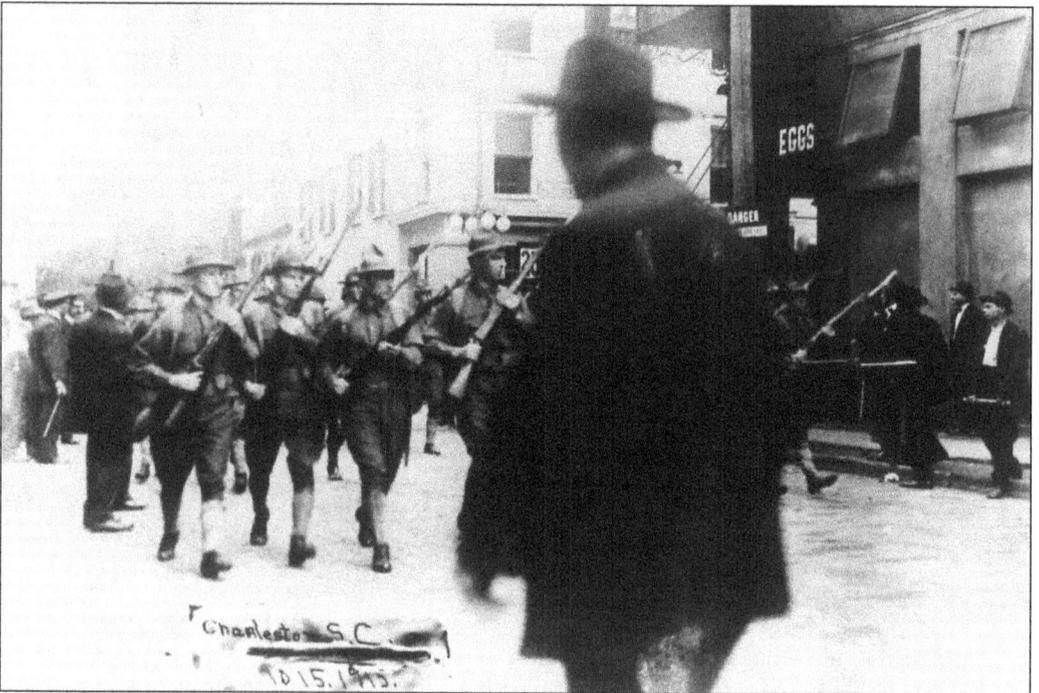

The election of November 1915 was hotly contested and tempers ran high. During a rally at the Freundschaftbund Hall, at the corner of Meeting and George, a reporter was killed in a shooting. The militia was called out to clear the streets and reestablish order. (MK 8516B)

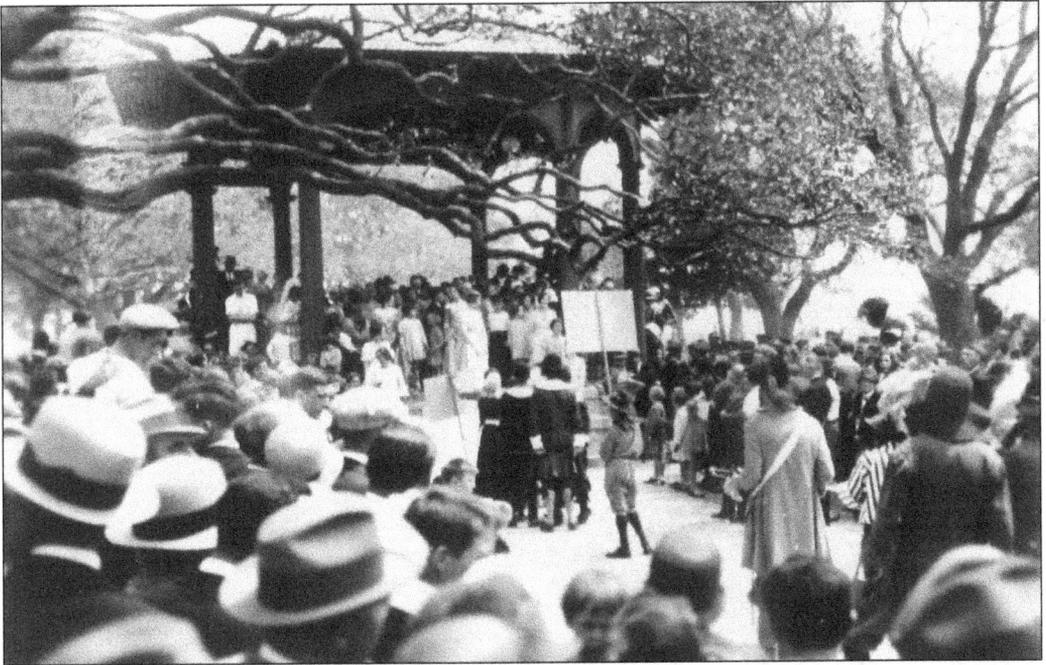

A crowd has gathered at the Bandstand in White Point Gardens in 1919 for the 250th anniversary of the settlement of Charleston. (MK 3211)

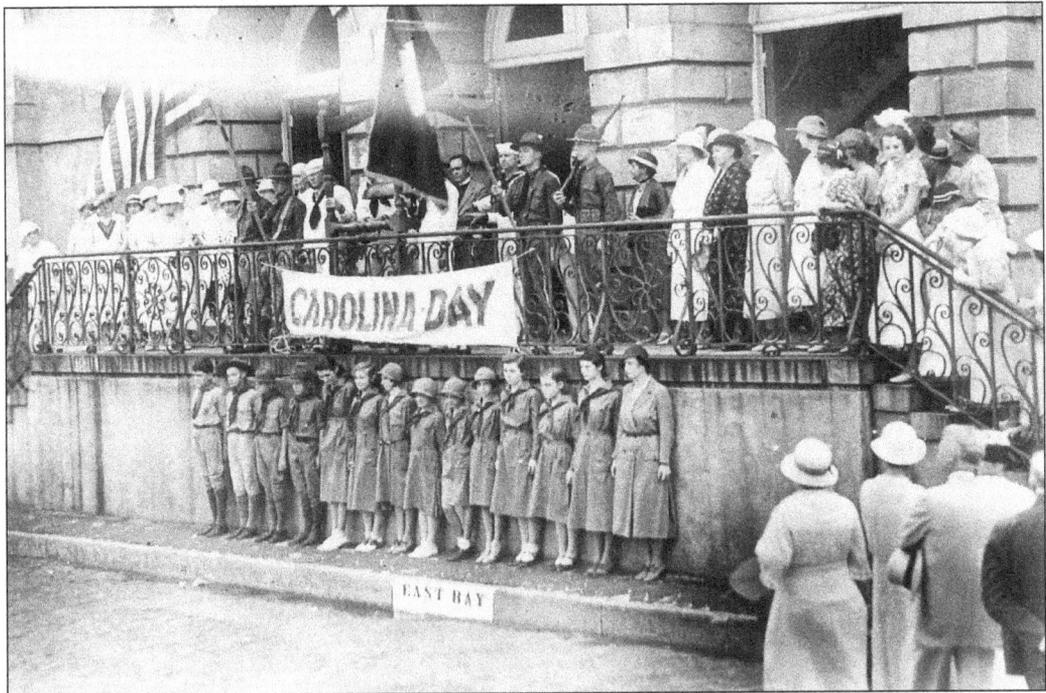

The June 28, 1776 victory of patriot forces on Sullivan's Island over a British invasion fleet has been celebrated in South Carolina ever since. Here, at the Old Exchange Building, a crowd of notables, dignitaries, and rather somber Girl Scouts have gathered after the parade down Broad Street. (MK 3216)

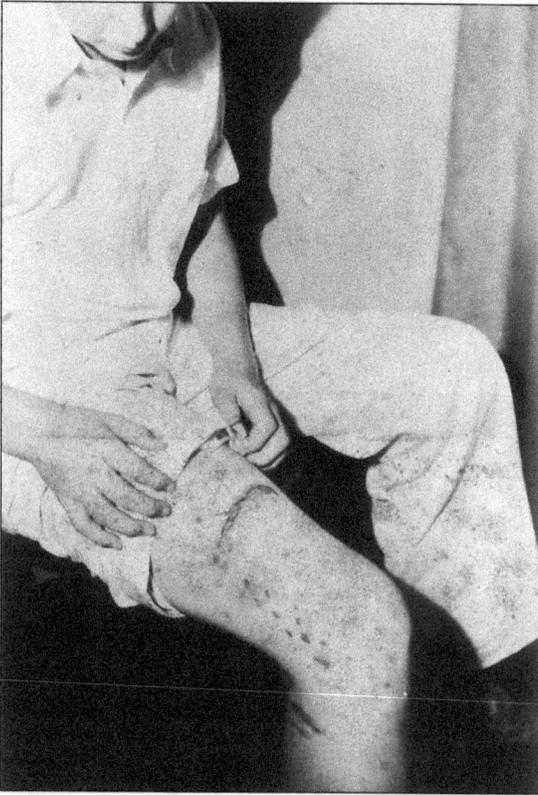

In June of 1933, young Drayton Hastie was swimming off Comings Point on Morris Island when he was attacked by a shark. The young boy managed to swim to shore and tell the tale. He showed his scars a year after the event. (MK 3656)

The end of the trolleys in Charleston was an end of an era for the city. In 1936, the South Carolina Power Company determined that the trolleys should be removed in favor of buses, which would allow for greater route flexibility. Here, the trolleys are gathered at Marion Square for the last time. (MK 14792)

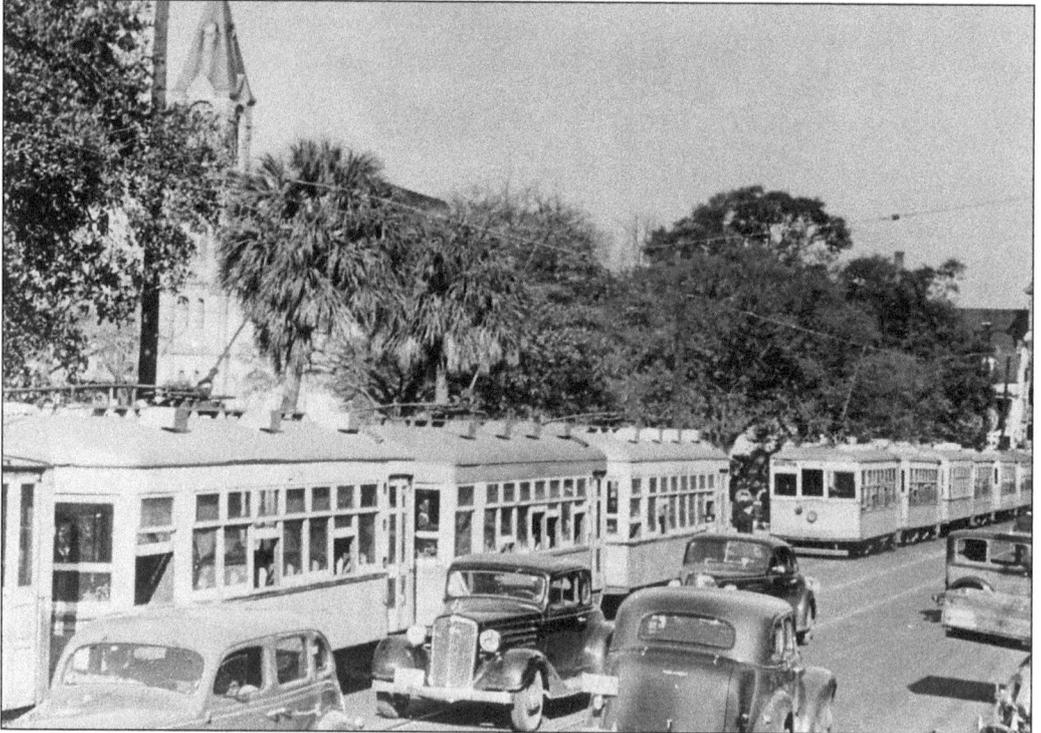

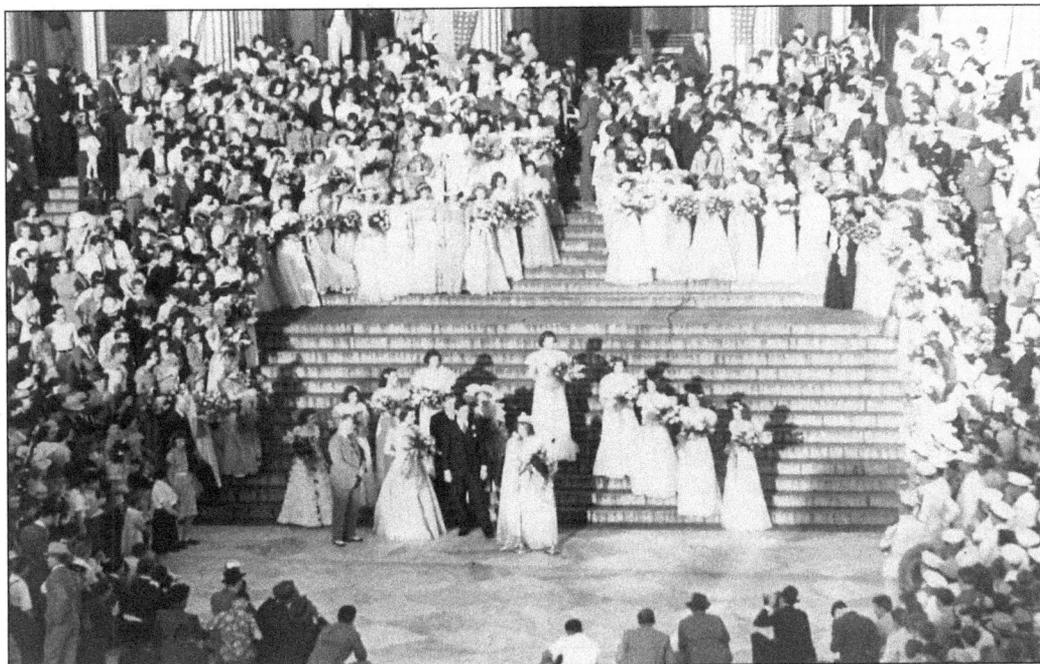

The Queen of the Annual Azalea Festival and her court congregate on the steps of the U.S. Custom House at the close of the 1937 festival. Azalea Week was a major activity in the 1930s, and judging by the crowd, the event attracted quite an audience. (MK 9927)

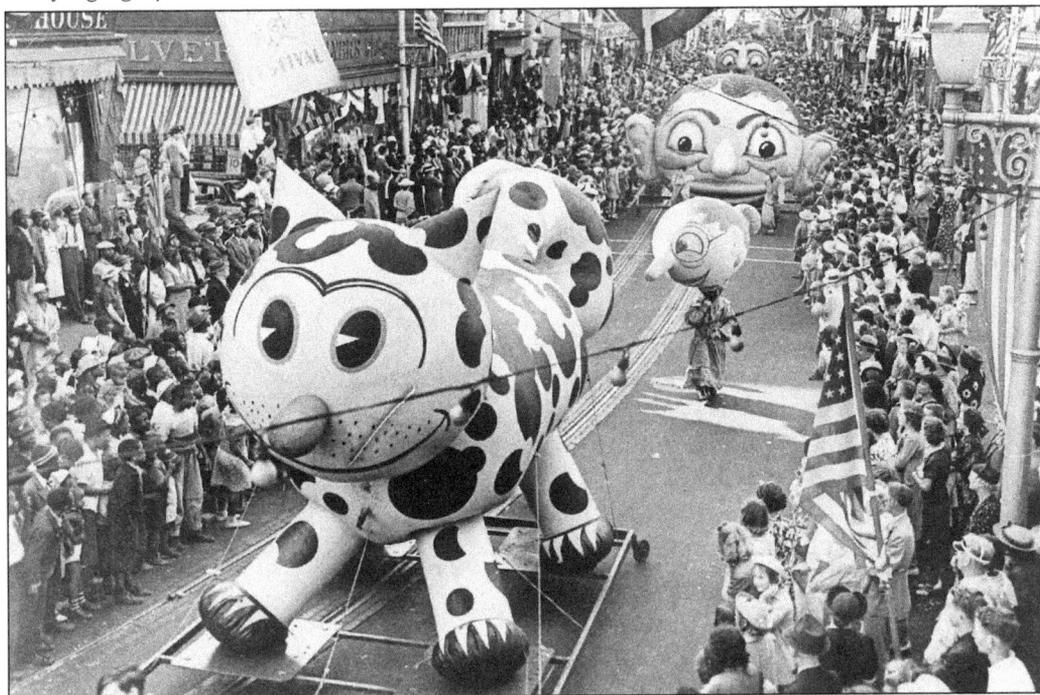

One of the big events of Azalea Week was the Azalea Parade. Here, at King and Beaufain Streets, a crowd watches one of the latest parade innovations, inflatable rubber floats, as they wind their way down King Street. (MK 9939)

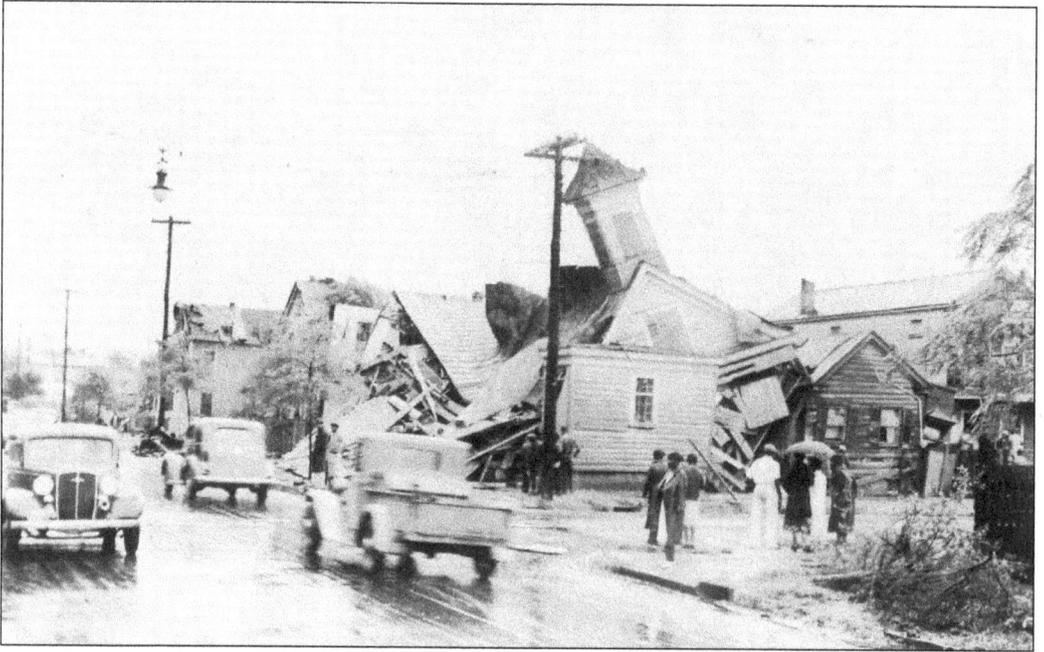

Tornadoes remain an annual threat to Charleston. The September weather of 1938 spawned five tornadoes that damaged different parts of the city. Here, at Ashley and Sumter Streets, Calvary Baptist Church was leveled in short order by a tornado. (MK 3372)

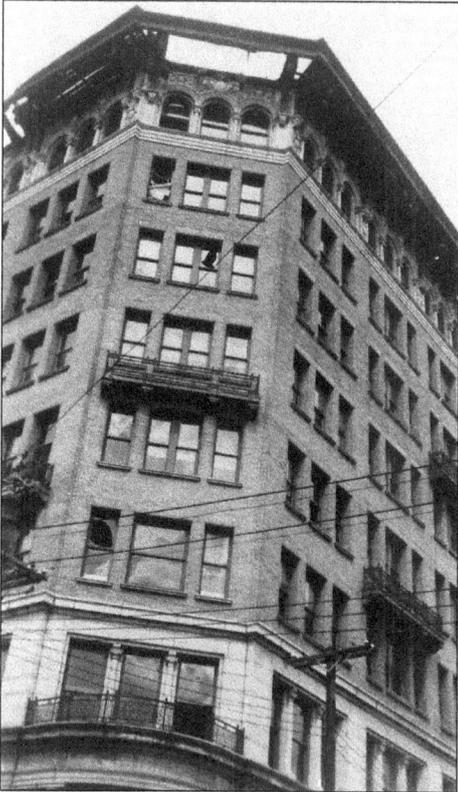

Another tornado struck the People's Building at the corner of Broad and State Streets. The damaged cornice was subsequently removed, accounting for the rather stark appearance of the building today. (MK 8916)

110

A tornado also touched down south of Broad. Here, at King and Lamboll Streets, number 19 was severely damaged by winds, which tore off the third-story piazza and blew out the drawing room walls. (MK 3435)

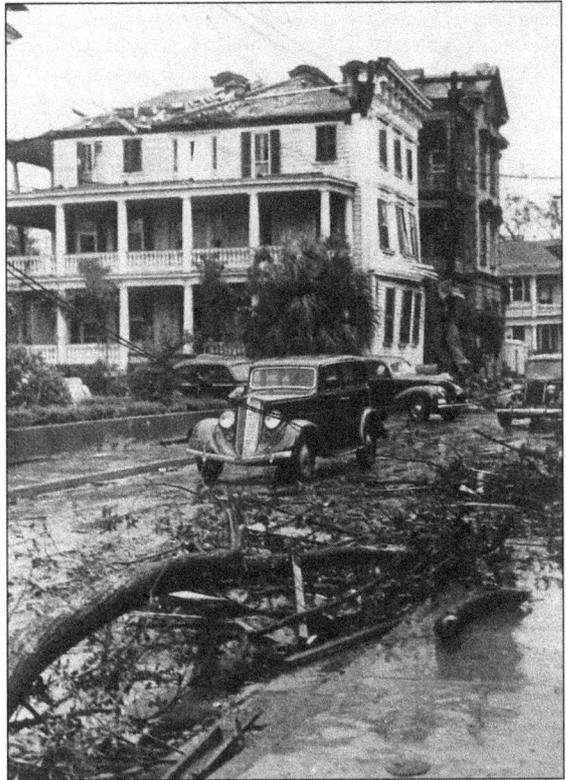

Damage inflicted to homes located on Elizabeth Street in the Mazyck-Wraggborough section of the city left many homeless. After the storm, residents loaded up their belongings to seek shelter in other parts of the city. (MK 3434)

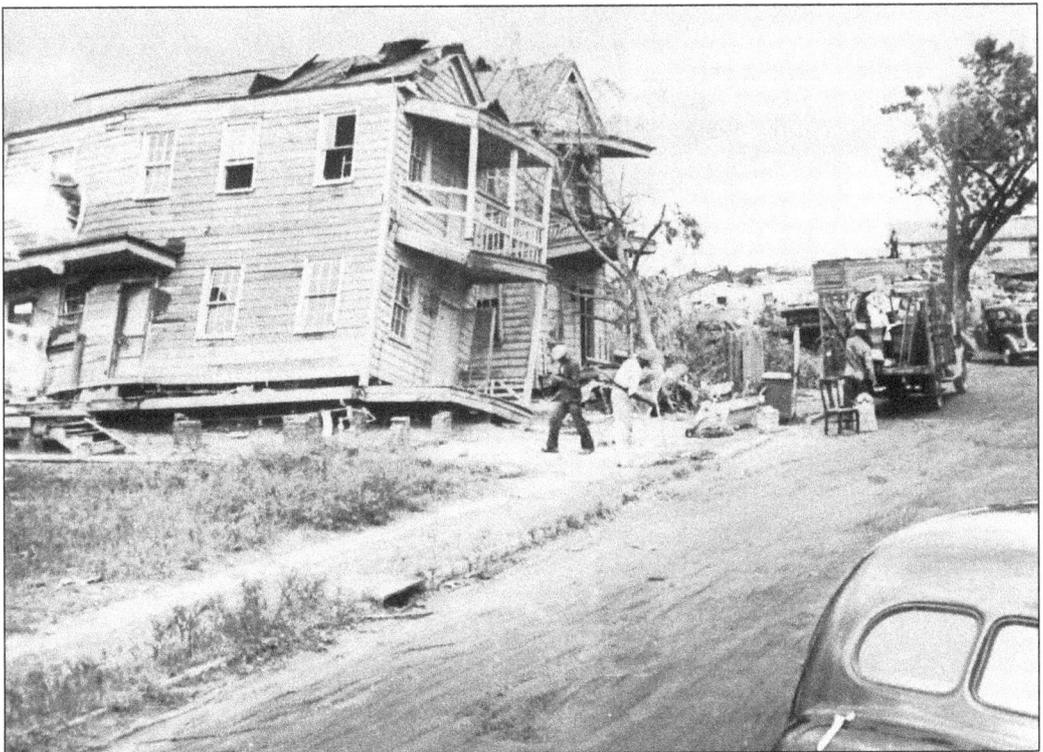

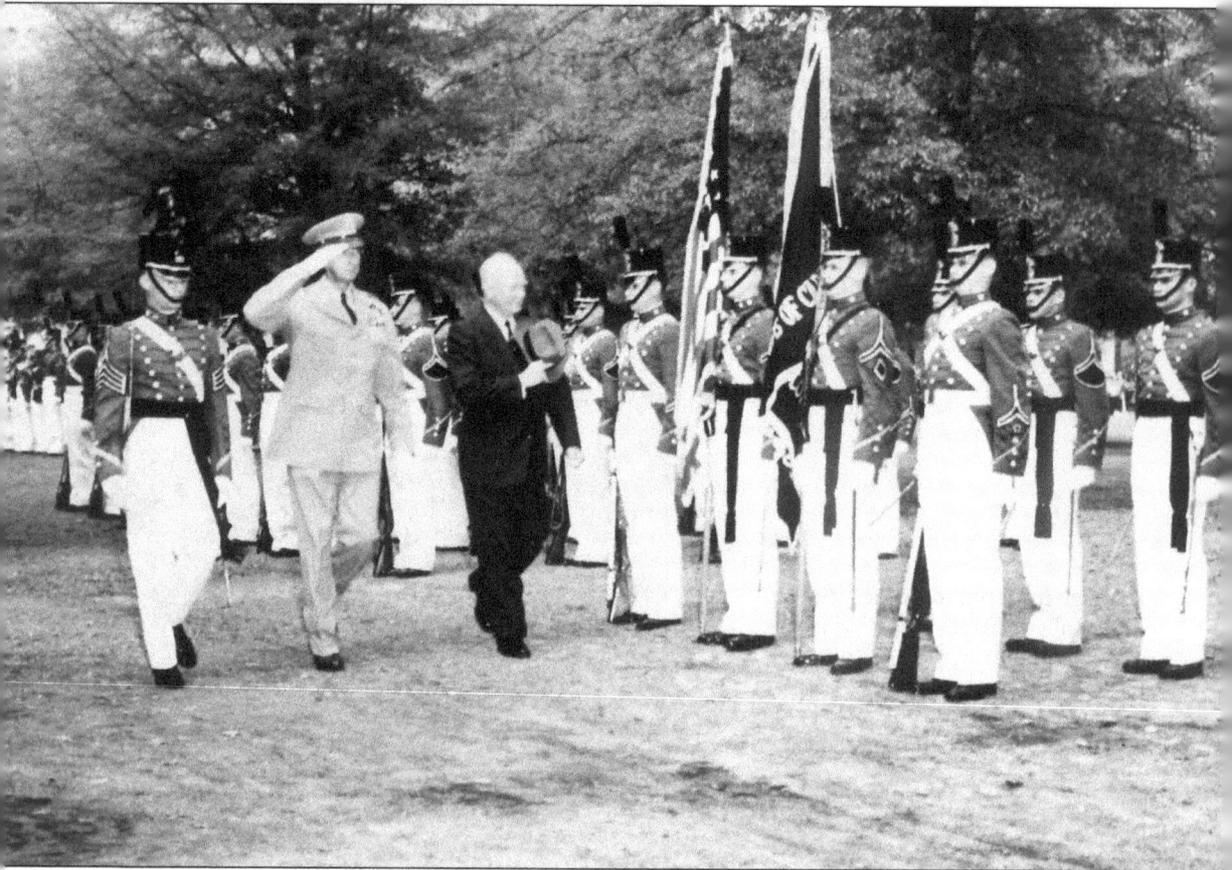

General Mark Clark and his boss, President Dwight D. Eisenhower, review the Citadel Corps of Cadets dress parade in the 1950s. (MK 8059)

Eleven

GONE BUT NOT FORGOTTEN

"Since the city must continue to grow, and since growth is change, Charleston is confronted with a more serious peril than she has ever faced since her founding. In the past, no matter what calamities overtook her, her people were one in their ideals—the city must be saved. Man and nature alike have attempted to destroy her; it is a paradox that she who has survived adversity and calamity may be obliterated for all time by the hand of progress."—Elizabeth O'Neill Verner, *Mellowed By Time.*

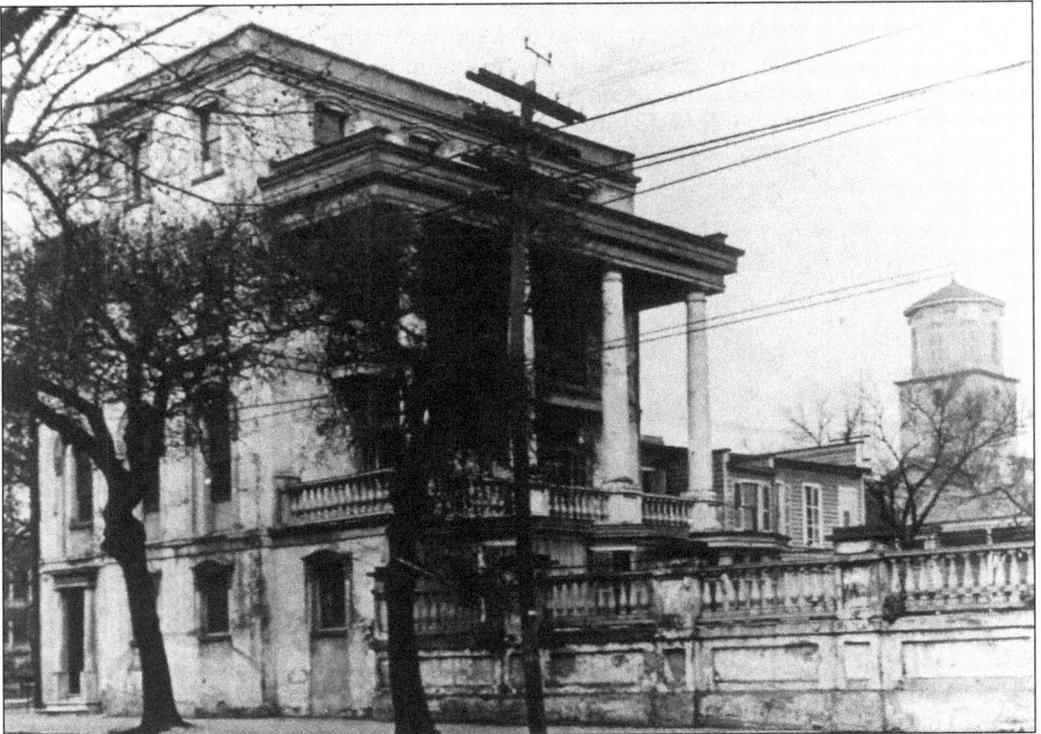

The Ancrum House stood at the corner of Charlotte and Meeting Streets. Facing Marion Square, its massive piazza and elegant appearance made it one of the great buildings of the city. It was torn down in the 1940s and the site used for construction of the Federal Building. (MK 2761)

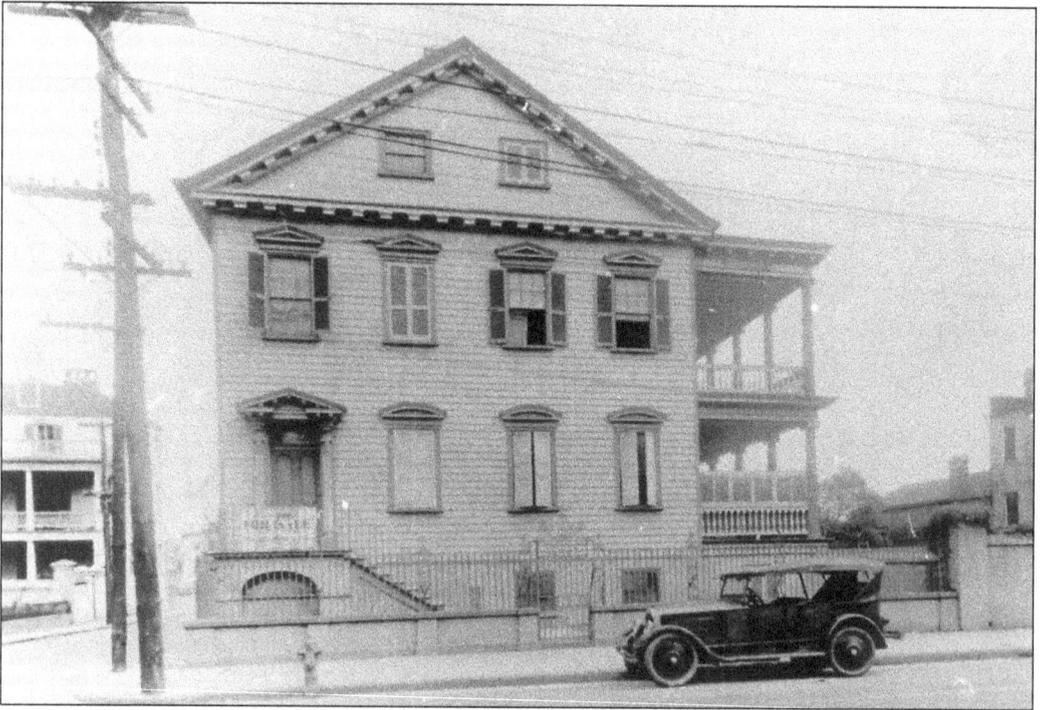

The Gabriel Manigault House was designed by Manigault as his Charleston residence, in the early part of the nineteenth century. Gabriel's grandson became director of The Charleston Museum in the 1870s. Unlike the Joseph Manigault House, it was demolished in 1926 to make way for an Esso Gas Station. (MK 13136A)

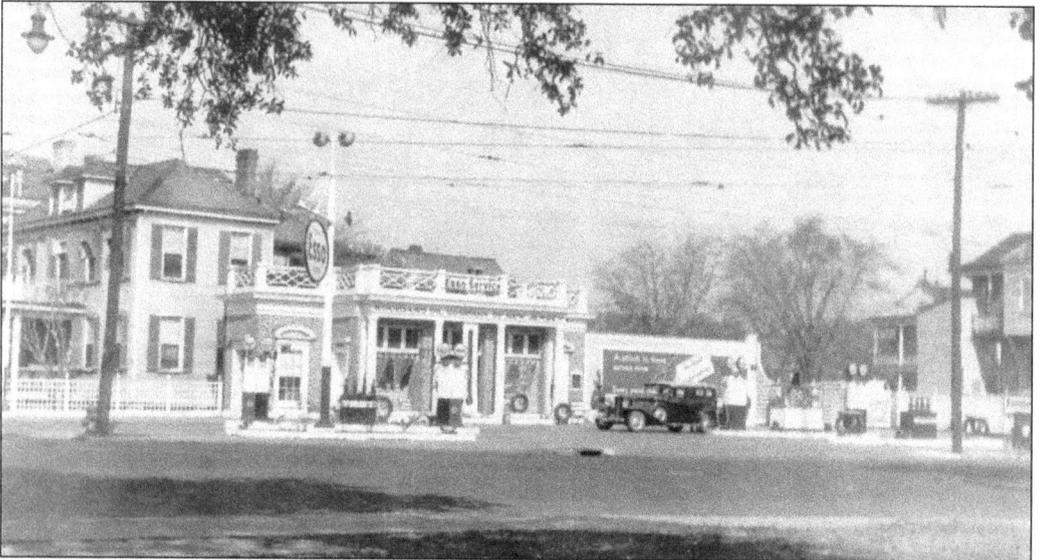

Bits and pieces of the Gabriel Manigault house survived for years as part of the architecture of a series of gas stations. Albert Simons used window details and columns in the exterior treatments, such as this station at Calhoun Street and Rutledge Avenue. The last remaining example of this woodwork can be seen at the Historic Charleston Foundation Education Center at the corner of Chalmers and Meeting Streets. (MK 3127)

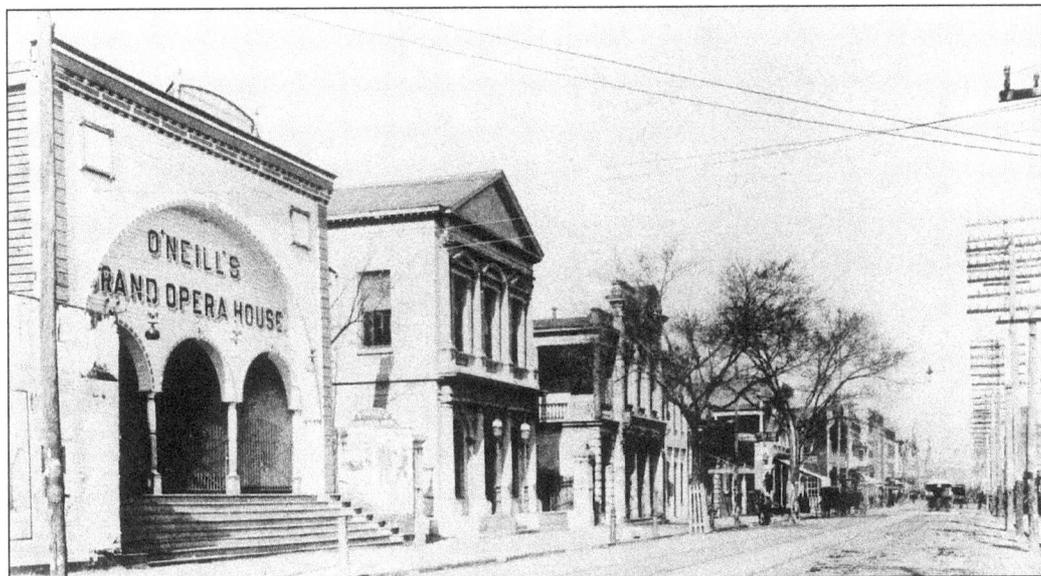

O'Neill's Grand Opera House at 135 Meeting Street was a center of entertainment for years. Originally constructed as the Exhibition Hall of the South Carolina Agricultural Society in 1881, by 1888 it was in use as an opera house. (MK 22152, AWC)

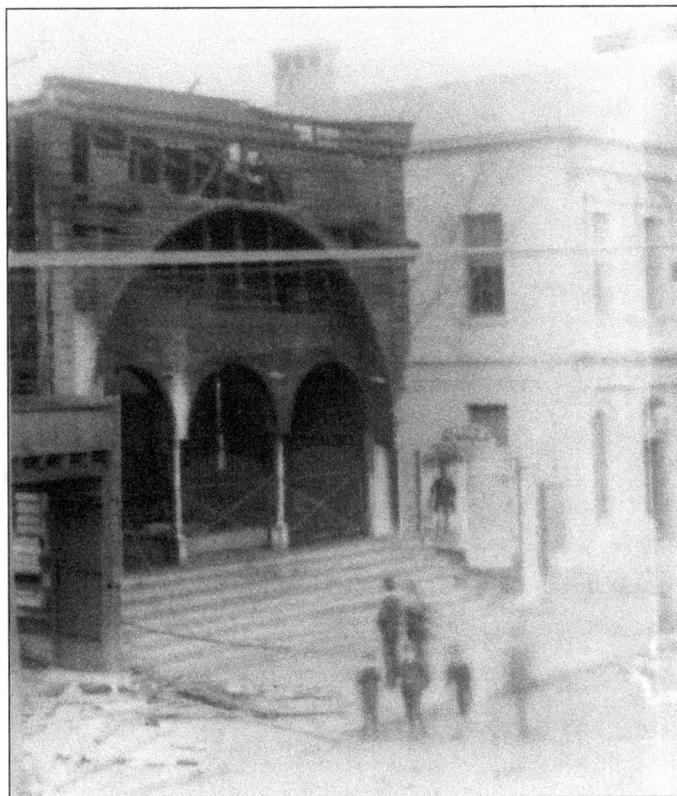

O'Neill's Grand Opera House was not so grand after a fire on New Year's Day, 1894. The site was cleared and The Gibbes Art Gallery was constructed here almost ten years later. (MK 15285)

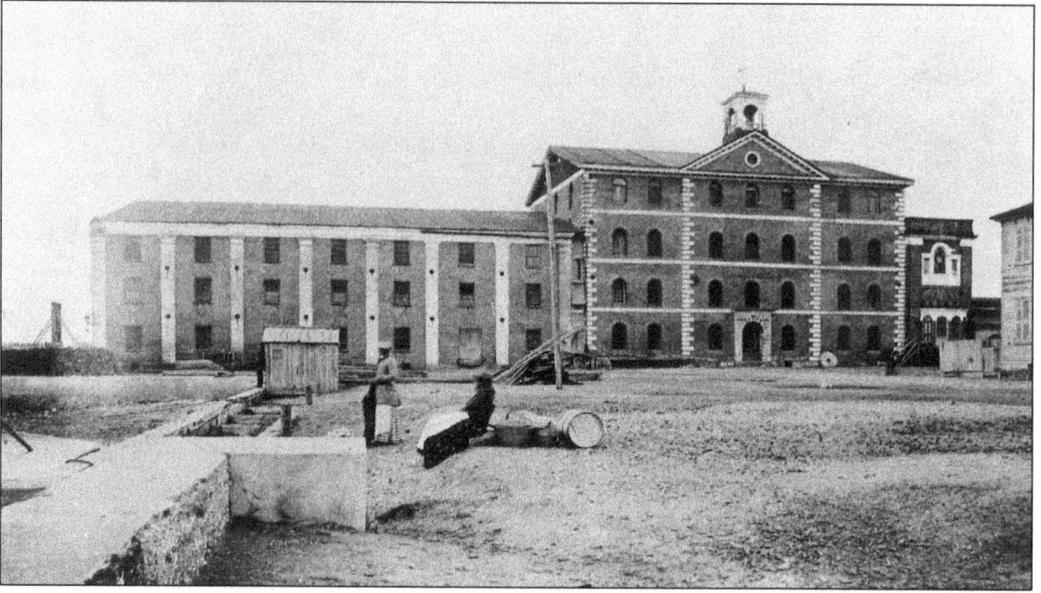

Chisolm's Mill, c. 1859, stood at the end of Tradd Street, on the west side of the city, at the Ashley River. It was a rice milling factory until the early 1900s when rice ceased to be a major crop in the Lowcountry. The main building fell into disrepair and was demolished after it suffered significant damage in the hurricane of 1911. The property was purchased in 1914 by the U.S. government. The wing to the left of the main buildings is part of the U.S. Coast Guard facility. (MK 22909)

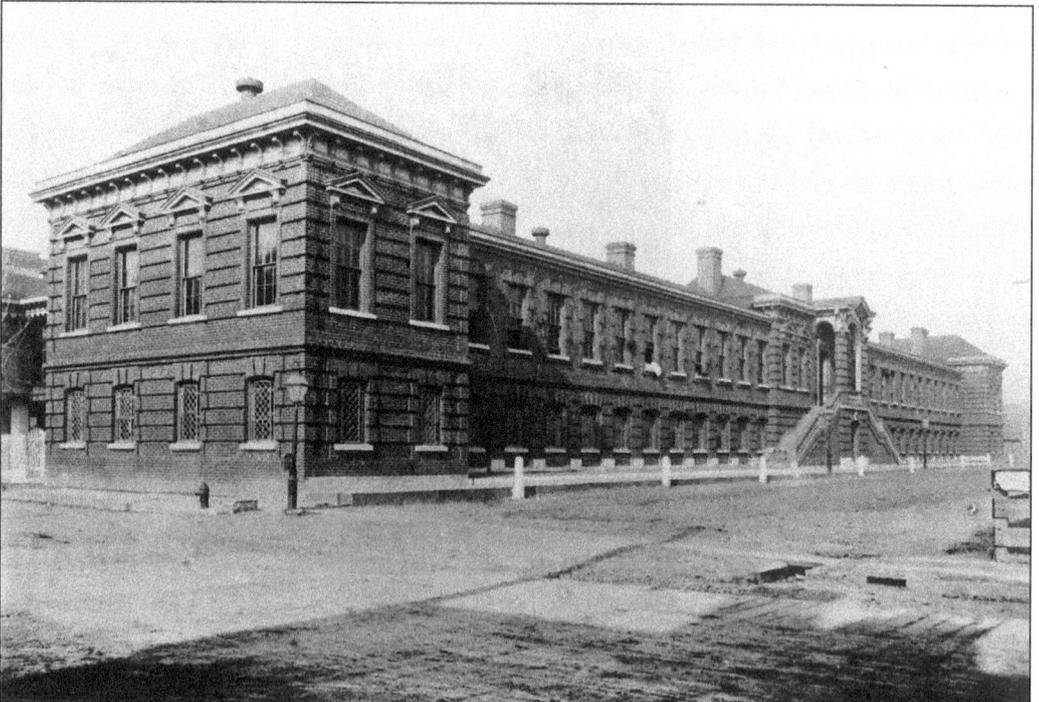

The old City Hospital was located at the edge of town on the corner of Calhoun and Barre Streets. It was built to care for Charleston's indigent citizens. (MK 21210)

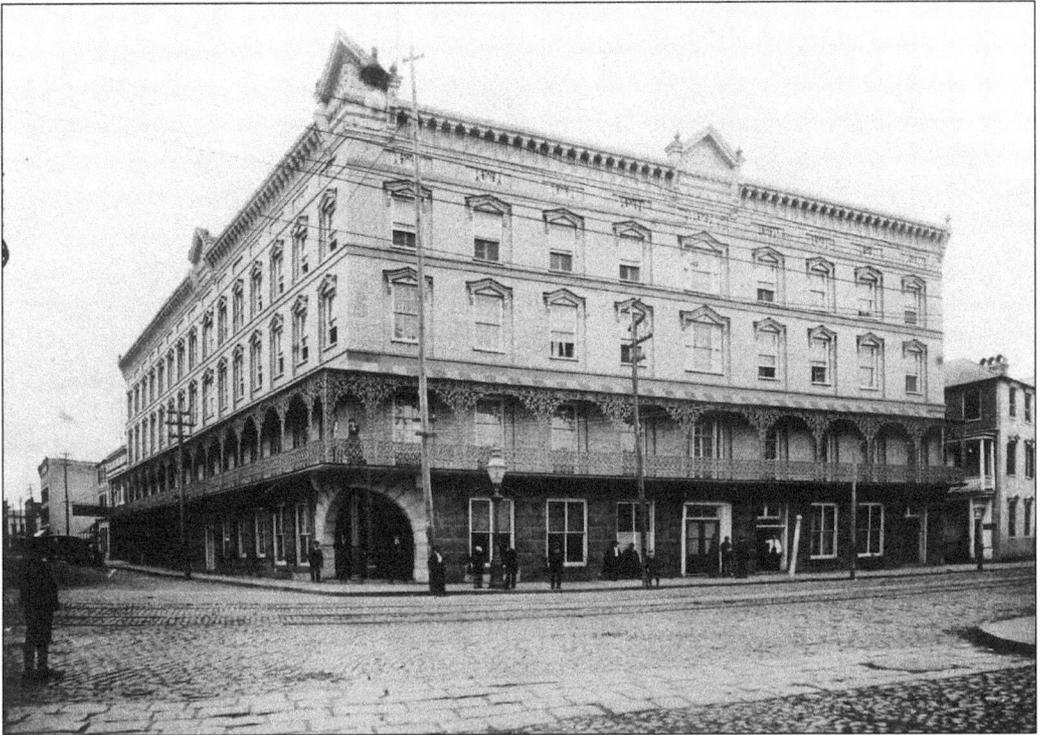

The St. Charles Hotel stood at the intersection of Meeting and Hasell Streets. Beautiful iron balconies and a unique corner entrance made this one of Charleston's finest hotels. Today, the King Charles Inn stands on the site and incorporates cast-iron decorative elements from the old hotel. (MK 21211, AWC)

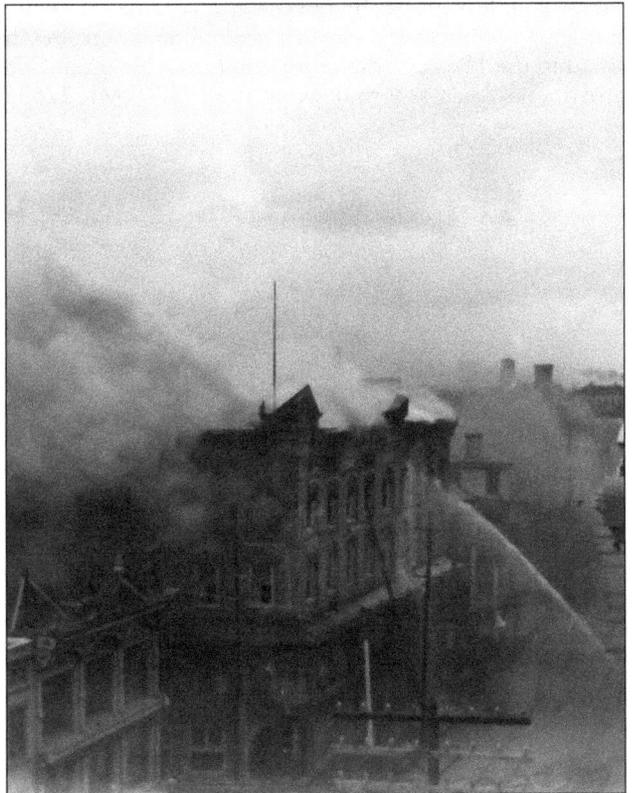

Fire was the scourge of Charleston until 1883, when Mayor Courtenay determined to make the city's fire department a full-time, professional city agency. In this 1900 view, a fire burns at the St. Charles Hotel. Fortunately, a city fire station was only one block away at Meeting and Wentworth Streets. It was rehabilitated as the Argyll Hotel. (MK 7593B)

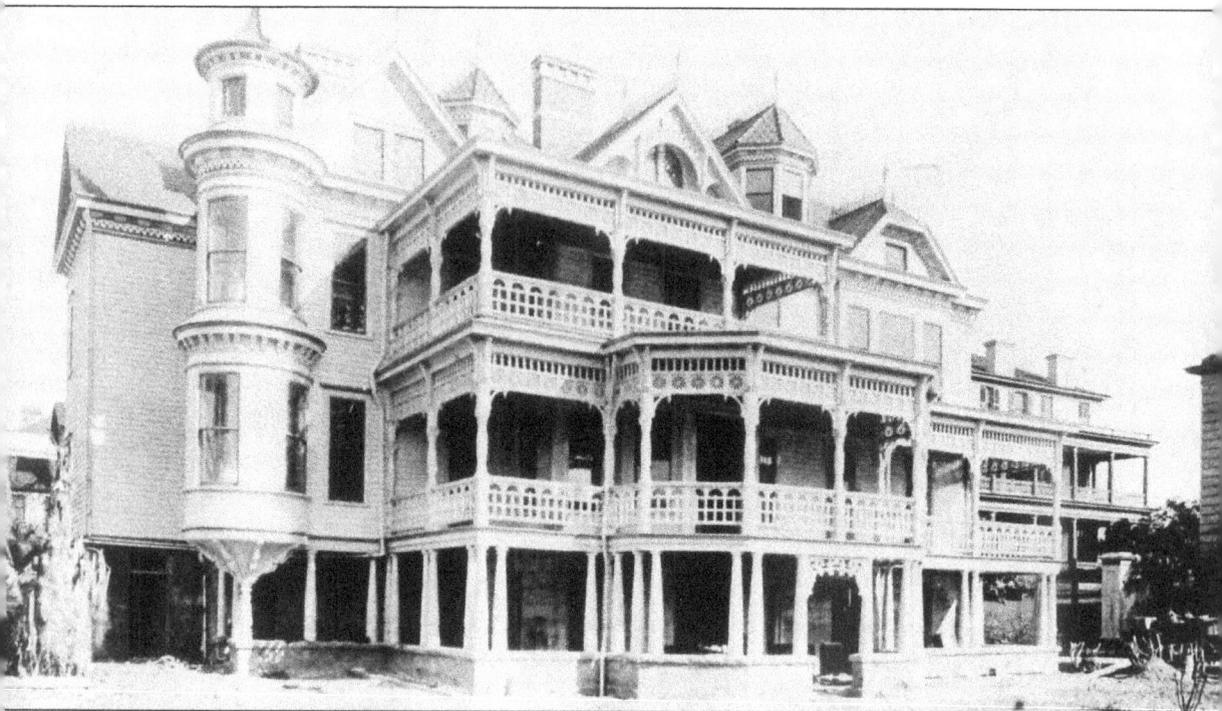

A.A. Heyward built his home in the latest Victorian fashion. The house stood at 11 Legare Street in the heart of the old downtown district, at the corner of Gibbes and Legare Streets. Enjoying some success despite a general downturn in Charleston's economy, Mr. Heyward was listed in the 1893 city directory simply as a "Planter." The house survived through the 1940s as apartments, but was torn down in the 1950s. (MK 22695, AWC)

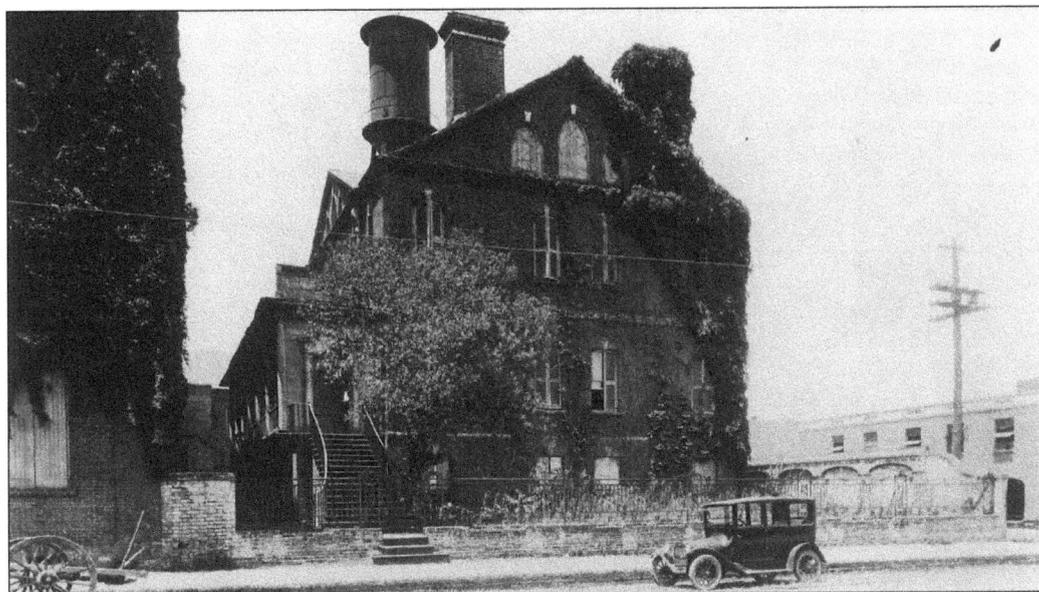

The J. Withers Mansion was an impressive suburban villa of the 1840s that stood near John and Meeting Streets across from the Joseph Manigault House. A fine property in the Regency taste, the house was purchased in 1880 by the Charleston Bagging & Manufacturing Company next door. The house survived as the superintendent's residence until 1926 when it was demolished. The site today is the courtyard of the Hampton Inn. The garden wall at the right of the photograph survives. (MK 6645A)

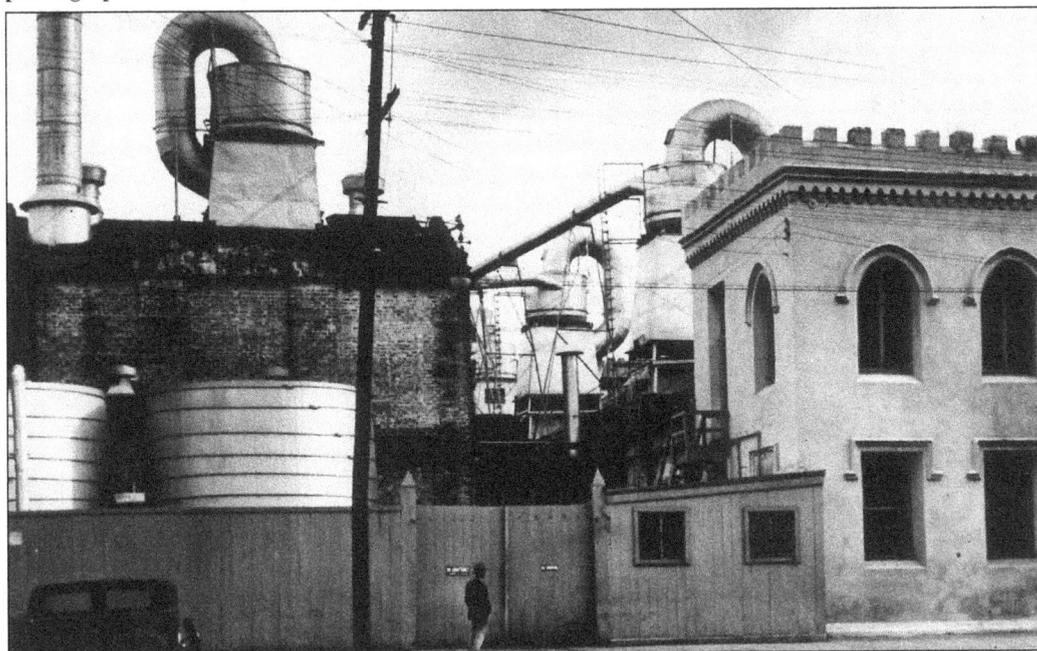

Charlestonians were forced to adapt to changing times following the War Between the States. Here, the carriage house of the J.C. Withers mansion has been adapted as part of the bagging plant that occupied the site. The carriage house was torn down in 1926. The building to the right was originally the Camden Depot. (MK 17408)

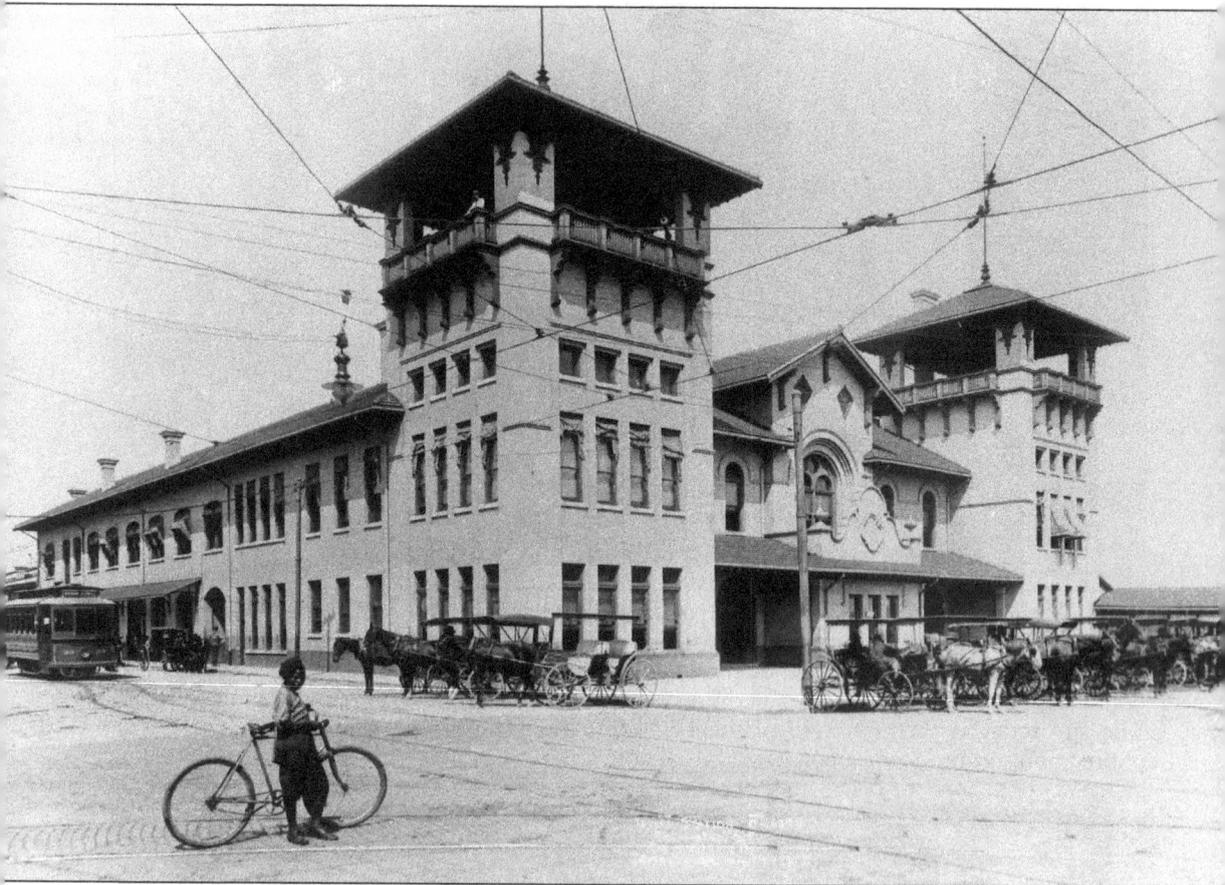

This 1910 view of Union Terminal was taken by photographer Irving Underhill of New York City. The station, built in the Beaux Arts California Mission style, served as the gateway to Charleston until it burned in a spectacular fire in 1947. (MK 10429)

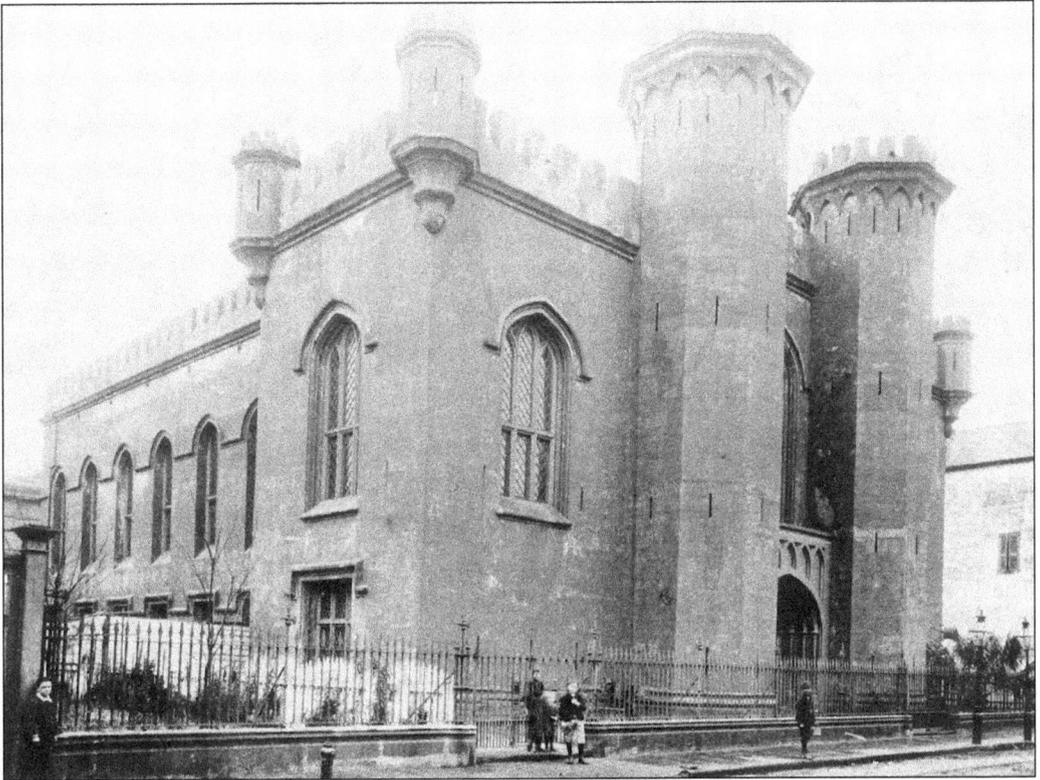

The German Artillery Hall was located on Wentworth Street between Meeting and King Streets. Built in 1845 by E.B. White, the hall served as a venue for concerts and events throughout the nineteenth and early twentieth centuries. The building was demolished in the 1930s to create a parking lot. (MK 22691, AWC)

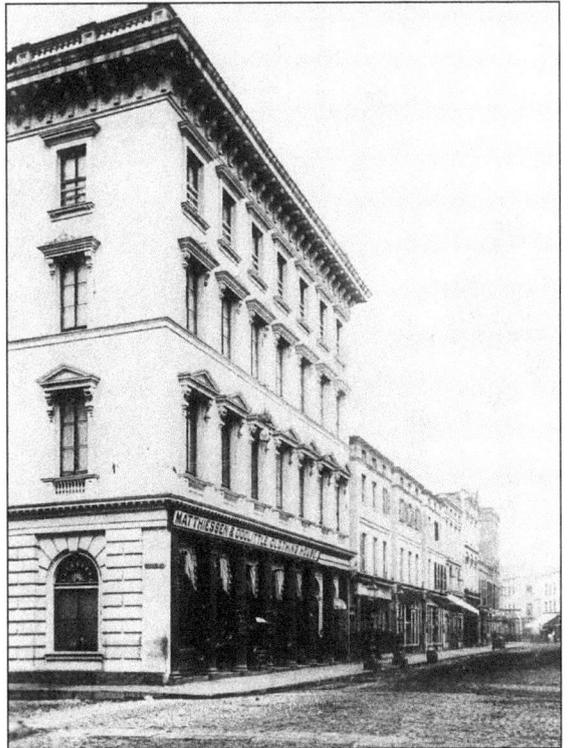

The Academy of Music was built, c. 1852, at the corner of Market and King Streets. The building housed a major auditorium after 1869. It was demolished in 1938 to make way for the Riviera Theater, which was subsequently renovated as a conference center in 1997. (MK 15325)

The Porter Academy was photographed in 1893. The main building seen here was designed by E.B. White in 1844 as a part of the U.S. Arsenal. It was occupied by Federal troops during Reconstruction and then leased to Reverend A. Toomer Porter for a school in the 1880s. The complex was demolished in 1963 to make way for the Medical University of South Carolina campus. (MK 22650, AWC)

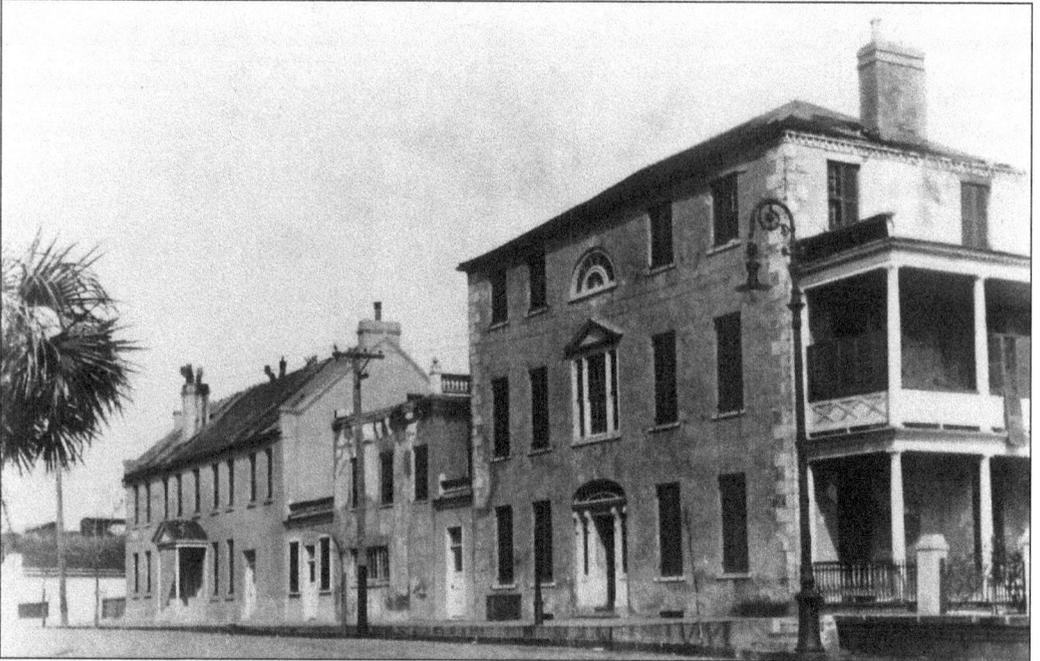

This view at the southern end of East Battery in 1900 shows the Missroon House at 40 East Battery. Directly adjacent stood several smaller offices and a large residence, which were demolished some time after 1925 to provide parking for the Omar Shrine Temple. Shrine offices were located in the Missroon House until 1996. It now serves as headquarters for the Historic Charleston Foundation. (MK 3416)

122

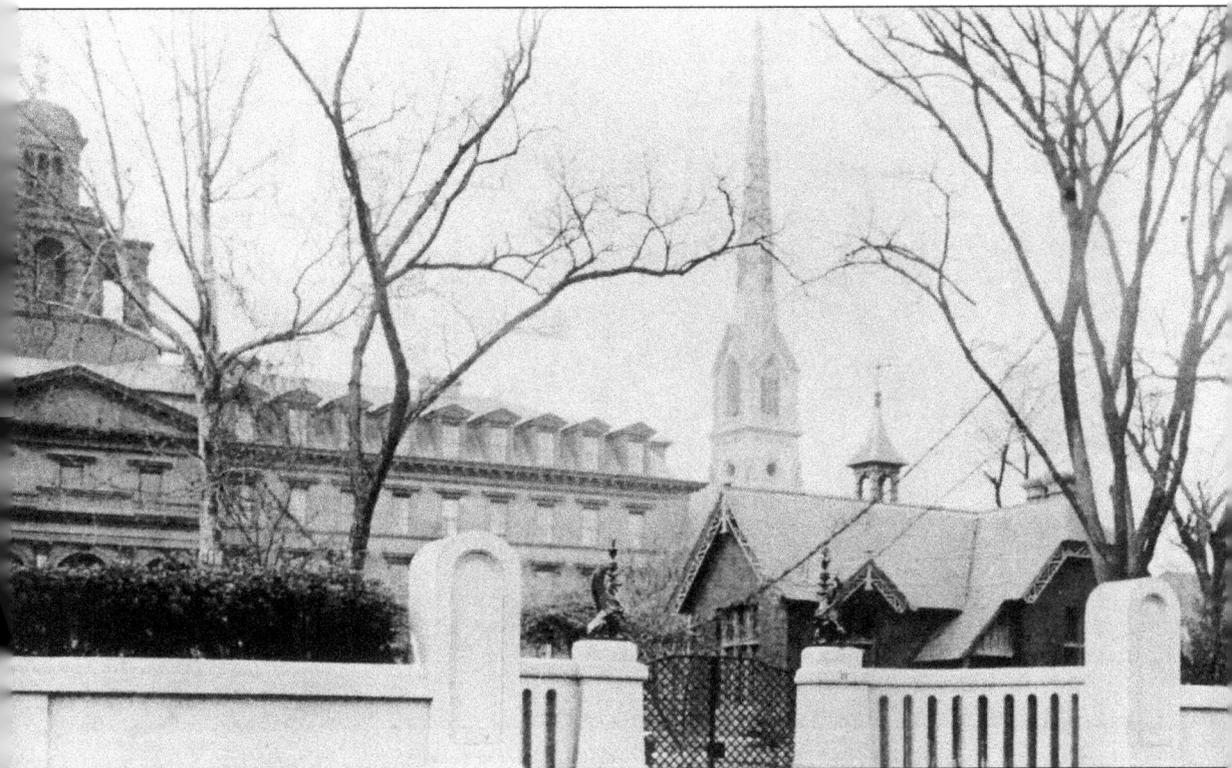

This 1893 view of the Charleston Orphan House shows the gatehouse and main building, designed by Jones and Lee Architects in 1853. The Orphan House was one of the major institutional buildings in the city, and it was demolished one hundred years later to provide for a new Sears and Roebuck store and parking. After one of the most heartfelt preservation fights in the city, the demolition of the Orphan House led the Preservation Society and Historic Charleston Foundation to double their efforts to prevent such losses in the future. (MK 22687)

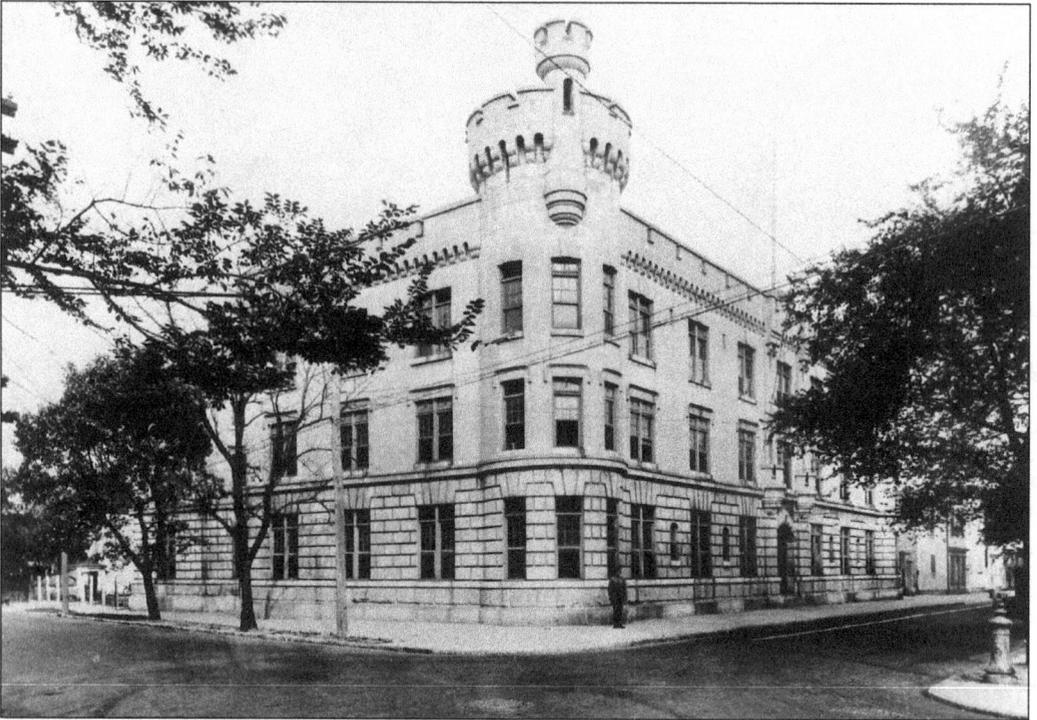

The City Police Station (c. 1914) at the corner of Vanderhorst and St. Philip Streets presented the formidable appearance of a castle. It occupied the full block between Vanderhorst and Warren Streets and was demolished in 1974. The Commissioners of Public Works built a new headquarters on the site in 1984. (MK 9120)

The Steam Fire Engine Company building at 41 Archdale Street was characteristic of the private volunteer engine houses placed strategically throughout the city. After consolidation of the city's fire departments in the 1880s, this building was used for commercial purposes. It was demolished in the 1950s in an effort to "clean up" the Archdale Street area. (MK 15254)

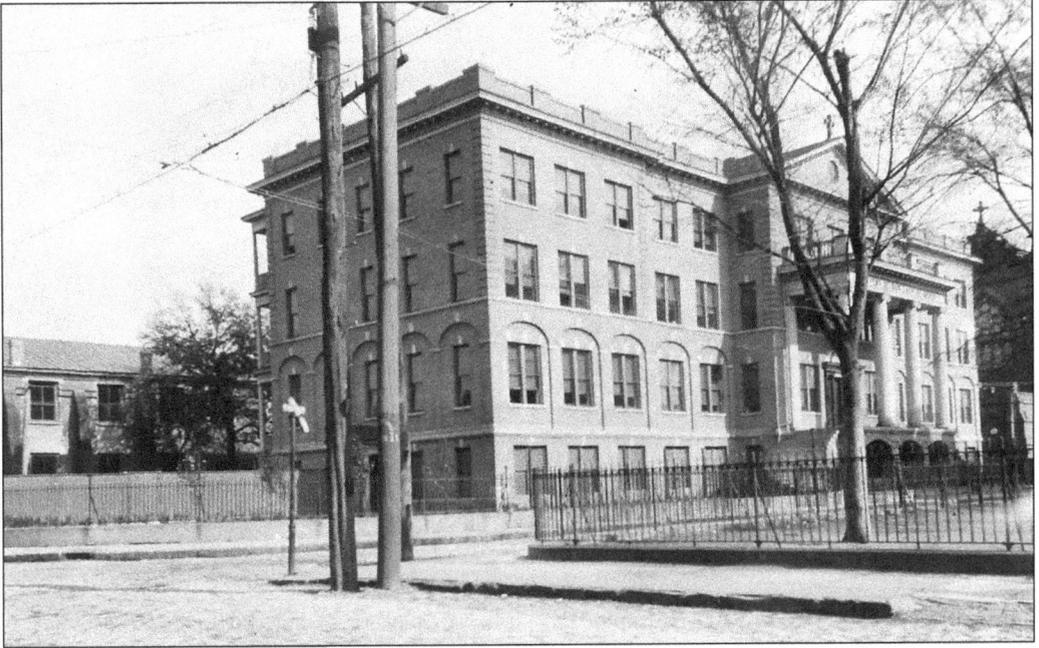

The Catholic Convent of the Cathedral of St. John was located at the corner of Queen and Legare Streets. It served the cathedral until the 1960s when it was torn down and replaced with townhouses. (MK 17093)

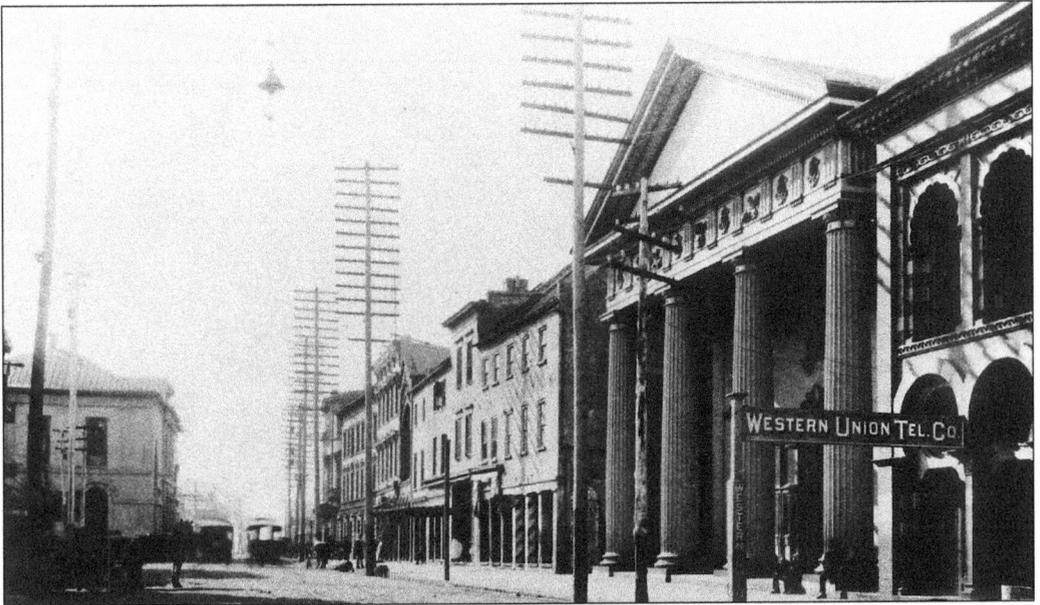

East Bay Street has historically been a center for trade and commerce. The Planters and Mechanics Bank at 139 East Bay Street provided regional banking services. The building was demolished in the 1960s to create a parking lot. The Farmers and Exchange Bank Building at the far right still exists. (MK 21205, AWC)

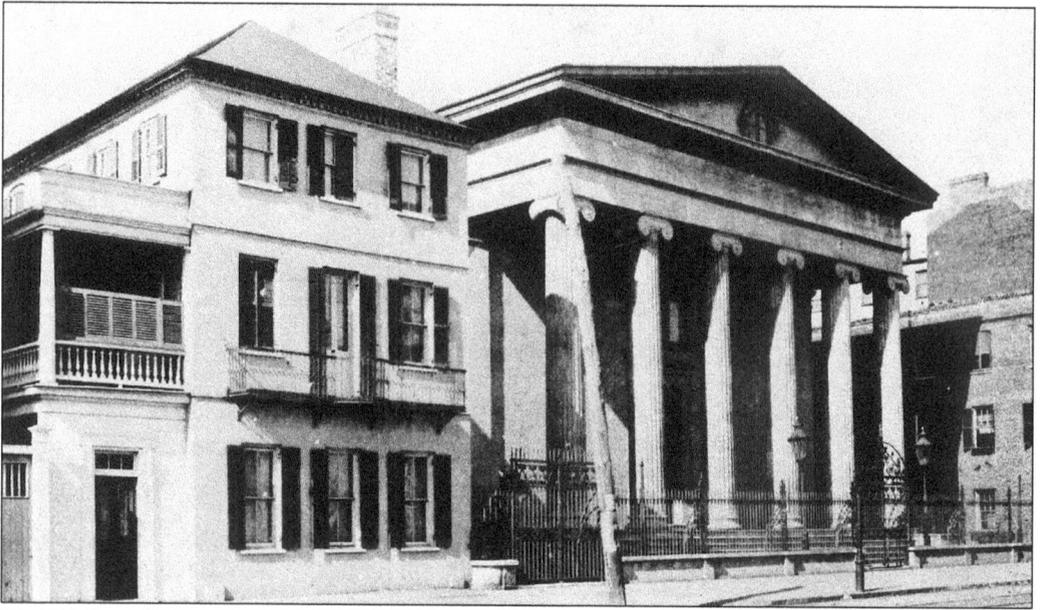

The Holmes House stood next to Hibernian Hall on Meeting Street until the 1970s when it was demolished to clear the way for the driveway to the County parking garage. (MK 21212)

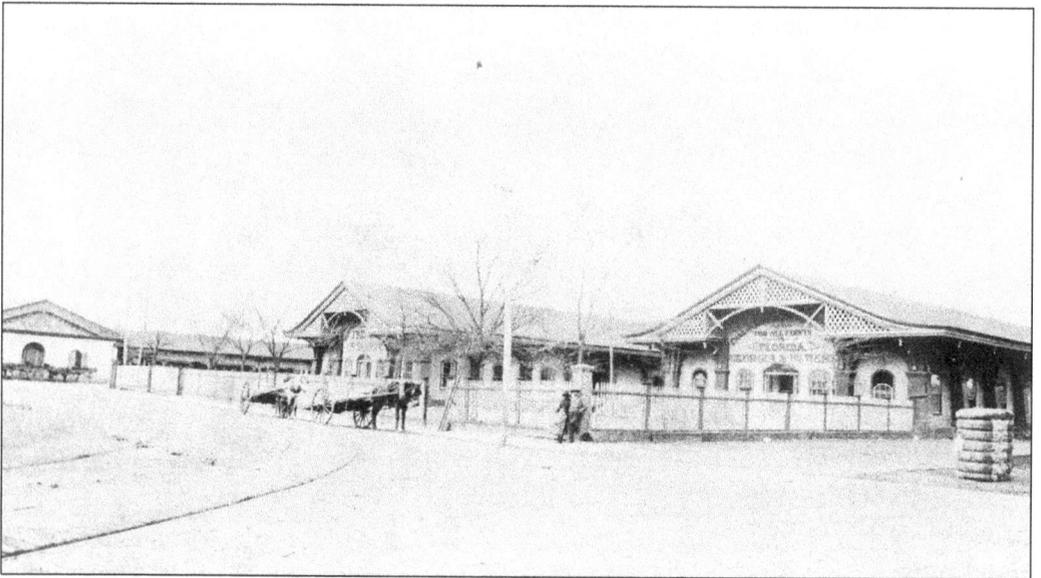

Seaboard Coastline Railroad Warehouses were located on East Bay Street. The last one burned in a tremendous fire in 1986. A bank building and commercial shopping center occupy the site today. (MK 22916, AWC)

126

These impressive houses on Wragg Mall were once called The Seven Days of the Week. They were built by William Aiken to provide rent income each day of the week. Two of the original seven houses remain on Wragg Mall. The Aiken-Rhett House, nearby on the corner of Wragg Mall and Elizabeth Street, now belongs to the Historic Charleston Foundation. (MK 22908, AWC)

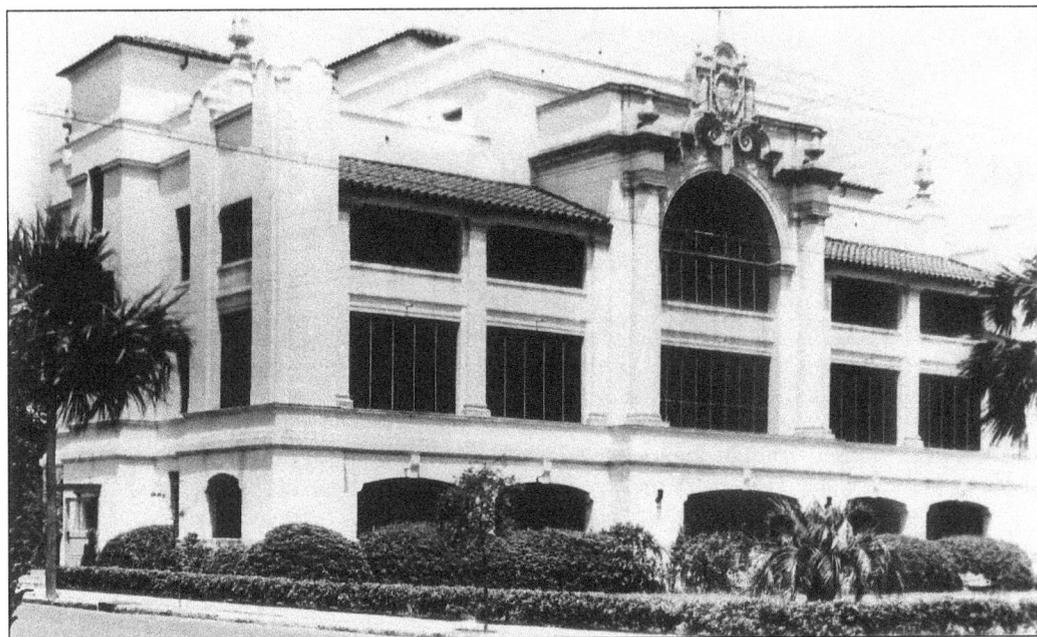

The St. Francis Hospital on Calhoun Street replaced the St. Francis Infirmary. Built in the Spanish revival style of the 1920s, the hospital building still stands, hidden by later additions, at the corner of Ashley Avenue. (MK 5792)

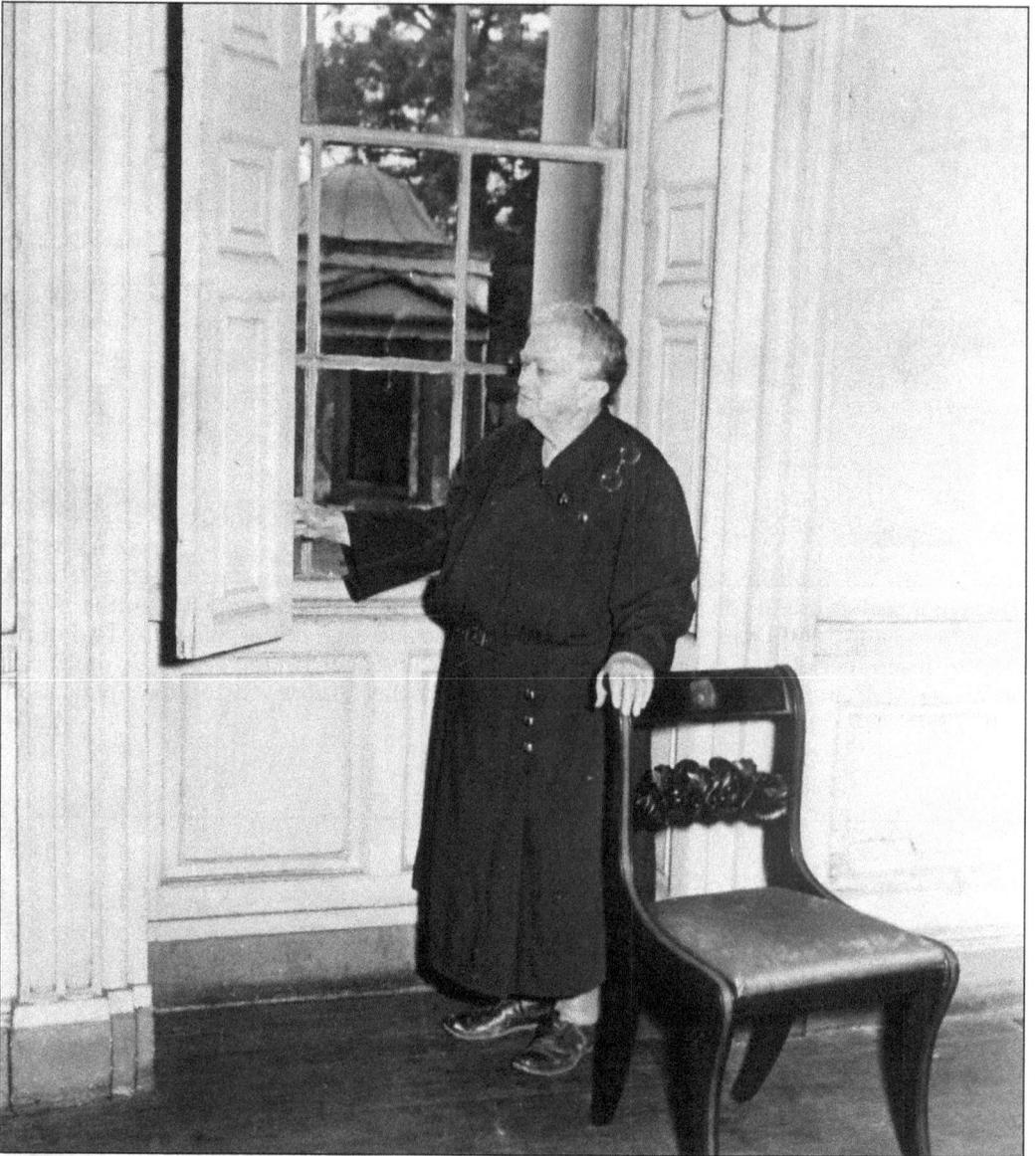

Susan Pringle Frost adjusts a shutter at the window of the Joseph Manigault House. The property, threatened with demolition to make way for a filling station, was saved by Mr. and Mrs. Ernest Pringle. The Preservation Society of Charleston was founded by Susan Pringle Frost and others to assist in the preservation of the house. As her friend Alston Deas observed:

> Her appreciation of Charleston Architecture was founded on a sentimental love for the old city. She saw it partly through a golden haze of memory and association, not only for its buildings, and streets, and vistas, but also for those men and women she had known, or of whom she had been told, who dwelt here, and created through a period of many generations, the town wherein she herself was privileged to dwell. . . . She never lost this personal feeling for the spirit, as well as the body, of Charleston. ("They Shall See Your Good Works," *Preservation Progress*, May 1962).

"Miss Sue" went on to save many other Charleston properties through her tireless efforts, and the Preservation Society continues her work today. (MK 5322)

www.ingramcontent.com/pod-product-compliance
Lightning Source LLC
Chambersburg PA
CBHW081415160426
42812CB00087B/2007